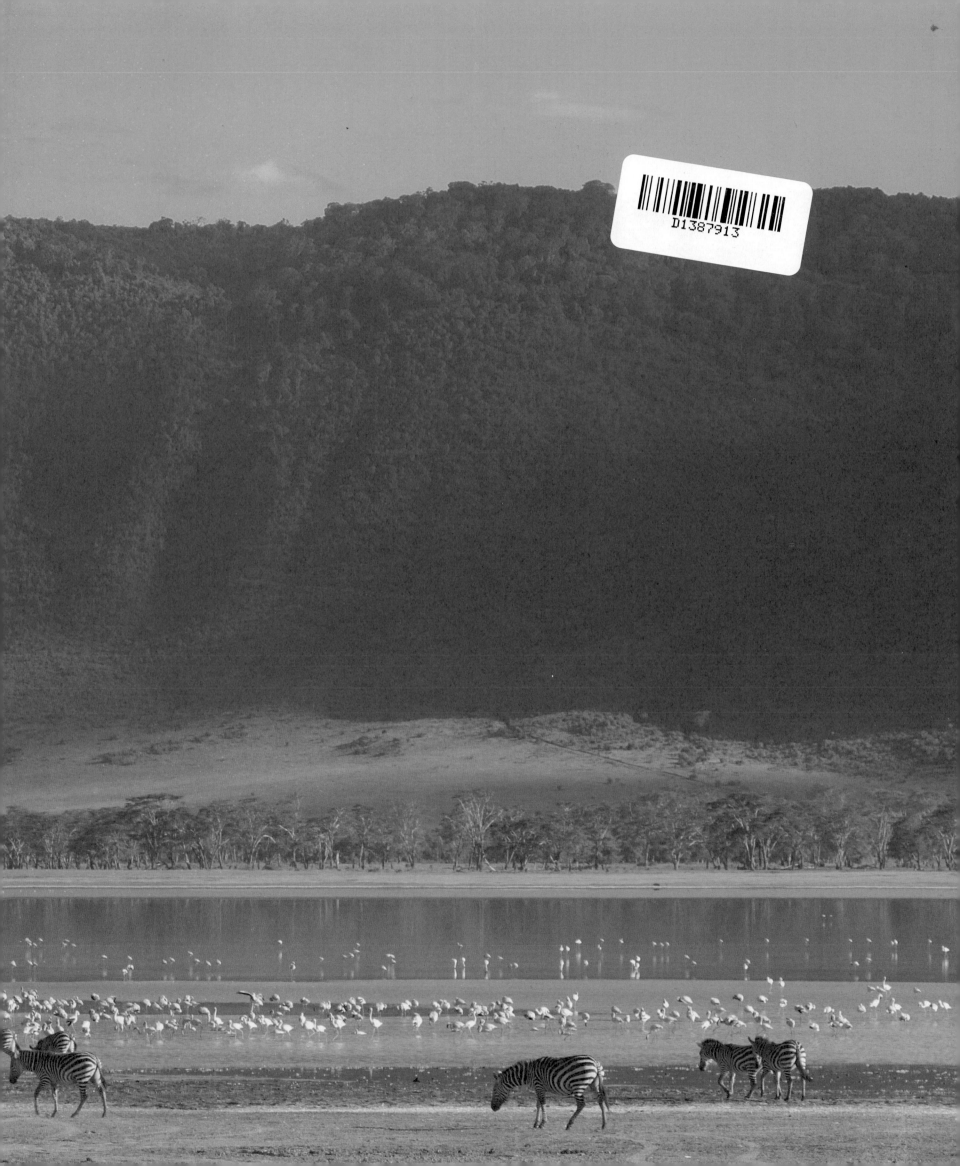

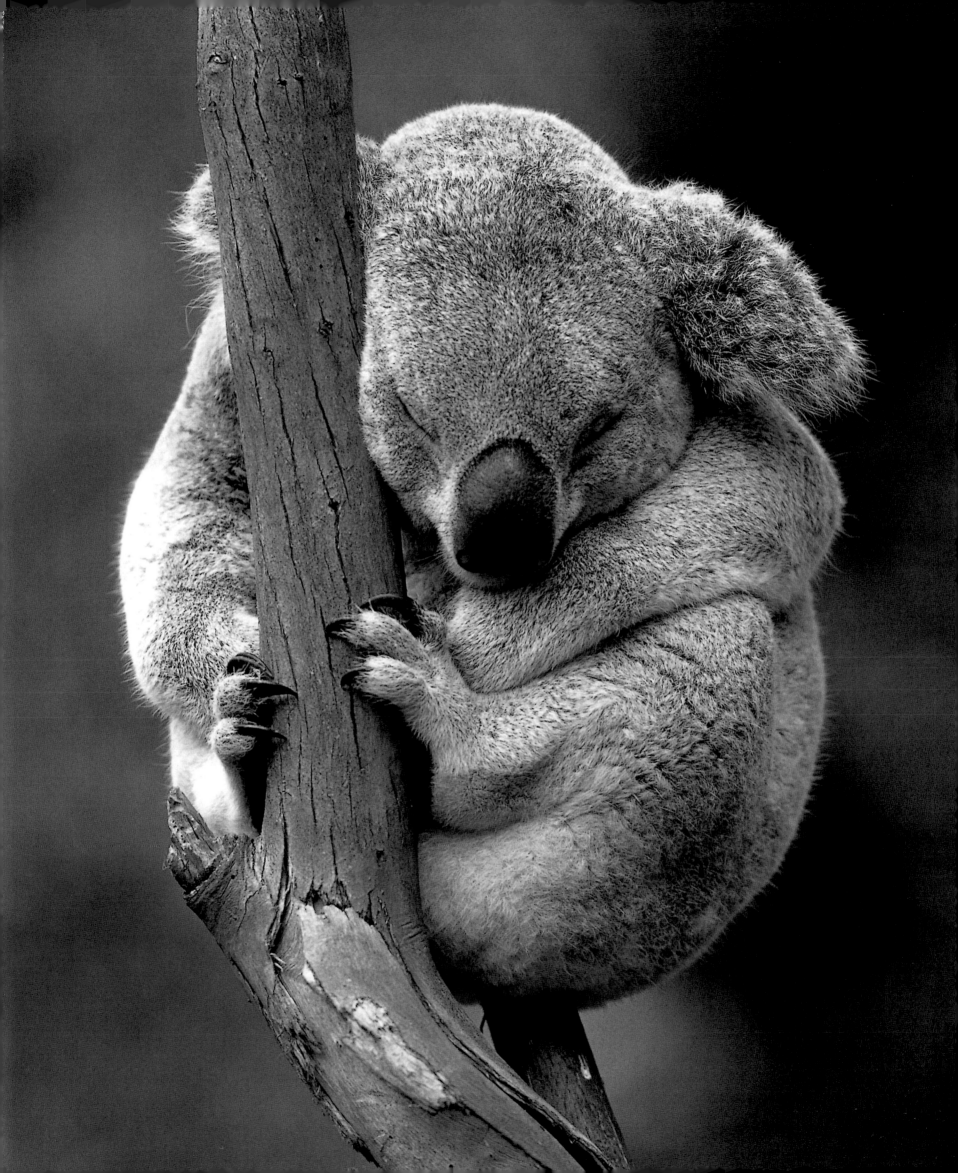

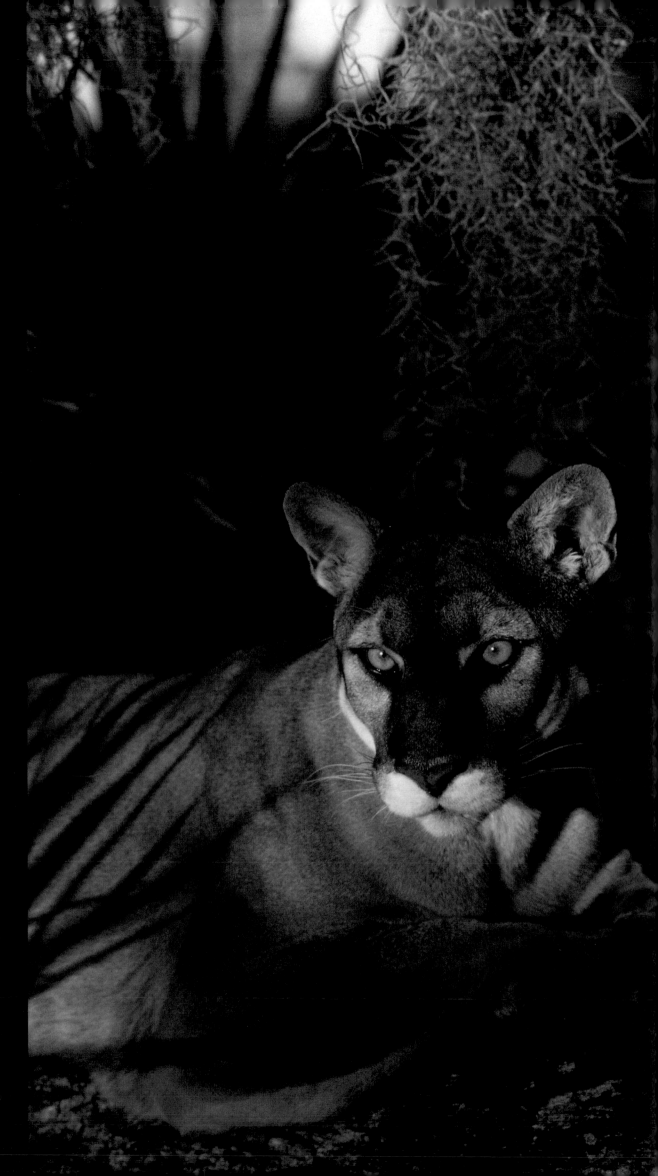

THIS IS A CARLTON BOOK

Text copyright © 2007 Carlton Publishing Group
Design copyright © 2007

Published in 2007 by Carlton Books Ltd
20 Mortimer Street
London
W1T 3JW

A CIP catalogue for this book is available from
the British Library.

ISBN 978-1-84442-637-9

Project Editor: Gareth Jones
Copy Editor: Liz Dittner
Senior Art Editor: Zoe Dissell/Anna Pow
Design: Smith Design
Picture research: Steve Behan
Production: Lisa Moore

Printed and bound in Dubai

10 9 8 7 6 5 4 3 2 1

PREVIOUS Koalas pass the overwhelming majority of each
day asleep, and their few waking hours are spent eating.

RIGHT Variously known as the Puma, Cougar or Mountain
Lion, *Puma concolor* is North America's largest cat.

GLOBAL SAFARI

JAMES PARRY

CONTENTS

LEFT Adult Green Tree Pythons are a bright iridescent green,
whereas the young of the species are yellow in colour.

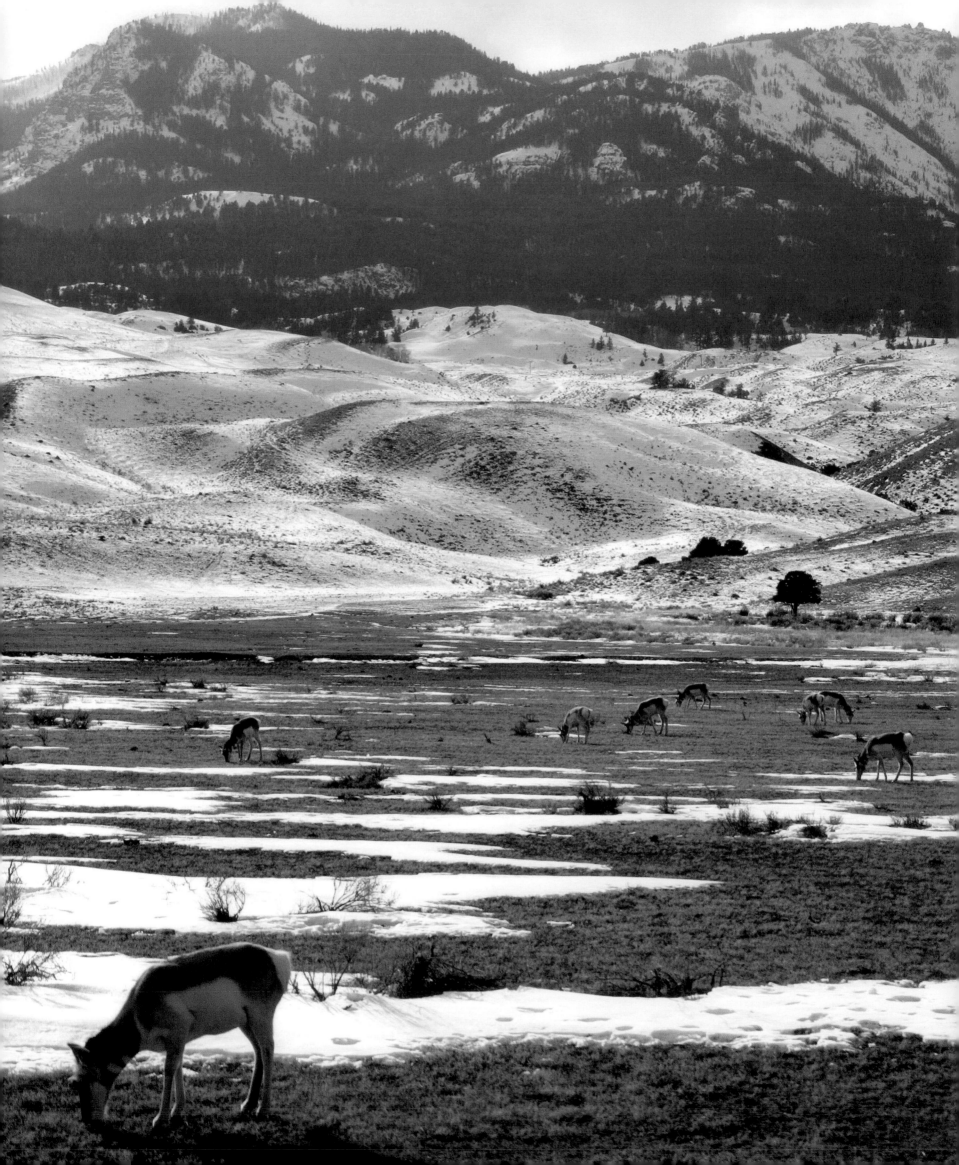

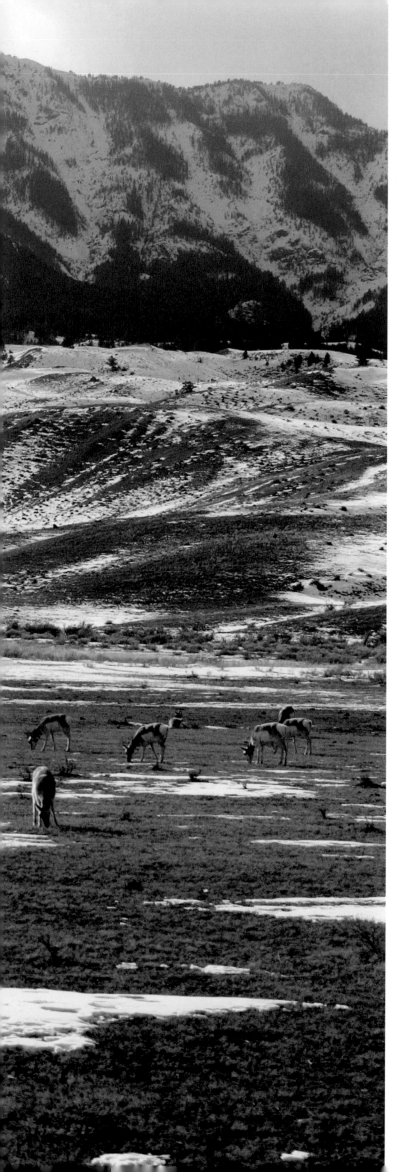

FOREWORD

Sundown in the spiny forests of Madagascar, watching graceful sifaka lemurs dance beneath the strange coral-like shapes of the Didiera trees, listening to the mesmerising songs of gibbons as they swing through the immense trees of the Bornean rainforest at dawn, breathing in the clean mountain air while standing on the top of the world surrounded by the snowy peaks of the Himalaya, paddling along rich, coffee-brown waterways in the heart of the Amazon rainforest: these are experiences that are etched deeply into my heart and fill me with joy whenever I think of them. We are all too often swept up in the hurly burly of our busy lives, but the natural world still has the power to stop us in our tracks and make us acutely aware of the here and now.

There are still many places where nature holds sway, where the rhythm of life continues as it has for thousands of years, where the richness and diversity of life is there for all to see. This book is a celebration of fifty of the most beautiful and exciting wildlife hotspots on Earth, a world tour which takes you through a variety of dramatic landscapes to come face to face with nature at its best – from the awe-inspiring megafauna of the great plains of the East African Serengeti, to the watery wilderness of the Pantanal in South America and from the tens of millions of seabirds nesting on the wild and remote islands of South Georgia to the orange clouds of Monarch butterflies wintering in Mexico. These are breathtaking spectacles that in the words of Douglas Adams just make you want to "burst into spontaneous applause"

This is a superbly rich guide for the intrepid traveller and armchair explorer alike. James Parry's evocative writing, combined with stunning photography, takes us off the beaten track into wonderful oases of nature, painting an intimate picture of these places and their wildlife and providing an insight into why they are so rich. Often we tend to think of the richest wildlife living only in far-flung corners of the world, but the section on Europe shows us how much there is still tucked away on our doorstep, some of which owes its diversity to man's traditional management of the land, such as in the Picos de Europa in Spain.

This is a critical time in our history, when we are facing the loss of much of our natural environment, and this book does not shy away from confronting some of the problems facing our remaining wilderness areas. At the same time, however, it is important that we are reminded of our own power to make a difference to the world around us. This book does just that through stories such as the successful reintroduction of wolves to Yellowstone National Park and European Bison to the Bialowieza forest on the border of Belarus and Poland. Projects like this are not without their difficulties, but these examples show us that we can turn things around and that with careful management, it is possible for people and wildlife to co-exist in an increasingly crowded world.

Books like this act as an inspiration to us all to strive to protect the beautiful places and wonderful wildlife of the planet we call home.

Charlotte Uhlenbroek

OPPOSITE A herd of Pronghorn
Antelope grazes in Yellowstone
National Park in a scene reminiscent
of much of the central United States
before the mid-nineteenth century.

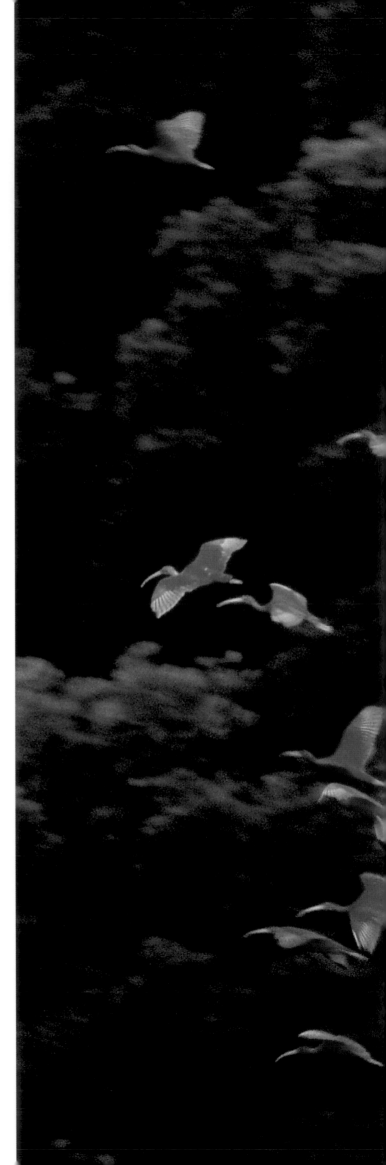

INTRODUCTION

Some of the most exciting moments of my life have been spent watching wildlife. Brought up in suburban London, from an early age I longed for the chance to travel to places with "proper animals", something larger and potentially more exciting than the hedgehogs and foxes I was able to watch near home. Annual summer holidays in Wales were simply not enough, although looking back on those years I now realise that it was precisely then that I developed the love of wildlife that has provided me with so much pleasure ever since.

Having the opportunity to travel and work overseas – and visit some of the great places for wildlife – is a real privilege, but over time it has only gone to reinforce a basic point: that it is the very fact that you can study wildlife anywhere, in the most unlikely of circumstances, that makes it such a stimulating and rewarding thing to do. Equally fundamental is the fact that some of the most remarkable wildlife spectacles involve the most unlikely creatures – for me, the sight of thousands of seabirds whirring above their breeding cliffs on St Kilda is definitely in the same league as watching Lions make a kill or Humpback Whales indulge in playful breaching. Size may matter in some circumstances, but it is definitely not everything in the natural world.

The choice of sites in this book reflects both geographical variety and diversity in terms of flora and fauna. It also touches on a range of associated issues, from the impact of poaching, habitat destruction and climate change through to conservation strategies and the potential value of ecotourism. For many of the species featured in this book the immediate outlook is not good; the next few decades could see the extinction in the wild of such iconic species as the Polar Bear, for example. In the case of the Tiger, the end may come even sooner. The work of organisations such as the Worldwide Fund for Nature, Wildlife Conservation Society and Birdlife International certainly offers hope and direction for the future, but the bottom line is that there is increasingly less space in the world for wildlife. Indeed, across much of Africa and Asia the number of large mammals surviving outside of protected areas has collapsed in recent decades and is still falling fast.

As the world's human population soars, so pressure on the environment intensifies. In rapidly developing countries, wildlife – and, more significantly, the habitats on which it depends – are often perceived as either a resource to be exploited to the point of exhaustion, or as an impediment to economic growth and progress. Yet, easy as it may be to become dispirited, we can turn the situation round. Indeed, in cases where wildlife is perceived by local people as worth more to them alive than dead, conservation becomes viable economically and thereby sustainable in the longer term. Ecotourism can be a valuable tool towards this end, so long as it puts money in the pockets of those living at the point of delivery. But equally important is the battle to win hearts and minds, to find a way of reconnecting people – growing numbers of which live in an increasingly urbanized and industrial context – with wildlife, and of helping kindle a sense of wonderment at the beauty and diversity of the natural world.

Ask the friends and family of any ardent naturalist and they will regale you with stories of enforced hours spent in freezing bird hides or route marches across windswept marshland in search of something small and brown that managed to evade observation, despite all the effort involved. Yet I would defy anyone not be moved by wildlife at some point in their lives. Surely even the most disinterested cynic could not fail to be captivated by the high-octane antics of a feeding hummingbird or by a tiny newly hatched turtle making its first desperate dash for the sea? We need to encourage these experiences, for it is through them that the forces striving for the protection and conservation of wildlife stand the best chance of ultimate success.

James Parry

RIGHT One of the world's most dramatic bird spectacles: Scarlet Ibises flying in to roost in the Caroni Swamp in Trinidad.

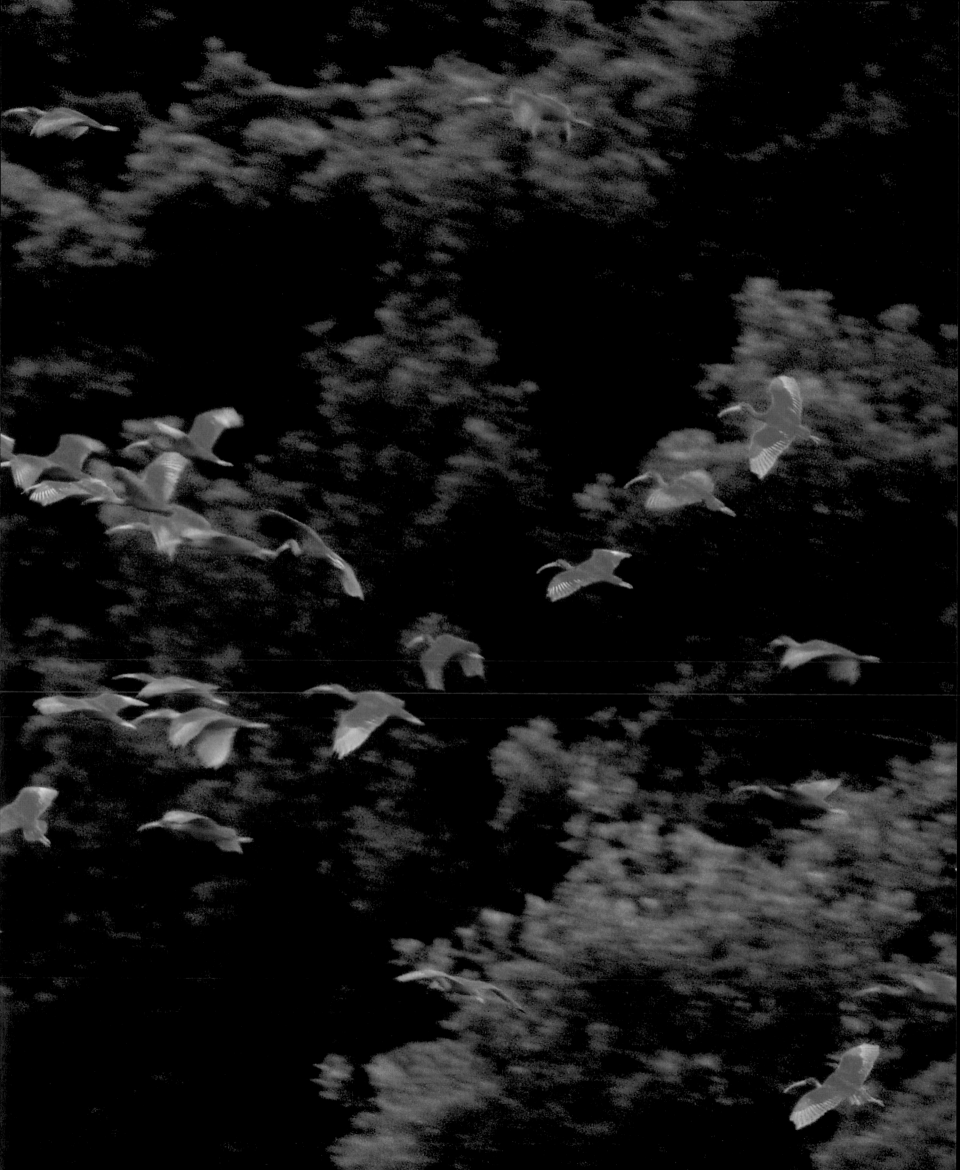

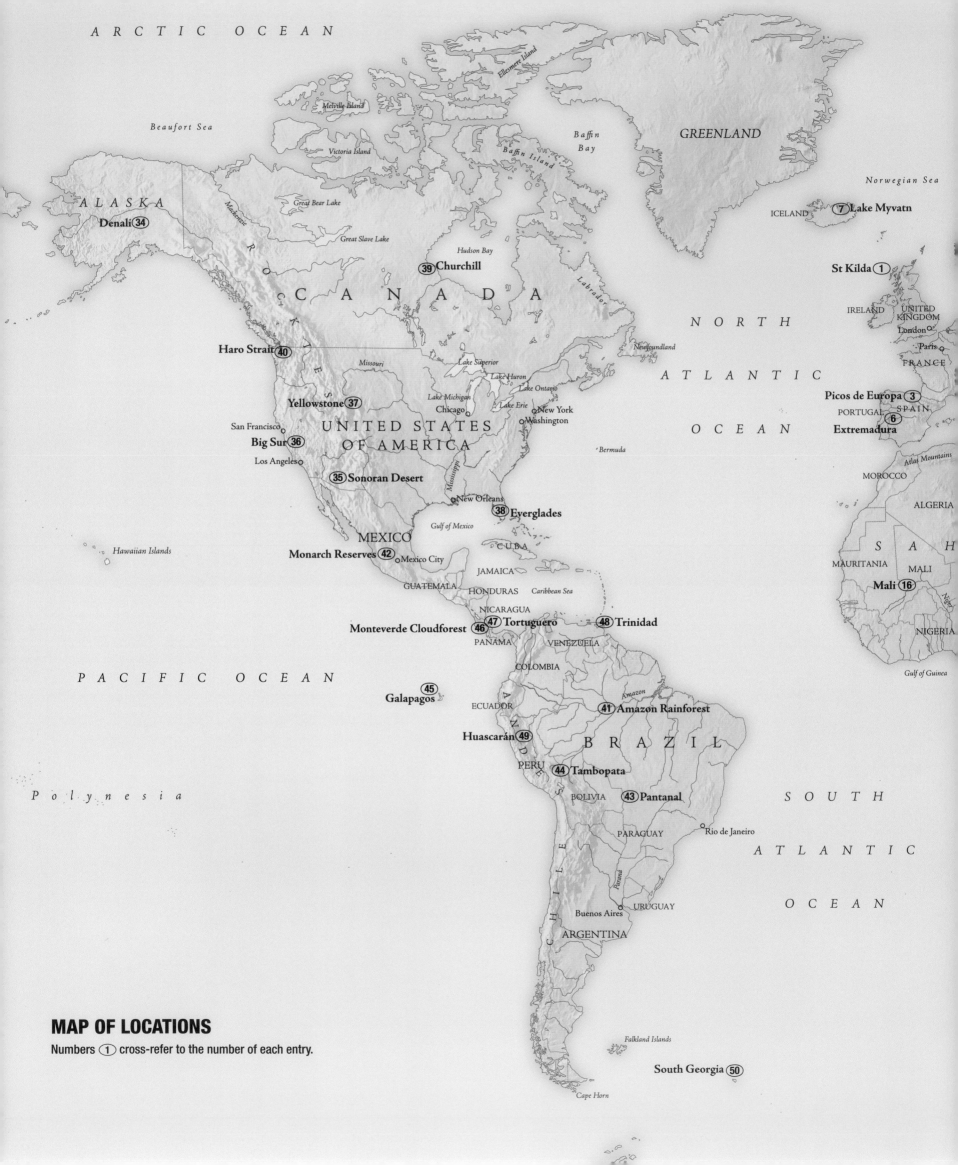

ARCTIC OCEAN

Beaufort Sea

GREENLAND

Melville Island

Victoria Island

Baffin
Bay

Norwegian Sea

ALASKA

ICELAND ⑦ Lake Myvatn

Denali ㉞

Great Bear Lake

Ellesmere Island

Baffin
Island

Great Slave Lake

Hudson Bay

C A N A D A

Labrador

St Kilda ①

IRELAND UNITED
KINGDOM

London

⑨ Churchill

NORTH

Mackenzie

Haro Strait ㊵

Missouri

Lake Superior

Newfoundland

A T L A N T I C

Paris

FRANCE

Yellowstone ㊲

Lake Huron

Lake Michigan

Chicago

Lake Ontario

Lake Erie

New York

Washington

O C E A N

Bermuda

Picos de Europa ③

PORTUGAL

SPAIN

⑥

Extremadura

San Francisco

UNITED STATES
OF AMERICA

Atlas Mountains

Big Sur ㊱

MOROCCO

Los Angeles

㉟ Sonoran Desert

Mississippi

New Orleans

S A H

MEXICO

㊳ Everglades

ALGERIA

Gulf of Mexico

Hawaiian Islands

CUBA

Monarch Reserves ㊷

Mexico City

MAURITANIA

MALI

JAMAICA

GUATEMALA

HONDURAS

Caribbean Sea

Mali ⑯

NICARAGUA

Monteverde Cloudforest ㊻

㊼ Tortuguero

㊽ Trinidad

NIGERIA

P A C I F I C O C E A N

PANAMA

COLOMBIA

VENEZUELA

Gulf of Guinea

Galapagos ㊺

ECUADOR

Amazon

㊶ Amazon Rainforest

Huascarán ㊾

B R A Z I L

PERU

㊹ Tambopata

P o l y n e s i a

BOLIVIA

㊸ Pantanal

S O U T H

PARAGUAY

Rio de Janeiro

A T L A N T I C

Paraná

URUGUAY

O C E A N

Buenos Aires

ARGENTINA

MAP OF LOCATIONS

Numbers ① cross-refer to the number of each entry.

Falkland Islands

South Georgia ㊿

Cape Horn

ARCTIC OCEAN

Svalbard

Franz Joseph Land

Severnaya Zemlya

New Siberia Islands

Barents Sea

Novaya Zemlya

East Siberian Sea

Wrangel Island

NORWAY

SWEDEN

FINLAND

S I B E R I A

Lena

St Petersburg

Baltic Sea

Moscow

Volga

R U S S I A N F E D E R A T I O N

Bering Sea

Lake Baykal

Sea of Okhotsk

Aleutian Islands

Berlin

POLAND

GERMANY

(2) **Bialowieza Forest**

UKRAINE

KAZAKHSTAN

Volga

Aral Sea

Lake Balkhash

MONGOLIA

(5) **Alps**

ROMANIA

(4) **Danube Delta**

Black Sea

Caspian Sea

Rome

ITALY

GREECE

TURKEY

Mediterranean Sea

IRAQ

IRAN

PAKISTAN

C H I N A

(18) **Ladakh**

Indus

Beijing

(27) **Qinling**

Yellow Sea

Sea of Japan

JAPAN

Tokyo

LIBYA

EGYPT

Red Sea

SAUDI ARABIA

Cairo

NEPAL

Ganges

Bharatpur (26)

(24) **Kaziranga**

Shanghai

Yangtze

A R A

NIGER

CHAD

SUDAN

YEMEN

Nile

Gir Forest (20)

(21) **Oman**

I N D I A

(22) **Kanha**

Mumbai

BURMA

Hainan

P A C I F I C O C E A N

ETHIOPIA

SOMALIA

CAMEROON

KENYA

(14) **Gabon**

Ivindo

Congo

Lake Victoria

Lope

Loango

(11) **Meru**

Bwindi (17)

(9) **Serengeti**

(15) **Ngorongoro Crater**

Mahale (8)

ZAIRE

Lake Tanganyika

TANZANIA

Lake Nyasa

SRI LANKA

(25) **Yala**

THAILAND

Bangkok

South China Sea

Kinabatangan

Taman Negara (19)

Danum (23)

Kuala Lumpur

M A L A Y S I A

Sumatra

Borneo

Sulawesi

PHILIPPINES

New Guinea

I N D O N E S I A

(31) **Tari Gap**

PAPUA NEW GUINEA

SEYCHELLES

Java

Timor

I N D I A N O C E A N

ANGOLA

ZAMBIA

MOZAMBIQUE

(13) (12) **Okavango**

Damaraland

NAMIBIA

BOTSWANA

Kalahari Desert

MADAGASCAR

Ifaty

(10) **Spiny Forest**

Berenty

(28) **Kakadu**

(32) **Daintree**

A U S T R A L I A

FIJI

SOUTH AFRICA

Cape Town

Cape of Good Hope

Perth

Flinders Bay

Fitzgerald River Nat. Park

(33)

(30) **Warrumbungle**

Sydney

Melbourne

Tasmania

NEW ZEALAND

(29) **Kaikoura**

S O U T H E R N O C E A N

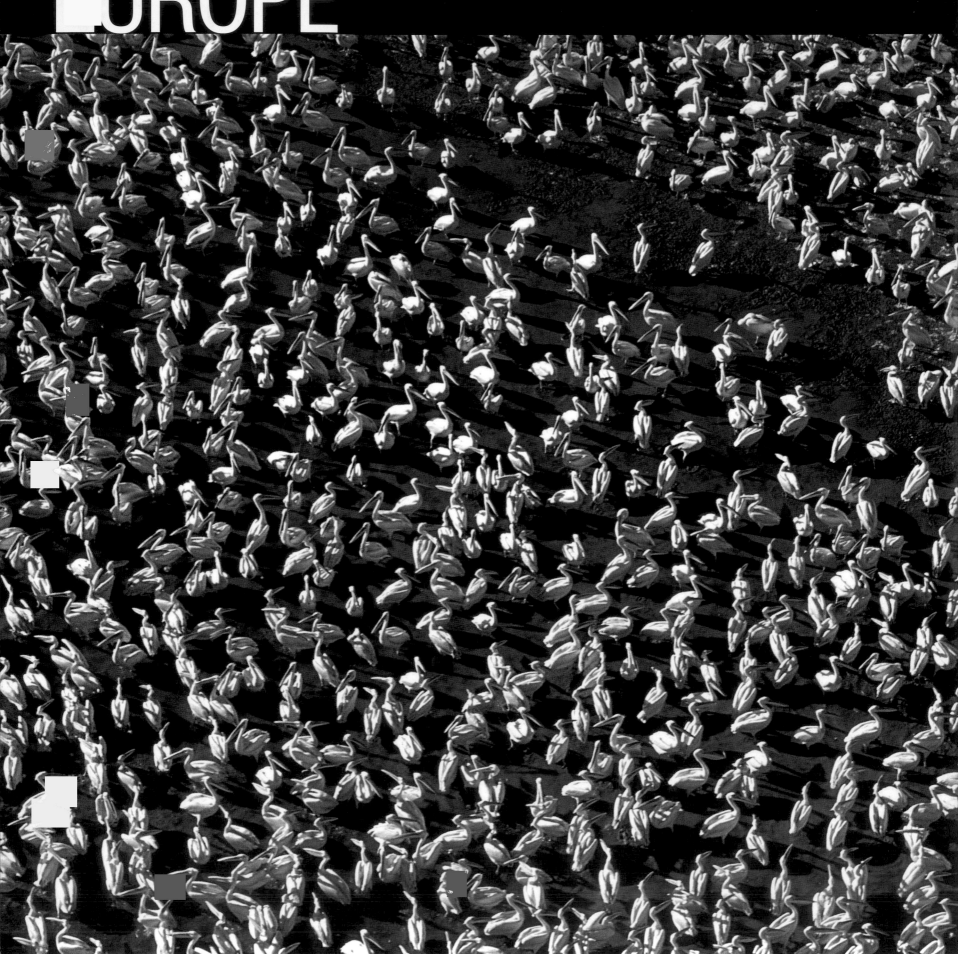

On the face of it, a wildlife safari in Europe might seem an odd proposition. This is, after all, one of the most developed parts of the world, much of it densely populated and with swathes of countryside turned over to industrial production of one sort or another. However, there are still wild places across Europe that remain suitable for large predators such as Brown Bear and Wolf, and impressive birds like Black Vulture and Great Bustard. The influence of the conservation lobby is felt as powerfully in parts of Europe as anywhere, and extensive protected areas are designed to safeguard a vast range of habitats. The priority accorded by many European countries to the conservation of wildlife is in part reflected in the number and range of programmes designed to save, or reintroduce, species once lost or at the very brink of extinction. Such flagship wildlife is mostly doing well, but environmental pressures remain intense. Today much of Europe's flora and fauna lives in largely man-made landscapes, the ability to adapt to new habitats and changing environments an increasingly critical factor for survival.

BELOW Thousands of Great White Pelicans gathered at one of their favoured locations in the Danube Delta.
Outstanding for waterbirds, the delta offers some of the best birdwatching in Europe.

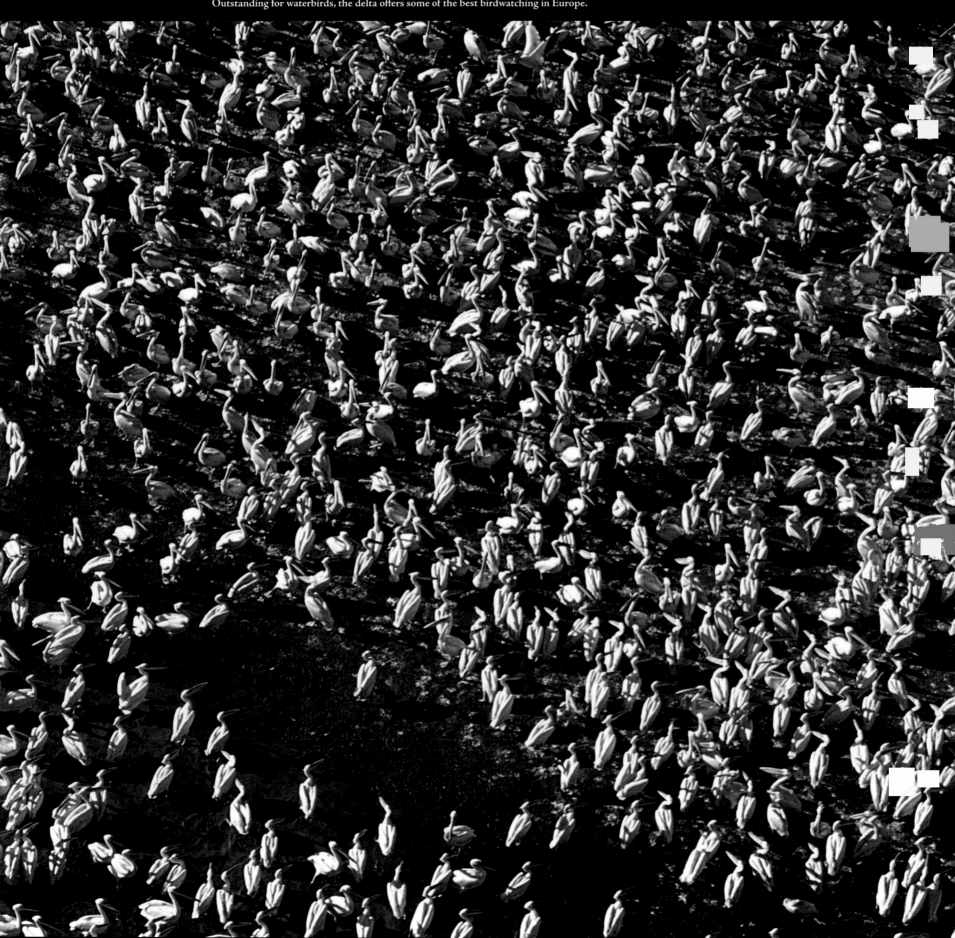

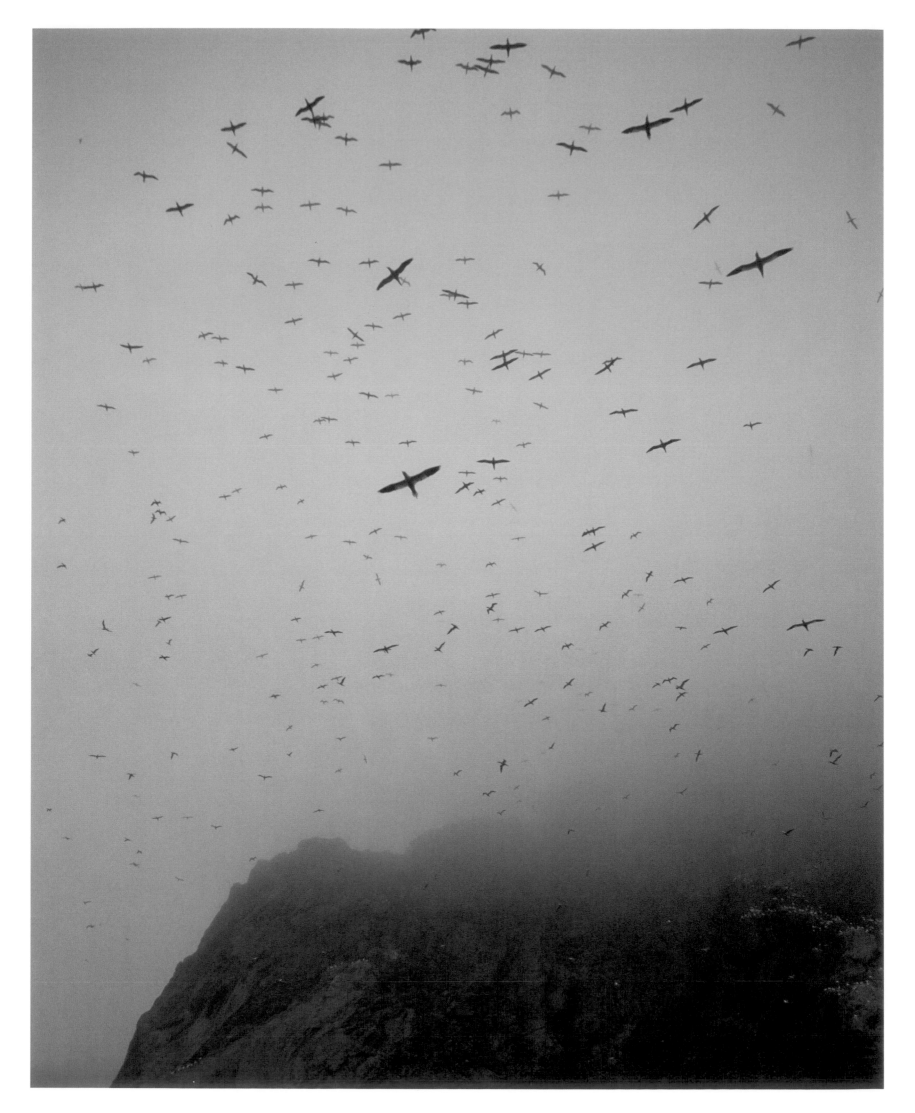

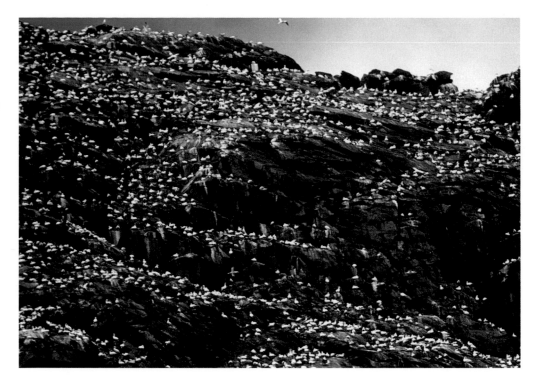

1. The Seabirds of St Kilda

The remote islands off the north and west coasts of the United Kingdom provide an unexpected location for one of the world's most extraordinary wildlife spectacles, yet one that rarely attracts the attention that it merits. It is here, on the very edge of Europe and against the backdrop of the roaring North Atlantic Ocean, that millions of seabirds rear their young in some of the biggest bird colonies found anywhere in the world. Layered up on towering cliffs up to 400 metres (1,300 feet) high, these amount to a real "Seabird Manhattan".

This is an area of dramatic, if forbidding, landscapes. Much of the terrain is treeless and inhospitable, at least to most species of landbird and mammal, and the climate is harsh. Although the presence of the Gulf Stream acts as a moderating influence on temperature, rainfall levels are high and this is one of the windiest places in Europe, with gusts of 170 kilometres (105 miles) per hour not at all unusual during the autumn and winter. Yet during the spring and summer the two basic requirements for seabird life are present here in spades – secure locations in which to lay eggs and rear young (provided by the area's abundant cliffs and offshore islands), and an adequate supply of food with which to sustain themselves and their broods (available in the ocean around them).

Accessing some of the best sites for nesting seabirds is not for the faint-hearted, and this is certainly the case for those determined to visit the biggest congregation of all: that located on and around the remote island of St Kilda. 97 kilometres (60 miles) west of the Outer Hebrides and accessible only by boat, and even then only when sea conditions permit, the island and its associated islets (more often known as "stacs") are home to at least 700,000 seabirds during the breeding season, April to August. This is the largest seabird colony in the north-east Atlantic and holds sizeable percentages of the total world population of certain species. Here one can see the largest Northern Gannet (*Morus bassanus*) colony in the world, with some 60,000 pairs, as well as Western Europe's biggest Northern Fulmar (*Fulmarus glacialis*) colony (67,000 pairs) and the UK's most populous Atlantic Puffin (*Fratercula arctica*) colony (250,000 pairs, despite having declined from an earlier estimated total of two million pairs).

The various species of seabird – 17 in total – that flock to the St Kilda group during the breeding season each have particular requirements and occupy slightly different habitat niches. The short turf of the cliff-top is home to crowds of Puffins, which nest in rabbit burrows and often evict the original tenants. Gannets are also cliff-top birds, needing open, flat surfaces or wide ledges on which to nest. Fulmars prefer the interface of grassy slope and rock ledge, laying their eggs in simple scrapes, whilst Common Guillemots (*Uria aalge*) and Razorbills (*Alca torda*) are truly birds of the cliff-face, incubating their eggs on bare ledges only a few centimetres wide and often next to a sheer drop of

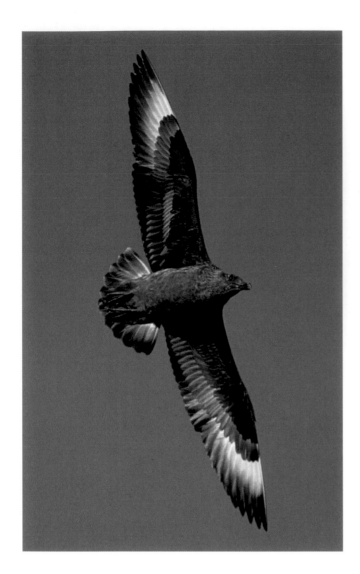

many metres to the sea below. Black-legged Kittiwakes (*Rissa tridactyla*), Great Cormorants (*Phalacrocorax carbo*) and European Shags (*Phalacrocorax aristotelis*) favour similar sites, but assemble a basic nest of seaweed in which to tend their eggs. Right at the bottom of the cliffs, often within range of the spray from the breaking waves, are the Black Guillemots (*Cepphus grylle*), which nest in crevices in the boulder-strewn shore.

A visit to these cliffs in May and June is a truly awesome spectacle, with countless numbers of birds whirring around, flying to and from the ledges as they feed their young, or bathing and resting on the water below. The levels of noise and activity are bewildering. Amazingly, some of St Kilda's most abundant seabirds are not even on view by day. During the breeding season, many thousands (it has still not been possible to establish an accurate figure) of Leach's Storm-petrels (*Oceanodroma leucorhoa*) come ashore under cover of darkness, flying in to their nest crevices in the turf and vegetation of the cliff-tops. They spend all day out at sea, feeding, before returning at night.

During winter the cliffs of St Kilda are empty and bleak. Most seabirds are out at sea at that time, spending the most inhospitable part of the year on the open ocean before returning to land in March and April. In the past the young birds were an important source of food for the island's human inhabitants, who eked out a living here until they were evacuated to the mainland in 1930. Today St Kilda is dedicated to wildlife and is a World Heritage Site. However, there are signs that all may not be well with its seabird colonies and, indeed, with those elsewhere around the UK.

In recent years some British seabird breeding colonies have failed spectacularly, with hardly any young being reared. This appears to be due to inadequate food supplies, especially the sandeels on which many seabirds depend. In 2005, when sandeels were in particularly short supply, visitors to St Kilda were treated to the pitiful sight of parent Puffins carrying beakfuls of inedible Pipe-fish in a desperate attempt to sustain their young. Many of the Puffin chicks starved in their underground burrows.

The main reason for the sandeel failure may well be global warming. The plankton upon which the sandeel fry feed is a cold water-loving organism, and as the local sea temperature has increased (the North Sea is now 2°C (4°F) warmer than 20 years ago), so the plankton has either died off or moved northwards. The seabirds may have to follow this northerly shift – and abandon their traditional nesting sites – if they are to survive. Meanwhile, other threats are having an impact. For example, the Leach's Storm-petrel population on St Kilda, which is Europe's largest, has been seriously reduced in recent years by predatory Great Skuas (*Stercorarius skua*). A recent colonist of St Kilda, the Great Skua is itself a rare bird, although numbers have grown substantially in response to the vast amounts of fish discarded by trawlers in the region. As the fishing industry has declined, so the skuas are turning to other seabirds as a food source. This now appears to be responsible for the present scenario of one seabird threatening the very survival of another.

ABOVE **One of the most persistent aerial predators, Great Skuas will remorselessly harry other seabirds until the latter regurgitate their last meal.**

RIGHT **Common Guillemot carrying a sandeel. The fortunes of the local sandeel population have a direct bearing on the breeding success of many of the North Atlantic's seabird populations.**

OPPOSITE TOP **Stac an Armin, part of the St Kilda archipelago and a major breeding site for seabirds. It is also where Britain's last Great Auk (*Pinguinus impennis*) was killed in 1840. The species is now extinct globally.**

OPPOSITE BOTTOM **Atlantic Puffins are arguably the most engaging of all seabirds. They tend to breed with the same mate each year, and will usually re-use the same burrow.**

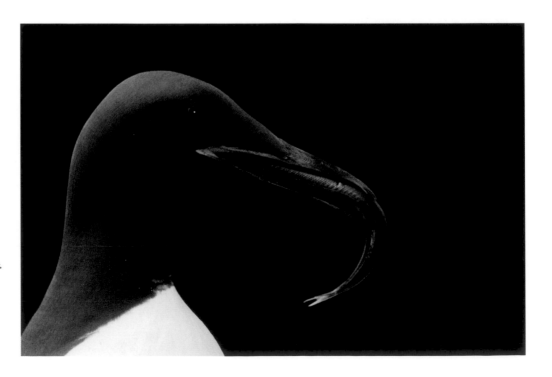

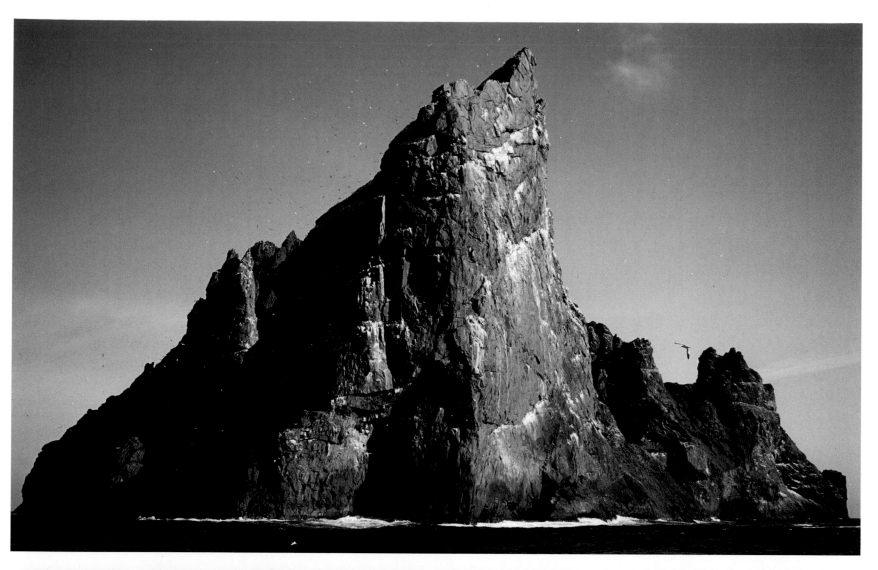

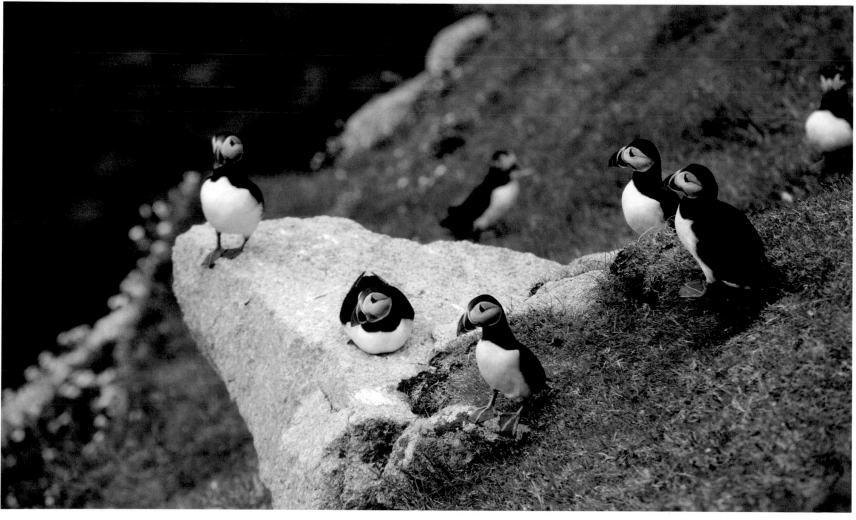

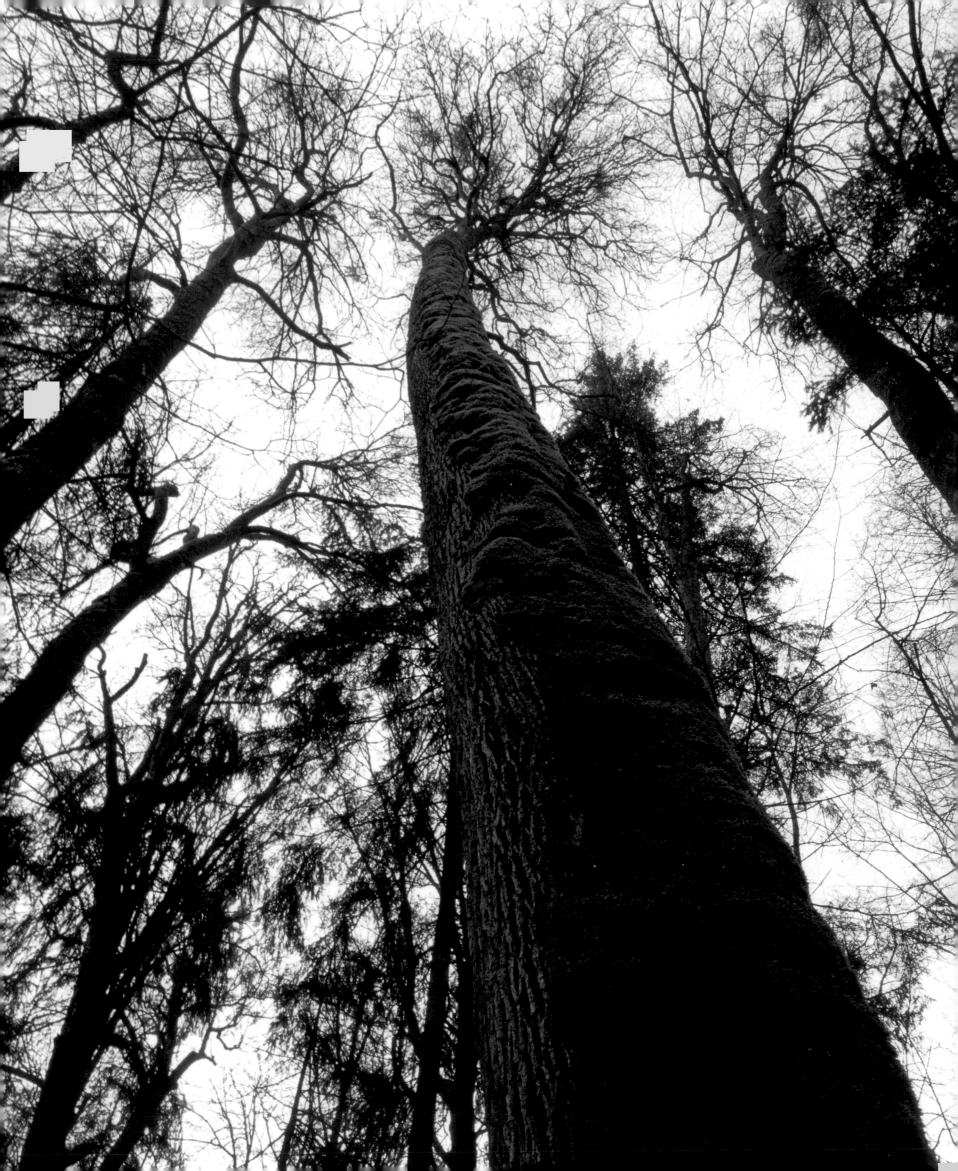

2. Europe's Last Wildwood: the Bialowieza Forest

Straddling the borders of Poland and Belarus, the Bialowieza Forest represents the last fragment of the "wildwood" that once covered much of Europe. This primeval landscape of virtually continuous woodland was progressively fragmented by human activity, to the extent that today virtually none of it remains. However, in this remote part of eastern Europe, remnants of the wildwood survived, with some parts of the Bialowieza basically unaltered in character since the last Ice Age over 10,000 years ago. The result is a unique opportunity to experience the type of landscape through which bands of hunter-gatherers would once have moved in their search for animals to hunt.

What makes the Bialowieza even more exciting is that some of those large mammals are still in residence. Nowhere else in Europe is it possible to find wild European Bison, Elk, Red Deer, Wolf and Lynx in one location, as here; only the Brown Bear is absent. Added to this are over 200 species of bird, including many that are rare and elusive elsewhere in Europe, and a stunning variety of plants and invertebrates. The value of the forest for wildlife was the main reason for its initial protection as a hunting preserve back in 1409, and for its designation as a National Park in 1921.

Bialowieza's great ecological wealth is due to its age and diversity. The huge variety of different plant and tree species forms a mosaic of different habitat types, each supporting a particular set of flora and fauna. At least 16 different forest types have been identified by biologists within the Bialowieza complex, the most dominant being a mix of deciduous oak, lime and hornbeam, which is thought to have been the typical vegetation of the temperate European wildwood. Also important are the spruce-pine forest, found in areas of poorer soil and supporting wildlife species more typical of northern Europe, and the alder forest, which occurs in wetter areas and is rich in ferns, mosses and invertebrates.

Walking through the older sections of Bialowieza's woodland is a truly remarkable experience. Some of the older trees are over 600 years old, with others reaching heights in excess of 40 metres (130 feet); the tallest specimens top a remarkable 55 metres (180 feet). Although much of the Bialowieza is closed-canopy woodland bisected by rides (which offer the best chance of catching

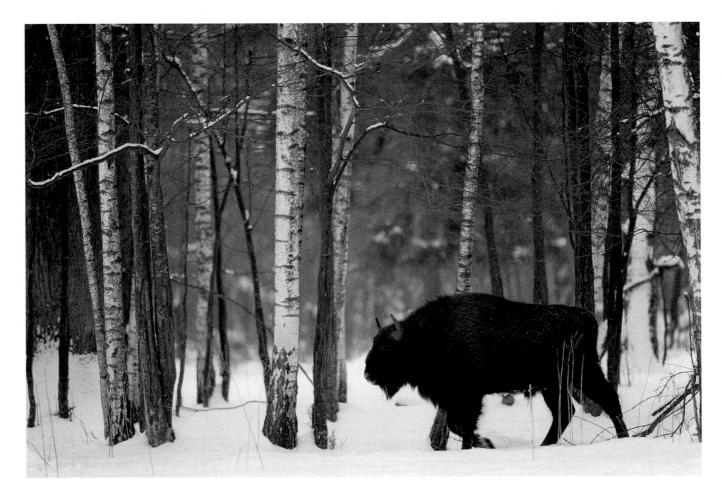

a glimpse of the more elusive animals), there are some open areas. These usually occur around the few settlements that are located within the forest confines, including the village that gives the forest its name. Farming continues here along traditional lines, with the patchwork of small fields – still worked partly by horse-drawn ploughs and wooden carts – making for a delightful rural landscape and one lost from almost all of western Europe. The forest also includes expanses of marsh and swamp, and it is here that some of the forest's more dramatic bird species should be looked for, such as Black Stork (*Ciconia nigra*) and Crane (*Grus grus*).

However, Bialowieza is known first and foremost as the home of the European Bison or Wisent (*Bison bonasus*), Europe's largest land mammal. Males can stand at almost 2 metres (6½ feet) at the shoulder, and weigh up to 900 kilograms (1,985 pounds). Although closely related to the American Bison (see page 171), the Wisent developed as more of a browser than an open-country grazer, and adapted to life in the forest, where it fed on foliage, flowers and tree bark. Two distinct sub-species were identified, a lowland form found in the forests of Eastern Europe, and an upland variety, which inhabited the Caucacus. Both populations were subject to excessive hunting, however, and the tumultuous events of the First World War signalled their demise in the wild. The last wild lowland bison was shot in 1919, but a breeding programme was subsequently set up, using animals held in captivity. In the 1950s European Bison were reintroduced to the Bialowieza, and today there are over 600 animals living wild in the forest, on both sides of the Poland–Belarus frontier.

Seeing bison in Bialowieza however, is not straightforward. They tend to live in small groups and are very shy, keeping within the denser sections of the forest for much of the time and moving away quickly and quietly from any disturbance. Obtaining a good view of them is more likely in winter, when the female and immature bison often gather to visit the feeding stations set up by park wardens to supplement the animals' diet during the colder months. Male bison live alone for most of the year, usually only approaching others of their kind during the mating season, from August to October. At this time it is possible to see – or, more likely, hear – the mature bulls bellowing as they go head-to-head in battle over the females.

A visit to the forest is more likely to yield sightings of deer. Both Red (*Cervus elaphus*) and Roe (*Capreolus capreolus*) are present in good numbers, as are Wild Boar (*Sus scrofa*). Elk (*Alces alces*) are scarce and harder to find, best looked for in the wetter alder woodlands and marshes. As for the Bialowieza's two main predators – the Wolf (*Canis lupus*) and the Lynx (*Lynx lynx*) – the chances of a sighting are very slim but not out of the question. Winter offers the best chance, especially when snow cover makes it possible to follow their tracks. With luck and patience it is possible to catch a glimpse of a pack of wolves as they move through the forest, and there are locations at which one can "sit and wait". One group of visitors once sat up all night at a watch-point in the hope of seeing wolves, only for a Lynx to wander past just before dawn.

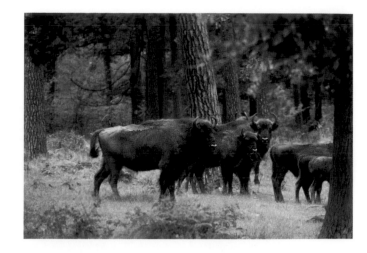

ABOVE **A group of bison cows and their calves. Although the forest's population breeds well and is increasing, the limited gene pool makes them prone to hereditary diseases.**

OPPOSITE **Bialowieza supports good numbers of wolves, but catching up with a pack is never easy. Following their tracks in snow can bring dividends, and occasionally excellent views are possible.**

BELOW **Areas of diverse wetland such as this are excellent for birds and are also among the best habitats in Bialowieza for Elk, which graze on aquatic vegetation.**

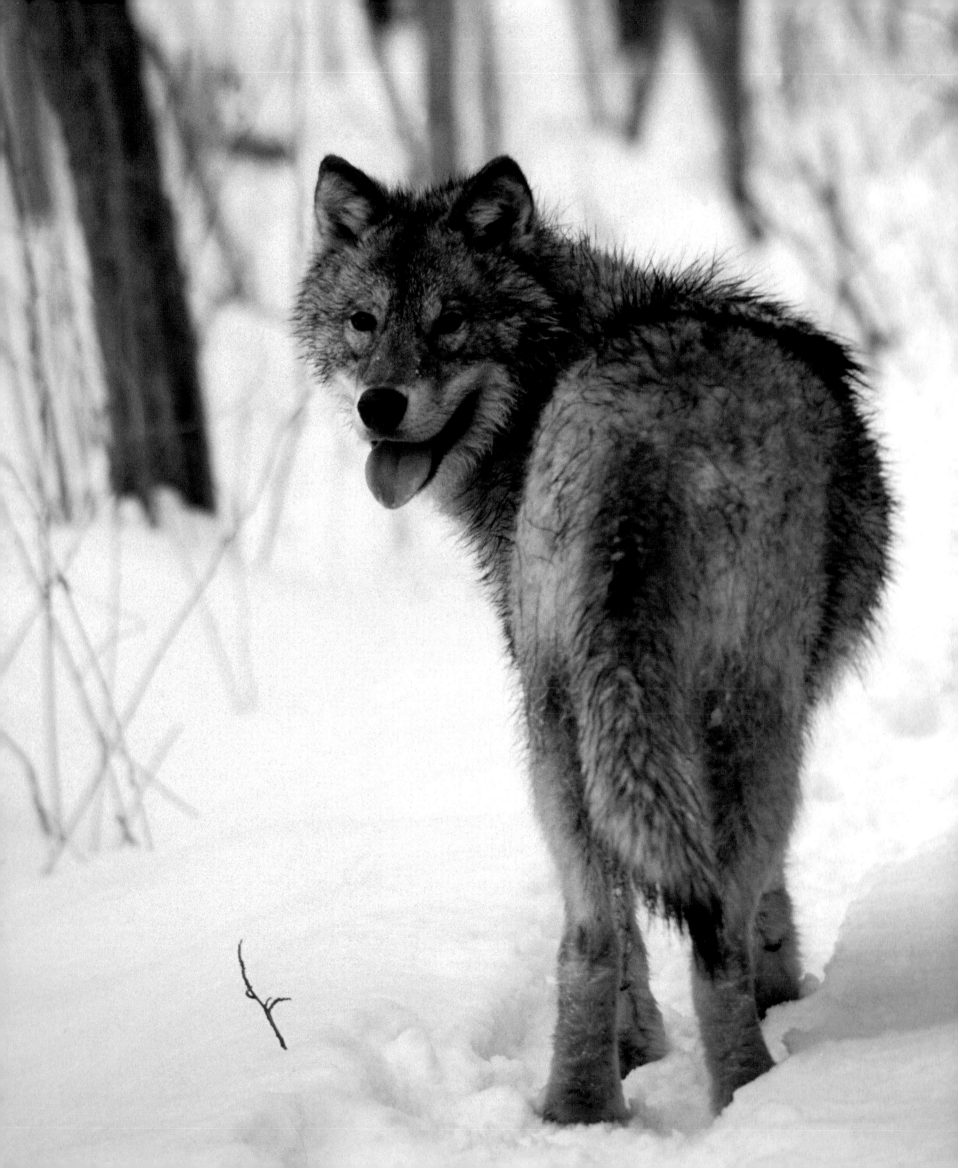

3. Butterflies in the Picos de Europa

Strung across the north of Spain as a westerly extension of the Pyrenees, the Cantabrican Mountains (*Cordillera Cantábrica*) run for 300 kilometres (185 miles) from the Basque country as far as the eastern edge of Galicia. This is rugged country, and at its heart sits the Picos de Europa, a group of three distinct limestone massifs that includes Torre Cerrado, the cordillera's highest peak at 2,648 metres (8,688 feet). Dissected by deep gorges through which rivers head north towards the Bay of Biscay, the Picos is home to a vast wealth of flora and fauna, with the number and diversity of species a direct result of the wide variety of habitats and conditions that are found here. These range from jagged rocky outcrops through high altitude plateaux and areas of limestone pavement to both evergreen and deciduous woodland (the latter mostly beech and sessile oak), tracts of heathland and flower-rich meadows.

What makes the Picos especially attractive to wildlife, and also to those interested in conserving its ecology, are the traditional land management techniques that continue here. These are based around the farming of sheep and cattle, and in some areas have remained essentially unchanged for hundreds, if not thousands of years. Local farmers traditionally practise a system of transhumance, by which in summer they take their livestock from the lower-level meadows up to the high altitude pastures (known locally as *vegas*); the meadows are then used for the production of hay, which sustains the animals when they are brought back down from the mountains in the autumn and kept in barns in the villages. The manure is collected and spread on the meadows as fertilizer.

The result of these patterns of land-use is a very attractive mosaic of meadows, managed woodland and orchards at lower levels, rising to rougher terrain at higher altitudes. Wildlife is abundant and diverse, virtually everywhere. In the more remote areas there are populations of large – but always hard to see – mammals such as Brown Bear (*Ursus arctos*) and Wolf (*Canis lupus*), along with both Red (*Cervus elaphus*) and Roe Deer (*Capreolus capreolus*), as well as Isard (*Rupicapra pyrenaica parva*). Birdlife is impressive, too: over 170 species have been recorded in the Picos, including many species of raptor. For its size – slightly under 100 square kilometres (40 square miles), including the Picos National Park at its heart – the area also contains an extraordinary number of plant species, with some 1,400 recorded to date and more doubtless awaiting discovery.

However, it is for one particular group of invertebrates that the Picos is justifiably regarded as world class: the butterflies. A remarkable total of 155 species has been recorded here – more than at any comparable site in Europe. This large number reflects the range of habitats, traditional land management patterns, and different microclimates that are found in this part of Spain. Butterflies are on the wing in the Picos from March right through to October and sometimes beyond, but the peak months are undoubtedly June and July. At this period, given favourable weather conditions, it is possible to see as many as 50 different species in one day.

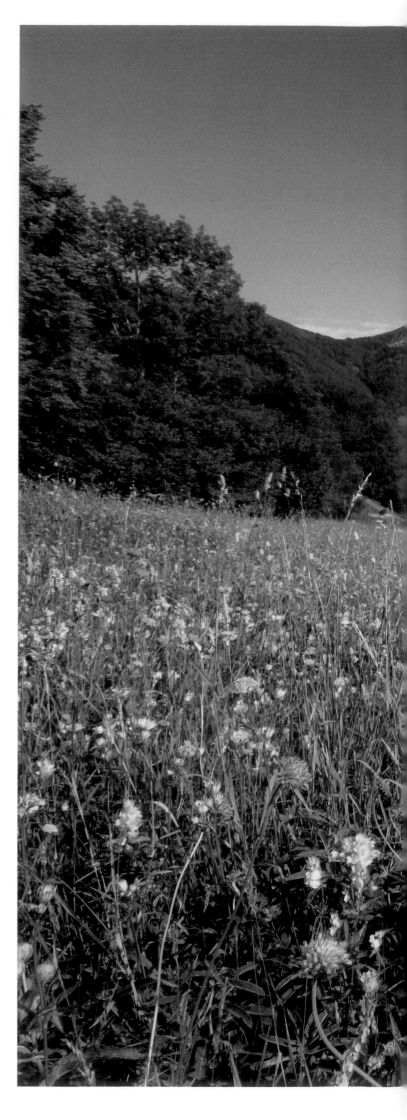

RIGHT The wildflower meadows of the Picos are one of the area's many wildlife-rich habitats. They are especially outstanding for butterflies, and in high summer can be teeming with a variety of species.

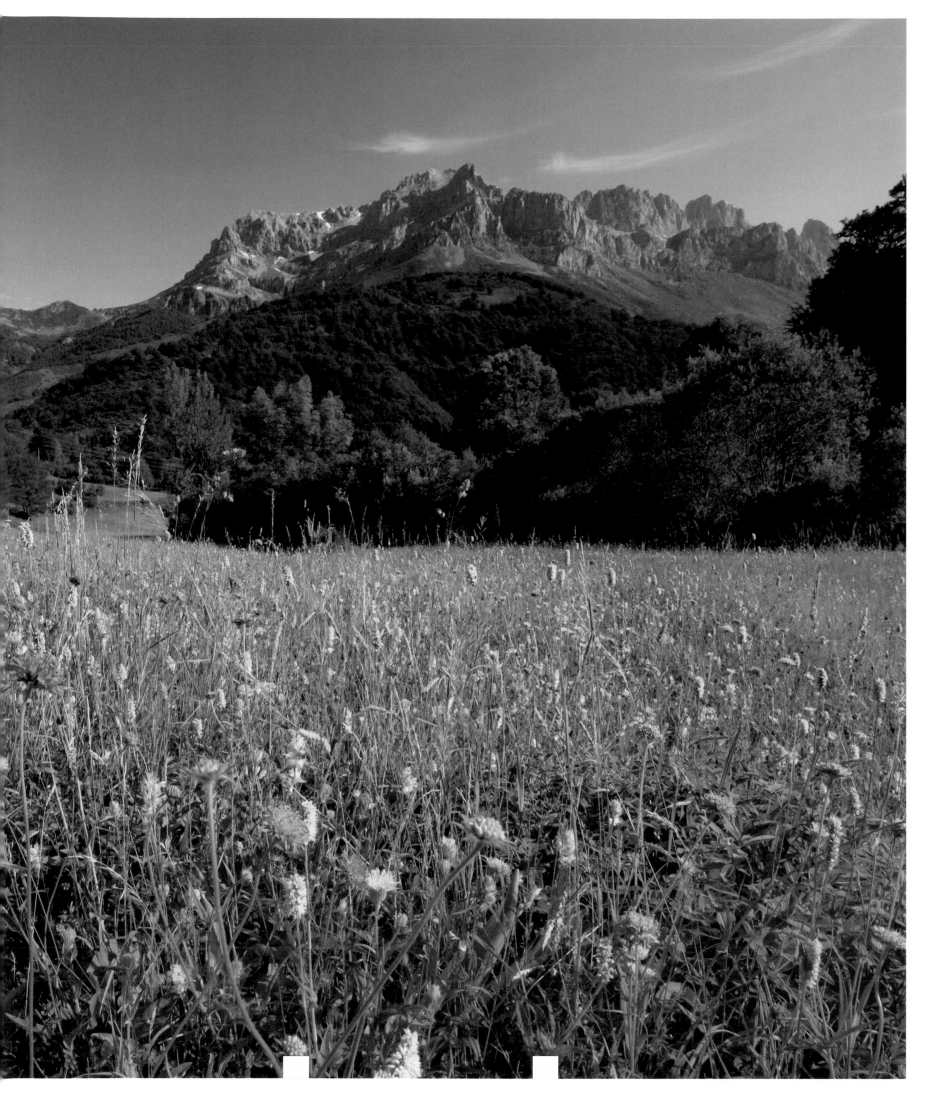

Among the best butterfly habitats are the flower-rich hay meadows, which in early to mid-summer simply teem with a dazzling variety of species. These include both Swallowtail (*Papilio machaon*) and Scarce Swallowtail (*Iphiclides podalirius feisthamelii*), many species of blue, including Black-eyed (*Glaucopsyche melanops*), Dusky Large (*Maculinea nausithous*), Green-underside (*Glaucopsyche alexis*), Long-tailed (*Lampides boeticus*) and Mazarine (*Cyaniris semiargus*), and coppers such as Purple-edged (*Lycaena hippothoe*) and Sooty (*Lycaena tityrus*). Also prominent – and difficult in certain cases for even the experts to tell apart on the wing – are the many fritillaries, with over 20 species recorded in the Picos. Commonly seen varieties include Dark Green (*Argynnis aglaja*), High Brown (*Argynnis adippe*), Knapweed (*Melitaea phoebe*) and Queen of Spain (*Issoria lathonia*). Patches of scrub and woodland edge in lowland areas are always worth exploring for species of hairstreak, especially Blue-spot (*Satyrium spini*), while more open areas of grassy ground with scattered broom and heather – generally close to the treeline – are the best places to look for Chapman's Ringlet (*Erebia palarica*), which is endemic to north-west Spain.

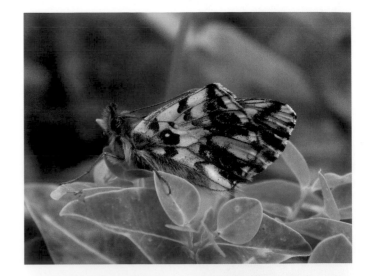

Some of the most exciting Picos butterflies require rather more effort to spot, as they are at home on the high altitude rockgardens and pastures. These include the flashy Apollo (*Parnassius apollo*) and the endemic local forms of Gavarnie Blue (*Agriades pyrenaicus asturiensis*) and Lefèbvre's Ringlet (*Erebia lefebvrei astur*), as well as Large Grizzled Skipper (*Pyrgus alveus*), Shepherd's Fritillary (*Boloria pales*) and Mountain Clouded Yellow (*Colias phicomone*). At this altitude most butterflies are on the wing slightly later than in the valley meadows, so late July and August can be best. Another distinct habitat with a particular butterfly community is the sheltered gorges and south-facing valleys of Liébana, where the warmer local conditions are suitable for more Mediterranean species, such as Cleopatra (*Gonepteryx cleopatra*) and Moroccan Orange Tip (*Anthocharis belia*), usually on the wing in May, as well as for the remarkable Giant Peacock Moth (*Saturnia pyri*), which is sometimes drawn to balcony lights and street lamps in the villages.

At a time when many species of butterfly are under pressure from habitat destruction (usually as a result of intensive agriculture, development and simple neglect), the Picos offers a refreshing and increasingly rare opportunity to see an exceptionally large number and wide variety of species in outstanding scenery. Where else in western Europe is it possible to wander through flower-filled meadows with clouds of butterflies of up to 30 species all in the air at the same time?

TOP **Like most species of fritillary, the underside of the Shepherd's Fritillary is a beautiful mosaic of colours.**

ABOVE **Chapman's Ringlet is a Picos speciality and one of the key targets for any butterfly enthusiast visiting the area.**

LEFT **The Giant Peacock Moth is Europe's largest moth species and found across much of the central and southern parts of the continent.**

OPPOSITE **The Apollo is one of the most beautiful of all European butterflies. A high-altitude specialist, it lives well above the tree line and is scarce across much of its European range.**

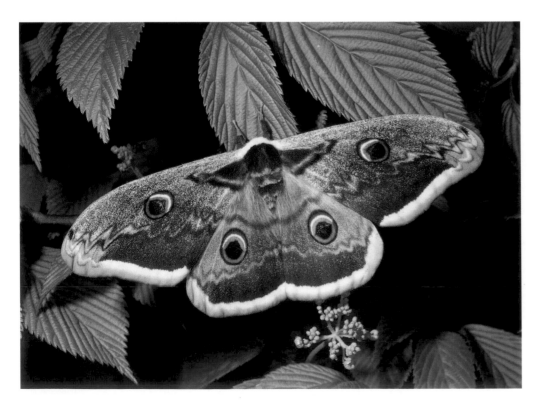

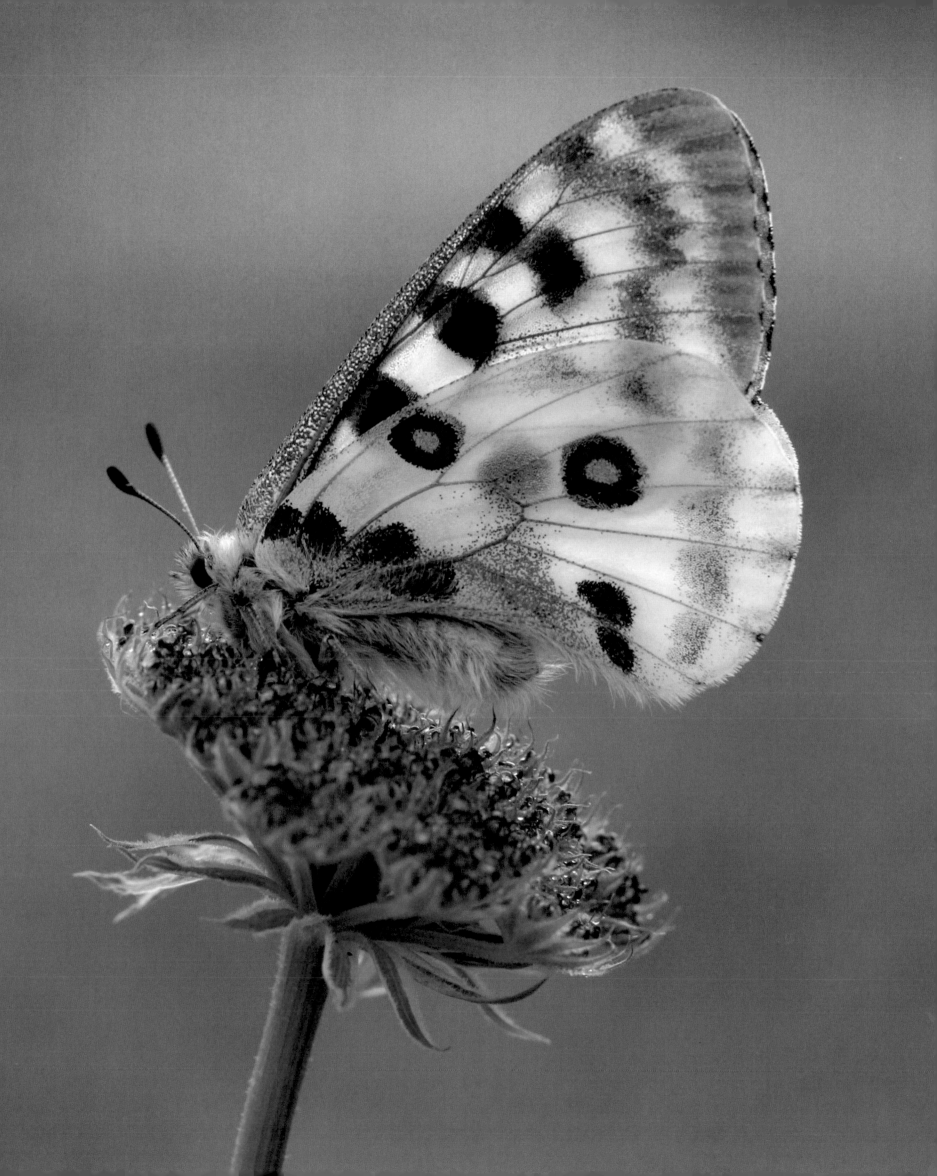

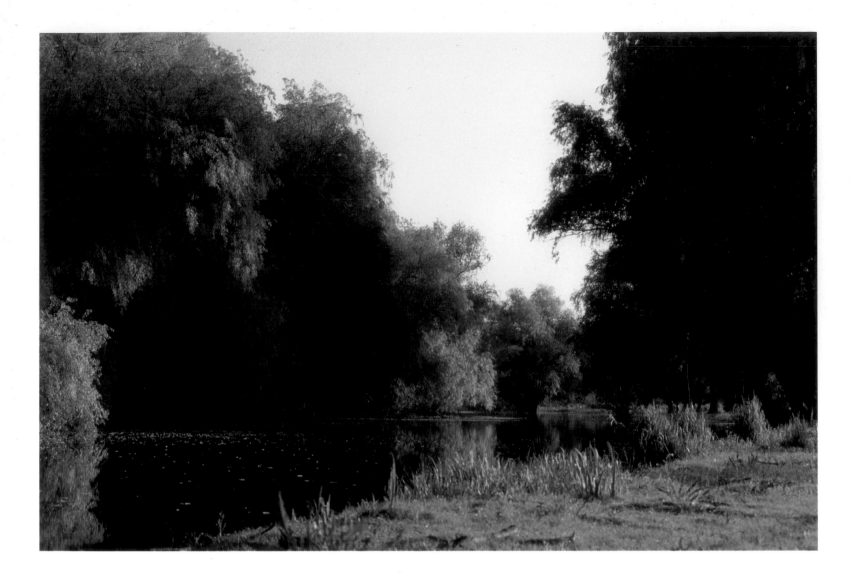

4. Waterbirds in the Danube Delta

Europe's second longest river after the Volga, the Danube rises in the mountains of Germany's Black Forest and winds its way eastwards through a further nine countries before finally reaching the Black Sea, some 3,200 kilometres (1,990 miles) later. The final section of its journey is through an immense delta – most of which lies within Romania, but with part in Ukraine – of forests, lakes, marshes and dunes. Three main channels carry the Danube through this delta, with a labyrinth of streams, channels and reedbeds twisting and weaving between them. The whole area is a paradise for wildlife, and particularly outstanding for birds. There are few, if any, places in Europe to rival it.

The delta is the result of millions of tons of silt being dumped by the river, and is constantly expanding into the Black Sea at a rate of up to 30 metres (98 feet) per annum. Some 580,000 hectares (143,000 acres) are designated by UNESCO as a Biosphere Reserve and World Heritage Site, but access to the best parts of the delta is not straightforward. Roads are few, and a local guide essential. The most satisfactory, and appropriate, way to explore is by water, and ideally by non-motorized boat. A silent approach gives visitors the best chance of getting up close to some of the delta's very special bird species. Top of many people's lists in the summer are pelicans, for which this is the European headquarters. Two species breed here: the Great White (*Pelicanus onocrotalus*), with an estimated 2,500 nesting pairs and usually quite easy to see, especially when in their "squadrons" soaring in an overhead thermal; and the much rarer Dalmatian (*Pelicanus crispus*), with no more than 40 pairs and so a harder proposition to pin down.

Locating anything in the delta is not necessarily straightforward, and it can be a bewildering place. In much of it there is no dry land as such, and some of the habitats are vast in extent. There are many huge reedbeds, for example, and it is not unusual to drift along in a boat for hours through a landscape of nothing but reeds. However, the lack of scenic relief is more than made up for by the high levels of avian activity. In summer the constant overhead traffic includes raptors, such as Marsh

ABOVE **The Danube Delta is a maze of emerald-green waterways, the banks largely cloaked in vegetation. Alive with buzzing insects in summer, this is a superb habitat for a wide variety of birds and other wildlife.**

OPPOSITE **Great White Pelicans with their decidedly reptilian-looking chicks. Pelicans were once more widely distributed in Europe, but numbers fell under pressure from hunting, habitat loss and disturbance. Today the delta is one of their last strongholds.**

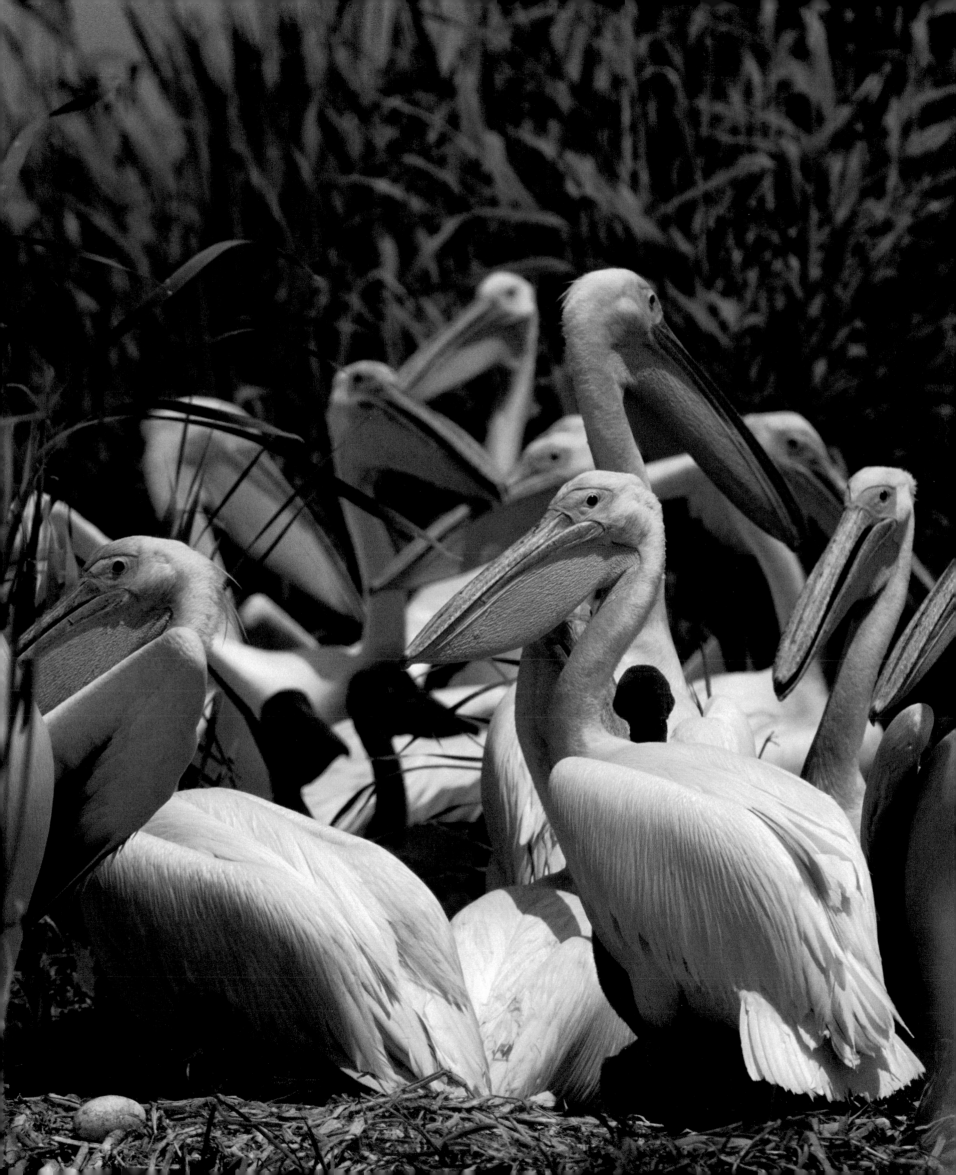

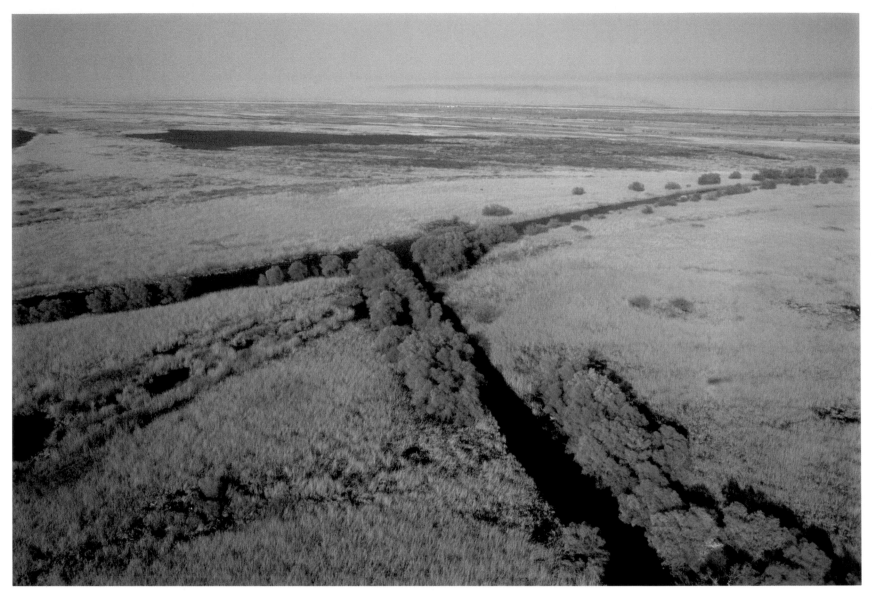

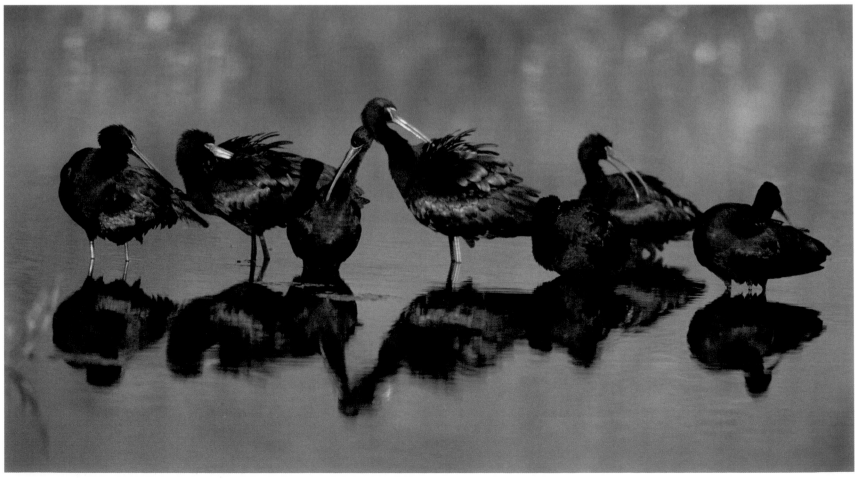

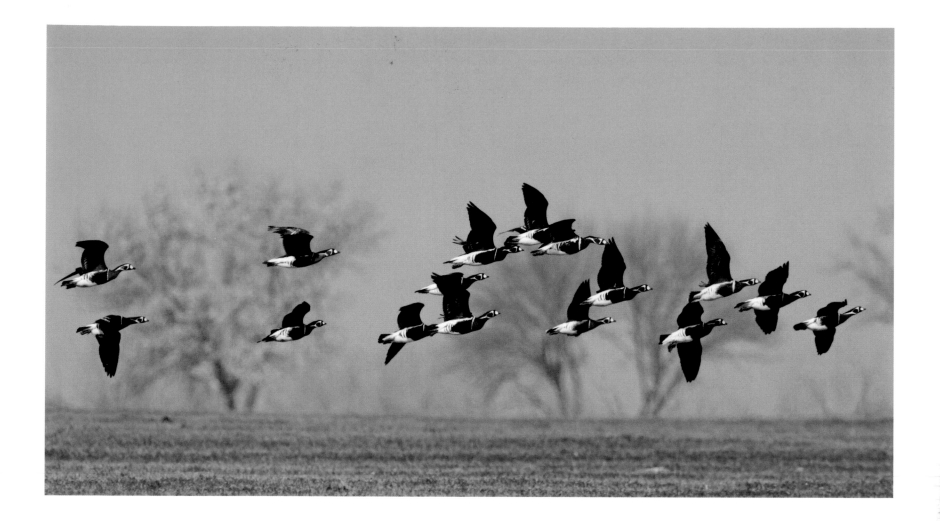

Harrier (*Circus aeruginosus*), Montagu's Harrier (*Circus pygargus*) and Red-footed Falcon
(*Falco vespertinus*), the latter an exciting sight as they acrobatically hawk dragonflies over the
reeds. Also prominent at this time of year are two of the area's most colourful birds: European Roller
(*Coracias garrulus*), a blaze of blue and chestnut as it moves from one prominent perch to another,
and European Bee-eater (*Merops apiaster*), a dazzling array of colours and yet often first noticed
thanks to its characteristic "pirrup" call, as it flies overhead. Both species are common summer visitors.

However, what makes any trip into the delta so rewarding is the outstanding selection of herons
and large wading birds that are invariably on view. Several species nest here in huge numbers,
including Little Bittern (*Ixobrychus minutus*), with as many as 10,000 pairs (at least one third of the
entire European population), Glossy Ibis (*Plegadis falcinellus*), Squacco Heron (*Ardeola ralloides*)
and Black-crowned Night Heron (*Nycticorax nycticorax*). These species are joined by 2,500 pairs
(60 per cent of the world population) of Pygmy Cormorant (*Phalacrocorax pygmeus*), a species
best spotted when perched on reeds overhanging the water.

The mosaic of ponds and lakes in the delta is also home to a range of other interesting waterbirds.
These include up to 20,000 pairs of Black Tern (*Chlidonias niger*) and at least as many Whiskered
Tern (*Chlidonias hybridus*), so elegant to watch as they dip and swerve for insects over the water's
surface. Among the water lilies it is always worth looking for Black-necked and Red-necked Grebes
(*Podiceps nigricollis* and *P. grisegena*), as well as Ferruginous Duck (*Aythya nyroca*) and Red-crested
Pochard (*Netta rufina*), two of the delta's most attractive ducks.

Whilst birding in the delta is a superb visual experience, equally exciting during spring and
summer is the diversity of sounds emanating from within the riverine forest and reedbed habitats.
Always chuntering away are a host of warblers, including Great Reed (*Acrocephalus arundinaceus*),
Marsh (*Acrocephalus palustris*), Moustached (*Acrocephalus melanopogon*), Paddyfield
(*Acrocephalus agricola*) and Savi's (*Locustella luscinoides*), the latter often singing at night. This
is also the best time to catch up with the secretive crakes: both Little (*Porzana parva*) and Spotted
(*Porzana porzana*) are often heard calling when it is dark, or nearly so, but they are virtually
impossible to see in the tangle of vegetation.

RIGHT **Eye-to-eye with a Dalmatian Pelican.** By far the rarer of the two pelican species found in Europe, the Dalmatian can be readily identified in the breeding season by the characteristic curled feathers on its head and nape.

OPPOSITE TOP **One of the most attractive members of the heron family, Squacco Herons** are common across much of the delta. Usually solitary, they are best looked for as they patiently stalk prey in vegetation next to water.

OPPOSITE BOTTOM **The Little Bittern** is one of the most numerous birds in the delta, with many thousands of pairs breeding in the dense reedbeds. Mainly crepuscular, they can be difficult to see well, and are often seen only in flight as they commute between their nests and feeding grounds.

Summer in the delta may be best in terms of total number of species, but winter brings its own birding highlights. Many thousands of geese flock in from the north, including fluctuating numbers of the endangered and fast-declining Red-breasted Goose (*Branta ruficollis*); several thousand of these most handsome birds spend the winter here, alongside even greater numbers of White-fronted Geese (*Anser albifrons*) and up to 500 of the globally-endangered Lesser White-front (*Anser erythropus*). Ducks are plentiful too, with several hundred thousand Pochard (*Aythya farina*) being a particularly impressive sight. This is also an excellent time of year for watching birds of prey, with White-tailed Eagle (*Haliaeetus albicilla*), Rough-legged Buzzard (*Buteo lagopus*) and Saker (*Falco cherrug*) all present.

Remarkable in so many ways, it is sad that the Danube Delta faces an insecure future. During the twentieth century many of the Danube wetlands upstream were dyked, dammed and drained, and the river's role as a working artery for industry and commerce brought pollution, environmental degradation and habitat loss. The delta survived, but despite its protected status it continues to face challenges. Foremost among these is the Bystroye Project, the construction of a maritime canal through prime bird habitat on the Ukrainian side of the delta. At the time of writing, work was continuing in the face of an international outcry.

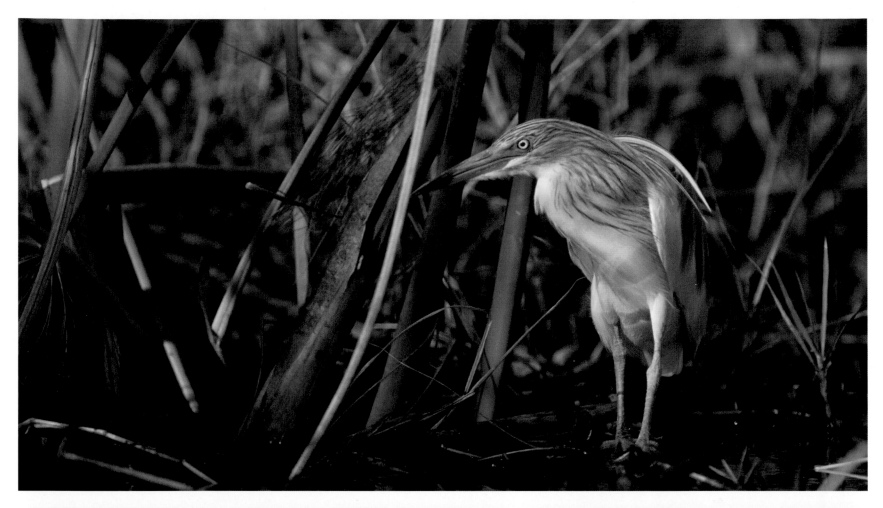

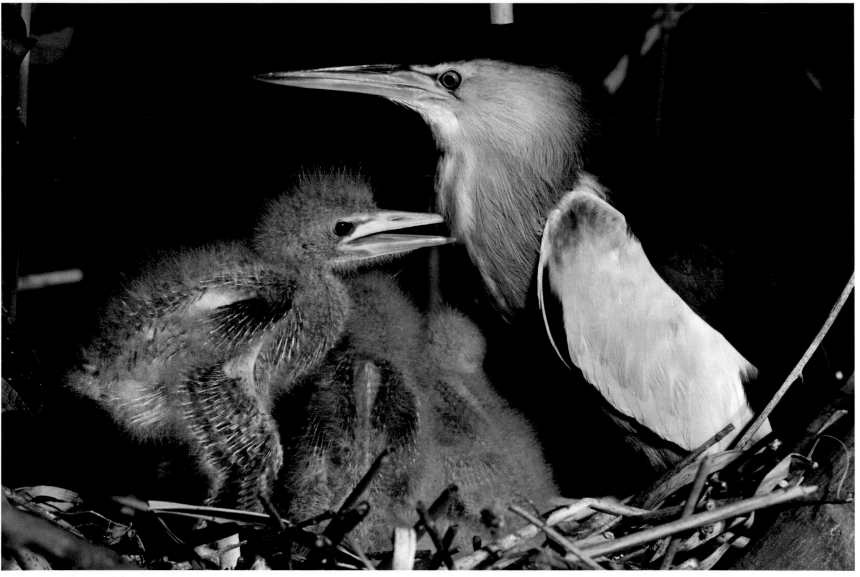

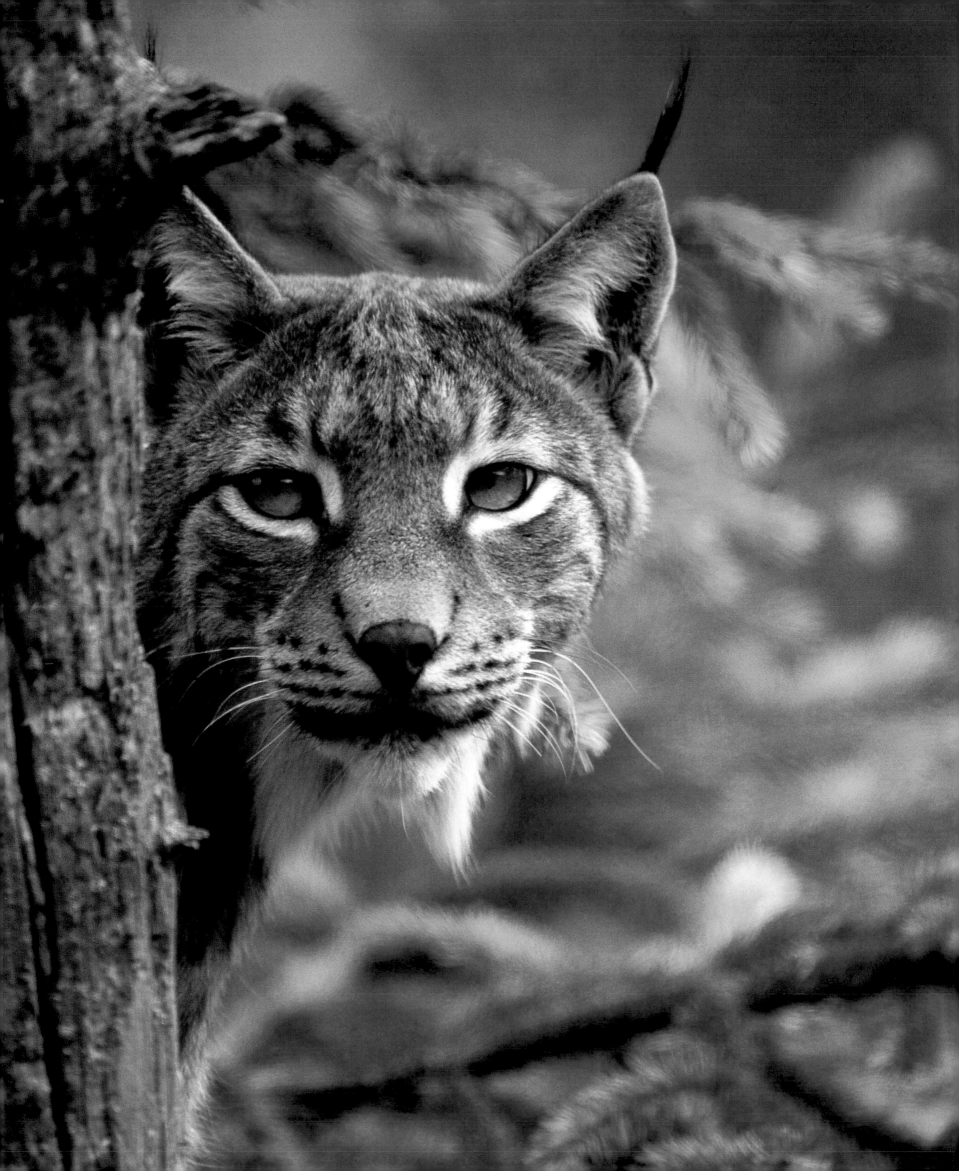

5. Top Predators in the Swiss Alps

OPPOSITE **A rare face-to-face encounter with a Eurasian Lynx. Shy and elusive, this beautiful cat has made a partial comeback in parts of central Europe from which it was previously exterminated.**

BELOW **Europe's largest predator, the Brown Bear is increasing in numbers in most of the countries where it still survives. However, its return to some Alpine valleys has not been universally welcomed.**

By the early 1900s, two of Europe's main predators – the Eurasian Lynx (*Lynx lynx*) and the Brown Bear (*Ursus arctos*) – had become extinct in Switzerland, where they had previously been common. Devastated by habitat destruction and overhunting, these species had – along with the Wolf (*Canis lupus*) (itself also wiped out regionally by this time) – stood at the top of the Alpine food chain. Their demise deprived the local ecosystems of an essential component and conservationists highlighted the impact this had on the environment, such as an uncontrolled deer population damaging habitat. More enlightened land management techniques during the twentieth century brought about the recovery of the forests required by the top predators and conditions began to look favourable for their possible return. It was clear, however, that this could not happen without a helping hand; the nearest surviving lynx population was located too far away from the Swiss Alps for recolonization to occur naturally, and the closest bears – just a handful left in the Italian Alps – were regarded as too few in number for this to be viable.

It was thanks to animals brought from Czechoslovakia in the 1970s that the return of the lynx to Switzerland became possible. The species was also reintroduced successfully at this time to the Jura Mountains in France and to the Eastern Alps in Slovenia. Lynx need large, interconnected areas of forest and plenty of cover from which to ambush their prey – primarily Roe Deer (*Capreolus capreolus*) – and these conditions are found across much of the Swiss Alps. Yet less than 10 per cent of suitable territory has actually been recolonized by lynx, of which there are estimated to be 100 or so now living wild in Switzerland – a lower figure than had been hoped for at the start of the project. The population is therefore stagnating, and showing signs both of inbreeding and of an imbalance in the male–female ratio.

The failure of the lynx to do better is at least partly explained by the intense antipathy shown to large predators by some rural communities in Switzerland, which have found it hard to break with their traditional loathing of an animal that undeniably takes livestock from time to time. Although

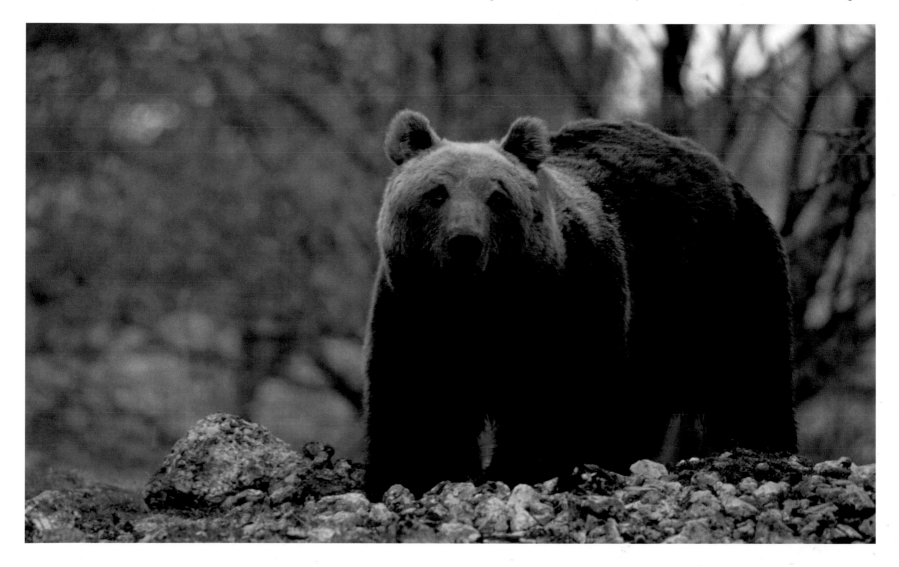

farmers receive government compensation for their losses, the atmosphere remains difficult – project researchers have occasionally been threatened by local people, and their equipment damaged; and at least 50 lynx have been illegally killed since the 1970s.

Meanwhile, Brown Bears are on the move in the Alps. In the valleys of Trentino, in the Italian Alps, a few individuals survived the onslaught of the nineteenth-century hunting mania, but the total number involved gradually declined beyond the point of viability. To help boost numbers and genetic diversity, 10 bears were relocated from the healthy population in neighbouring Slovenia between 1999 and 2002. These have since bred successfully and formed the nucleus of an expanding population which conservationists hope will recolonize much of the Alps. There is no doubt that enough suitable habitat exists, and that there are adequate "green corridors" along which the bears can move into new territory on the Swiss side of the frontier. This is precisely what happened in the summer of 2005, when a young male bear appeared in south-east Switzerland's Münstertal, the first on Swiss territory for over a century. Initial reactions were overwhelmingly positive, but these soon changed when the bear started killing sheep. The problems that can arise when bears reappear in locations from which they have been absent for so long were brought into tragic focus in 2006, when another adolescent bear from the Italian population moved into Austria and thence into Germany – the first wild bear seen there for over 150 years. Amid much controversy, it was eventually shot because of the perceived risk it posed to human life.

Yet there are signs of hope. Misunderstandings over the ecology and behaviours of large mammals once also extended to birds of prey – the Lammergeier or Bearded Vulture (*Gypaetus barbatus*) was hunted to extinction in the Alps because it was erroneously believed to attack lambs and even children. Today, Lammergeiers are better understood, and over 100 of them can be seen flying free across the region, the result of a four-site reintroduction programme. Several adult pairs are breeding successfully in the wild each year, and the species has been enthusiastically welcomed back to many of its old haunts and has helped to boost local tourism. The potential for large mammals to do likewise is increasingly appreciated. In Germany's Harz Mountains, for example, the growing local population of lynx is used as a major focus for ecotourism. Although the chances of actually seeing such a shy beast are always small, the very fact of its presence in the area's forests is enough for visitors to want to come.

The return of the big predators remains controversial, but it is very real. The bears and lynx have even been joined by naturally recolonizing wolves, the advance guard of which has dispersed to the Alps from packs living in the Italian Apennines. Meanwhile, conservationists are trying to work closely with the authorities to reduce the areas of potential conflict between these predators and local farmers. This may mean changes in animal husbandry techniques (including the return of the traditional guard dogs employed by shepherds and cowmen to protect their stock, which have been shown to reduce losses), and diversification by farmers into ecotourism in areas where large predators can be watched safely and valued for the enhancement to any wild area they undoubtedly are.

BELOW **The Lammergeier has been successfully reintroduced to the Alps and the local population is growing. As a carrion feeder, this species tends to visit carcasses when all other predators have had their fill, and is rarely, if ever, responsible for the kill.**

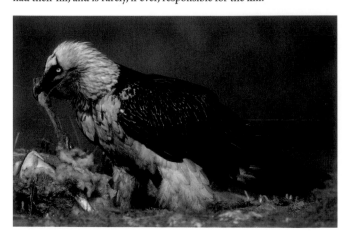

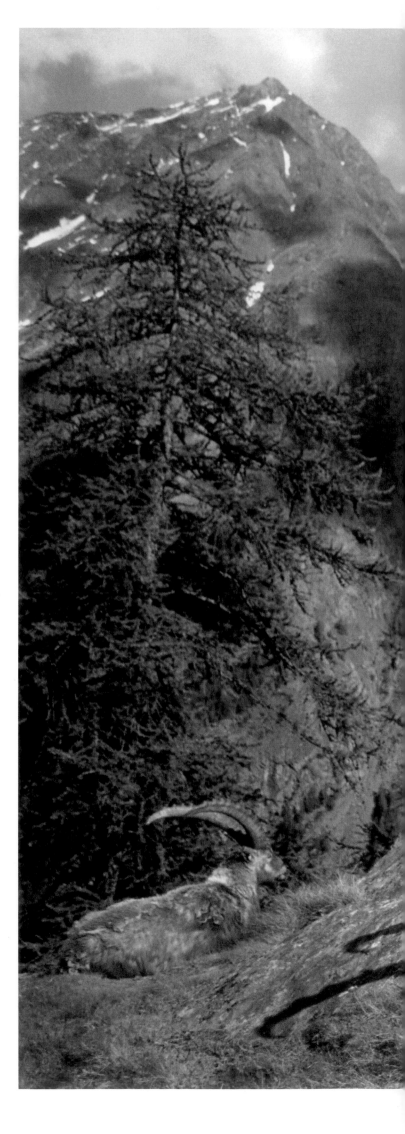

RIGHT **The survival of the Alpine region's wolves is dependent on the presence of adequate numbers of prey animals. Although deer are the most frequently taken, wolves will sometimes hunt Alpine Ibex (*Capra ibex*), a more challenging target in view of the terrain they inhabit.**

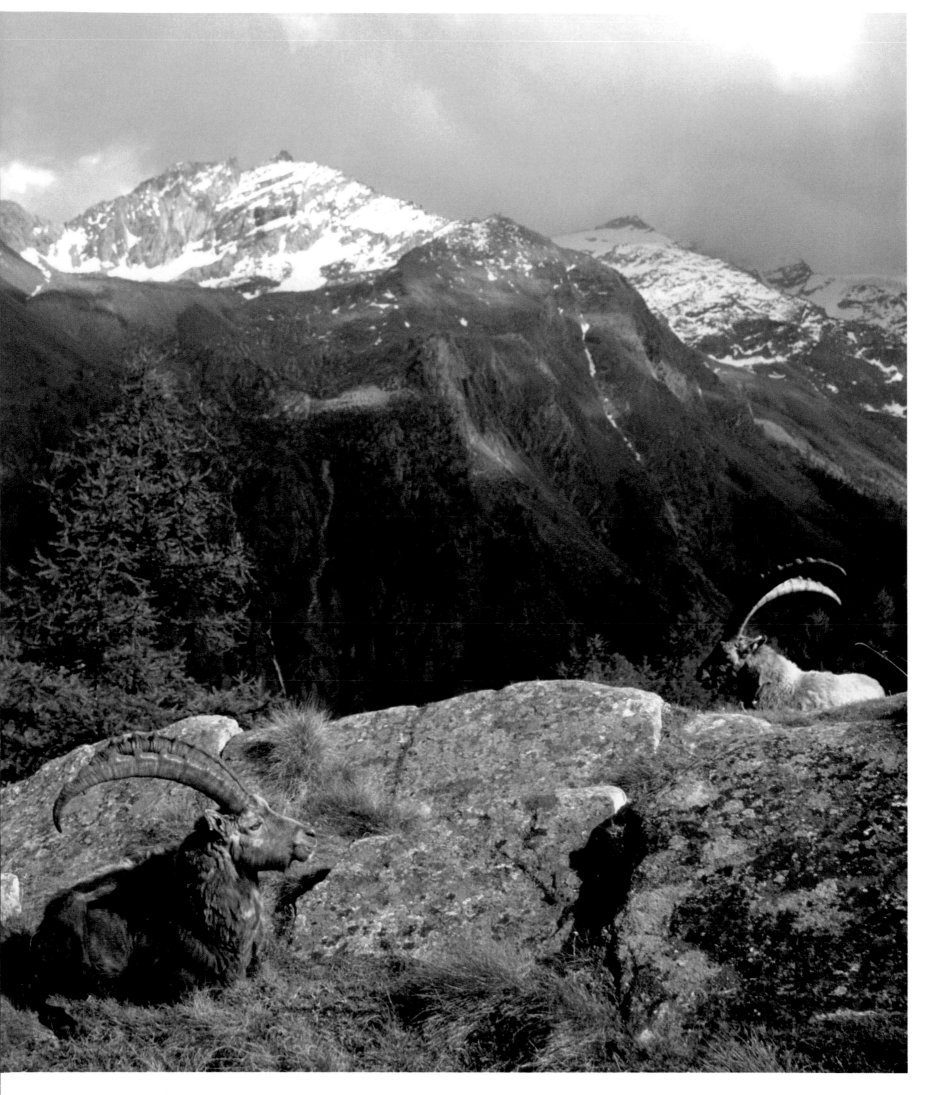

6. Spain's Wild West: Extremadura

OPPOSITE A mature Spanish Imperial Eagle, complete with the white "shoulder" or scapular patches that denote full adulthood. One of world's rarest raptors, this impressive predator feeds mostly on rabbits but will take a range of other prey, including waterbirds and even reptiles.

Spain is one the richest countries in Europe for wildlife. The geographical location and the variety of habitat types and microclimates mean high levels of biodiversity by European standards, and the relatively low human population (for the size of the country) has helped ensure the survival of many superb places for wildlife. This is nowhere more so than in the region of Extremadura, in the remote southwest of the country, towards the border with Portugal. Here one can explore a magical landscape of rolling hills, extensive tracts of open pasture studded with holm and cork oaks and, at lower levels, a vast sweep of semi-desert steppes. A network of rivers, creeks and rocky outcrops add to the mix. The huge vistas are extraordinary, and the range of plants, birds, animals and insects quite staggering.

Visitors should not be fooled into thinking that this is a pristine, natural wilderness. The dominant landscape type is *dehesa*, a type of open wood-pasture which has evolved as a result of centuries – if not thousands of years – of human activity. Extremaduran soils are notoriously unproductive, too thin and lacking in nutrients to support arable agriculture on a large scale. Cereal cultivation is practised on a rotational basis, the land being allowed to lie fallow and revert to pasture after one year under crops. It is then grazed by cattle, sheep and pigs, their dung helping to reinvigorate the soil. In subsequent years increasingly mature scrub encroaches; this is then cleared and the land replanted, the cycle beginning anew.

The result of this process is a landscape that is both aesthetically pleasing and highly rewarding in terms of the flora and fauna it supports. Extremadura is outstanding for wildlife generally, and particularly important for birds. Over 200 species are regularly recorded here, but it is for its exciting birds of prey that the region is renowned. This is the place to come if you want to see vultures, eagles, falcons and other raptors – 16 species regularly occur here, and the area probably has the highest density of raptors in Europe. One of the best locations for watching them, especially vultures and eagles, is Montfragüe National Park, north of the town of Trujillo. The star bird here is the Spanish Imperial Eagle (*Aquila adalberti*), which breeds regularly only in Spain and has a total world population of fewer than 200 pairs. It is one of five species of eagle found in Montfragüe – the

BELOW A profusion of wild flowers among the evergeen oaks of Montfragüe National Park. This type of wood-pasture habitat is important for a range of wildlife and is an essential component of the Extremadura ecosystem.

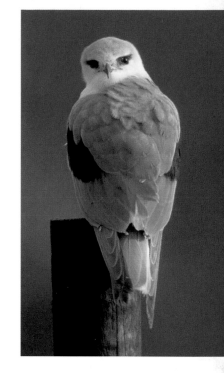

ABOVE The beautiful Black-winged Kite is a relatively recent colonist from Africa and is now well established on the plains of Extremadura. It nests in trees, the female making an untidy platform from twigs brought to her by the male.

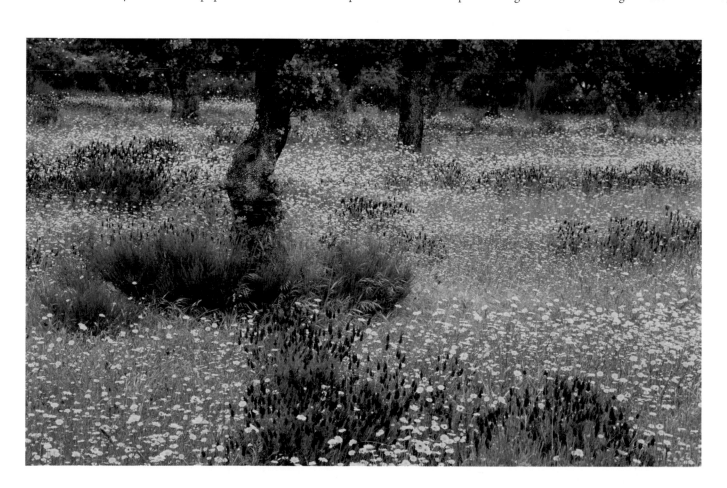

others being Golden (*A. chrysaetos*), Booted (*Hieraaetus pennatus*), Bonelli's (*H. fasciatus*) and Short-toed (*Circaetus gallicus*). With luck, it is possible to see them all here in a single day, and there have been occasions when all five species have been watched in the air simultaneously!

However, sorting out the different types of raptor when they are little more than specks in the sky is not straightforward. More immediately identifiable are the vultures, of which three species occur here. The most important of these in global terms is the Black Vulture (*Aegypius monachus*), the largest bird of prey in Eurasia and one that is struggling to hold its own outside Spain, which supports the vast majority of the estimated European population of 1,500 pairs. More common is the Griffon Vulture (*Gyps fulvus*), and there are also good numbers of Egyptian Vulture (*Neophron percnopterus*).

The famous "vulture rock" of Peñafalcon or Salto del Gitano is one of the best sites to watch these extraordinary birds. A large colony of Griffons nests on the cliffs (there are over 400 pairs in the wider park), and the parent birds are constantly gliding about or soaring on thermals. The area's Black Vultures do not breed on the cliffs, however, instead building their massive nests in the tops of mature oak trees. Extremadura's healthy population of vultures is due to the large number of livestock and deer. The carcasses of dead animals provide a rich source of carrion for the birds and, for visitors, the exciting opportunity to watch mixed groups of vultures lumbering about on the ground, jostling and squabbling over their latest meal.

One of the most enchanting and sought-after birds of prey here is a relatively recent arrival. The Black-winged Kite (*Elanus caeruleus*) is primarily an African species, a familiar sight on the savannahs of East Africa in particular. The first birds arrived in the south of Spain in the 1970s, and it is perhaps not surprising that the species has prospered in the flat landscapes of this part of Spain. It is best looked for perched on a suitable vantage point, scanning the ground for reptiles or rodents, or drifting along close to the ground, its wings held in a shallow 'V'.

The open spaces of Extremadura are also the European headquarters of the Great Bustard (*Otis tarda*), the continent's heaviest flying bird. Driven to extinction or extreme rarity in many of its former haunts by a combination of hunting, disturbance and modern farming, a substantial population survives here. Shy, and constantly on the lookout for danger, they are certainly a majestic sight as they stride across the plains. For most of the year the sexes gather in separate flocks, but in the breeding season the mature males seek out potential mates and stage an extravagant courtship display, in which they bring their wings forward and seemingly "invert" themselves into a huge white pom-pom. An extraordinary sight, and one of the great springtime events in Extremadura.

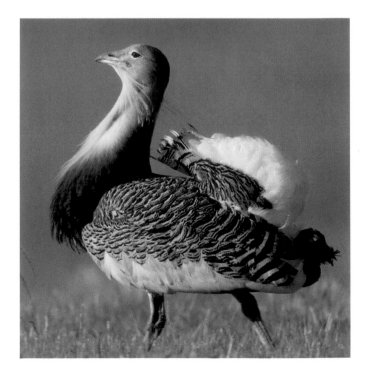

7. Waterfowl at Lake Myvatn

ABOVE **Lake Myvatn sits amid breathtaking scenery. Once the winter snow and ice have receded, the lake begins to attract the waterfowl for which it is renowned. Although the many species of duck are the main draw here, there is also much bird interest on the surrounding moorland.**

Dramatic scenery and the highest concentration of nesting duck in Europe are the main reasons for visiting Lake Myvatn, in the north of Iceland. Some 10,000 pairs of duck, of 15 different species, nest here. Collectively this is an extraordinary sight, but there are two particular species guaranteed to get a naturalist's pulse racing: Barrow's Goldeneye (*Bucephala islandica*) and Harlequin Duck (*Histrionicus histrionicus*). For most birdwatchers these exotic-looking birds are confined to pipe-dreams or to a visit to an ornamental wildfowl collection, yet at Lake Myvatn they can be seen quite easily, either swimming out on the water or, in the case of the Harlequins, loafing around on waterside rocks. Both species are essentially North American birds, with Iceland as their European outpost; indeed, Barrow's Goldeneye breeds nowhere else in Europe, whilst the Harlequin Duck is found only in Iceland and southern Greenland.

Fed by mineral-rich springs rather than by a river, the lake covers about 37 square kilometres (14 square miles) and is set against a stunning backdrop of mountains, solidified lava flows, high-pressure steam vents and bubbling mud. The Icelandic word *myvatn* means Midge Lake, and a visit there during the summer soon reveals why – the shores are literally alive with midges (mainly chironomidae flies). However uncomfortable this might make it for human visitors, it is one of the reasons why so many birds come here to breed – the vast number of insects and their larvae (millions of which live in the nutrient-rich sediment at the bottom of the lake) are a vital source of food for young ducklings, as well as for other species of bird, such as waders.

A scan across the lake in spring and summer reveals an extraordinary array of waterfowl. Biggest of all are the Whooper Swans (*Cygnus cygnus*), a large flock of which gathers here in summer, followed by Pink-footed Geese (*Anser brachyrhynchus*), which nest near the lake. A great assortment of different ducks is also present – out in the middle of the lake are those species that dive for their food, including Tufted Duck (*Aythya fuligula*), the commonest species

RIGHT A male Barrow's Goldeneye. Iceland is a European outpost for this species, and in late summer virtually the entire male population on the island gathers at Myvatn to moult. The Icelandic name for this species, *húsönd* or "house duck", is derived from its habit of nesting in holes in stone buildings and walls.

RIGHT An adult Slavonian Grebe in full breeding plumage. Many pairs nest at Myvatn, usually on smaller ponds around the main lake. The species is also found across northern Eurasia and in North America, where it is known as the Horned Grebe.

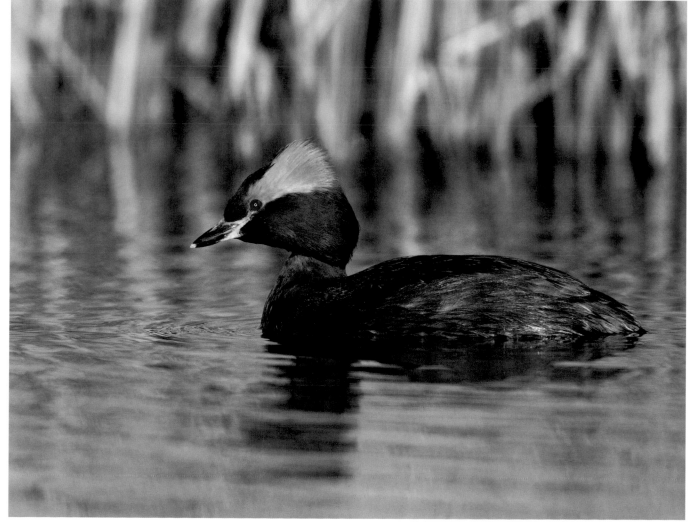

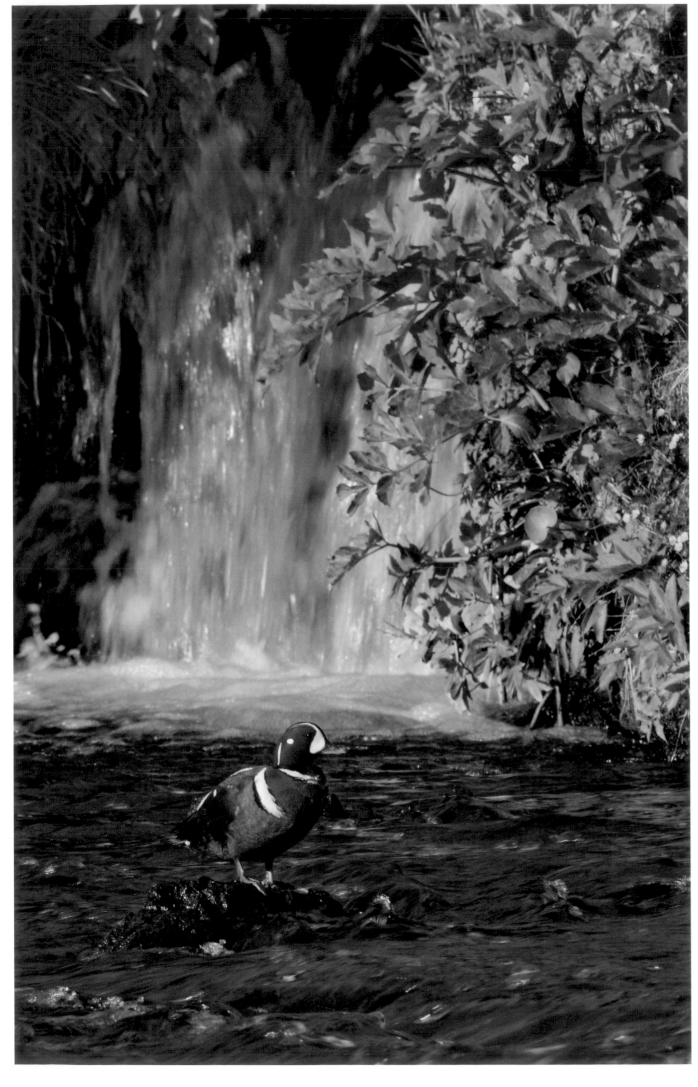

LEFT A male Harlequin Duck in typical habitat. Although it mostly winters at sea, in spring and summer this species has a distinct preference for fast-flowing water and is best looked for near waterfalls and rapids. Female birds are dark brown with white head markings.

at Myvatn, Common Scoter (*Melanitta nigra*), Greater Scaup (*Aythya marila*) and Red-breasted Merganser (*Mergus serrator*), whereas dabbling ducks (those that "up-end" to find their food) such as Common Teal (*Anas crecca*), Eurasian Wigeon (*Anas penelope*), Northern Pintail (*Anas acuta*), Mallard (*Anas platyrhynchos*) and Gadwall (*Anas strepera*) are usually found closer to the shore, which has many shallow inlets, and around the 50 or so islands in the lake. However, Myvatn is not deep – it has an average depth of just 2.5 metres (8.2 feet) – and so most species of waterfowl are able to range over much of the lake.

One of the best local birding spots is in the northern corner of the lake, where the Laxa River, which connects Myvatn to the sea and leaves the lake in three channels, flows through a series of cascades and pools. The bridge that crosses the river is one of the best places from which to locate Harlequin Ducks, which mostly frequent the river and rarely move out onto the wider lake, and Barrow's Goldeneye. Certain other species of duck prefer the smaller pools and "crater lakes" that are scattered over the surrounding landscape. These include Long-tailed Duck (*Clangula hyemalis*), one of the most stunning of all waterfowl. Equally resplendent in their breeding colours are Slavonian Grebes (*Podiceps auritus*) and the dainty Red-necked Phalarope (*Phalaropus lobatus*), groups of which are a common sight as they spin like tops on the water, disturbing the insects below and pecking them up at an extremely fast rate.

The best time to visit Lake Myvatn is undoubtedly in late June to early July, when many of the ducks have young families and thousands of ducklings can be seen bobbing about on the water, anxiously escorted by their parents. This is also a good time to explore the surrounding pastures and moorland, which are notable for breeding waders, including Whimbrel (*Numenius phaeopus*), as well as for typical Icelandic landbirds such as Ptarmigan (*Lagopus mutus*) and Snow Bunting (*Plectrophenax nivalis*). Winter is bleak at Myvatn and snow covers the ground for most of the time between November through to March, and sometimes beyond. The lake does not freeze over totally, however, and some birds do remain, notably groups of Barrow's Goldeneye, which congregate on the open areas of water between the ice and move away only in the harshest of conditions.

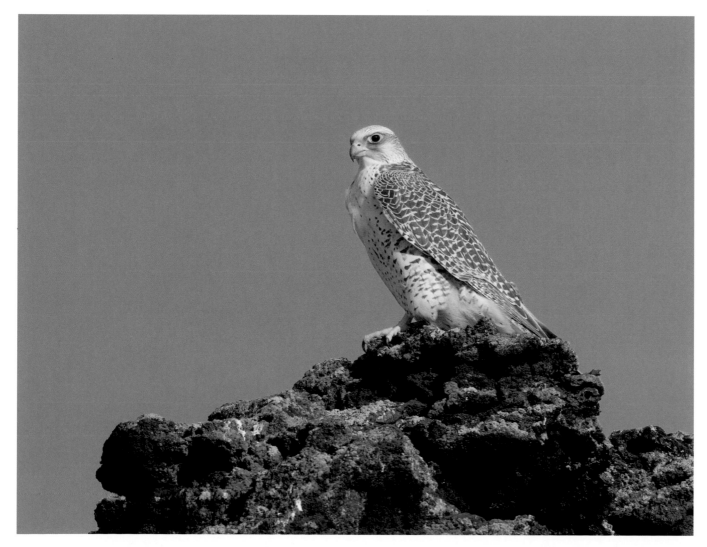

LEFT The world's largest falcon, the Gyrfalcon (*Falco rusticolus*) is regularly seen around Myvatn. An awesome predator, it stages dramatic attacks on the lake's ducks and is most often seen in summer, when parent birds are busy feeding their young.

AFRICA

The continent of Africa is quintessential safari country. Indeed, the word "safari" is the Swahili term for a journey, and not necessarily one with any wildlife dimension. In the nineteenth century "safari" came to be associated in East Africa with expeditions dedicated to the hunting of large animals, and the concept of wildlife watching only gained popularity in the years after the Second World War. By this time the great herds known by the big game hunters of old were already dwindling fast, and the first sparks of a conservation movement had been lit. Today many thousands of visitors enjoy a camera-only experience in the former hunting grounds of East Africa, with the great national parks of Kenya and Tanzania still the top destination for those keen to watch large mammals in the wild. Meanwhile, other African destinations offer the chance to see exciting wildlife in equally superb landscapes, from the desert rhinos of Namibia to the lemurs of Madagascar and the gorillas of Gabon and Uganda. Indeed, sensitively managed wildlife tourism offers a way ahead for many African communities, as well as hope for wildlife that finds itself under increasing pressure.

BELOW Against a backdrop of flamingos, a zebra comes to drink in the Ngorongoro Crater. The floor of the crater offers an unbeatable combination of breathtaking scenery and a great variety of easily observable wildlife.

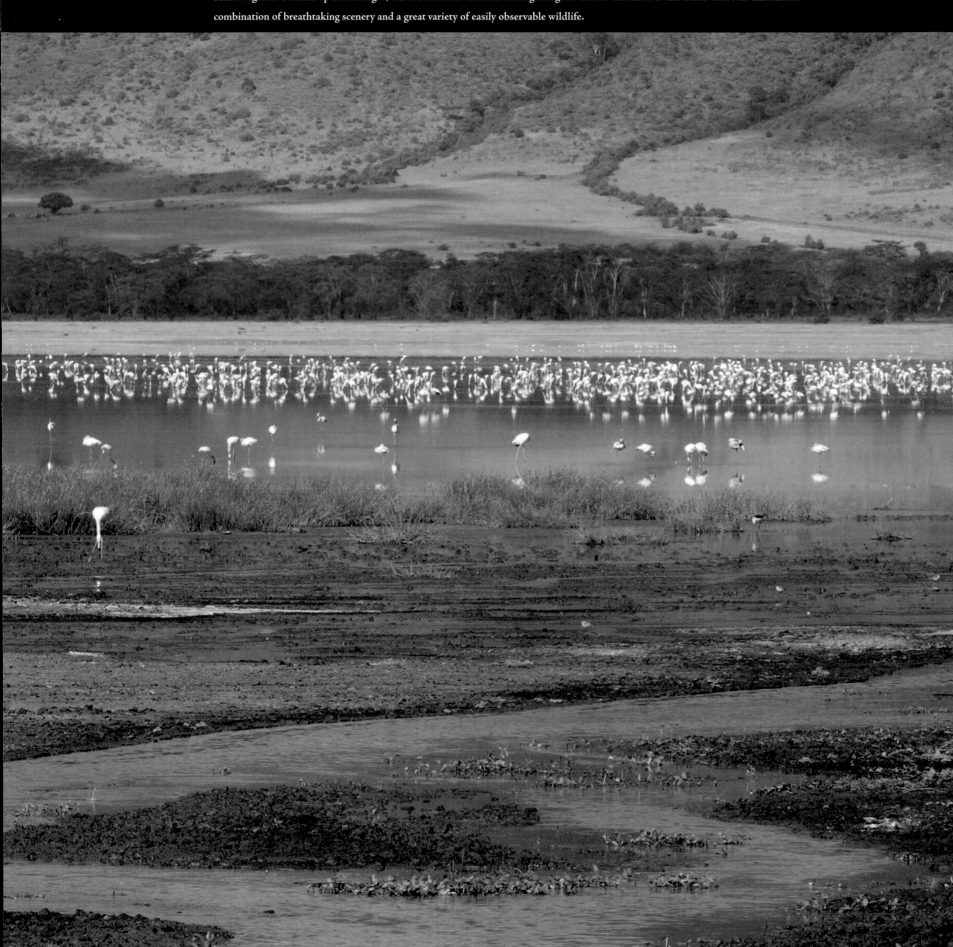

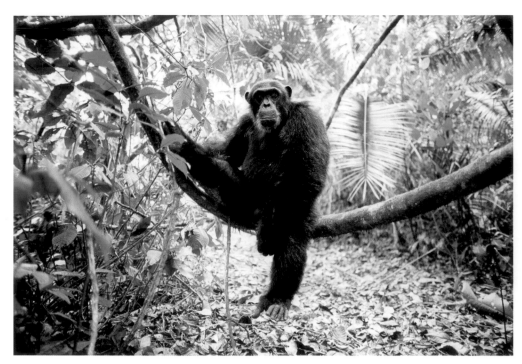

8. The Chimpanzees of Mahale

Idyllically located alongside Lake Tanganyika, Africa's deepest lake and the world's longest, Mahale Mountains National Park sits at the very heart of Africa, just 100 kilometres (60 miles) from the spot where Henry Morton Stanley famously encountered David Livingstone in 1871. This is still remote country, and a completely different experience from that enjoyed on the traditional East African safari circuit. For a start, there is no road access to the park; most visitors arrive by boat and stay at one of the camps on the sandy shores of the lake against a spectacular panorama of forest and mountains. The view on arrival is breathtaking, and even from the boat, before landing, it is possible to hear evidence of Mahale's most celebrated inhabitants – the thrilling whoops of the park's Chimpanzees (*Pan troglodytes*) calling from within the depths of the forest.

Tanzania has a long pedigree in Chimpanzee research. The two oldest wild Chimpanzee research centres in the world are both based here and have been active for over 40 years: one at Mahale itself, established by Kyoto University, and the other at nearby Gombe, where primatologist Jane Goodall began her work in 1960. Gombe Stream National Park lies north of Mahale and covers only 52 square kilometres (20 square miles). Hemmed in by agricultural land on three sides and by the lake on the fourth, its well-studied community of habituated Chimps have achieved global recognition. Some individuals are themselves veterans of African conservation – Fifi, now one of the senior matriarchs, has been known to Goodall since she first arrived at Gombe, when Fifi was just three years old.

Being more remote than Gombe, Mahale has not yet received these levels of attention, and nor are some of Gombe's problems – such as the encroachment of agriculture, and illegal hunting – such critical issues here. Mahale is also a much bigger park, covering 1,600 square kilometres (620 square miles), and so has a greater range of habitats and larger populations of wildlife. The mountain slopes rise steeply from the lakeshore and are mostly covered in thick forest, which gives way to bamboo thickets and open grassland on the summits. The forest is inhabited by prolific birdlife and several species of monkey, including Blue (*Cercopithecus mitis*), Red Colobus (*Procolobus badius*) and Red-tailed (*Cercopithecus ascanius*), as well as ungulates, such as Blue Duiker (*Cephalophus monticola*) and Bushbuck (*Tragelaphus scriptus*). Other species of antelope

ABOVE The Chimpanzees of Mahale are among the best-studied in the world, and exciting encounters with the habituated community there are virtually guaranteed.

RIGHT Mahale National Park enjoys a superb location on the eastern shore of Lake Tanganyika. The forests that cloak the mountain slopes are rich in wildlife.

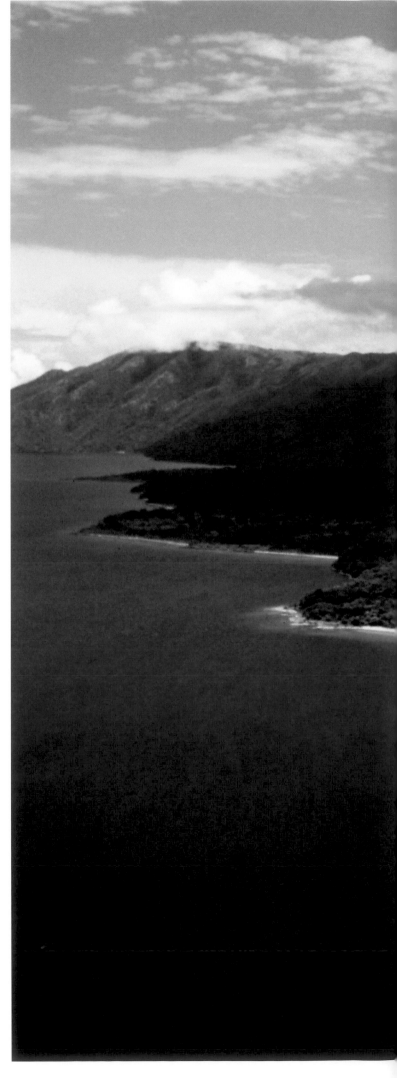

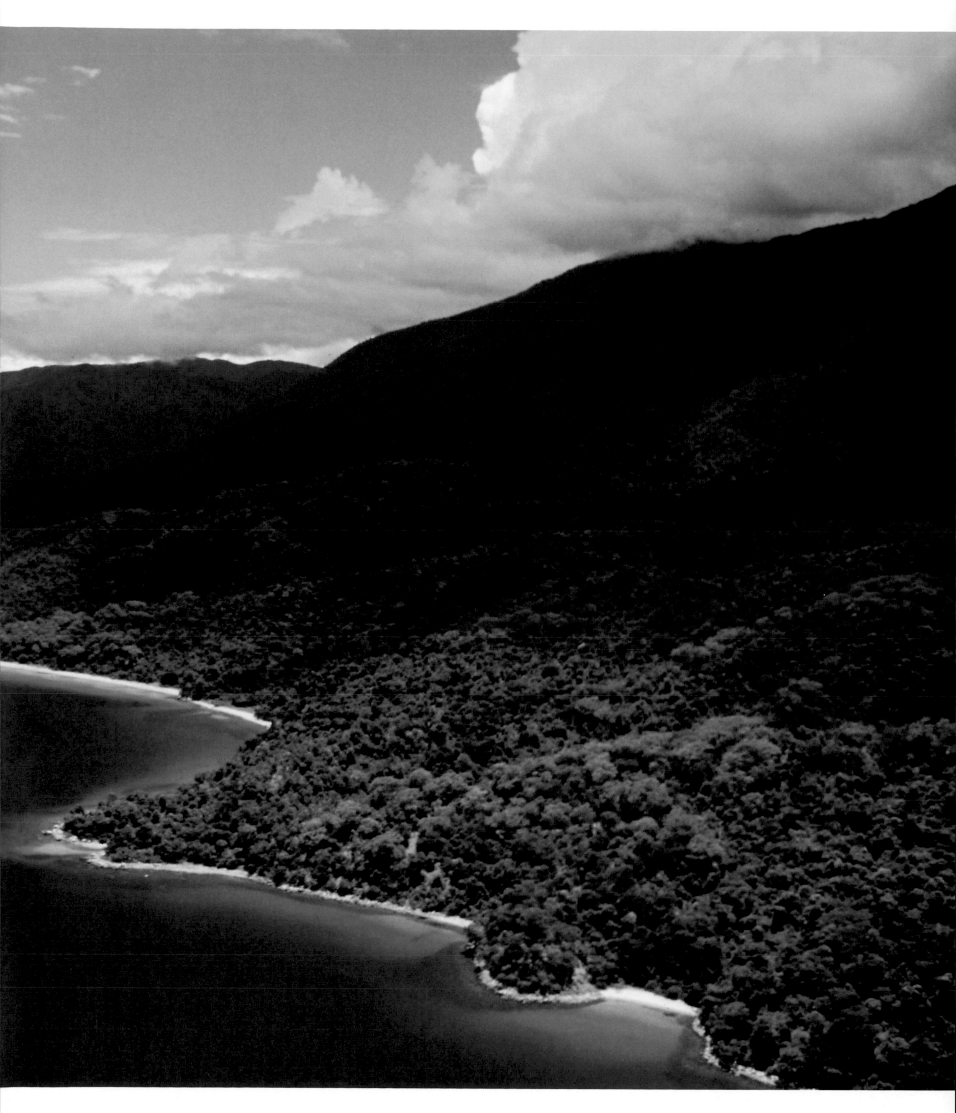

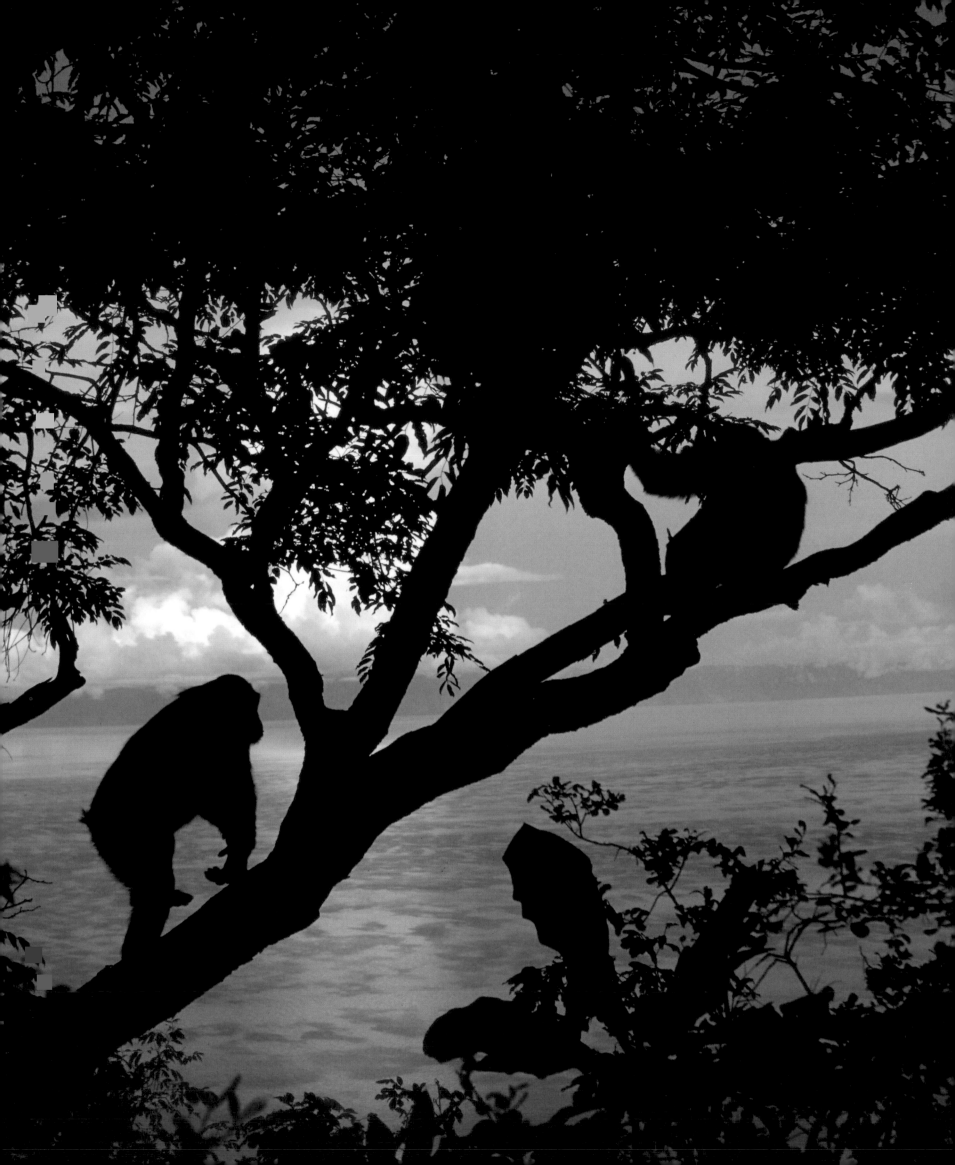

BELOW Chimpanzees have a
huge and varied diet. They will
often experiment with potential
foodstuffs by testing them in
their mouths, very much as
humans would.

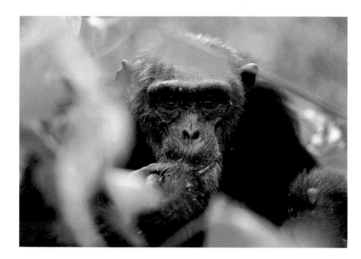

are found in the south of the park, where the landscape levels out into plains covered by miombo woodland. Lions (*Panthera leo*) have also been recorded from here.

However, it is the Chimpanzees that are the main wildlife attraction at Mahale. Approximately 700 live in the park, in an estimated 14 separate groups; one of these – known as the Mimikire or "M" community – has been habituated to humans, in the sense that group members will tolerate being observed from relatively close quarters. The group contains roughly 60 individuals, under the leadership of an alpha male (the present incumbent is named Alofu) and subject to the usual bonds, responsibilities and tensions that a typical family of *Homo sapiens* might experience. The hierarchy within the group, with status fiercely contested and vigorously defended, defines everything the group members do. The alpha male will dictate the movement of the group through the forest, decide on when to stop and what to eat, as well as where the group will bed down for the night. He is also in a position to bestow such critical factors as preferential mating rights, which means that there is endless jockeying for rank, and that the fortunes of individual Chimps constantly wax and wane.

Access within the park is strictly on foot, and park guides lead visitors each morning to wherever the Chimps can be watched without causing them any disturbance; no approach is allowed closer than 10 metres (33 feet) and this allows the opportunity to observe the animals behaving as naturally as possible. Chimps spend much of their waking hours feeding, and most observations therefore involve watching them feasting on fruit and engaging in the subtleties of Chimpanzee group etiquette. They are noisy animals, constantly interacting vocally with one other and the wider group via a vast range of shrieks, grunts and hoots; boisterous behaviour between males in particular is quite normal and related to the constant quest for dominance. Occasionally it is possible to watch Chimps pursuing and killing prey such as Red Colobus Monkey. This can be a shocking experience, but Chimps are omnivorous and hunting for meat is very much part of their daily lives. They are great opportunists, and will take more or less anything that comes their way.

Chimpanzees have few natural enemies. There have been records of both Lion and Leopard (*Panthera pardus*) taking Chimps, but in the latter case at least the tables can be turned and there are documented cases of Chimpanzees killing Leopard. The biggest threat to Chimps actually comes from their close relatives: humans. Chimpanzees share 98 per cent of their genes with us, and this makes them susceptible to almost all of our viruses and diseases. With no natural immunity to human-transmitted germs such as the common cold, they are highly vulnerable. Indeed, in 2006 an outbreak of pneumonia at Mahale was responsible for the death of several Chimps in "M" group and served to underline the need to keep human contact within strictly defined parameters. These restrictions help protect the Chimps and do nothing to impair what is one of the most enthralling of all wildlife experiences.

OPPOSITE Chimpanzees are diurnal
and spend the night in trees, where
they build nests of branches, vines
and leaves.

RIGHT Young Chimpanzees are
highly playful, their antics serving
to reinforce family bonds and
prepare them for adulthood.

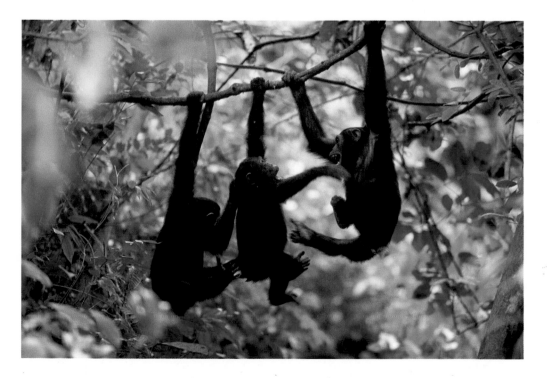

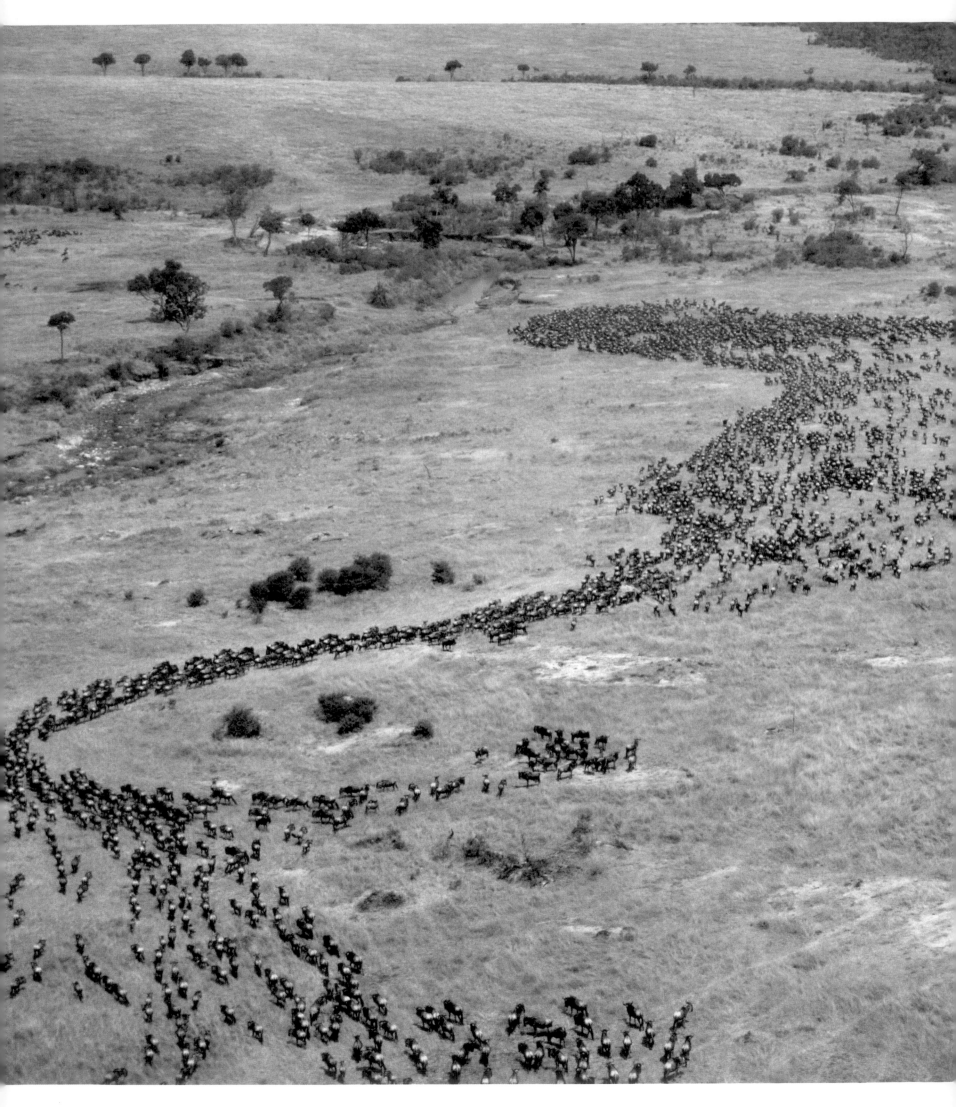

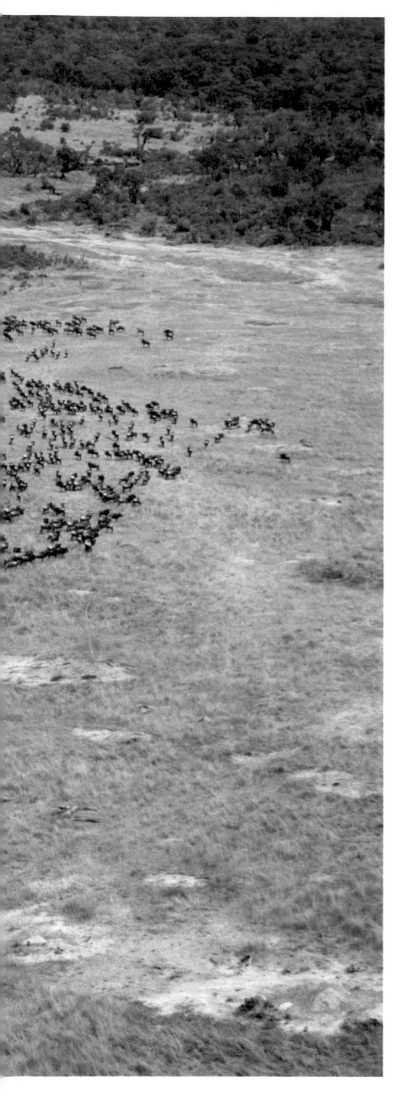

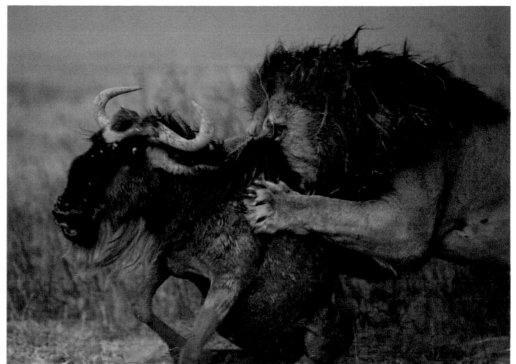

9. The Great Migration of the Serengeti

The sheer scale of the Serengeti is difficult to comprehend, even when you are actually in it. Everything about it impresses, from the sight of massive herds of zebra and wildebeest to a chance encounter with a lone cheetah dozing on a kopje, or a family of mongooses chasing each other across the plains. Few other places in Africa can lay claim to such a density and variety of wildlife. As if that were not reason enough to come here, the backdrop against which such superlative wildlife viewing takes place is also second to none – some 14,500 square kilometres (5,600 square miles) of seemingly unending grassland (or savannah), rolling hills, woodland and rocky outcrops. For many visitors this is quintessential Africa.

Established in 1951, the Serengeti is Tanzania's oldest national park and one of the last places in the world where it is possible to watch vast numbers of large, wild animals roaming free and behaving much as they have done for thousands of years. Still largely free of human interference and manmade obstacles, this behaviour includes the epic annual migration of Western White-bearded Wildebeest (*Connochaetes taurinus mearnsi*) and other ungulates, a 3,200-kilometre (2,000-mile) trek involving up to 1.5 million animals. Yet as dramatic as this spectacle undoubtedly is, it is just one aspect of the natural history of this remarkable place. The Serengeti is also famous for having one of the highest densities of carnivores in Africa, with Lion (*Panthera leo*), Leopard (*Panthera pardus*) and Cheetah (*Acinonyx jubatus*) all present in good numbers. There are also significant populations of Spotted Hyena (*Crocuta crocuta*), African Elephant (*Loxodonta africana*) and Giraffe (*Giraffa camelopardalis*), the latter perhaps the most iconic animal of the acacia-dotted plains.

However, the Serengeti is not without its frustrations. At times it is possible to drive for hours and see hardly anything; come back to the same location a few weeks later and it might

LEFT **Scenically outstanding, the plains of the Serengeti are also home to millions of animals. The annual migration of Western White-bearded Wildebeest and other ungulates is one of the most extraordinary wildlife spectacles in the world.**

ABOVE **A male Lion bringing down a wildebeest. Lions will stalk their prey to as close as possible, and then mount an attack. They usually kill by a bite to the neck or throat, and are capable of bringing down animals as large as African Buffalo and even young Elephants.**

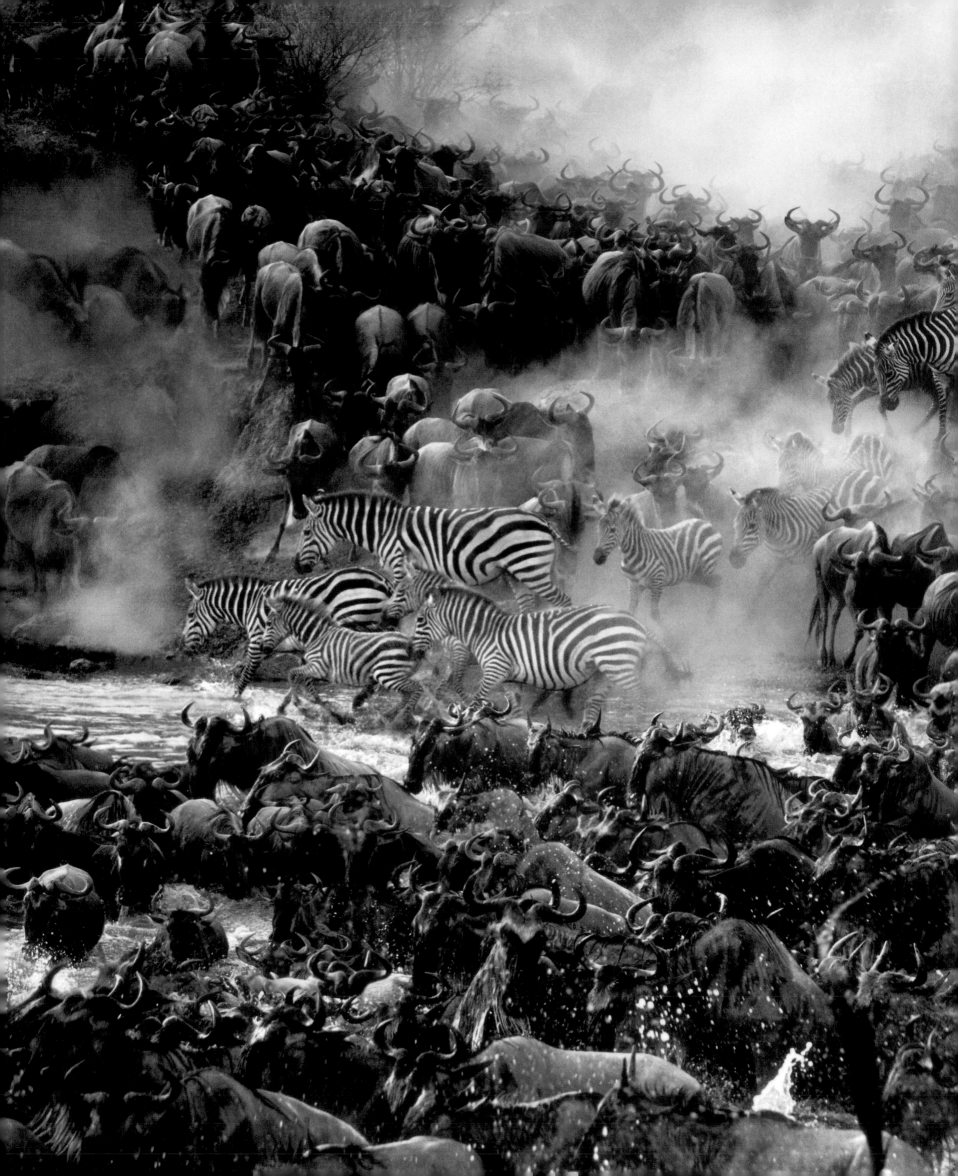

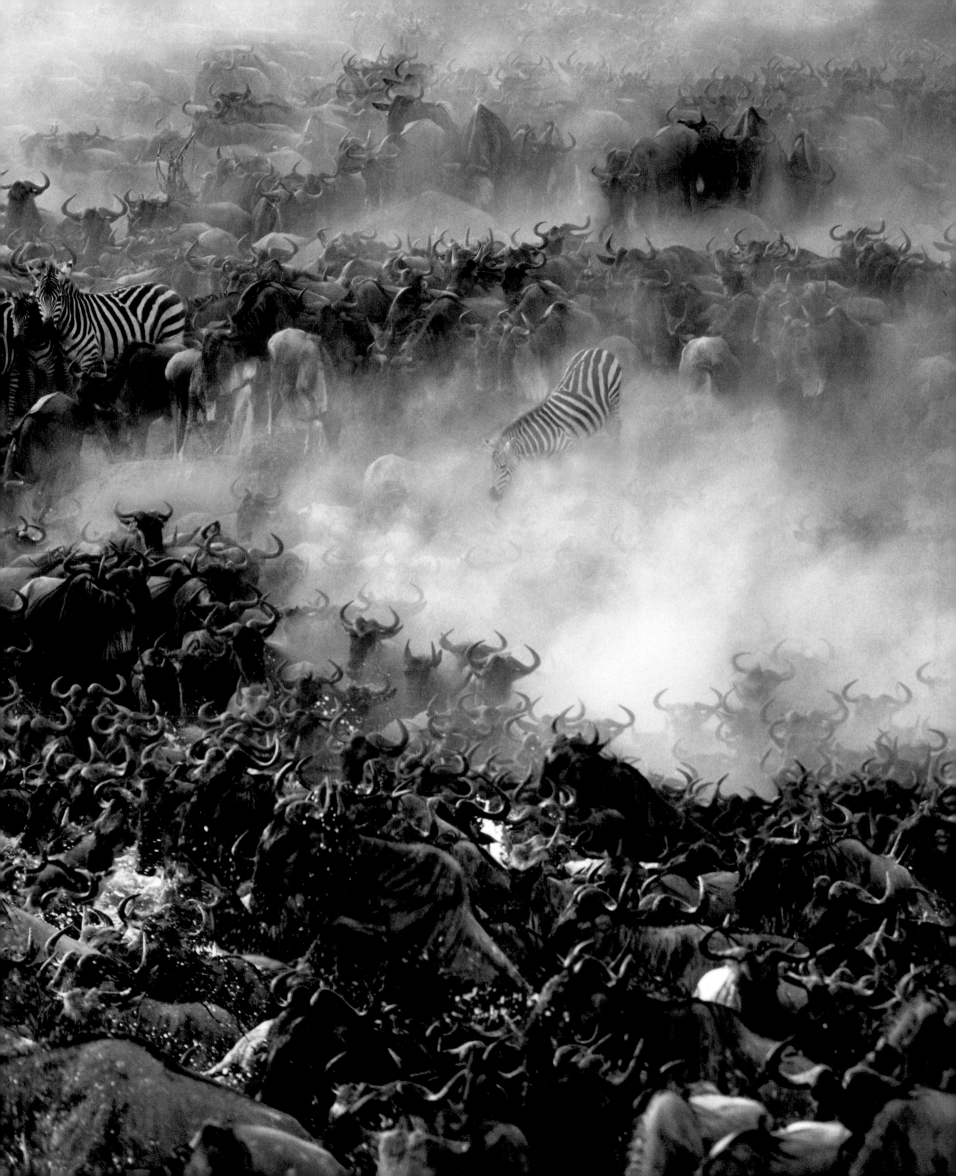

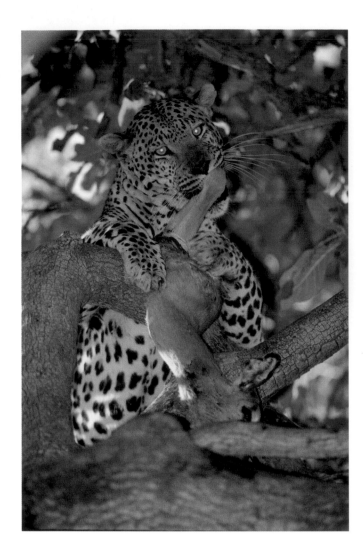

LEFT **After a successful kill, a Leopard will usually drag its prey up a tree in order to avoid having it stolen by Lions or Spotted Hyenas. Leopards are generally solitary creatures and, being nocturnal, are less often seen than the other big cats.**

OPPOSITE **Cheetahs are diurnal and hunt by sight. Although capable of tremendous speed, their stamina is limited, and they will only pursue prey for a distance of 400 metres (1,300 feet) or so. They overheat easily, so will always try and avoid hunting during the middle of the day.**

be teeming with animals. This is because life here, as in much of Africa, is dictated largely by rainfall patterns. There are two wet seasons in the Serengeti, with the main rains falling in April and May and a second, usually less significant, period of rain occurring from October to December. However, it can rain at any time of the year here, and in some years there is hardly any precipitation at all. The location and quantity of rainfall are therefore critical factors in determining where, and how plentiful, the grazing is for ungulates, which move around accordingly in search of fresh pasture.

The onset of the autumn rains marks the start of the annual migration, involving mainly Wildebeest, accompanied by 200,000 or so Thomson's and Grant's Gazelle (*Gazella thomsonii* and *G. granti*) and Plains Zebra (*Equus quagga*), on a clockwise route around the Serengeti–Masai Mara ecosystem, crossing the Kenya–Tanzania border twice. This quest for fresh grazing and water initially takes the animals south from Kenya's Masai Mara National Reserve, across the Mara River and down into the far southern corner of the Serengeti, where the herds spend the first three months of the year. It is here that the female wildebeest drop their calves – as many as 400,000 in one season. The herds remain spread across the great southern plains until the grazing and water are exhausted. By late May they are heading back north, and funnelling through the western corridor of the Serengeti ecosystem. Here the animal rut takes place, the frenzied males attempting to service half a million or so females.

By July the migration is moving northwards towards the Kenyan border. Two watery obstacles lie in its way: the Grumeti and the Mara Rivers, the latter already crossed once earlier in the year. Both rivers are noted for their Nile Crocodiles (*Crocodylus niloticus*) – indeed, the Grumeti is reputedly home to some of the largest specimens in Africa – and the Mara also has dangerous rapids. Undeterred, the wildebeest push on, jamming up against the water's edge before finally taking the plunge. This spectacle has made for some dramatic wildlife film-making, in which huge crocodiles either leap out of the water and grab wildebeest by the muzzle or simply pull them underwater as they thrash their way desperately across the river. Yet the vast majority of those attempting the crossing make it successfully and scramble up the opposite bank on to the green pastures of the Masai Mara, where they remain until it is time to head south again towards the end of the year.

Attendant at every stage of the migration are the big cats – Lion, Leopard and Cheetah. Not all of them move around following the herds, as there are always more sedentary populations of gazelle, zebra and African Buffalo (*Cyncerus caffer*) to feed upon, but the areas with the highest density of prey animals are bound to attract the greatest number of predators. Prides of lion are common across much of the Serengeti, but particularly favour the marshy areas, where they mount nocturnal ambushes on buffalo and zebra. Almost always solitary, leopards will often hunt along watercourses, such as the Mara River, where their presence adds to the already hazardous crossing for the wildebeest. Cheetahs, however, are animals of the open plains and rely on short but incredibly fast sprints to catch their prey– usually gazelle or Impala (*Aepyceros melampus*). Although exciting to watch, the activities of the predators are little more than a sideshow to what is the greatest known animal migration on Earth, and despite this seeming barrage of attack, the great migratory herds continue their way undaunted, their overall numbers unaffected.

PREVIOUS PAGES **River crossings are a fraught experience for the migrating animals, as currents and crocodiles are always likely to ensnare the unwary and the weak or fatigued. Even so, the vast majority cross successfully and continue their journey in search of fresh grazing.**

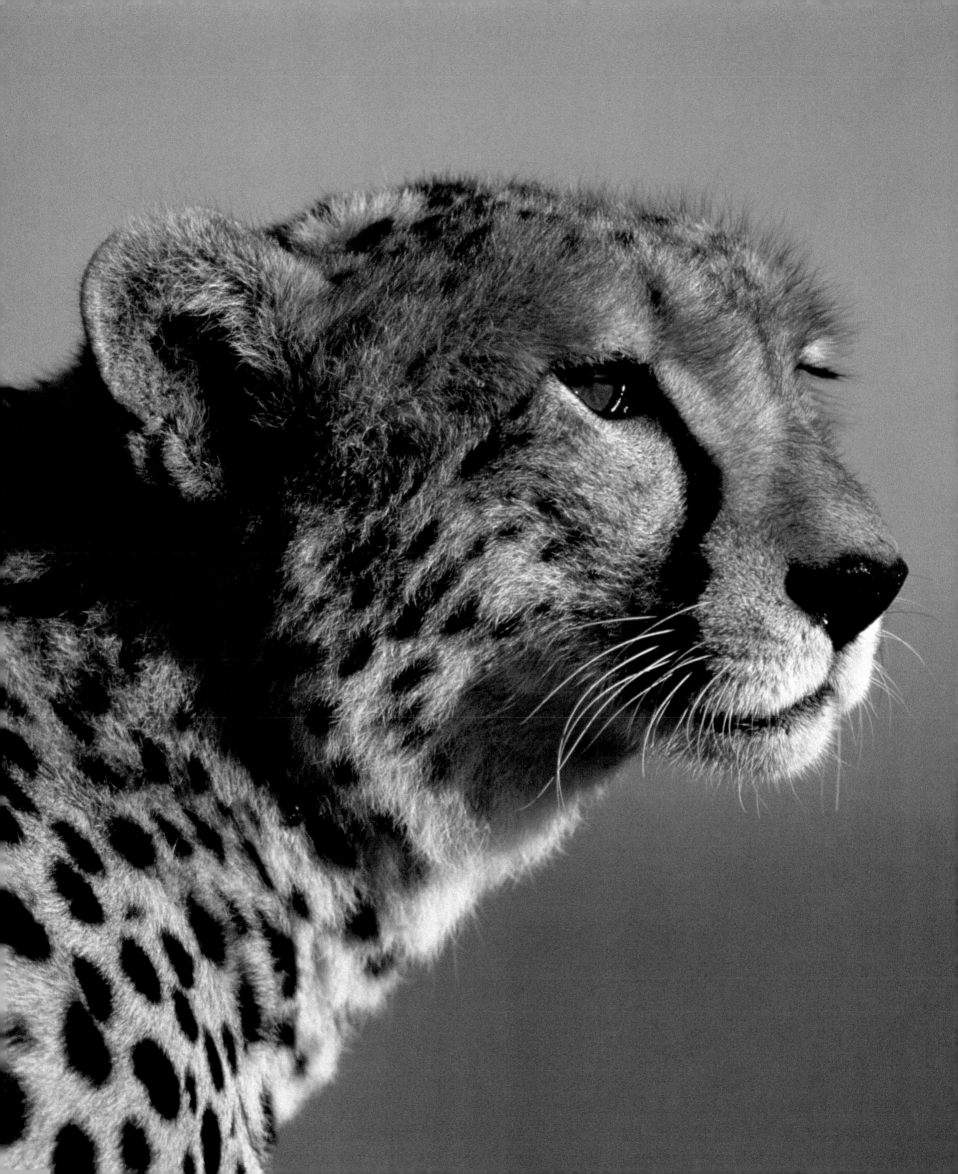

10. The Spiny Forest of Madagascar

One of the most unique and biologically distinct places on Earth, Madagascar defies all labels. The world's fourth largest island, it lies off the coast of Africa, but there is little about it that feels "African". Its wildlife has been separated from the mainland long enough to have evolved in many different directions, and is now largely endemic. Indeed, if you exclude introduced species, over 50 per cent of Madagascar's birdlife, 80 per cent of its native plants, 90 per cent of its reptiles and all of the island's mammals, including, most famously, its lemurs, are found nowhere else in the world. Nor are the majority of the island's inhabitants African in origin. Most Malagasy are descended from Indonesians, who came here as the first human arrivals only 1,500 years ago, and arrived at a place inhabited by now-extinct giant lemurs the size of gorillas and by the largest birds that ever lived, the Elephant Birds (*Aepyornis* sp.), which stood up to 3 metres (10 feet) tall.

A naturalist's paradise, to be sure, but Madagascar is also the focus of some of today's most pressing conservation concerns. Heavily populated and with high levels of poverty, the island has lost over 80 per cent of its original forest cover, with half of this disappearing in the last few decades. Extensive tracts of forest have been cleared to make way for cultivation, and the remaining trees are being felled at an unsustainable rate to meet the demand for firewood and charcoal production. The impact of soil erosion is highly visible across much of the island and the reason why astronauts, gazing down on Earth from outer space, have remarked that Madagascar "looks as though it is bleeding to death" – the loose, red soil is washed down off the higher ground and into the sea, where it turns the inshore waters rufous in colour.

Typical of the island's extraordinary climatic and landscape diversity, Madagascar's forests can be divided broadly into three types: tropical rainforest in the wetter north and east; deciduous forest in the west, and the remarkable "spiny forest" in the arid south and south-west. This unique landscape, sometimes known as the spiny desert or deciduous thicket, covers an estimated 14,000–16,000 square kilometres (5,400–6,200 square miles) in total, and is one of the most important eco-regions in Madagascar, home to a wealth of mammals, birds, plant and reptiles. It lies in the driest part of Madagascar, with annual rainfall rarely exceeding 400 millimetres (16 inches) and sometimes failing to arrive at all. The ability to withstand extended periods of drought is therefore central to survival, and the local vegetation is characterized by species of thorn-covered shrubs and trees, over 90 per cent of which are endemic to this area.

At first sight the landscape and general terrain of the spiny forest look similar to the deserts of the south-western United States, but on closer examination the dominant plants are revealed as belonging to an endemic family, the *Didiereaceae*, and in particular to the genera *Alluaudia* and *Didierea*. These are woody plants bearing small deciduous leaves, which are shed at the onset of the dry season, and many species have slim, tapering branches that are covered in spines. Particularly impressive are *Alluaudia procera*, one of the thorniest species of all, and *Alluaudia ascendens*, which is the tallest, reaching heights of up to 15 metres (50 feet). Also characteristic of the spiny forest is the amazing octopus tree *Didierea madagascariensis*, as well as a variety

ABOVE *Pachypodium lamerei* is a classic spiny forest species, its water-storing trunk liberally covered in thorns.

OPPOSITE **The branches of the octopus tree *Didierea trolli* form a maze of spine-covered tentacles. Amazingly, some species of lemur are not deterred from scrambling over them.**

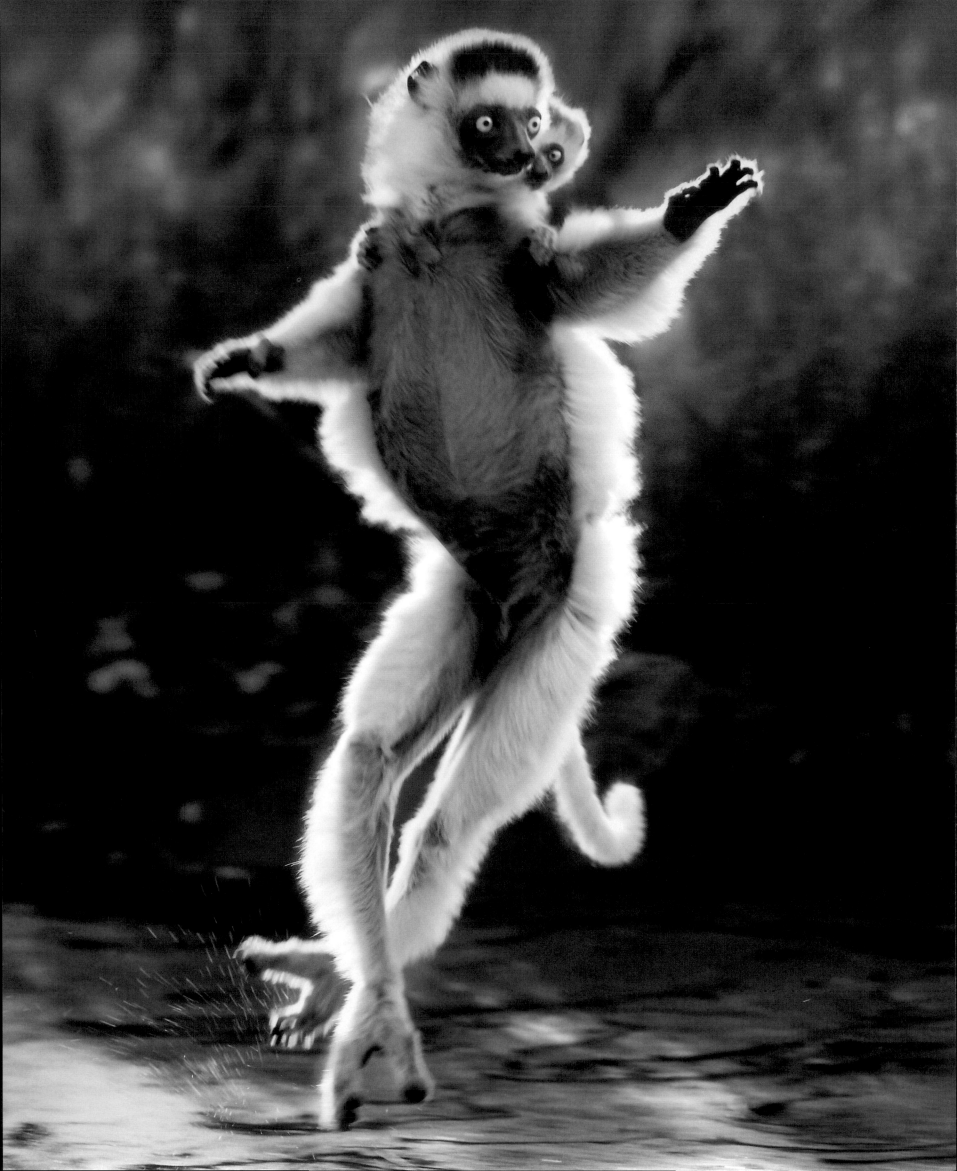

of deciduous and evergreen succulents, and trees with bloated, water-storing trunks, such as baobabs and species of Pachypodium or "elephant foot".

Wildlife in the spiny forest is quite outstanding, and exhibits the high levels of endemism found elsewhere in Madagascar. Several bird specialities are restricted to this eco-region, including Verreaux's Coua (*Coua verreauxi*), Long-tailed Ground-roller (*Uratelornis chimaera*), and Sub-desert Mesite (*Monias benschi*); the last two species occur only in a narrow coastal strip of spiny forest north of Toliara (Tuléar). Another target for wildlife enthusiasts is the Radiated Tortoise (*Geochelone radiata*), one on the most beautiful of all chelonians. However, top of the wish list for most visitors to the spiny forest are probably the lemurs that live here, notably Verreaux's Sifaka (*Propithecus verreauxi*) and the Ring-tailed Lemur (*Lemur catta*). Both species can be seen reliably in the reserve at Berenty, which includes areas of spiny forest as well as dry, gallery forest. The Ring-tails are as at home on the ground as up in the trees, and close views are guaranteed. Sifakas, however, are more strictly arboreal, and generally more wary of humans. However, when they do come to the ground they are remarkable to watch, thanks to their particular form of locomotion. Arms aloft, and feet held together, they jump sideways in a rapid but undeniably comical movement.

What future for Madagascar's spiny forest and its wildlife? With many rural Malagasy relying heavily on natural resources to sustain themselves, growing population pressure is causing the degradation and fragmentation of habitats right across the island. In particular, some areas of the spiny forest have been cleared totally and replaced by crops such as maize and sisal. One of the more sobering aspects of a visit to those areas of forest close to human settlement is the frequent sound of trees being chopped down, a situation which is unlikely to change until alternative options become feasible for local people. Conservation usually stands a better chance of succeeding when it is related to forms of appropriate economic development; in this case, initiatives – including ecotourism – are being developed that will help local people to rely less on the spiny forest, or at least to manage it sustainably.

11. The Renaissance of Meru National Park

In the 1970s Meru was one of Kenya's showcase national parks. Teeming with game, it offered spectacular wildlife viewing in scenery that epitomized the timeless beauty of the East African landscape. The area was well known as one of Kenya's biodiversity hotspots and had achieved worldwide fame through the work of Joy and George Adamson, who came to Meru and, in 1958, successfully reintroduced Elsa, an orphaned lioness, to the wild. The ensuing film and publicity made Meru one of the most popular tourist destinations in Kenya, with 40,000 visitors a year flocking to see the abundance of wildlife here, particularly the large-tusked African Elephants (*Loxodonta africana*), numerous Black Rhino (*Diceros bicornis*) and prides of Lions (*Panthera leo*).

However, during the late 1970s and '80's Meru was subject to a vicious onslaught by bands of poachers and Somali bandits, known as *shifta*, armed with semi-automatic weapons. Under-resourced park rangers were no match for such intruders, and the game in the park was decimated. The elephant population collapsed, and rhinos were completely wiped out. One of the saddest episodes was the killing, in 1988, of several captive White Rhinos (*Ceratotherium simum*) that had been introduced from South Africa in a bid to establish a viable population at Meru, and were protected around the clock. Several of the rangers responsible for their safety were murdered or injured in the attack, at which point it became clear that the situation at Meru had become very grave indeed. The following years saw a further deterioration, with the remaining smaller game being intensively poached for the bushmeat trade, and the murder of two tourists in the park and of George Adamson in the neighbouring Kora National Park. As a result, visitor numbers to the area slowed to almost zero and, with its game populations so depleted, Meru was at risk of being degazetted as a national park.

ABOVE **Joy Adamson with her orphaned lioness, Elsa.** The story of how Elsa was successfully re-introduced to the wild in Meru is one of the great wildlife stories, and sparked worldwide interest in the park. The lioness's grave is at Meru.

RIGHT **Grevy's Zebra is the largest** of the wild equids. Still poached for their attractive hides, numbers have fallen in recent decades and today they are found only in localized parts of northern Kenya and southern Ethiopia.

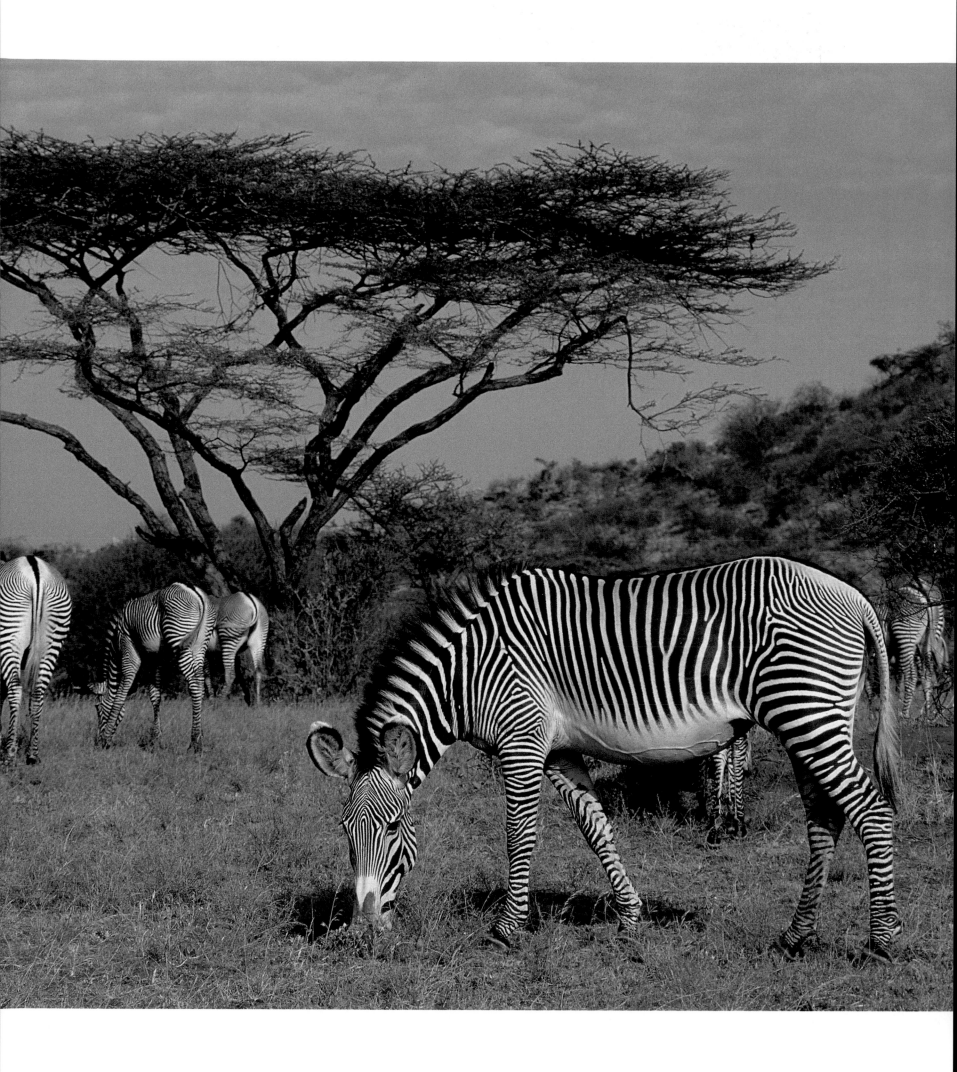

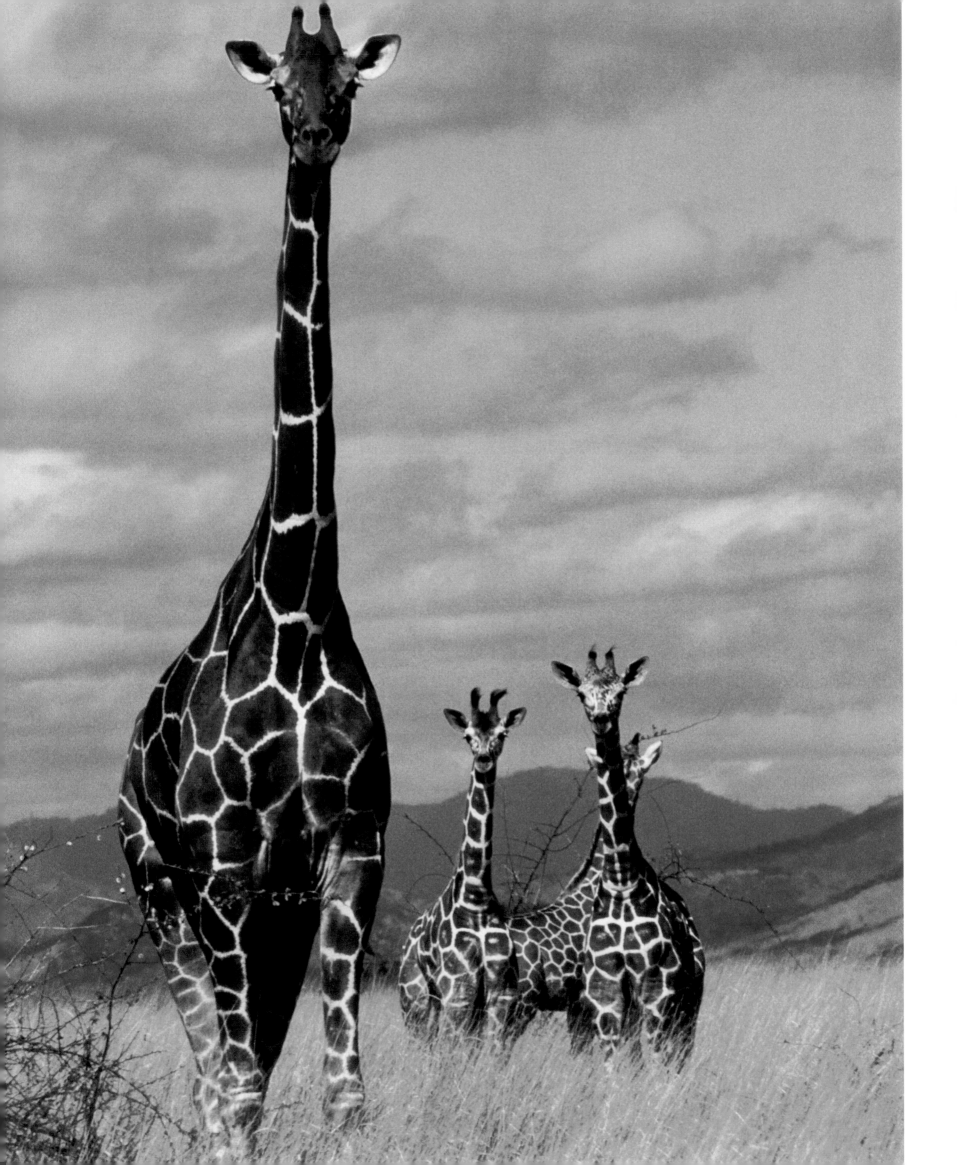

Today, however, this grim scenario has been completely turned around and Meru's future is looking bright. A highly motivated and committed team of wardens has restored the park's security and infrastructure, and an ambitious restocking programme has been implemented. This has seen the return to Meru of species that were previously wiped out or reduced to perilously low numbers. A variety of typical plains game has been reintroduced, along with an initial stock of 56 African Elephant (comprising nine different families), which were translocated from the Laikipia plateau in the most successful initiative of its kind to date. These animals have helped augment the remnants of what was once a large local elephant population. Perhaps most symbolically, a small nucleus of both Black and White Rhinos has been established in a special section of the park, and includes the sole survivor from the massacre of 1988.

The magical landscape of Meru had, of course, remained unchanged by the dark years. Against a stunning backdrop of the Nyambeni Hills, and of Mount Kenya when conditions are clear, the park is bounded by three great rivers, including the Tana on its southern flank. Covering 870 square kilometres (320 square miles) and straddling the equator, Meru sits in the transition zone between the classic savannah habitat of southern Kenya and the sub-desert conditions of the north.

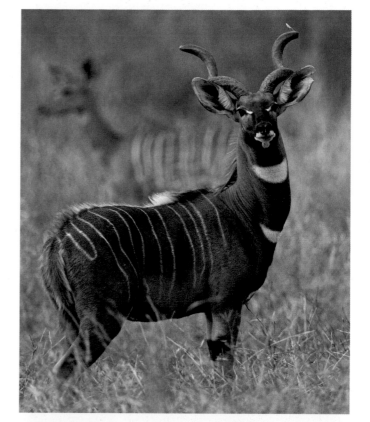

This location is reflected in the wide diversity of landscape types found here, as well as in the local animals and birds: in addition to species more typical of wetter savannah, such as Impala (*Aepyceros melampus*) and Kongoni (*Alcelaphus buselaphus cokii*), there are also dry-country specialists, such as Grevy's Zebra (*Hippotigris grevyi*), Reticulated Giraffe (*Giraffa camelopardalis reticulata*), Beisa Oryx (*Oryx beisa*) and Gerenuk (*Litocranius walleri*). Meru is also one of the best places in Kenya to see Lesser Kudu (*Tragelaphus imberbis*). Much of the park is covered by open wooded grassland, studded by acacias and Combretum trees, and along the many streams that bisect the park there are excellent stands of riverine forest, containing fig trees, tamarinds and doum palms, as well as significant areas of marsh and swamp.

As the numbers of game have increased, so predator numbers have picked up. In particular, Meru is now an excellent place to see Cheetah (*Acinonyx jubatus*). These elegant cats were always present in the area, and it was here that the Adamsons rehabilitated their tame Cheetah, Pippa, to a life in the wild. So it is fitting that Cheetahs are now again stalking across the plains of Meru in good numbers. Typically, they prey on gazelles or Impala (*Aepyceros melampus*), but at Meru they commonly take Dik-dik (*Madoqua* sp.). Roughly one-third to one-half of Cheetah pursuits are successful, but Cheetahs are often subsequently robbed of their prey by Lions (*Panthera leo*) or Spotted Hyenas (*Crocuta crocuta*) and so need to eat quickly after they have made a kill. Watching Cheetahs at a kill is consequently a rare and short-lived privilege, but as likely at Meru as anywhere.

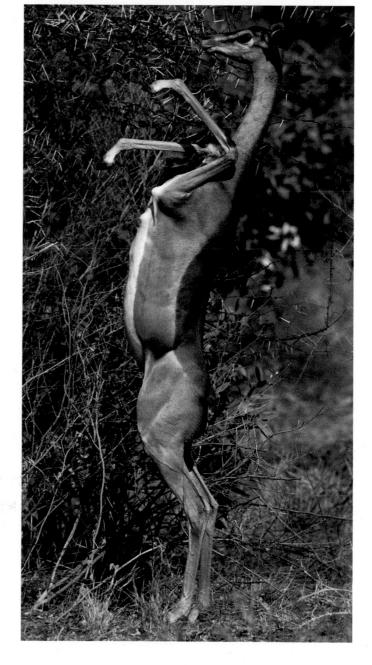

RIGHT TOP **Lesser Kudu is a** localized species and very much an animal of the dry scrub that is typical of parts of Meru. Shy and wary, it rarely gives good views. Only the males have horns.

OPPOSITE **Arguably the most** handsome of the giraffe sub-species, the Reticulated Giraffe is a dry-country specialist. The deep chestnut-brown coat is broken up by narrow white "crazing".

RIGHT **Gerenuk means "giraffe-** necked" in Somali, and the animal's long neck and ability to stand on its rear legs to browse on taller bushes distinguish it from other species of antelope.

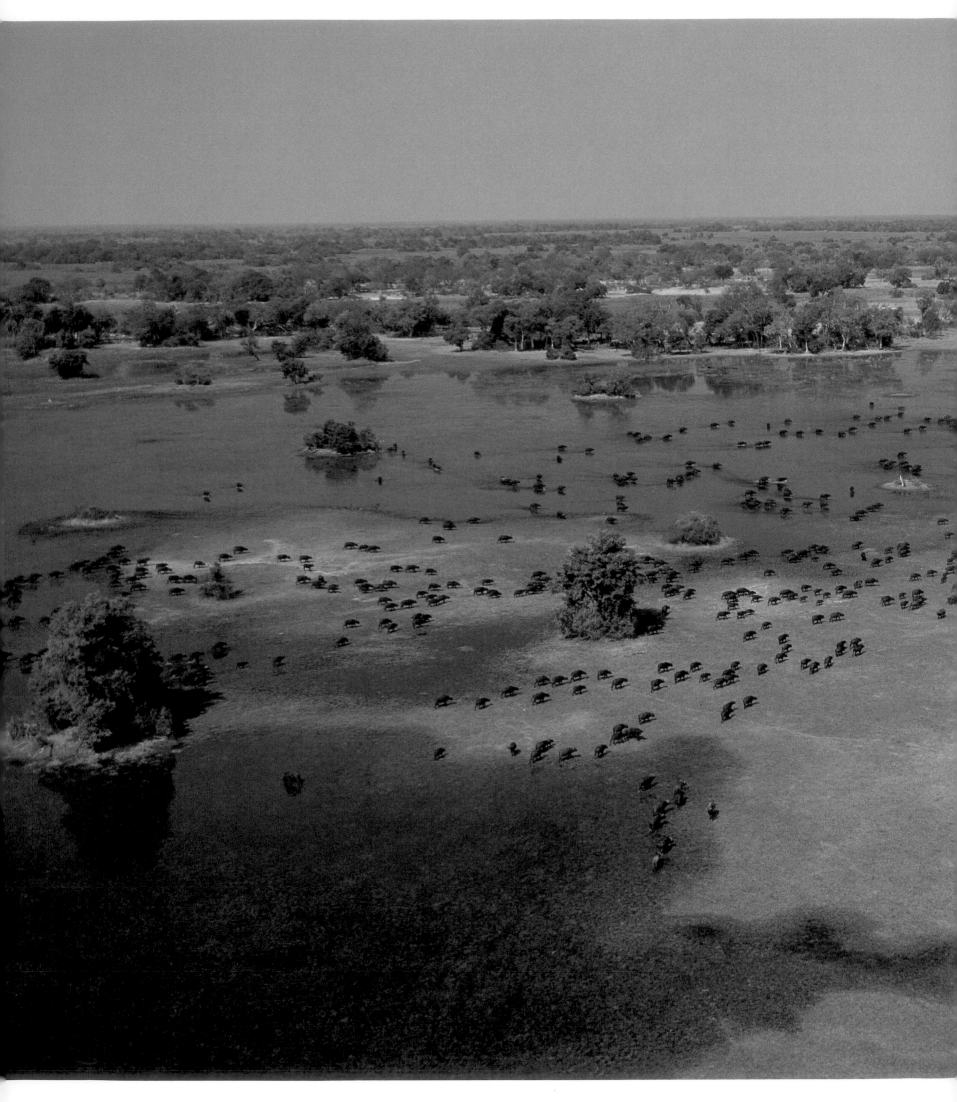

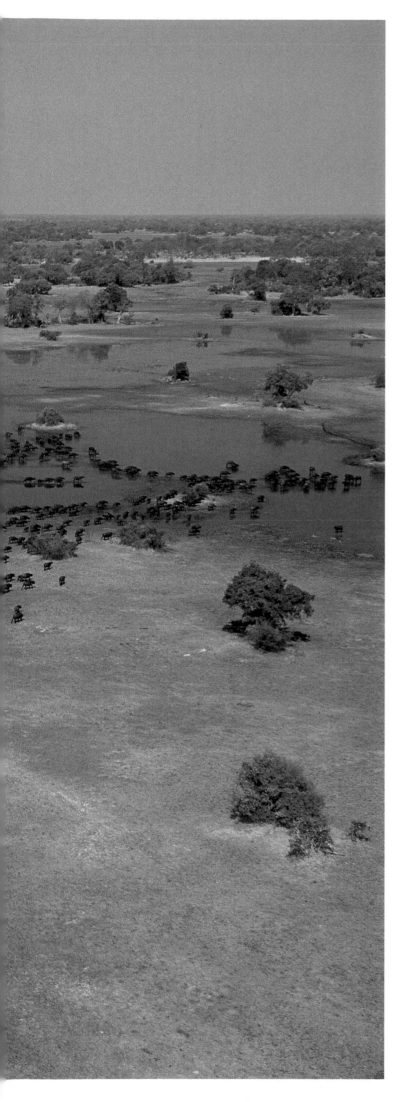

12. The Wild Dogs of the Okavango

Every autumn, heavy rains in the Angolan Highlands bring life to the parched landscape of north-west Botswana, over 1,000 kilometres (600 miles) away. The rainfall drains off the hills into the Okavango River which, with no access to the sea, swells and forges off towards the south-east, emptying four months later into the vast inland delta with which it shares its name. Covering some 15,000 square kilometres (5,800 square miles), the delta contains a few areas of permanent water but depends almost totally on the annual inundation from Angola to sustain it. As the waters fan out into the dusty pans and desiccated grassland, the landscape is revitalized, soon transforming into a superb mosaic of lush pasture, swamps, miombo and mopane woodland, floodplain islands, open lagoons fringed by papyrus and palms, and winding channels and oxbow lakes covered with carpets of water lilies. Although much of this landscape is transient – islands come and go, for example, depending on water levels – by May the delta supports huge numbers of wild animals, which move into the area *en masse* to take advantage of the abundant grazing.

There are particularly large numbers of African Buffalo (*Syncerus caffer*), sometimes to be found in herds of as many as 1,000 individuals, as well as many African Elephants (*Loxodonta africana*) and species of ungulate, including Okavango specialities such as Southern Lechwe (*Kobus leche*) and Sitatunga (*Tragelaphus spekeii*). The usual attendant predators are also present, and over 400 species of bird have been recorded here, including one of southern Africa's most localized species, the Slaty Egret (*Egretta vinaceigula*). The times of plenty for the area's wildlife are relatively short-lived, however. The combination of high daytime temperatures and generally shallow water result in an evaporation rate as high as 96 per cent, and by October much of the delta is dry again.

One of the most exciting local inhabitants is the African Wild Dog (*Lycaon pictus*), for which the Okavango (and especially the Moremi Game Reserve) represents a last stronghold. Once widely distributed across much of sub-Saharan Africa, Wild Dog numbers have fallen dramatically in recent

LEFT **A large herd of African Buffalo moving across part of the Okavango Delta. One of the most numerous large mammals in the delta, Buffalo are also among the most dangerous. Lone bulls are especially unpredictable.**

ABOVE **A group of female Impala, arguably the most elegant of all African antelopes, alert and clearly sensing the presence of a predator. Such a group would normally be the harem of a single adult male, who will defend his territory and females with great vigour.**

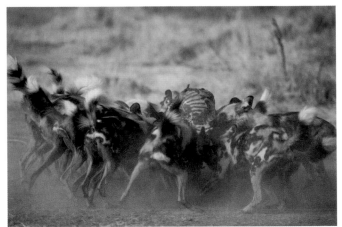

decades and in some countries they are now feared to be extinct. Although diseases such as canine distemper are known to have been responsible for the disappearance of some local populations, the main reason for their decline is disturbance and persecution by humans, particularly by livestock farmers fearing for their animals. Although highly peripatetic, and therefore potentially able to recolonize areas from which they have been wiped out, Wild Dogs are an increasingly rare sight across Africa. The total global population is now estimated to be fewer than 5,000, with only six populations containing more than 100 individuals. In the Okavango you stand as good a chance of seeing one as anywhere.

Wild Dogs are only distantly related to domestic dogs. In their behaviour they perhaps most resemble wolves, as they are pack animals and display the same close social and family bonds. There is one interesting behavioural difference, however. Whereas wolves use aggressive behaviour to reinforce pack hierarchy, wild dogs rely on cooperation. Violence between pack members is therefore unusual. Indeed, elderly or sick dogs are often cared for, and fed by, other pack members. A pack usually comprises 10 or so animals, and has only one breeding pair – the other adults hunt for food and assist with the rearing of the lead (or alpha) pair's litter. Except when the pups are very young, the pack is constantly on the move, rarely remaining more than a day or so in one place. The dogs range over vast areas in their quest for prey, and usually hunt at dawn and dusk, seeking out shade during the middle of the day.

Watching a pack of Wild Dogs hunting is one of the great wildlife experiences. The dogs rely on a combination of speed, stamina and cooperation to run down their prey (typically Impala [*Aepyceros melampus*]), and can keep moving at speeds of up to 50 kilometres (30 miles) per hour for as much as 5 kilometres (3 miles). A hunt begins with a "scout" – usually a subordinate pack member – going on ahead to identify the location of potential prey and to start the chase. The other pack members soon catch up and fan out, attempting to surround the chosen prey animal on all sides whilst communicating with each other via their distinctive and bird-like "chirping" calls. Once the animal tires and slows, the dogs will start nipping at it, eventually pulling it down. Wild Dogs have one of the highest success rates of any predator, with an estimated 70 per cent or so of their hunts resulting in a kill.

Protected by law in Botswana, Wild Dogs are just about holding their own here, but in recent years an expansion in commercial cattle ranching in areas adjacent to the Okavango has seen the enclosure of large tracts of open country through which wildlife has traditionally moved. This has adversely affected migratory animals such as Blue Wildebeest (*Connochaetes taurinus*), as well as Wild Dogs, which are now at greater risk of coming into conflict with farmers when they stray outside the protected areas. Elsewhere in Africa they are increasingly confined to areas that may support too few prey animals to sustain a viable population of dogs. It is unclear what future there may be in the wild for a species such as this, one that requires such vast expanses of wild terrain in which to thrive and which is losing out in the face of so many pressures.

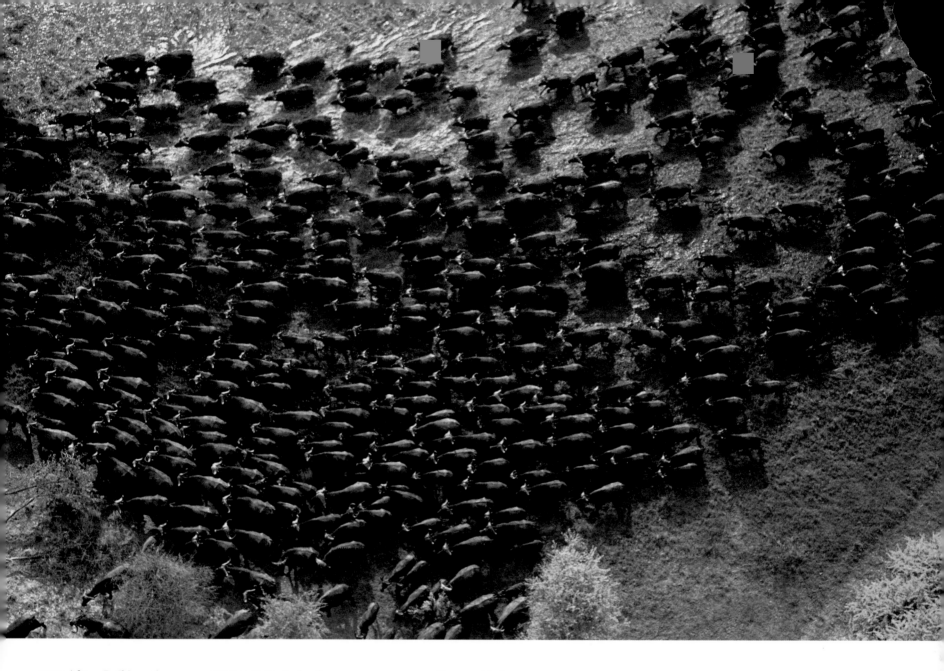

ABOVE **African Buffalo on the move.** One of the dominant herbivores in the Okavango Delta, buffalo often gather in large herds but rarely mix with other species.

GATEFOLD CENTRE **In the aftermath of the rains, the Okavango provides ideal conditions for large numbers of zebra, which move into the area to take advantage of the abundant new vegetation.**

CLOSING PAGE **Not surprisingly, congregations of the delta's grazing animals draw the attention of its predators, including Wild Dog.**

LEFT FLAP **The Southern Carmine Bee-eater (*Merops nubicoides*) is one of the delta's most stunning birds, and particularly spectacular when nesting colonially in riverbanks.**

RIGHT FLAP **During the dry season the Okavango's grazing animals, such as these Impala, are increasingly concentrated around the dwindling sources of water.**

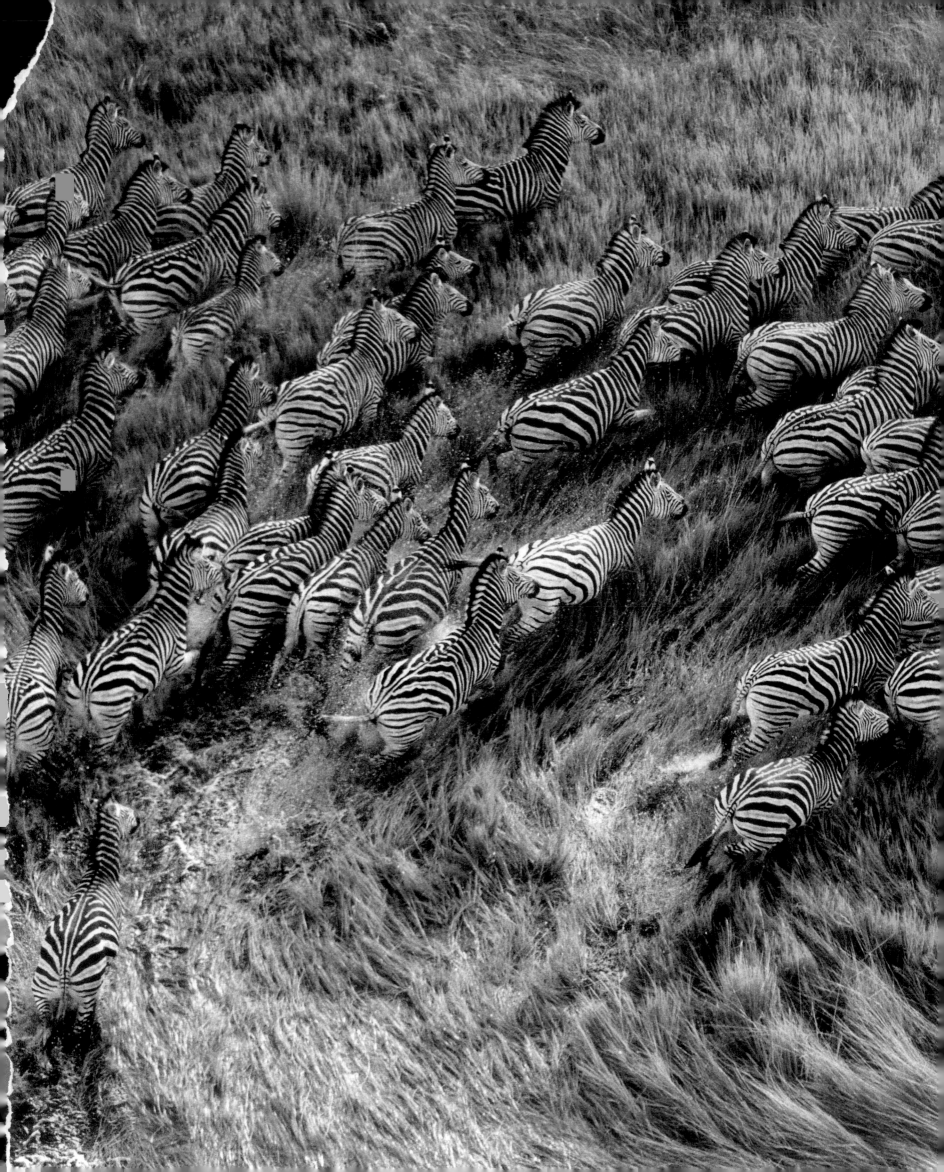

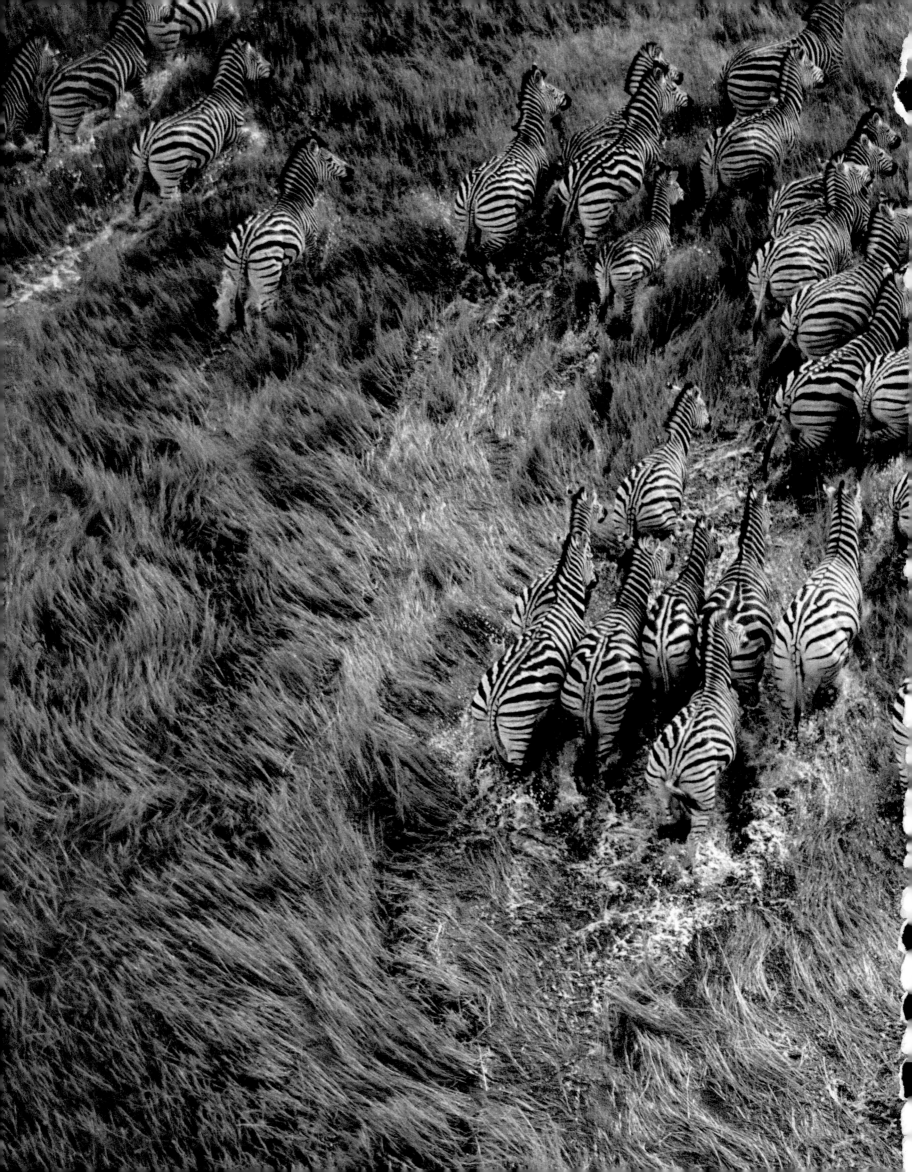

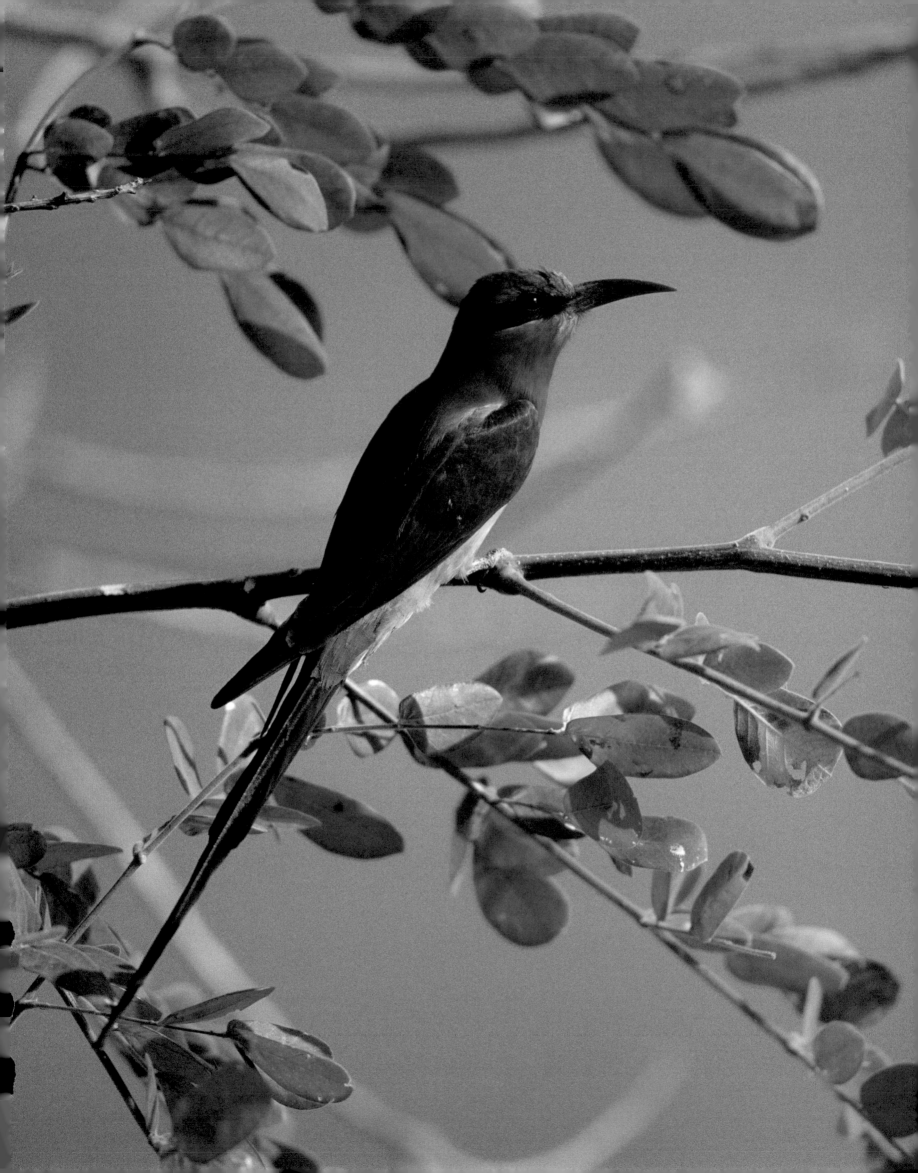

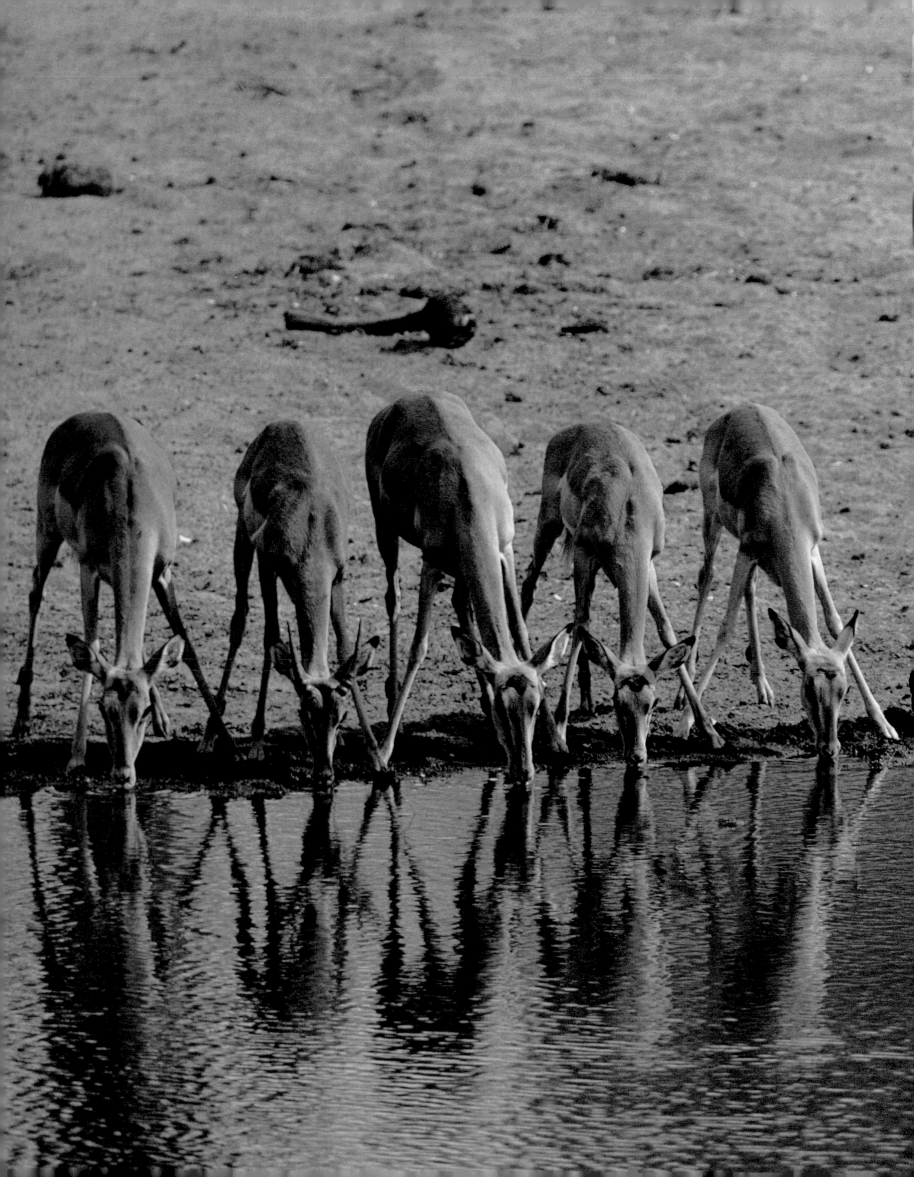

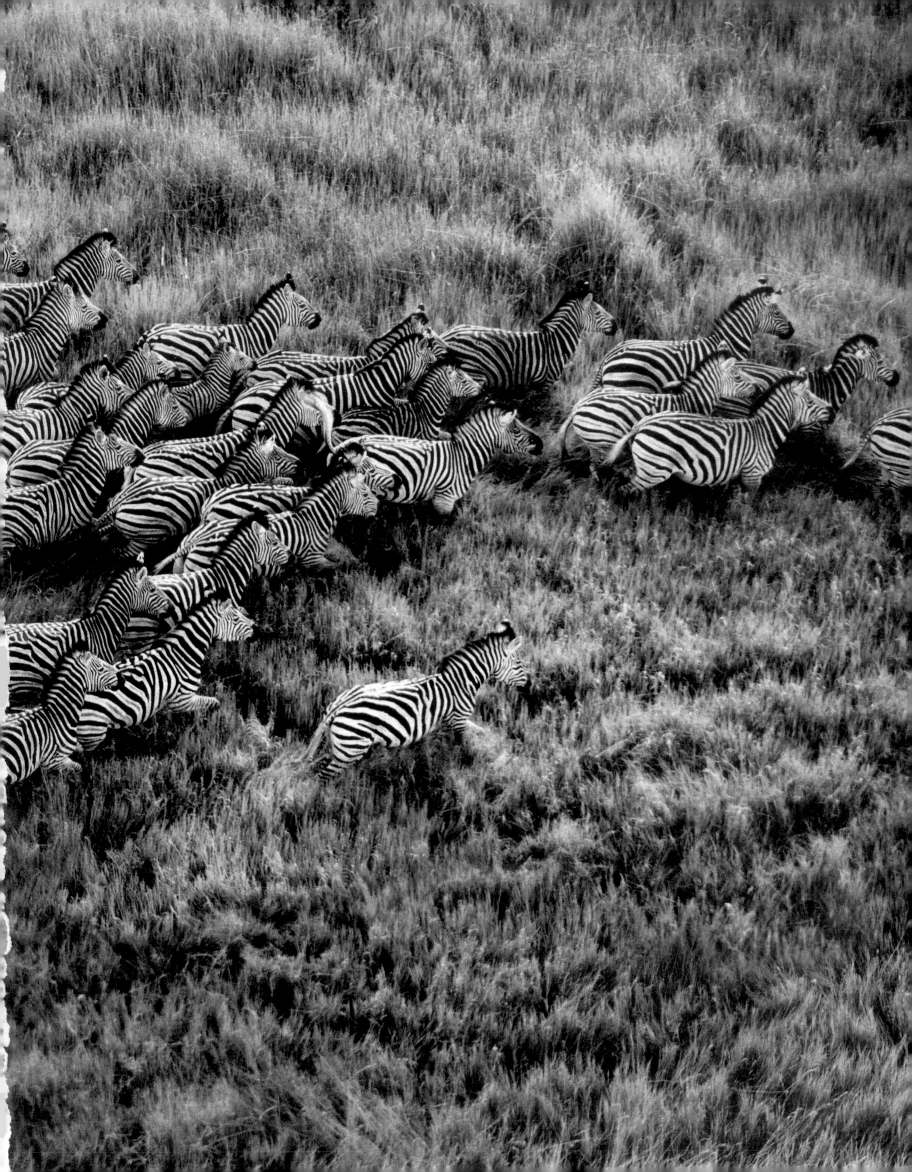

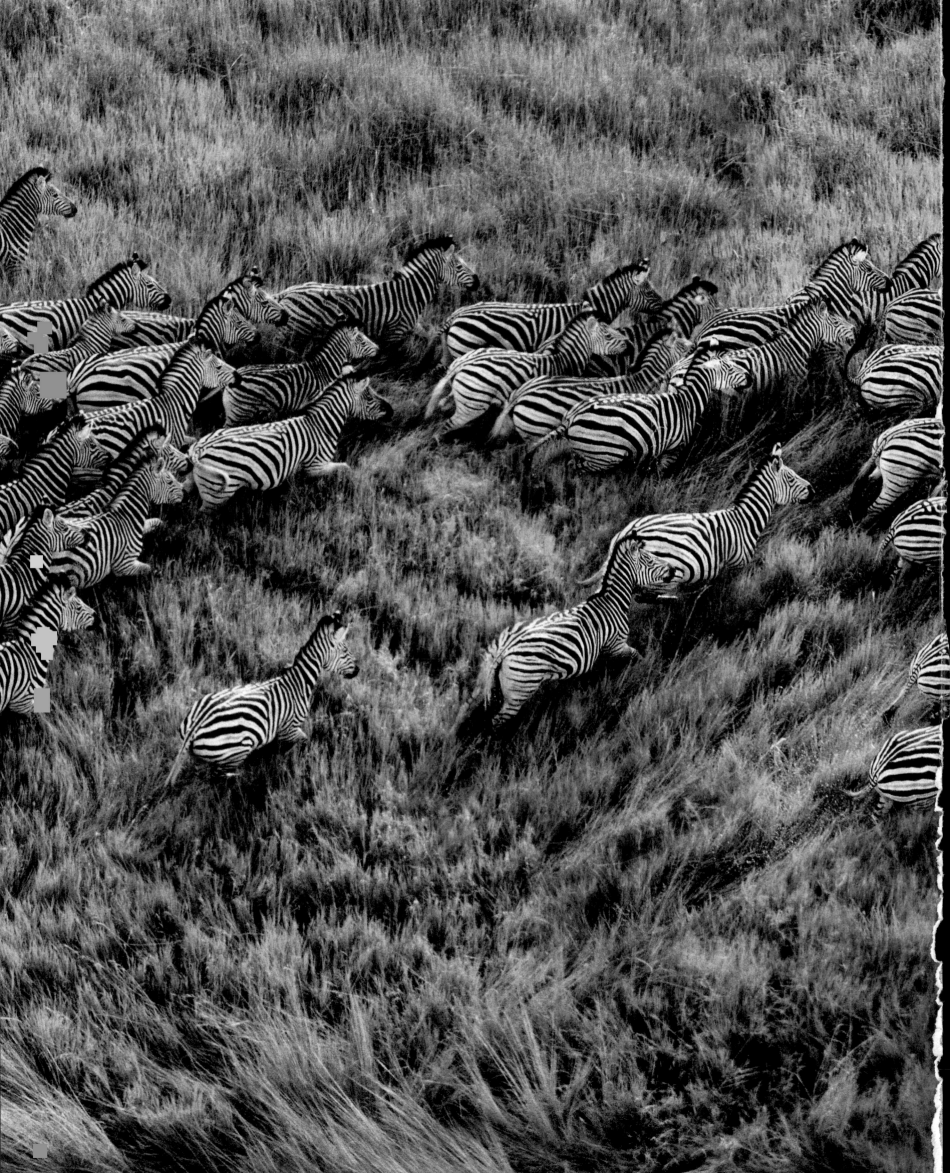

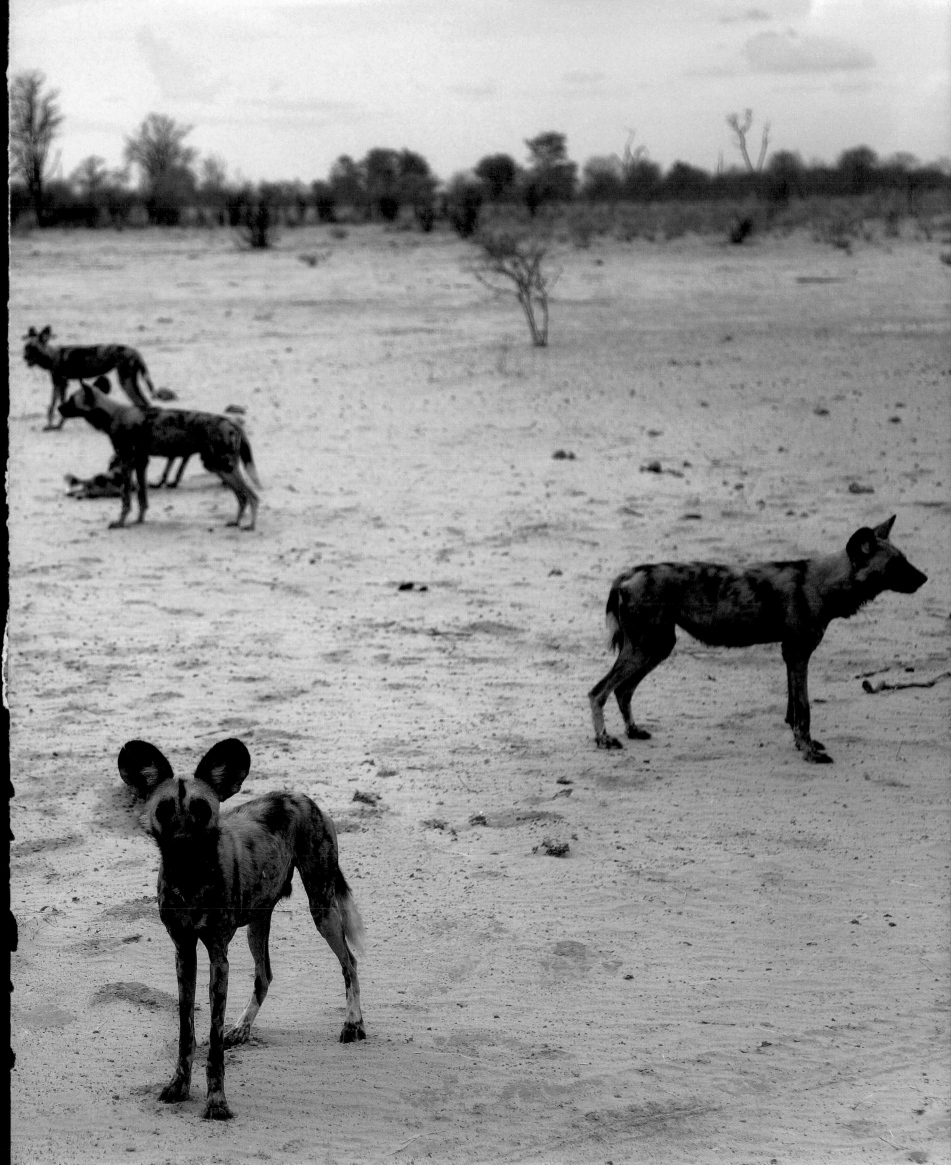

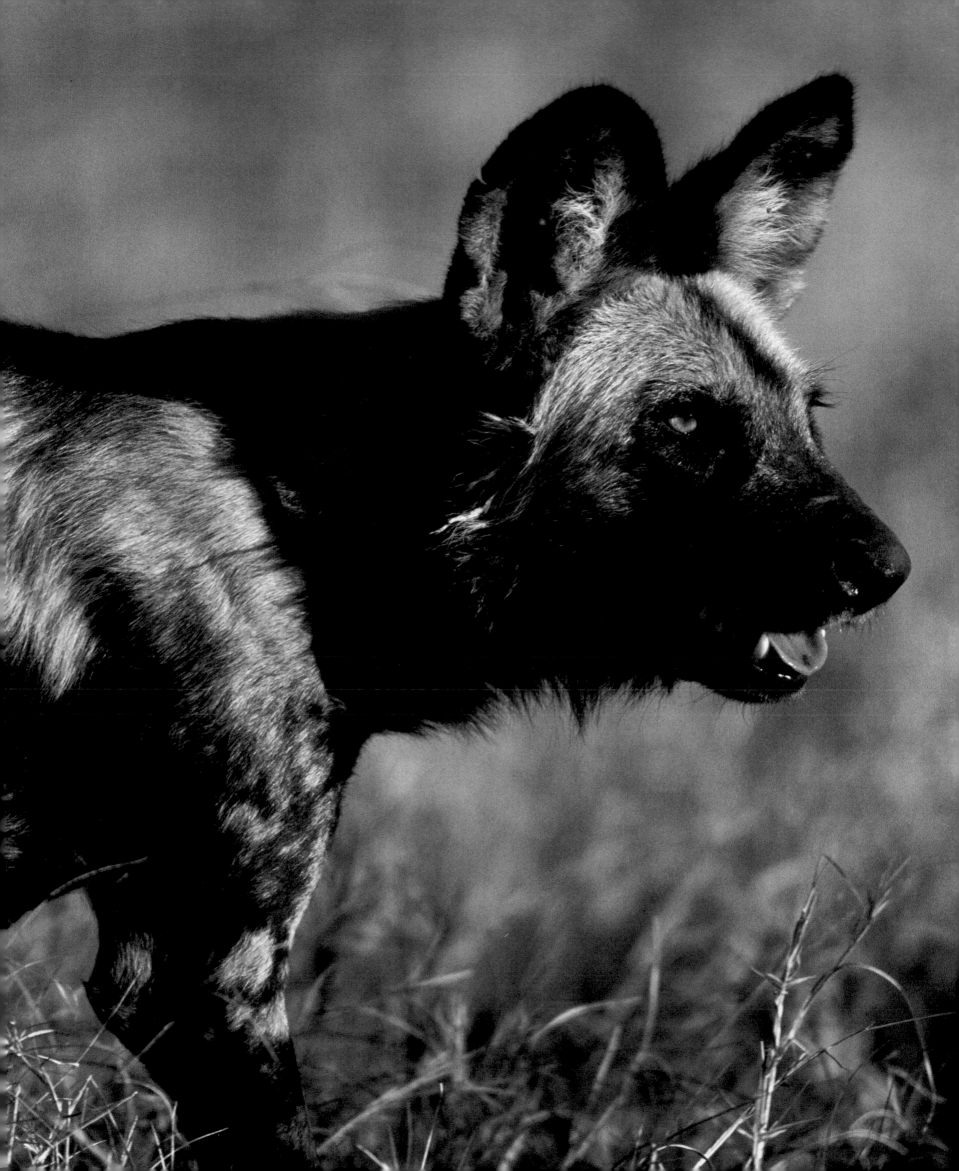

13. The Desert Rhinos of Namibia

Namibia can claim some of the most spectacular landscapes in Africa. Six times the size of Britain but with a population of fewer than two million people, it is a remarkable country of soaring sand dunes, deep canyons and vast gravelly plains. In the far north of the country, the Kunene region – covering the area also known as Damaraland and Kaokoland – is a land of rolling stone-covered hills, covered by sparse vegetation and dissected by seasonal river courses. Rainfall is very low, and temperatures high throughout the year.

In this forbidding landscape lives the largest remaining population of free-ranging Black Rhinoceros (*Diceros bicornis*) in the world. Hammered by poaching for horn in the 1970s and 1980s, Black Rhino numbers in the wild collapsed from an estimated 70,000 in the late 1960s to fewer than 2,500 in 1995. The species became extinct in several countries and critically endangered throughout its range, reduced to small isolated groups and individuals. These animals were secure only if guarded round-the-clock by armed wildlife rangers, and for their own safety many were darted and relocated to fenced enclosures where they could be protected more effectively.

Only in Namibia did a reasonable number of rhinos survive in the wild, many of them in the largely inaccessible landscapes of Damaraland. Even here they were highly vulnerable, and during the early 1980s commercial poachers moved into the area. Following the killing of several rhinos in 1988, a number of animals were captured by conservationists. Some were translocated to safer areas, whilst others were "dehorned", in an attempt to make them less attractive to poachers, and then released. Rhino horns are made of keratin and so grow back, but the policy probably saved the lives of the individual animals concerned. With poaching now under control, all of Namibia's rhino population is horned and numbers have more than doubled from their low point in the 1980s.

PREVIOUS **A Wild Dog in hunting mode,** with head lowered and eyes focused on potential prey. The hunt will start with the dogs trotting towards the selected animal; once the latter starts to run, the dogs break into a full racing hunt and may reach speeds of up to 55 kilometres (30 miles) per hour. Once it is within reach, the prey is usually brought down by a bite to the groin.

BELOW **Rhinos drinking at a** waterhole in Etosha National Park, east of Damaraland. Although not especially social by nature, rhinos will congregate in small groups at favoured waterholes. The jostling and interaction makes for superb wildlife viewing.

BELOW **In a land of low rainfall and sparse** vegetation, desert-dwelling rhinos will often stay around a particular source of food for several days, remaining until they have eaten almost every last leaf.

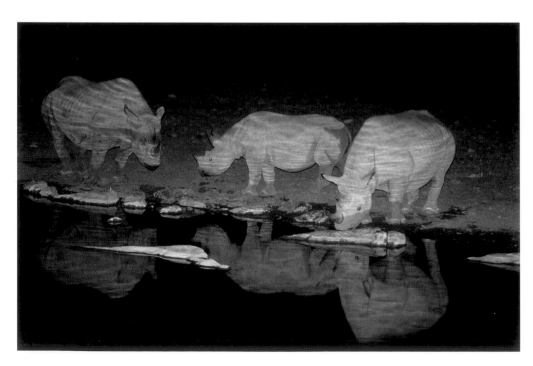

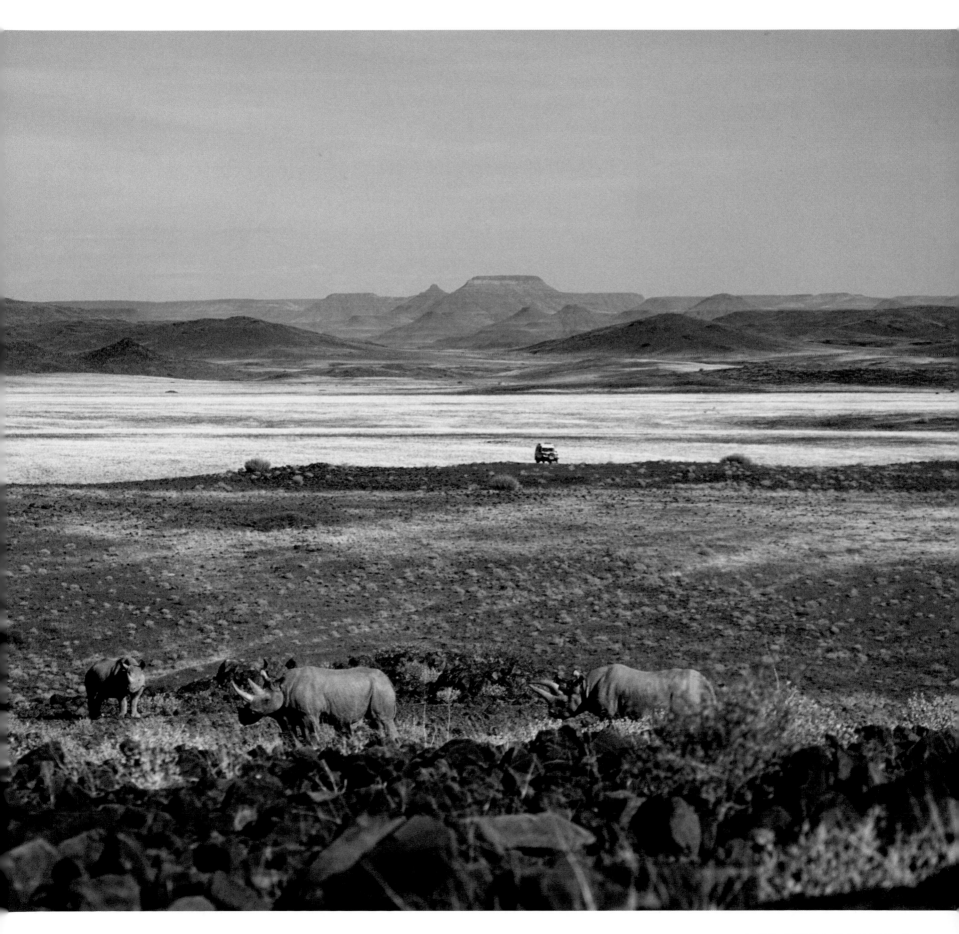

The desert subspecies of Black Rhino is specially adapted to life in arid conditions. The animals cope well with the barren and stony terrain, and are surprisingly adept at scaling rocky slopes in search of food and, equally important, shade. They can survive without water for up to four days, and are flexible on diet, living on different plant species at various times of year, depending on what is available. A particular favourite are species of *Euphorbia*, some of which are highly toxic to most other animals (including humans), but which the rhinos tackle with relish. They have been known to browse on a particularly appealing plant for several days, only moving on when there is nothing left on it to eat. Rhinos also find euphorbias useful as shade, and they will tuck themselves in underneath a bush and often fall asleep; for such large beasts they can be surprisingly difficult to see when settled down like this.

The low density of available food means that desert rhinos can range over 2,500 square kilometres (965 square miles) in search of sustenance, although home ranges normally cover 500–600 square kilometres (190–230 square miles) – still hugely impressive for an animal not normally associated with great mobility! They are predominantly solitary creatures, usually coming together only for mating, although small groups sometimes gather in loose association, mainly when there is plentiful browsing in a particular area. Females give birth to a single calf, which will remain with its mother for up to two and a half years.

Although the areas in which the Damaraland rhinos live are mostly communal lands with no formal conservation status, the difficult terrain and remoteness has helped protect the animals. Teams of rangers, often including former poachers who are experienced in rhino habits, now track and monitor the 130 or so rhinos; detailed records are kept of sightings, and many of the individual rhinos are known to the team that protects them. One of the key signs that a rhino is using a particular area are territorial middens, where individual animals spray urine (often bleached white with the sap of the euphorbia they have eaten) and kick dung as a means of advertising their presence to other rhinos. Although picking up the signs of a rhino having passed by is relatively easy for the expert eye, actually catching up with the beast itself can be a time-consuming and arduous task.

Damaraland's rhinos represent the fastest-growing wild rhino population in Africa and are among the centrepieces of Namibia's expanding wildlife tourism industry. The desert landscapes they inhabit re also home to a range of other exciting animals; these include desert-adapted African Elephant (*Loxodonta africana*) which, like the Black Rhinos, are able to survive in conditions far removed from those enjoyed by most of their brethren elsewhere in Africa (although see page 81); Lion (*Panthera leo*), which after being virtually exterminated locally by local herdsmen have begun to move back into Damaraland in recent years; Cheetah (*Acinonyx jubatus*), of which Namibia can claim one of the healthiest populations in Africa; and a range of ungulates, including the iconic Gemsbok (*Oryx gazella*). Wildlife densities in Namibia's desert regions may not rival those of elsewhere in southern Africa's "safari belt", but the dramatic landscapes here provide a unique backdrop to the fascinating local wildlife.

RIGHT **Despite a reputation for ungainliness, rhinos are surprisingly nimble-footed. They can cover vast distances in search of food and are able to move easily across tracts of gravel and even sand.**

OPPOSITE **Although equipped with poor eyesight, rhinos have well-developed senses of smell and hearing. They are not overly aggressive, but can be unpredictable and should be treated with respect at all times.**

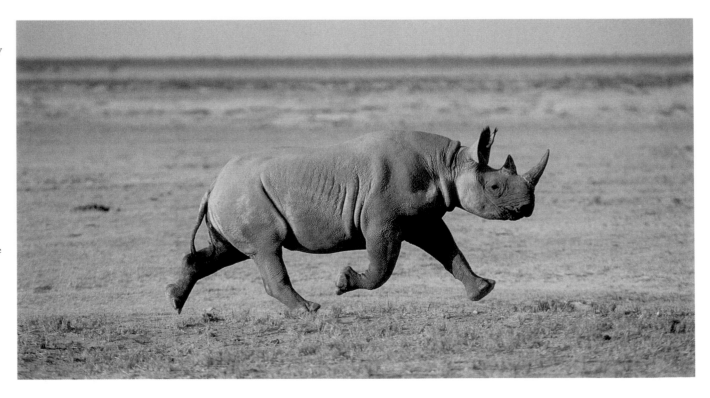

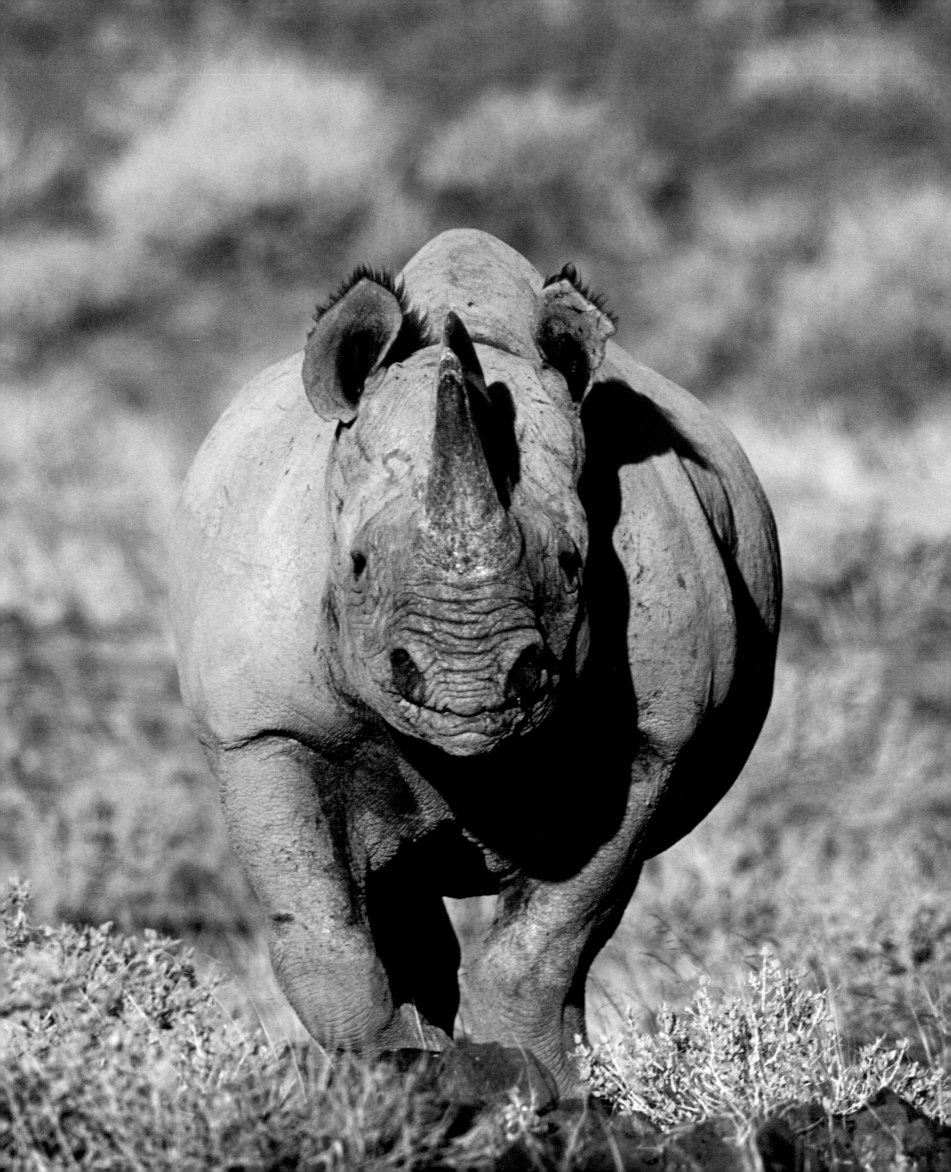

14. The Forest Animals of Gabon

Sparsely populated, wealthy and politically stable, Gabon is something of a rarity in a region still largely beset by poverty and political upheaval. Located within the vast Congo River basin, three-quarters of Gabon remain under tree cover. The exploitation of the country's oil reserves has meant that – to date, at least – there has been little need to plunder the country's forests for their timber. In an enlightened and visionary move, in 2002 President Omar Bongo declared that 28,500 square kilometres (11,000 square miles) of Gabon – including some of the best tracts of unspoilt primary rainforest – were to be set aside to create a new network of 13 national parks. One of the objectives was to develop ecotourism in order to help sustain the Gabonese economy in future, when oil revenues begin to decline.

Eleven per cent of Gabon is now gazetted as national park land; no other country in the world can match this, with the exception of Costa Rica. Many of the parks are largely pristine, with illegal hunting and disturbance thankfully still rare. Landscape quality and levels of biodiversity are very high, and Gabon has all the ingredients required to become one of the world's top destinations for watching wildlife. The three showpiece parks are: Lopé, offering some of the best primate-watching in the world; Ivindo, which affords the rare opportunity to see normally secretive forest mammals out in the open; and Loango, home to some of the most remarkable wildlife sights of all, with elephants wandering along sandy beaches and hippos forsaking their freshwater habitats to swim in the surf.

Most of the 4,910 square kilometres (1,895 square miles) of La Lopé are lowland rainforest, with areas of open grassland in the north of the park. A total of 63 species of mammal have been recorded here to date, including sizeable populations of African Forest Elephant (*Loxodonta cyclotis*), Western Lowland Gorilla (*Gorilla gorilla*), Chimpanzee (*Pan troglodytes*) and Forest Buffalo (*Syncerus caffer nanus*), as well as Red River Hog (*Potamochoerus porcus*) and marsh-loving Sitatunga (*Tragelaphus spekeii*). Lopé is also home to the endemic Sun-tailed Guenon (*Cercopithecus solatus*), a species of monkey only discovered in 1984.

Lopé has great potential as a destination for gorilla-watching. Gabon is one of the last strongholds of the Western Lowland Gorilla, a species under serious threat in most of its range owing to habitat destruction and the demand for bushmeat. An estimated 45,000 gorillas live in Gabon, with approximately 4,000 of these in Lopé. Work is ongoing to habituate some of the family groups so that gorilla-tracking will be possible here as it is with Mountain Gorillas elsewhere in Africa (see page 85).

Meanwhile, Lopé is one of the best places in the world to see Mandrill (*Mandrillus sphinx*), of which an estimated 1,350 live within the park. The world's largest monkeys, Mandrills are highly social animals and usually found in large groups, sometimes numbering up to several hundred individuals. As with most primates, a group normally comprises females and youngsters under the stewardship of a dominant male. Terrestrial by habit, Mandrills are usually seen foraging for food on the forest floor or in clearings, only climbing trees at night to sleep, or when threatened.

The most exciting features of Ivindo National Park are its extraordinary "bais". Bai is the local name for the open, often marshy, clearings that occur deep in the heart of the primary rainforest. The existence of such places only became apparent in 2000, following a remarkable 3,200-kilometre (2,000-mile) trek through the region's pristine forests by biologist Michael Fay.

LEFT **The dramatic facial markings of an adult male Mandrill are one of the more obvious aspects of sexual selection, and become brighter in colour when he is aroused. Mandrills are closely related to baboons and are similarly omnivorous in diet.**

Fay discovered some of the best wildlife viewing in Africa, particularly at Langoué Bai, where many large mammals congregate in the open to graze, bathe, drink and rest. Herds of African Forest Elephant and Forest Buffalo are commonplace here – both normally live in the depths of the forest and are very difficult to see well – and at certain times of year groups of Western Lowland Gorilla come to the bai to feed on grass roots and other vegetation.

The African Forest Elephant (*Loxodonta cyclotis*) is recognized as a separate species from the African Elephant (*Loxodonta africana*), which is now referred to by some scientists as the African Bush Elephant. The forest species is distinctly smaller, with rounded ears and straighter tusks. The nature of the Forest Elephant's preferred habitat makes it difficult to estimate the total population, but there is no doubt that the species is under pressure across much of its range. Here, at least, large numbers are able to live unmolested. Indeed, it is probable that the more remote elephant herds in Gabon may never have encountered humans.

Covering 1,550 square kilometres (600 square miles), Loango National Park contains a stunning diversity of scenery – a mixture of forest, grassland, swamps, mangroves, lagoons and 100 kilometres (60 miles) of beach along the Gulf of Guinea. The range of habitat types, and their proximity to one another, means that the park supports an equally impressive range of wildlife, with sightings of Gorilla, Chimpanzee, Mandrill, Elephant and Humpback Whale all possible in a single day within a few kilometres. Most famously, elephants, hippos and even gorillas can sometimes be seen foraging on the beaches here. Offshore, up to six species of whale are regularly recorded, including large numbers of Humpbacks (*Megaptera novaeangliae*) from July to September, as well as three species of marine turtle. The park is also excellent for other reptiles, with all three types of African crocodile found here. Loango's unspoilt character, variety of scenery and impressive wildlife make it a strong contender for the most beautiful and exciting park in Africa.

ABOVE **A visit to Loango National Park offers the unusual opportunity to see large mammals, such as buffalo and elephant, actually beachcombing, having wandered out of the forest that reaches almost to the shore.**

OPPOSITE **The tusks of the African Forest Elephant are noticeably straighter, and more downward-pointing, than those of their relative. It is thought that this is an evolutionary development in response to the need to move through thick vegetation, in which upward-curving tusks would be an impediment.**

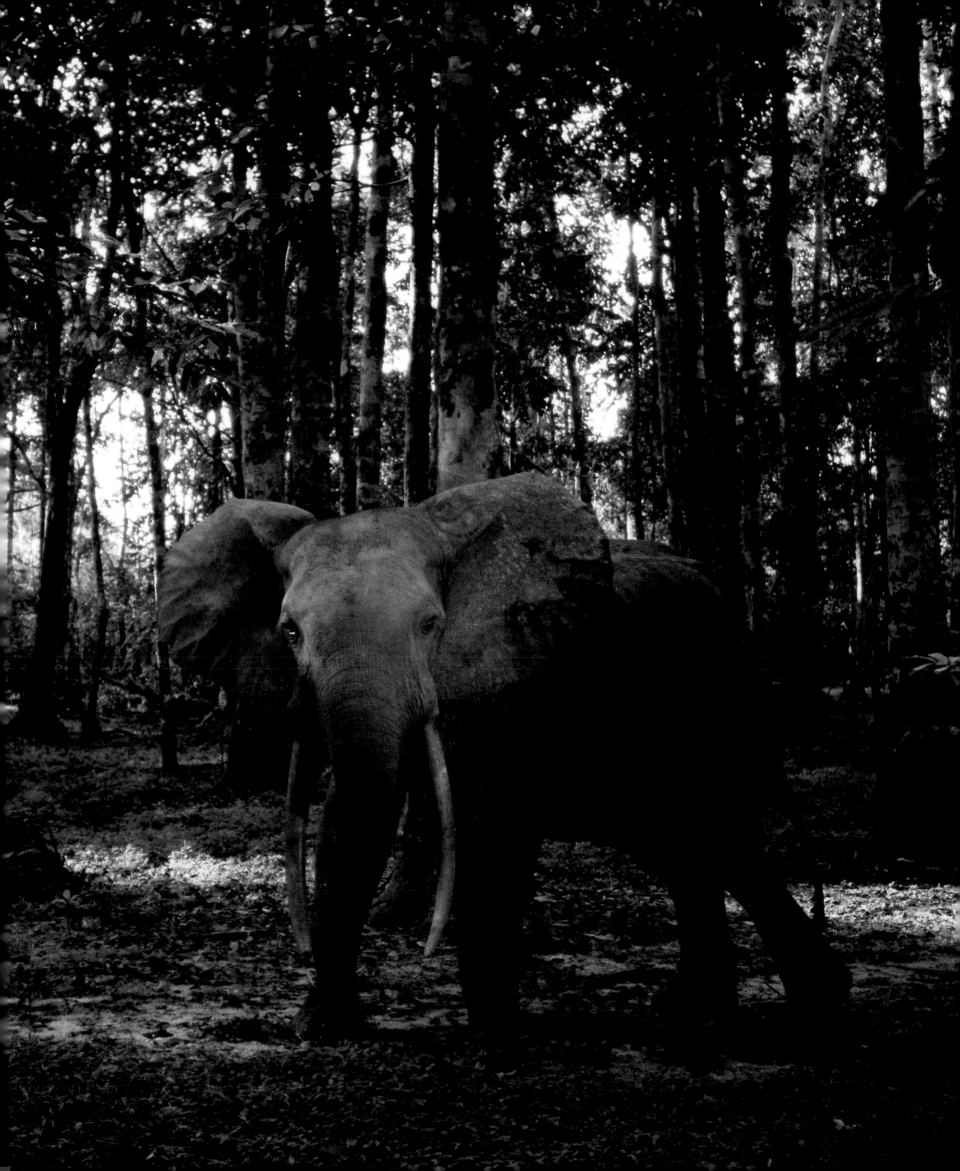

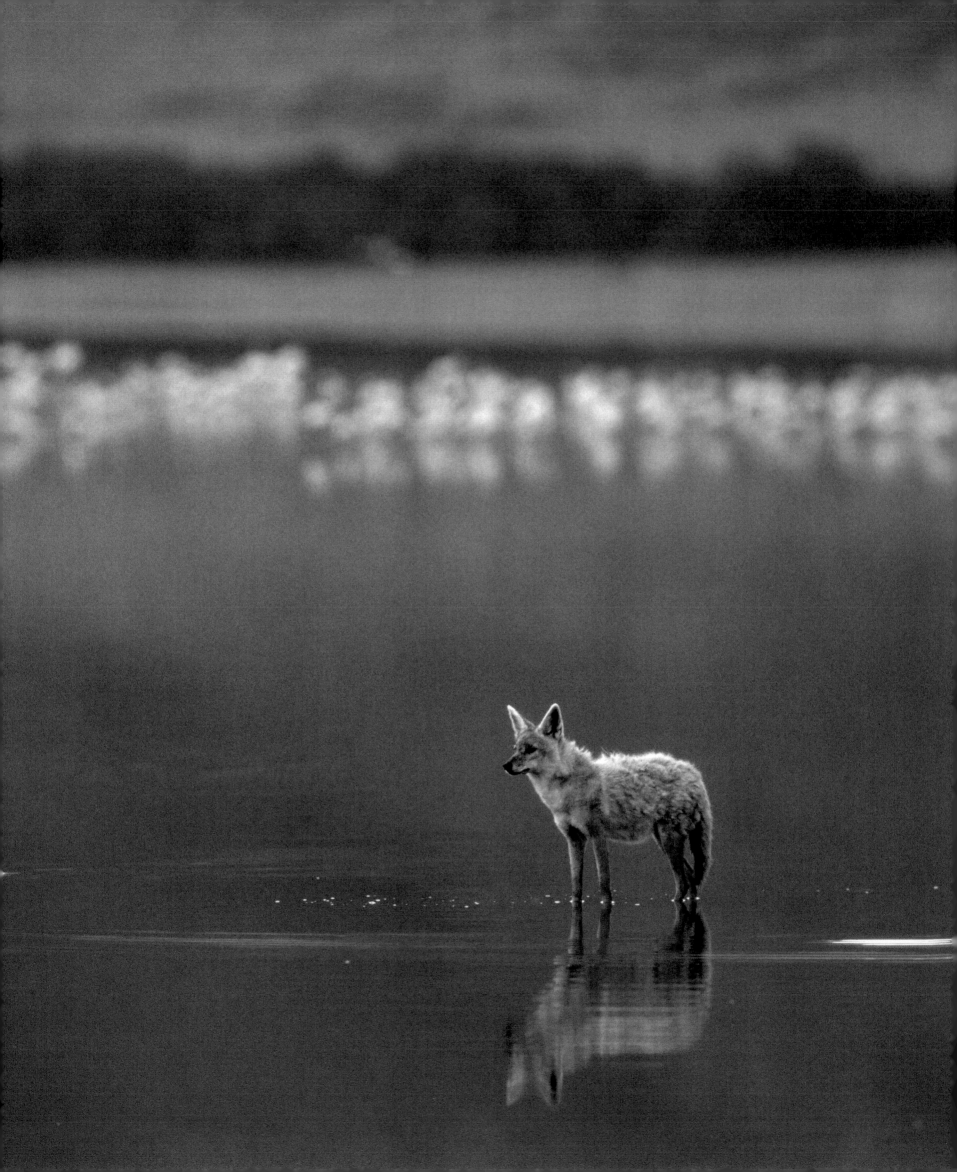

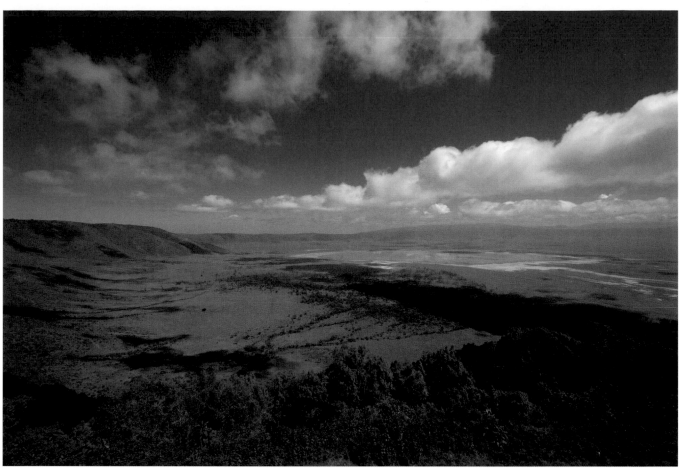

15. Into the Ngorongoro Crater

Even if it were totally devoid of wildlife, the Ngorongoro Crater would be one of the world's greatest natural spectacles. Forged out of cataclysmic volcanic activity over two million years ago, it is the largest unbroken, unflooded caldera in the world. At 20 kilometres (12 miles) across and with a rim 600 metres (2,000 feet) above the plains below, it makes for breathtaking views. The walls of the crater were originally part of a giant volcanic dome, the top of which collapsed to become the crater floor. This has now come to represent East Africa in microcosm: a landscape of classic open savannah, acacia scrub and woodland (the Lerai Forest) with areas of swamp and even a soda lake, Lake Makat, which is fed by the Munge River.

Part of the Ngorongoro Conservation Area (NCA), which covers 8,280 square kilometres (3,200 square miles), the crater is designated a World Heritage Site and Biosphere Reserve, and the extensive and varied highland landscape of which it is just one small component comprises one of the most important ecosystems in East Africa. The NCA is also of great significance to human history, as it includes seminal archaeological sites such as Oldupai Gorge and Laetoli, where the fossil footprints of ancestral humans dating back 3.6 million years have been found.

The fact that the breathtaking scenery of the crater is also home to a population of some 20,000 large mammals, as well as a variety of interesting birds and other fauna, makes this an outstanding place for anyone interested in wildlife and its conservation. Almost all the classic African savannah species are present, including a small population of Black Rhinoceros (*Diceros bicornis*), for which Ngorongoro provided one of the last refuges in Tanzania following poaching in the 1980s. The crater floor covers 250 square kilometres (100 square miles) and is constantly thronged by loosely mixed herds of grazing ungulates, including Western White-bearded Wildebeest (*Connochaetes taurinus mearnsi*), Plains Zebra (*Equus quagga*), Thomson's and Grant's Gazelle (*Gazella thomsonii* and *G. granti*) and Common Eland (*Taurotragus oryx*), as well as good numbers of African Buffalo (*Cyncerus caffer*) and Warthog (*Phacochoerus africanus*). The wetter areas hold Waterbuck (*Kobus ellipsiprymnus*), and Hippos (*Hippopotamus amphibius*) can be found in the pools at Mandusi swamp and Ngitokitok

LEFT **A Golden Jackal (*Canis aureus*) against a backdrop of flamingos on Lake Makat in the Ngorongoro Crater. Highly opportunistic, jackals are always on the lookout for small prey which they can catch themselves, as well as for scraps left behind by larger predators.**

ABOVE **One of the best views in Africa, looking down into the Ngorongoro Crater from the rim, several hundred metres above. The crater contains a wide range of habitats, which helps explain its attraction to such a variety of wildlife.**

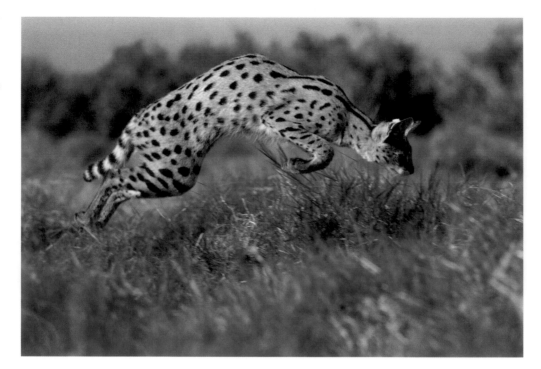

springs. The largest mammals in the crater are the solitary bull African Elephants (*Loxodonta africana*), several of which are always present. Up to 50 different mature males may visit the crater floor from time to time, but the local herds of female elephants and their youngsters are rarely seen there, preferring to keep to the forests on the crater rim.

The classic African predators are also here, including Lion (*Panthera leo*). Like most of the animals in the crater, the various prides are habituated to vehicles and a close approach is usually possible. The other main crater predators are Spotted Hyena (*Crocuta crocuta*), common and hard to miss, and Leopard (*Panthera pardus*), rarely seen and usually keeping to the forests on the slopes. Meanwhile, another member of the cat family, the Serval (*Leptailurus serval*), is worth looking for in areas of long grass and reeds. This enchanting species feeds mostly on rodents and birds, and the crater is one of the best places in Africa to try and see one.

The animal population of Ngorongoro can – and does – move freely in and out of the crater. The fact that so much wildlife is resident here all year round (although numbers are higher during the dry season) is due to the perennial sources of water and good grazing that are on offer. There are notable absentees, however. These include Giraffe (*Giraffa camelopardalis*), which traditionally were thought incapable of handling the slopes down to the crater floor but which probably find insufficient browse here, as well as Impala (*Aepyceros melampus*) and Topi (*Damaliscus lunatus*), both common enough elsewhere in the NCA but strangely not in the crater itself. Cheetahs (*Acinonyx jubatus*) are highly peripatetic, wandering the plains outside the crater and periodically descending to the crater floor.

Birdlife in and around the crater is prolific and includes both Greater and Lesser Flamingos (*Phoenicopterus roseus* and *P. minor*), flocks of which fly in each morning to feed at Lake Makat. Iconic birds of the East African lakes and highly sensitive to changes in their environment, flamingos are currently in decline at one of their Rift Valley headquarters, Lake Nakuru in Kenya. Exactly why this should be so is not yet clear, but water levels there have fallen as a result of excessive extraction to irrigate the farmland around the lakeshore, and the concentration of pollutants in the lake has increased accordingly.

Whilst providing undoubtedly spectacular wildlife viewing, the Ngorongoro Crater is not without its problems. The numbers of certain grazing species have declined in recent years, as have some of the predators that depend on them. There is inevitably a significant human dimension, too. The conflict between the demands of wildlife conservation and the rights of local people has rumbled on for decades, and was exacerbated by the expulsion of the Maasai and their livestock from the crater itself in the 1970s. Meanwhile, as one of Tanzania's most lucrative tourist attractions, the crater is vulnerable to accusations of being overexploited, to the extent that the experience for both the tourists and the animals themselves is falling below what is deemed appropriate or sustainable. Always a delicate balancing act, this dilemma sits at the very heart of ecotourism.

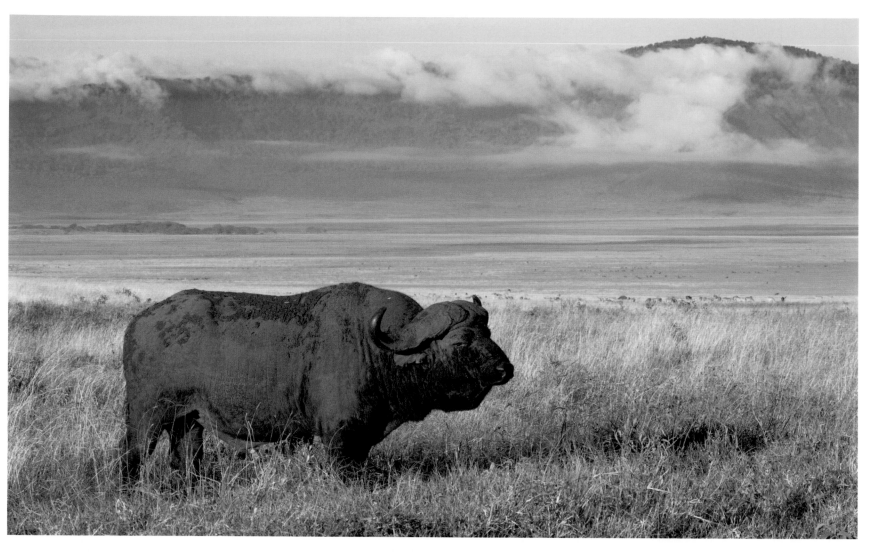

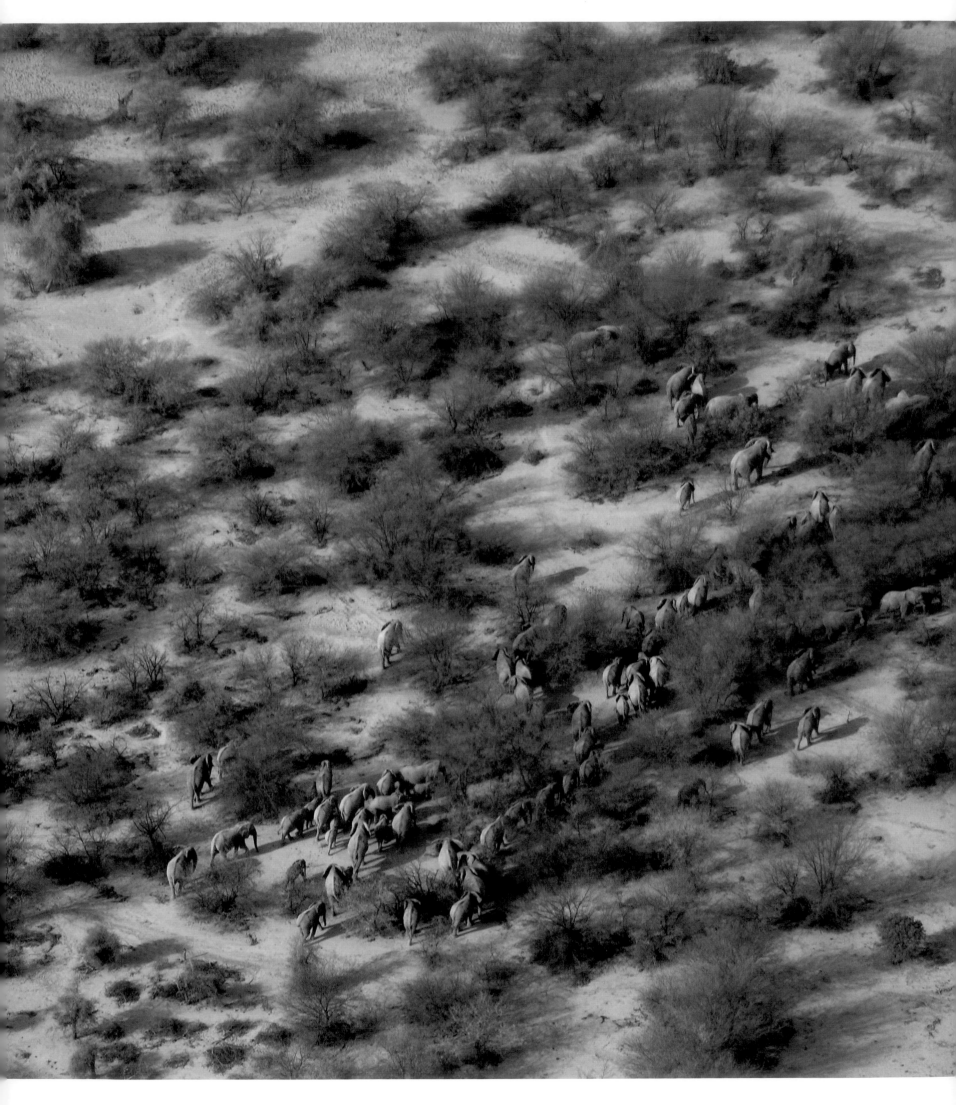

LEFT A herd of elephants moves through the parched landscape of the Sahel. The eternal quest for water takes this remnant population on an extraordinary and increasingly difficult migration.

RIGHT Blanched a pale shade by the desert dust, Mali's nomadic elephants can appear almost ghostly at times. That they can survive at all in this harsh environment is little short of remarkable.

16. The Nomadic Elephants of Mali

"Elephants can be seen everywhere, and I can see many good-sized elephant tusks. My host tells me that he can buy plenty in Timbuktu. They are brought in by tribesmen ... They do not hunt elephants with guns but set out traps; I so regret not having witnessed such an event." This account was written by the French explorer, René Caille, who in 1828 became the first European to reach the fabled desert city of Timbuktu and return alive. At that time sizeable herds of African Elephant (*Loxodonta africana*) were still a common sight in this region, especially in the marshes along the River Niger, and great migrations of them took place across the area as they moved in search of water and adequate browsing.

The harsh and arid environment of the Sahel may seem an unlikely place in which to find elephants, but their presence here is almost certainly a relic from a time when the region received higher levels of rainfall and was far more abundantly vegetated. As the climate changed, and the desertification of the Sahel gathered pace, so conditions became less suitable for elephants and their numbers declined.

Overhunting undoubtedly accelerated the elephants' demise, and by the 1920s the great herds of earlier times had all been wiped out. Although in 1970 there were still four distinct populations of elephants living in Mali, this has now shrunk to a single population comprising some 300 individuals divided into several groups for most of the year. Living mainly in a vast, arid area called the Gourma, between the River Niger and the border with Burkina Faso, this is the most northerly population of African Elephants in the world and one of the last surviving in West Africa.

What makes these elephants even more remarkable is the huge cyclical journey they undertake each year in their quest for water, one of the scarcest commodities in this increasingly drought-affected region, where lakes and wells of longstanding have dried up in recent years. Although nomadic, desert-dwelling elephants are also found in Namibia (see page 70), the Mali population travels far greater distances – a total of up to 1,200 kilometres (750 miles) in a year, and sometimes as much as 50 kilometres (30 miles) in a single day – as they move between ever-dwindling sources of water. They are living in conditions which by any standards are marginal, and which for elephants – an adult needs to drink in excess of 150 litres (30 gallons) of water every day – must surely be at the very brink of survival.

The elephants' annual migration starts from the very north of Burkina Faso, when, in November, they move across the border into Mali on the first stage of their long, anti-clockwise journey in search of water. Heading north, they follow a route, punctuated by temporary and permanent sources of

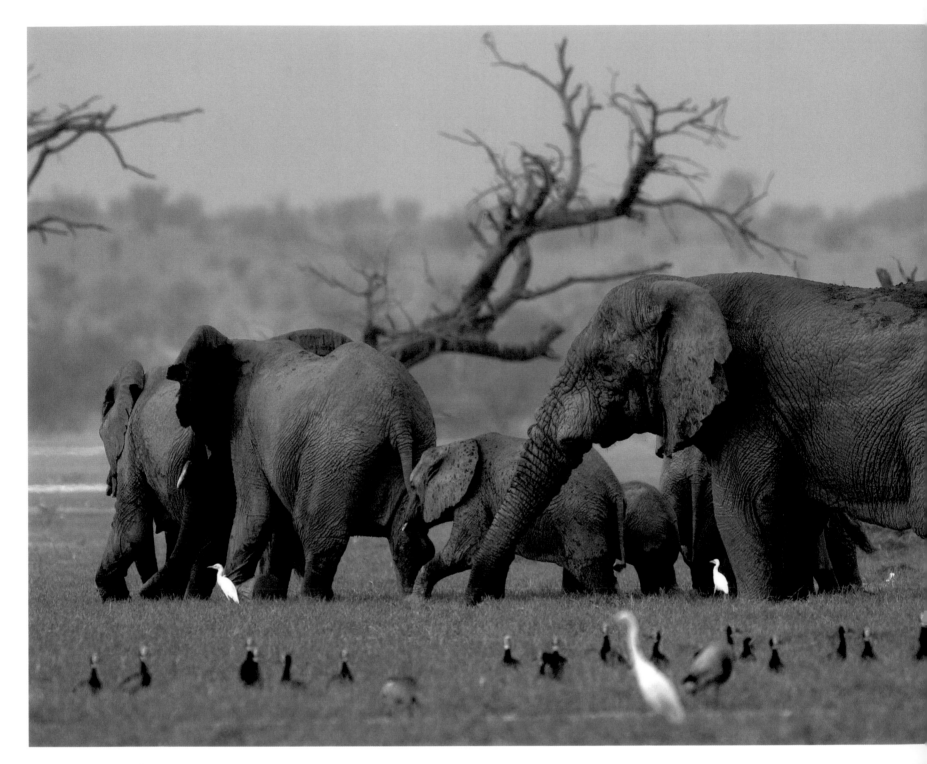

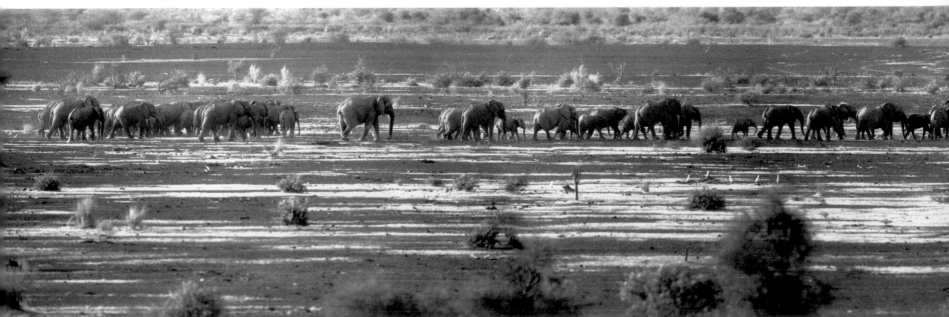

water, which leads them by February/March to Lake Gossi and thence to the Réserve de Douentza and the marshes around Lake Benzéma, where almost the entire population congregates and remains during the dry season. A place of reliable water and good grazing and forage, this is one of the best locations to try to see the elephants, and is where the females usually give birth to their calves. In anticipation of the arrival of the rains, usually in May or June, the animals start to move south, travelling mostly at night to avoid expending too much energy during the fierce heat of the day. They unerringly know where to go to find water, and there is no margin for error in their journeys – if they choose the wrong location and a waterhole is dry, the whole herd may perish. By August the elephants are back in Burkina Faso, where they remain untiltheir migratory cycle begins again in November.

In Mali the elephants have an interesting and delicate relationship with the local human inhabitants, mostly Tuareg and Fulani (Pheul). Many are traditional pastoralists and herders of cattle, sheep and goats, as well as donkeys and camels. They have traditionally valued the presence of the elephants, often following them as they moved towards sources of water, and benefiting when the elephants trampled down thick vegetation, which opened up new areas of grazing for the herders' livestock. Historically, the animals have therefore been tolerated, and allowed to share resources such as water. However, in recent decades increasing efforts have been made to encourage nomadic pastoralists to settle and develop permanent agriculture, often around the few surviving permanent supplies of water, such as Lake Gossi. This intensification of land use is disrupting the elephants' ancient migration routes and bringing them into conflict with the very people with whom they have enjoyed an essentially harmonious relationship for hundreds of years.

Nomadic animals are notoriously difficult to protect and, despite increasing understanding of their seasonal movements, Mali's elephants can be erratic and seemingly capricious in their habits. Sometimes they can all but disappear for days or weeks on end, impossibly hidden in a landscape with, ironically, scarcely any cover. Then, they will suddenly emerge out of the dust like an apparition.

The future of these magnificent animals now hangs in the balance, and depends on several factors, such as the creation and protection of reliable watering sites, preferably away from human settlements, and the maintenance of safe corridors along which the elephants can continue their traditional seasonal movements. GPS tracking collars have been attached to some individuals to gain a more advanced understanding of where they go and when, but with desertification continuing to ravage the region it may well be that in 50 years' time there will be nowhere left in which the elephants of Mali will be able to seek refuge.

LEFT During the dry season, the elephants congregate where there are still accessible sources of water. With advancing desertification, competition over water resources is intensifying and the number of elephants that the region can sustain is likely to fall further.

BELOW Mali's elephants are used to the presence of domestic livestock and have traditionally been respected by the region's human inhabitants. With an increasing change in land use from nomadic pastoralism to sedentary agriculture, this ancient relationship shows signs of breaking down.

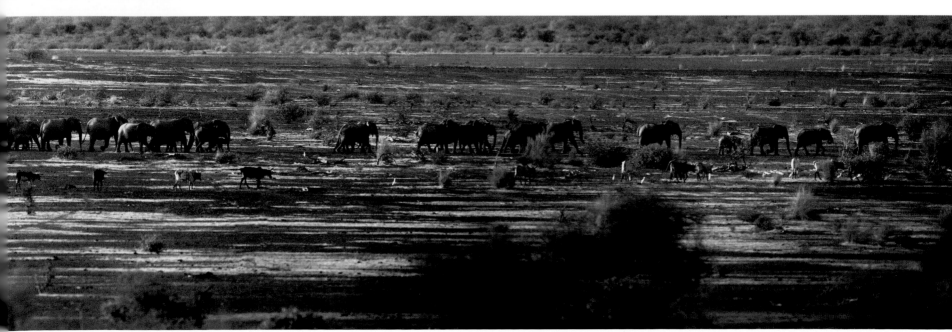

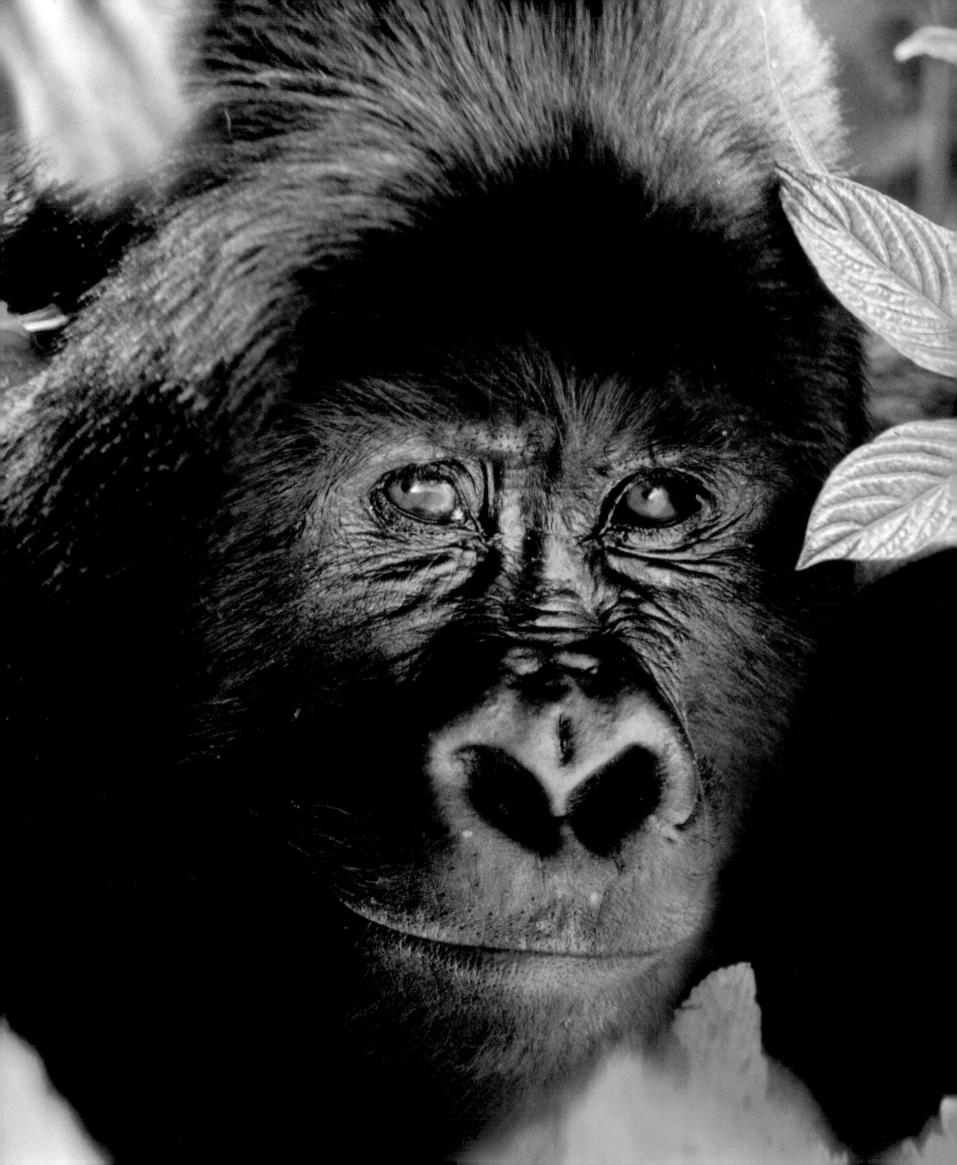

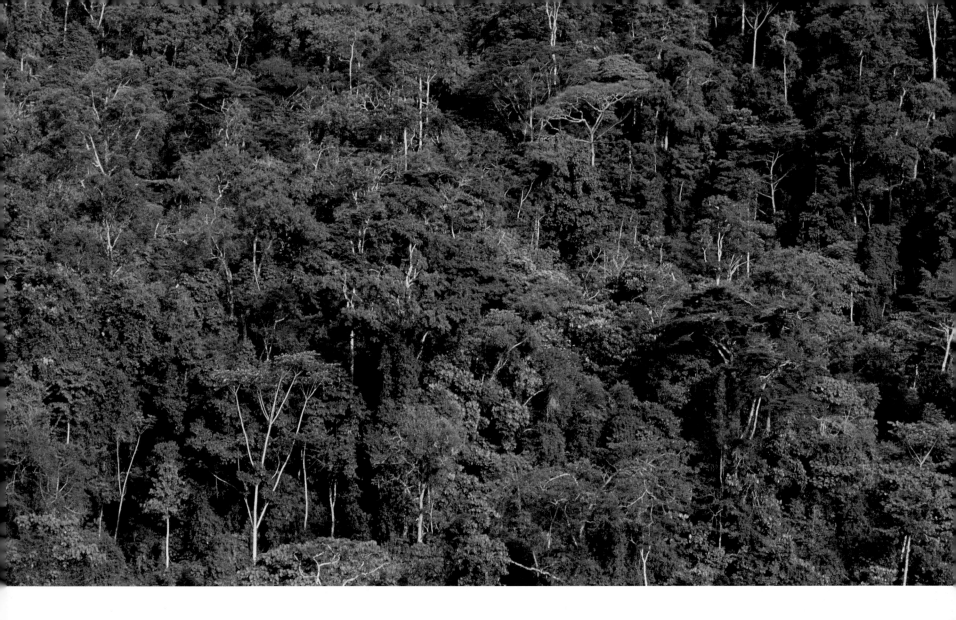

17. Within the Impenetrable Forest

OPPOSITE **Getting close to gorillas can be a moving experience for visitors to Bwindi. One of our closest relatives, these powerful but largely peaceable creatures remain highly endangered across their range, and vulnerable to poaching and disturbance.**

ABOVE **Steep slopes and dense vegetation make for difficult terrain, and much of the Impenetrable Forest more than lives up to its name. Wildlife watching in such habitat can be hard work, and requires large reserves of patience and stamina.**

Straddling the borders of three countries – the Democratic Republic of Congo, Rwanda and Uganda – are the dramatic Virungas, a chain of eight volcanoes. Forming a western branch of the Great Rift Valley, which cleaves its way up Africa, some of these volcanoes remain active and periodically erupt with dramatic and disastrous effects. Yet, with peaks reaching in excess of 4,000 metres (13,100 feet) and very high levels of rainfall, the slopes of the volcanoes are cloaked in lush vegetation and are home to a range of fascinating wildlife. Sadly, in recent decades large areas of these once-extensive tracts of forest have become increasingly degraded by logging and cleared for agriculture. One of the best surviving remnants is an outpost at the top end of the Virunga chain in south-west Uganda: Bwindi Impenetrable Forest, renowned for its population of Mountain Gorillas (*Gorilla gorilla beringei*).

Bwindi is a primeval forest – i.e. it has been continuously tree-covered for several thousands of years – and one of the most biologically diverse places in the world. The figures speak for themselves: around 350 species of bird, 200 or so of butterfly and at least 120 types of mammal have been recorded here. There are several endemic species, and many more that have very localized distributions in East Africa. The park covers 331 square kilometres (128 square miles) of very rugged terrain, ranging in height from 1,160 metres (3,800 feet) to as much as 2,607 metres (8,553 feet), and both lowland rainforest and afro-montane forest occur here, the latter being one of the rarest habitats in the whole continent. Bwindi has a unique, rather mysterious atmosphere – the mass of huge trees festooned with vines, creepers and epiphytic plants can feel overwhelming, and it is often difficult to spot birds and animals in the thick foliage. The landscape is incised by deep valleys, their steep slopes sheering off into a tangle of dense undergrowth, which gives the forest its name and makes access to much of the area virtually impossible. This has doubtless helped save Bwindi from the fate of other, more accessible, swathes of forest.

The total world population of Mountain Gorillas numbers about 700, all of them living in the dense forests of the Virungas and at Bwindi. No respecters of political boundaries, in the past the gorillas used to roam freely back and forth across the borders of Congo, Rwanda and Uganda, but such movements are increasingly dangerous for them, if not impossible, as their forest homes have become fragmented by disturbance and the expansion of farmland. Local political upheavals do not help, although to date they have not proved as disastrous for the gorillas as for the local human population. Approximately 330 gorillas live currently at Bwindi, divided into 12 or so groups. A typical group contains 10–15 animals, led by a mature male or "silverback" and his harem of several females, along with various immature "blackback" males and youngsters.

Gorillas are vegetarians, and those at Bwindi are known to feed on over 60 different species of plant. They often forage in clearings, where the higher levels of sunlight encourage the growth of their favoured foodstuffs. Their appetites are prodigious – an adult male might consume up to 20 kilograms (45 pounds) of vegetable matter per day – and healthy gorillas always have conspicuous potbellies. The search for food begins soon after waking at first light and continues till about midday, when the gorillas usually settle down for a nap. They will feed again later in the afternoon, before finding a suitable place to spend the night; each adult gorilla will make its own nest of branches and foliage, the group usually congregating around the dominant male. Gorillas are the most terrestrial of all the great apes and spend approximately 90 per cent of their time on the ground, moving around on all fours. They usually stand up only to reach a particularly tempting morsel to eat, or to make a threat display – the classic "chest-thumping" of *Tarzan* films.

Two of the gorilla groups in Bwindi are habituated to people, in the sense that they will tolerate human presence within certain parameters designed by conservationists to ensure the gorillas are not unduly disturbed or exposed to the risk of infection; the common cold can be fatal to them. Although access to these groups is strictly controlled by (very expensive) permit and is under close supervision, it provides one of the most exciting – and, for many people, emotional – wildlife experiences of all. It is a great privilege to sit within a few metres of a majestic silverback male surrounded by his females and offspring of various ages, all unconcernedly going about their daily business – many visitors describe themselves as feeling both humbled and exhilarated. Finding the gorillas can involve a walk of up to four hours through strenuous terrain and, while sightings cannot be guaranteed, it is a rare group of visitors that comes away disappointed.

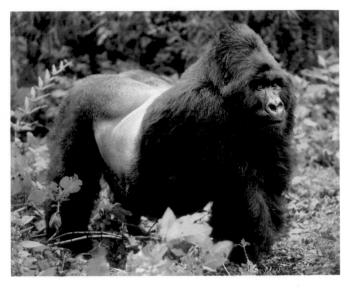

ABOVE **Male gorillas attain their silverback status when they are 10 years old or more. Fully grown, they weigh twice as much as females and present a formidable aspect. The family takes its cue from the silverback, who decides when and where to stop for food and rest.**

OPPOSITE **Baby gorillas stay with their mother for several years. Most male youngsters, and the majority of females, eventually leave their natal group. This helps retain genetic health but in areas where gorilla populations are fragmented this natural dispersal is not always successful.**

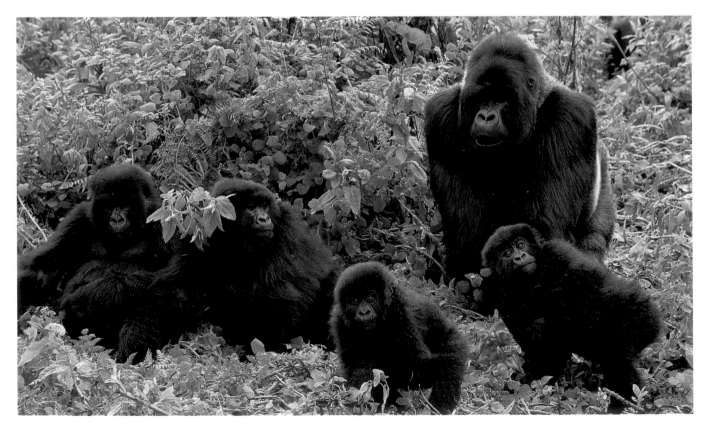

LEFT **Gorillas live in close family groups. Bonds between family members are strong, and re-inforced by mutual grooming. The dominant silverback is responsible for family discipline and security, and disputes are rare. He is usually assisted by two or three younger males or "blackbacks", who act as sentries.**

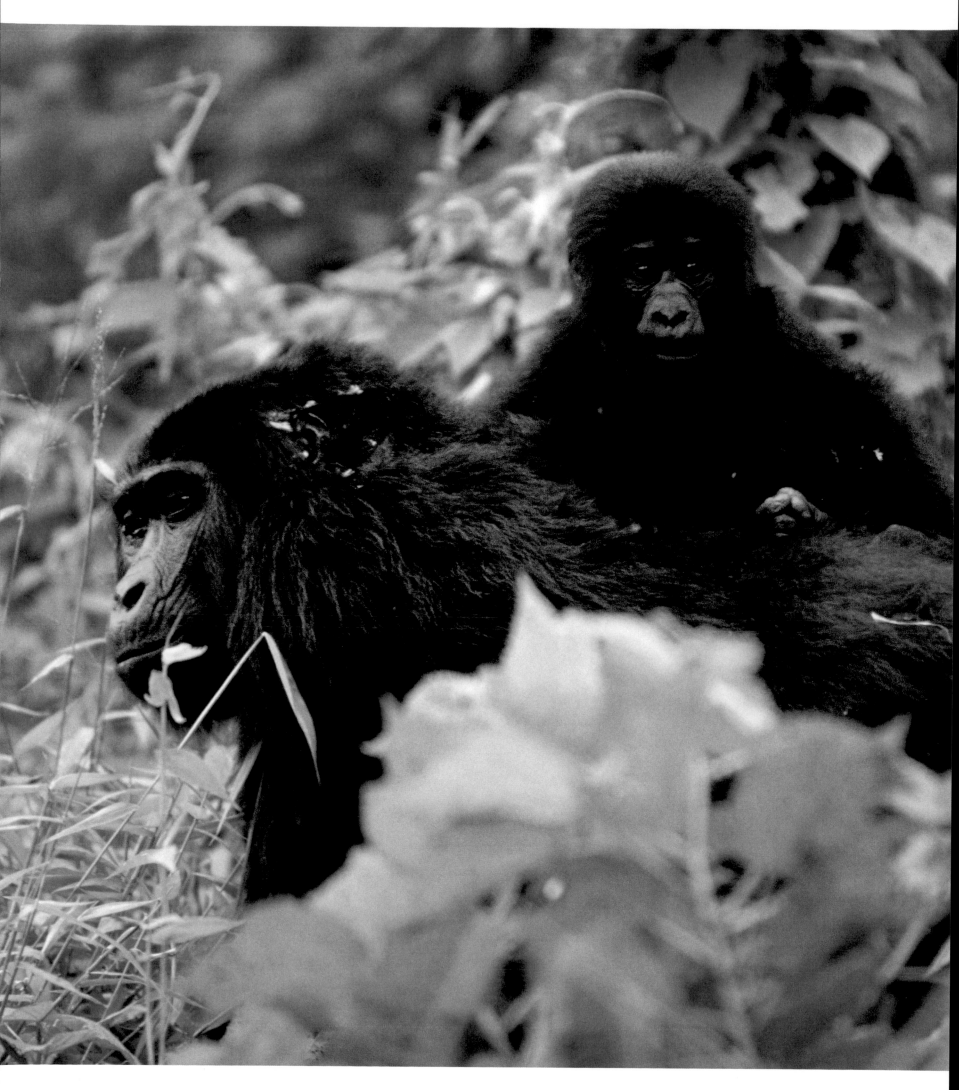

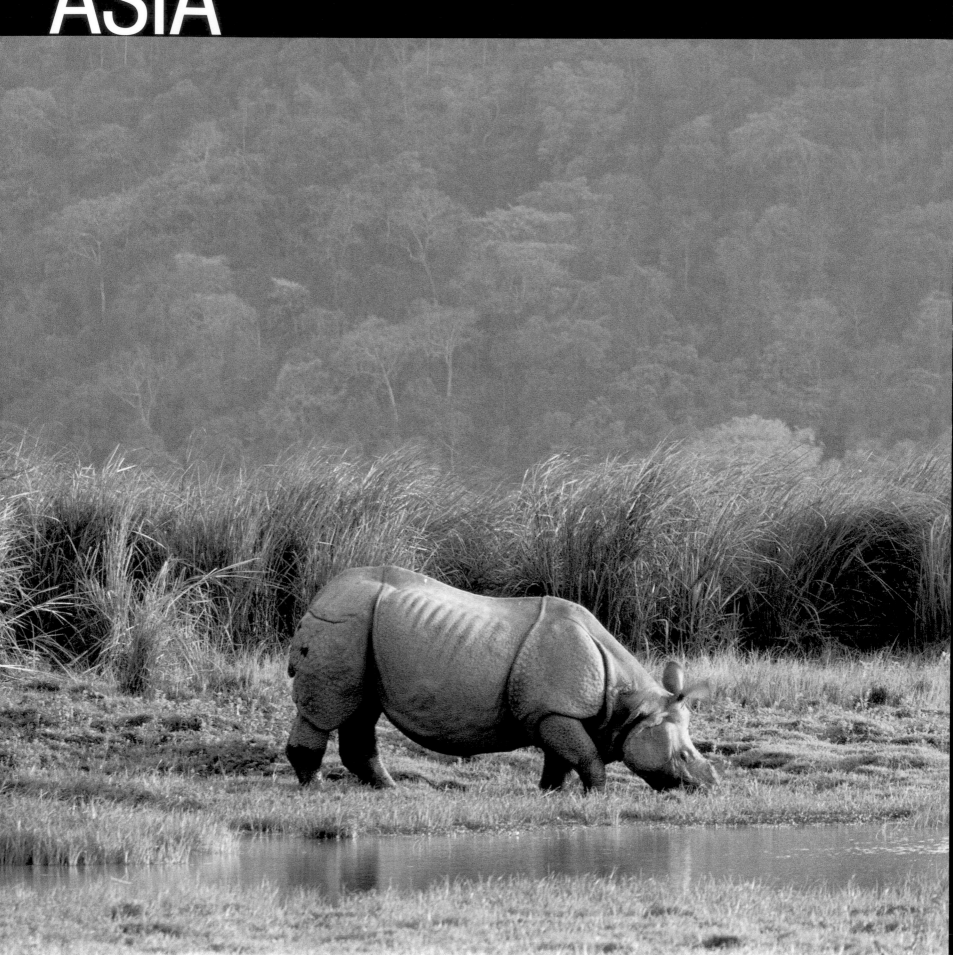

One hundred years ago, Asia contained some of the finest wildlife areas in the world. From the largely unexplored deserts of Arabia, home to herds of gazelle, oryx and ostrich, to the pristine rainforests of south-east Asia, the haunt of elephant, rhinoceros and tiger, there was a rich abundance of animals of great variety and number. Today, both habitat and wildlife are greatly diminished, the inevitable consequence of a massive – and ongoing – expansion in the continent's human population. With the local extinction of many species already well advanced, the next decade may possibly see the almost total disappearance in the wild of animals as iconic as the Tiger and Orang-utan. However, the opportunities are certainly there to make sure this does not happen. Asia's network of national parks is second to none, and ecotourism can provide the economic basis for communities to begin to value local wildlife as an asset worth protecting, rather than as a resource to exploit until it is exhausted. Whilst deforestation continues apace in some regions, in others initiatives are underway to safeguard endangered flora and fauna and to revive previously logged rainforests.

BELOW A Great One-horned Rhinoceros grazing in Kaziranga National Park, one of the last strongholds for this species.

18. The Snow Leopards of Ladakh

Some animals have attained almost mystical status in our perception. Living in places so remote and inaccessible that they are hardly ever seen by anyone except local villagers, they assume a supernatural quality, able to appear and vanish at will. The Snow Leopard (*Uncia uncia*) is such a creature. Rare, shy and elusive, it is found in some of the world's most inhospitable places, where its general lack of visibility is reinforced by its luxuriant spotted coat of dark and pale grey, white and cream – perfect camouflage against its dappled, rocky environment. Widely but thinly distributed across the mountainous parts of central Asia, this is one of the hardest animals in the world to find. Even specialist fieldworkers and researchers can go for months, or years, without catching a glimpse. Nowhere offers a good chance of a sighting, but some sites are more likely than others, if only because it is known that a sizeable population of Snow Leopards lives there.

One such place is Hemis National Park in Ladakh, northern India. Designated in 1981 and covering some 3,350 square kilometres, (1,300 square miles) the park takes its name from Hemis Gompa, a nearby Buddhist monastery, and extends over the Markha and Rumbak Valleys and the Zanskar River. This is high-altitude terrain, ranging from 3,300–6,000 metres (10,830–19,690 feet) above sea level, and the climate is extreme, with temperatures as low as –20°C (–4°F) in winter and very low precipitation, almost all of which falls as snow during winter. Much of the landscape is barren, cold desert, backed by snow-capped peaks and with areas of scrub, woodland and forest in the valley bottoms. Few people live here, mostly farmers and herders of sheep and goats.

Hemis is also home to a variety of Himalayan wildlife and has been the focus of research into Snow Leopards for over 20 years. All the raw ingredients required by Snow Leopards are present in the park: rugged, rocky terrain with plenty of cliffs, chasms and ridges, plus a plentiful supply of prey. Four species of wild sheep and goat are found here, including good numbers (3,000 or so) of the Snow Leopard's preferred prey, Blue Sheep or Bharal (*Pseudois nayaur*), which thrive on the rich summer grasses of the natural mountain terraces. This is often where the leopards come to hunt. Relying on ambush to catch

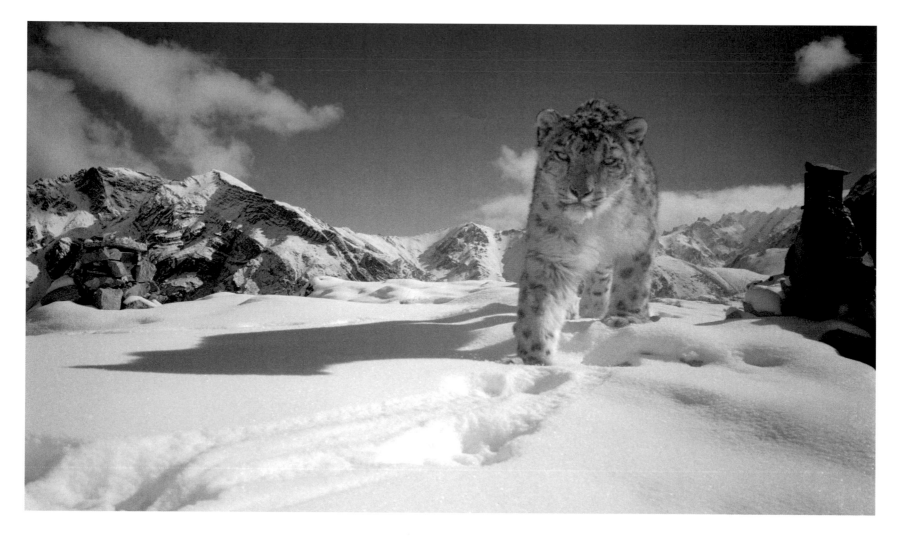

their prey, they stalk it patiently until they are within close enough range to make a quick sprint and grab the animal, usually by the nape or underside of the neck. If undisturbed, a Snow Leopard will take two or three days to consume a kill, staying near the carcass and defending it against scavengers such as vultures until it has had its fill.

It is not clear exactly how many Snow Leopards live within the park, but there may be as many as 100. These are notoriously difficult animals to see, and evidence of their presence is often restricted to the discovery of pugmarks, faeces and territorial scrapes, which are readily found. However, at Hemis remote camera traps have proved very useful in understanding leopard movements and have provided evidence of successful breeding: images of a female with two cubs, for example. Precise counts are impossible to achieve, however. Snow Leopard home ranges vary hugely and are not as vigorously defended as with most other large cats, several individuals sometimes wandering in and out of the same general home range. The size of a range is also flexible, and may vary from as little as 30–40 square kilometres (11.5–15.5 square miles) in areas where (or at times when) prey is plentiful, to as much as 1,000 square kilometres (400 square miles) when prey is scarce. Snow Leopards can also be highly mobile, and are capable of travelling 20 kilometres (12.5 miles) or more in a single night.

Although the Snow Leopard is ostensibly protected throughout much of its range, enforcement is virtually impossible owing to the nature of the terrain in which it lives. Whilst the species may benefit from the fact that part of its distribution spans contested political borders to which access is highly restricted, in most (if not all) of the 12 countries in which it is found there is evidence of illegal persecution. Much of this is poaching for skins and body parts, the latter used in traditional Chinese medicine, but an equal threat to this species is from herders and pastoralists who suffer leopard predation of their livestock. The retaliatory or retributive killing of Snow Leopards in areas where losses of precious cattle, sheep and goats are high is, sadly, a regular event. Conservation initiatives are therefore increasingly focused on the creation of predator-proof livestock corrals, so that conflict between the leopards and humans is reduced. Indeed, in those parts of Nepal and Ladakh where such corrals have been introduced, retaliation has virtually ceased.

A further threat to Snow Leopards generally is the decline and disappearance of their natural prey, either as a result of excessive hunting or of the overgrazing by domestic stock of precious upland grassland areas. This reinforces the need for holistic, community-based conservation policies, which can help people and wildlife co-exist better and also support sustainable wildlife tourism, with trekking and "homestay" opportunities in local villages. Meanwhile, the spectre of global warming looms – with the region's glaciers already receding, devastating floods are an increasing threat, and such climate-related changes may have a serious impact on the people and wildlife of the park. The total world population of Snow Leopard may be in the region of 4,000–7,000, but they are thinly spread. A visit to Hemis National Park is always worthwhile, but the chances are that you will not see a Snow Leopard. Even so, it is fantastic to know that they are out there.

RIGHT Abandoned dwellings in a Ladakh valley. Life here is harsh for humans and animals alike, but the development of community-based ecotourism is now offering new opportunities for local people.

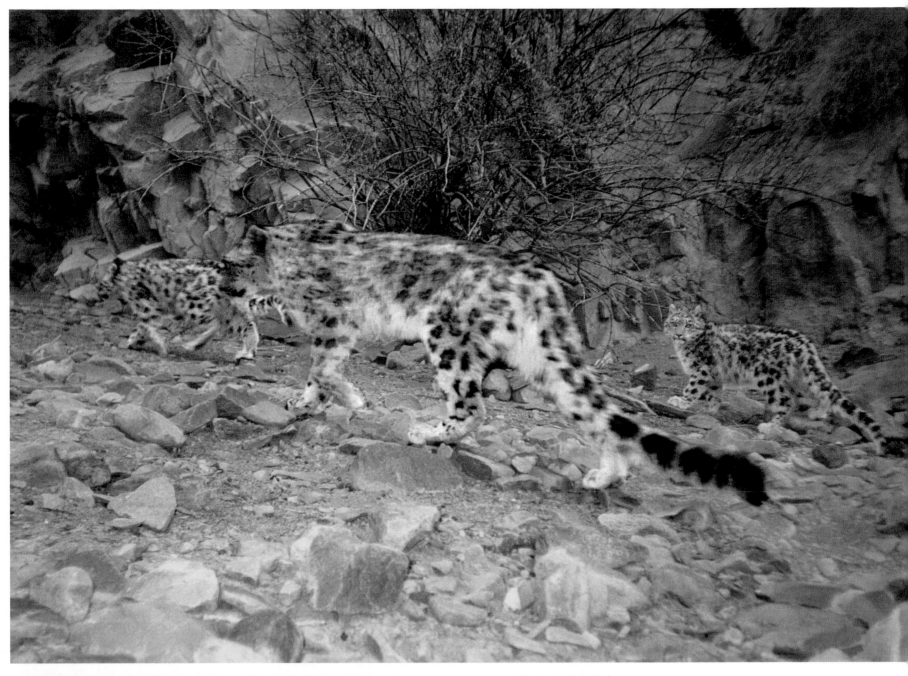

ABOVE An exceptionally rare shot of a female Snow Leopard with two cubs. Camera traps are placed along frequently used trails, with the leopards appearing to be largely unconcerned by the flash that is triggered when an image is taken.

LEFT Typical Snow Leopard terrain. The animals' patterned coat provides perfect camouflage against such backdrops, and helps explain why this species is one of the hardest to see in the wild.

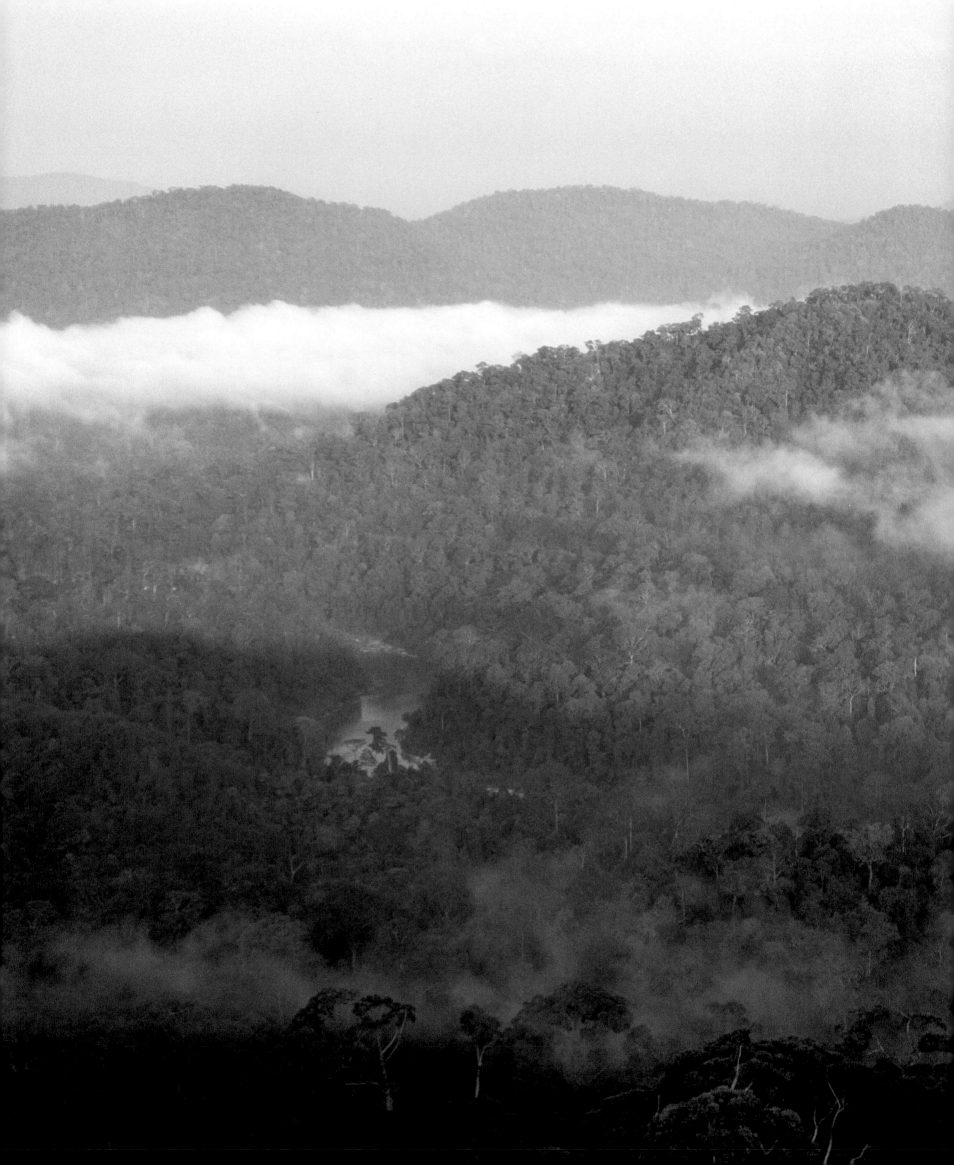

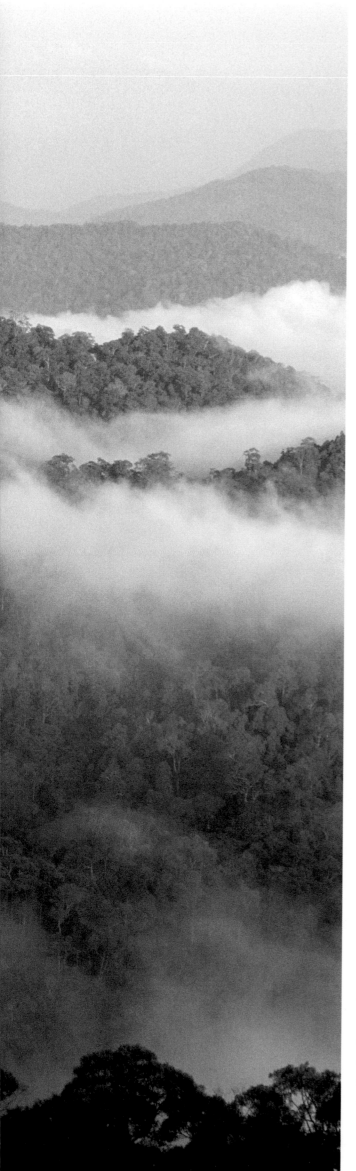

19. Taman Negara: the World's Oldest Rainforest

With plant fossil evidence dating back 130 million years, Taman Negara has a convincing claim to be the oldest of all rainforests. Established in 1938 as the first national park in what was then colonial Malaya, it is now one of the most important protected areas in independent Malaysia and plays a central role in that country's contribution to wildlife conservation. The fact that *taman negara* is Malay for simply "the national park" underlines its pre-eminent position. Part of a unbroken tract of forest which extends up Peninsular Malaysia into Thailand, the national park itself covers 4,343 square kilometres (1,677 square miles), but abuts contiguous forest reserves of more than twice this extent, so that the actual area available for wildlife is considerably greater – some 13,000 square kilometres (5,000 square miles) in all.

Taman Negara is full of glorious, pristine forest. On arrival at the main access points to the park, vast tracts of tropical hardwoods festooned with creepers extend as far as the eye can see. The park's vegetation is hugely diverse, due in part to the variability in terrain. Although the lowest point is just 60 metres (197 feet) above sea level, the topography is generally hilly and rises to mountains that culminate in Gunung Tahan, Peninsular Malaysia's highest peak at 2,187 metres (7,175 feet). There are an estimated 14,000 different plant species in the park – one of the highest totals of anywhere in the world – and various vegetation zones. At lower levels, dipterocarp rainforest and riverine forest (strung along the park's many rivers and streams) predominate, rising through hill dipterocarp forest to montane forest comprising oaks and conifers above a shrub layer (of mostly rattan and species of palm). Higher up still (above 1,500 metres [4,900 feet]) comes a swathe of cloud forest, in which the trees are often enveloped in swirling mists, the moisture promoting the vigorous growth of mosses and ferns. The cloud forest then gives way to a more open landscape of ericaceous scrub, small fan-palms (including one species found nowhere else in the world) and high-altitude shrubs like rhododendron.

Rain can fall here at any time of year, and at higher levels it reaches an average annual total of 3,800 millimetres (150 inches). Not surprisingly, the vegetation is extremely lush, and much of the forest is deep and impenetrable. With hardly any roads in the park, access is only on foot. It can be very hard-going and virtually impossible in many places, but it is this very inaccessibility that makes Taman Negara such a haven for wildlife. Instances of illegal access, disturbance and hunting are thankfully low, and this explains the continued presence in the park of large mammals, such as Asian Elephant (*Elephas maximus*), Sumatran Rhino (*Dicerorhinus sumatrensis*) and Tiger (*Panthera tigris*). One of the most enjoyable ways of experiencing the forest is by boat trip on the Tahan River; the vegetation extends right down to the water's edge and there is excellent birdwatching all around.

A day watching wildlife in the lowland rainforest starts very early, just before first light. Sleeping late is not really an option, not least because the air is soon resonant with the excited whooping and crooning of gibbons as they start their morning. A very early walk through the forest also offers the best chance of coming across some of the shyer nocturnal species on their way home from a hunting foray, such as East Asian Porcupine (*Hystrix brachyura*) or Common Palm Civet (*Paradoxurus hermaphroditus*). As the

sun comes up, so the tropical dawn chorus of birds moves into top gear. The variety and volume of sounds can be extraordinary and invariably includes the guffawing and noisy flapping about of hornbills, several species of which are found in the park. A particularly distinctive sound – and one hard to miss – is that of the Great Argus Pheasant (*Argusianus argus*), a large bird that is surprisingly difficult to see as it moves around on the forest floor. The male's territorial call is one of the great forest noises, a very loud and raucous "kwah-wah" that is guaranteed to make heads turn.

By mid-morning life in the forest is much quieter, and the birds in particular are busy foraging for food. This is often a good time to climb up to the world's longest canopy walkway at Kuala Tahan. At 30 metres (98½ feet) high, it offers an ideal opportunity to meet the tree-top birds on their own level, as they move around in search of insects and fruiting trees. Meanwhile, one of the most successful and enjoyable ways of observing wildlife in Taman Negara is to spend the night in a hide overlooking one of the several salt licks. Although nothing can be guaranteed, this is certainly your best shot at seeing elusive animals, such as Malayan Tapir (*Tapirus indicus*) and Sun Bear (*Helarctos malayanus*).

Although Taman Negara's large mammals are only present in small numbers, thinly spread and rarely seen, the populations of most key species in the park remain viable and seem to be holding their own. In particular, the park is a stronghold for the highly endangered Indo-Chinese race of Tiger (*Panthera tigris corbetti*), and is one of 10 sites identified as being crucial to the survival of Tigers globally. Camera traps have been used here to try to estimate the Tiger population, with the latest available evidence suggesting that around 100 Tigers live in the park and that numbers are stable. Taman Negara is not entirely without problems, however. In particular, the opening up of new roads in the region, and the upgrading of existing logging tracks adjacent to the park, may provide a means through which encroachment and illegal hunting could become problems.

OPPOSITE TOP **Taman Negara supports good numbers of hornbills, and close views are sometimes possible from the canopy walkway. This is a female Wreathed Hornbill (*Aceros undulatus*).**

BELOW **Rapidly becoming one of the world's rarest mammals, the Sumatran Rhinoceros hangs on in very small numbers, widely scattered across its once extensive range.**

OPPOSITE BOTTOM **Impeccably camouflaged for life on the forest floor, the Great Argus Pheasant is more often heard than seen. The same applies to most forest birds, and patience and luck are required to see them well.**

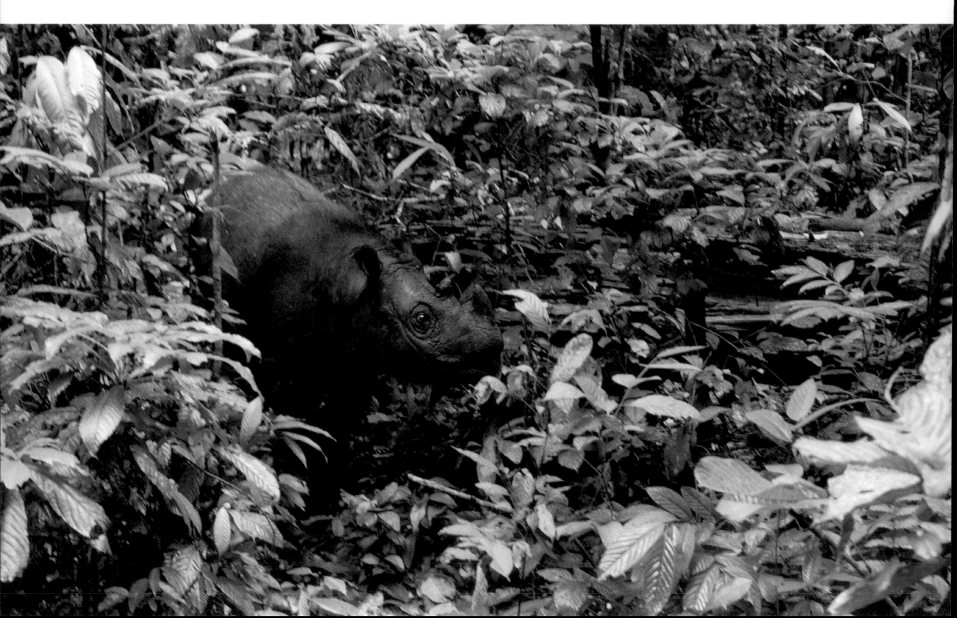

20. The Asiatic Lion's Last Stand: Gir Forest

Until the first half of the nineteenth century the Asiatic (or Indian) Lion (*Panthera leo persica*) was found across much of south-west Asia, from Turkey east to India. In earlier times it had even been present in south-east Europe, but by the early 1900s the combined pressures of excessive hunting and habitat destruction had reduced the total global population to just a handful of animals in the Gir Forest on the Saurashtra Peninsula in Gujarat, India. Here they were carefully protected by the Nawab of Junagadh, and from a very low ebb the number of Asiatic Lions in the wild has now risen to over 350. However, these are all still in Gir, a situation that has prompted a range of difficult conservation issues and made the future of the lions a subject of heated debate and controversy.

Although genetically distinct from the African Lion, the Asiatic Lion is very similar in general appearance; there are some key differences, however. Asiatic Lions are usually slightly smaller than their African cousins, and whilst the males generally have shorter manes, their overall coat is often shaggier and in particular their tail tuft and elbow tufts are longer. Both sexes have a longitudinal fold of skin running along their belly, a feature not present in the African Lion. And although social in its habits, the Asiatic species forms smaller prides than African Lions, with the males in particular tending to live more solitary lives.

The Gir National Park and Lion Sanctuary – known as the Gir Protected Area (GPA) – is an isolated hilly area in an otherwise flat landscape. An oasis of natural vegetation in a sea of farmland and settlements, the GPA is dominated by mixed deciduous and thorn forest and bisected by many rivers: ideal habitat for lion. It is home also to a range of ungulates, including Sambar (*Cervus unicolor*), Chital (*Axis axis*), Nilgai (*Boselaphus tragocamelus*) and Wild Boar (*Sus scrofa cristatus*). Although these species form the lions' natural prey, in recent times the lions have lived increasingly on the large numbers of cattle that graze the sanctuary and its associated buffer zone.

One of the most interesting aspects of the Asiatic Lion in Gir, and a factor that may partly explain its continued survival there, is the ability of the species to co-exist with people. Historically, the lions of Gir have been surprisingly ambivalent to human presence, simply moving quietly away when approached. For many decades they have therefore been able to live alongside the groups of Maldhari pastoralists who share their territory and have traditionally shown respect and tolerance to the lions, despite their predation of domestic cattle (for which the Maldharis are compensated by the Indian government).

However, in recent years this relationship has become more problematic. The grazing of the Maldharis' 20,000 or so cattle is degrading the area's vegetation cover and destroying the habitat of the lions' more natural prey species. Meanwhile, some lions are leaving the core area and roaming into the surrounding farmland, where they come into contact with people who are less used to living in close proximity to lions. There are other pressures, too. For example, the GPA is traversed by three roads and a railway line (sadly, there have been instances of lions and other animals being run over), and holy temples within the protected area are attracting up to 100,000 pilgrims each year.

So, although Gir has proved successful in saving the world's last wild Asiatic Lions from extinction, it is clear that urgent action needs to be taken to secure their future properly. Confining the 350 or so remaining animals to a single relatively small area, and one under such pressures, renders the species highly vulnerable. Not only could a natural or environmental catastrophe result in the lions' eradication, but the population is in a genetic "bottleneck", with little genetic variability and serious levels of inbreeding. There is also the added risk of disease being spread by the domestic livestock that lives in the area.

OPPOSITE TOP **Generally tolerant of humans, the trusting nature of Gir's lions may have contributed to the killing by poachers in March 2007 of two lionesses and a cub. Their claws and bones were removed, fuelling speculation that the animals were slaughtered for use in Chinese medicine.**

OPPOSITE BOTTOM **A fine male Chital. Also known as the Spotted or Axis Deer, this is the commonest deer species in India and widely distributed. As both a grazer and a browser, it is able to live in range of forest and grassland habitats.**

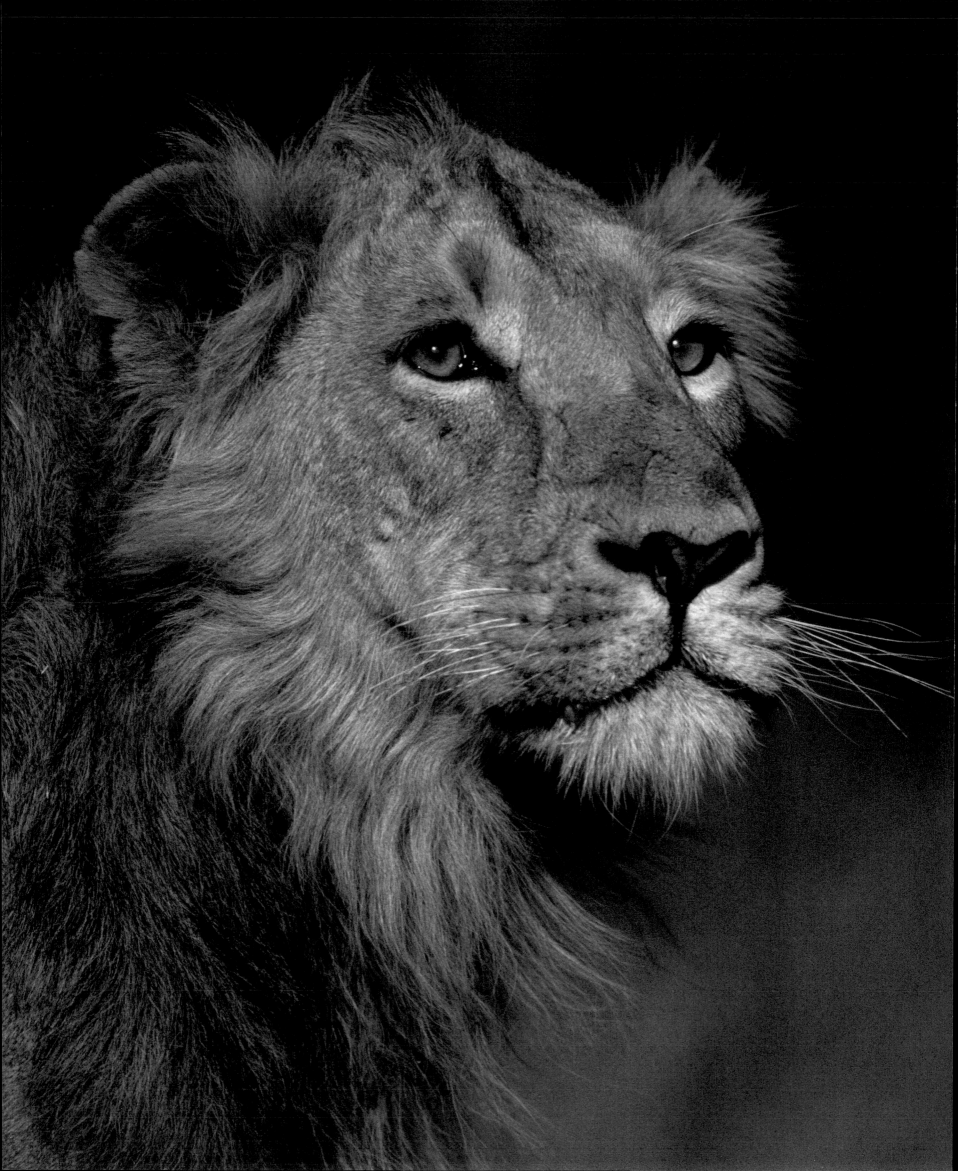

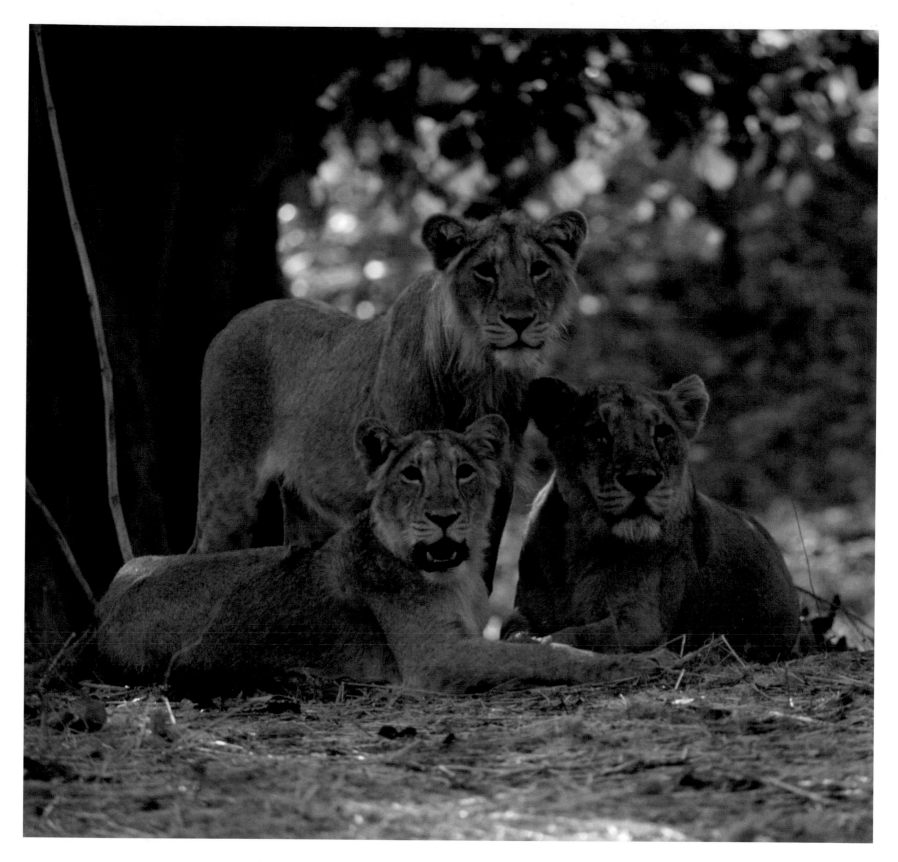

Whilst the resettlement of the Maldharis and their cattle outside the GPA is an obvious way of reducing both disturbance and grazing pressure, such a policy is potentially expensive and contentious politically. In any case, as pastoralists, the Maldharis are loath to leave one of the few areas left in this part of India that can support their way of life. Plans are still pending to translocate about 30 Asiatic Lions to the Palpur-Kuno Wildlife Sanctuary in Madhya Pradesh and establish a second wild population there. A captive breeding programme, with participating zoos around the world, may yet prove to be the salvation of the species in the wild, as it offers the possibility of reintroductions and thereby the establishment of a new gene pool. For the time being, however, Gir offers the only chance to view Asiatic Lions in the wild.

OPPOSITE **Male Asiatic Lions generally have less heavy manes than their African counterparts, but are shaggier on the body and have a diagnostic belly fold which the African Lion lacks.**

ABOVE **A lioness and two sub-adults. One third or so of cubs die within their first year, but thereafter the mortality rate decreases sharply and most wild lions will live for between 16 and 18 years.**

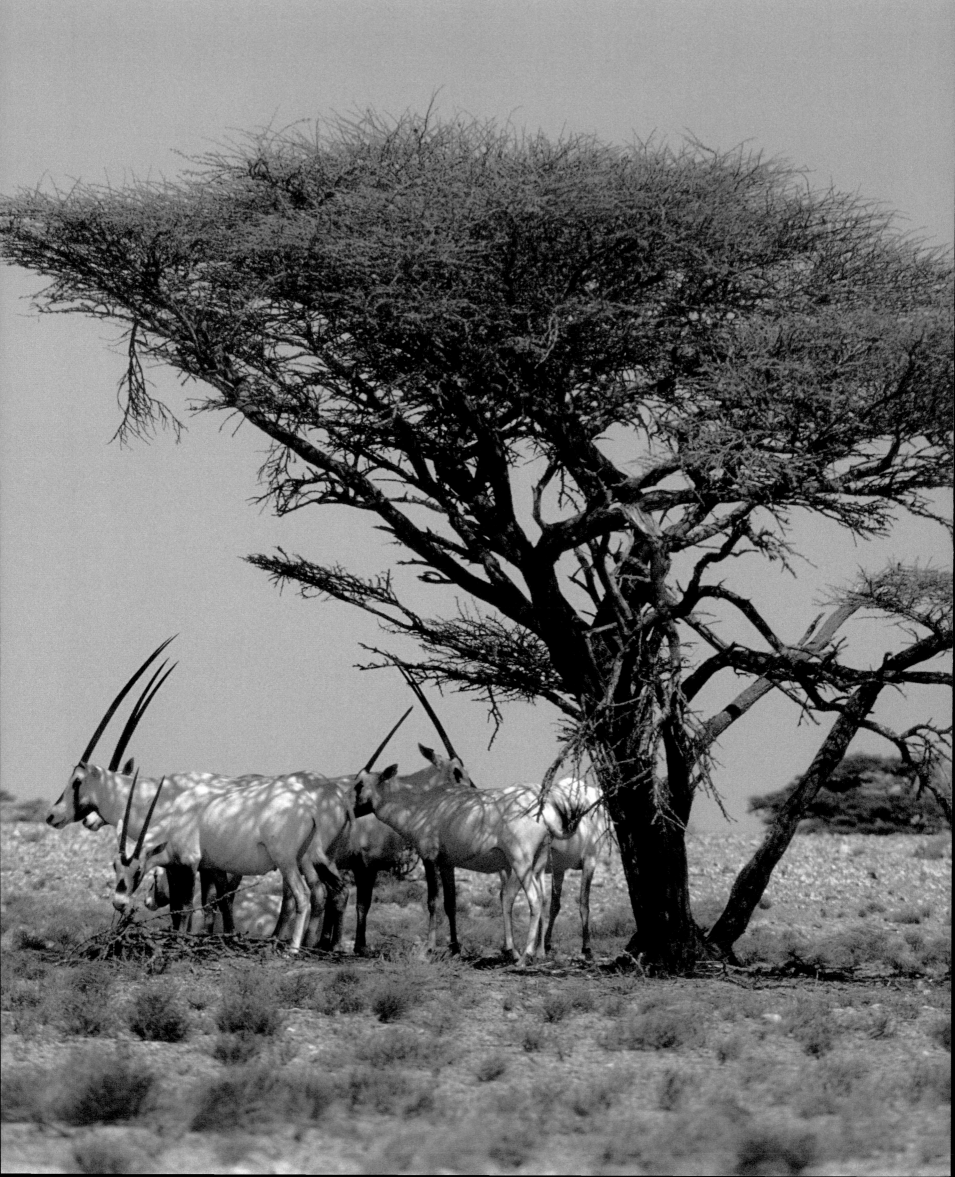

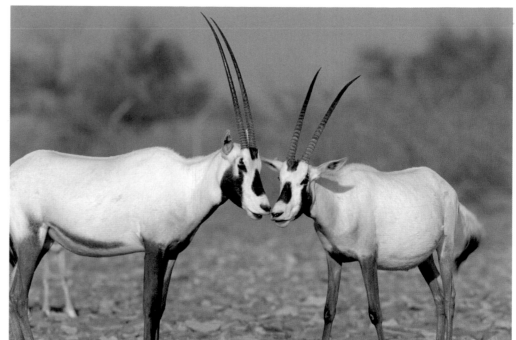

21. Success and Failure: the Arabian Oryx in Oman

Early travellers to Arabia returned with stories of an extraordinary beast that resembled the fabled unicorn. Pure white, with a single horn rising from its forehead, it was believed to dwell in the remote deserts where no outsider had ever been. Only in the eighteenth century, when European scientists were able to investigate the natural history of Arabia with rather more rigour, did it become clear that rumours of unicorns in the desert could probably be attributed to sightings of the Arabian Oryx (*Oryx leucoryx*). A type of antelope with a white hide and darker markings on its face and legs, this species has two long horns which, when seen in profile, can look like a single, unicorn-style horn.

The Arabian Oryx was once widely distributed across the arid wastes of the Middle East and Arabian Peninsula and is superbly adapted to desert conditions. Its white coat reflects light, helping keep the animal cool in summer. During the colder winter weather, the white hairs stand on end, revealing the black skin below – this absorbs heat from the sun. Oryx are highly mobile, constantly on the move in search of grazing and water; they are assisted in this by their wide hooves, which allow them to pass easily over soft sand. Capable of detecting distant rainfall, they will head towards it to seek fresh grazing.

During the first half of the twentieth century the arrival of motor vehicles and the greater availability of firearms in Arabia proved a fatal combination for the oryx, along with most of the region's other large animals and birds. The Cheetah (*Acinonyx jubatus*) and Arabian Ostrich (*Struthio camelus syriacus*) were wiped out completely, and the once plentiful herds of gazelle and oryx were decimated by overhunting. By the 1960s only a handful of Arabian Oryx hung on in a remote corner of the Sultanate of Oman; the last one was shot here by a hunting party in 1972.

By this time, however, a captive population of Arabian Oryx had been established at Phoenix Zoo in the USA, with a view to re-establishing the species in the wild once the appropriate

LEFT AND ABOVE **Although the white coat of the Arabian Oryx helps reflect heat, the animals will always seek out shade if it is available. Supremely adapted for desert life, they range over huge areas in search of grazing and water.**

conditions and better security had been established. The location subsequently chosen for the reintroduction, known as the White Oryx Project, was the Jiddat al-Harasis, a remote and extensive plateau in the heart of Oman, on the edge of the legendary Empty Quarter. The landscape here is characterized by extensive gravel plains and is notable for the heavy mists that settle across it in the early morning, drenching the sparse local vegetation with moisture. These are ideal conditions for oryx, which are mostly sustained by grazing on the wet foliage and are thereby able to do without actually drinking water for up to several weeks at a time if they have to.

Following the arrival of the first batch of five oryx in 1980, their numbers grew under careful protection until by the mid-1990s a free-ranging population of 400 or so was present, living alongside very good numbers of Mountain Gazelle (*Gazella gazella cora*). But then disaster struck. The success of the project meant that it was no longer possible to keep such a close eye on so many animals, which were wandering in groups of various sizes over an area of some 3,000 square kilometres (1,200 square miles). Organized bands of poachers moved into the area and proceeded to capture the oryx, mostly to order, to supply the private zoos of wealthy individuals elsewhere in the Gulf and Arabian Peninsula. Many of the animals died in the capture process or in the subsequent attempts to smuggle them out of Oman across the desert.

Today, only 100 or so Arabian Oryx remain in the Jiddat, and they are now under very close protection in a secure area. Sadly, because the poachers concentrated on stealing females, from which their clients could breed, only a handful of breeding females remain in the original herd – too few for it to be sustainable. After several years of undoubted success, the project is now at a crossroads. Meanwhile, reintroduced herds of Arabian Oryx are still at large elsewhere, including in Saudi Arabia, the United Arab Emirates, Jordan and Israel, but the Omani experience flags up the inherent dangers in such schemes. With the demand for captive oryx still strong, the future of the species in the wild is once again in doubt.

The setbacks of the oryx project notwithstanding, Oman remains one of the best places in Arabia for watching wildlife. The Jiddat al-Harasis supports one of the last regional breeding populations of Houbara Bustard (*Chlamydotis undulata*), a bird reduced to perilously low levels by overhunting. On the rocky Huqm escarpment, which overlooks the eastern side of the Jiddat, live herds of Nubian Ibex (*Capra ibex nubiana*), and the whole area is home to Caracal (*Caracal caracal*), which prey on the plentiful local gazelle population, probably the largest anywhere in the Middle East. Elsewhere, in the mountains in the north and south of the Sultanate live small numbers of the very elusive and endangered Arabian Leopard (*Panthera pardus nimr*), which is the subject of a captive breeding programme designed to secure it against possible extinction in the wild.

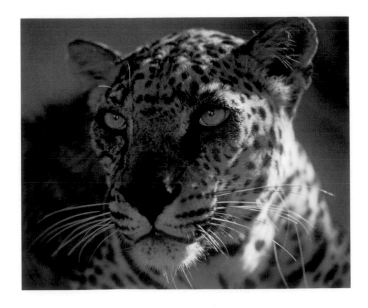

ABOVE **Numbers of the Arabian Leopard, one of the smallest of the Leopard subspecies, are at a critically low ebb. Less than 100 may survive in the Arabian Peninsula, with Oman holding one of the few potentially viable populations.**

OPPOSITE **Although still relatively common in areas where it enjoys protection, like all larger mammals in Arabia the Mountain Gazelle has suffered in recent years from illegal hunting and disturbance.**

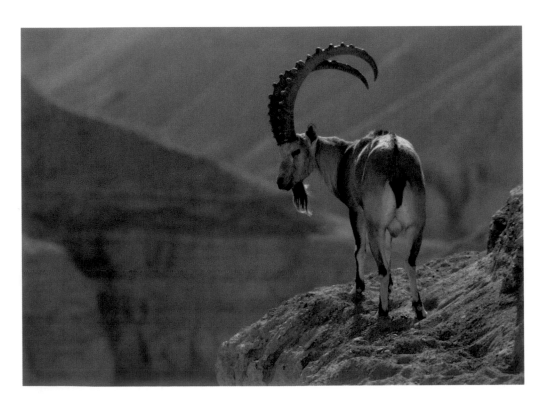

LEFT **Nubian Ibex are found in mountainous terrain across Arabia. The adult males sport magnificent curved horns, once highly prized as a hunting trophy and a familiar motif in ancient Arabian decoration.**

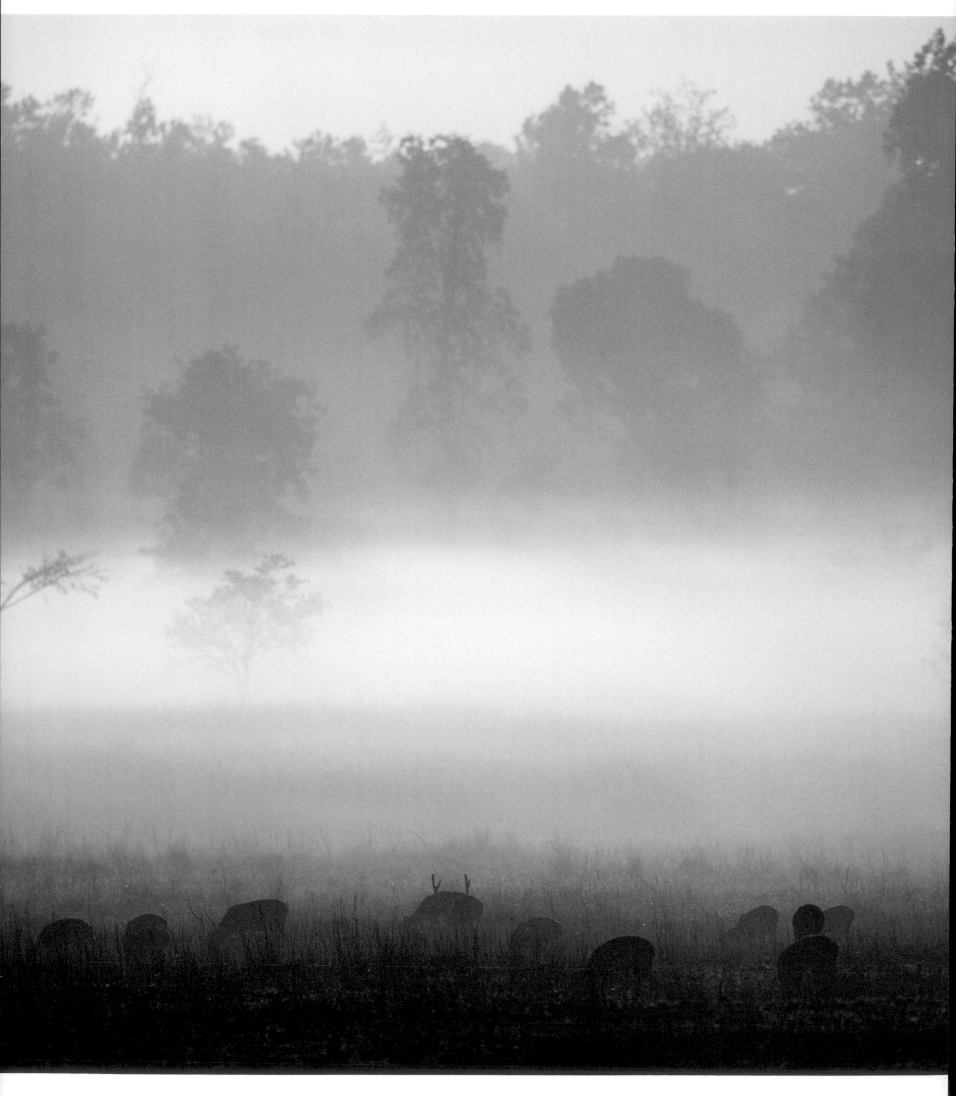

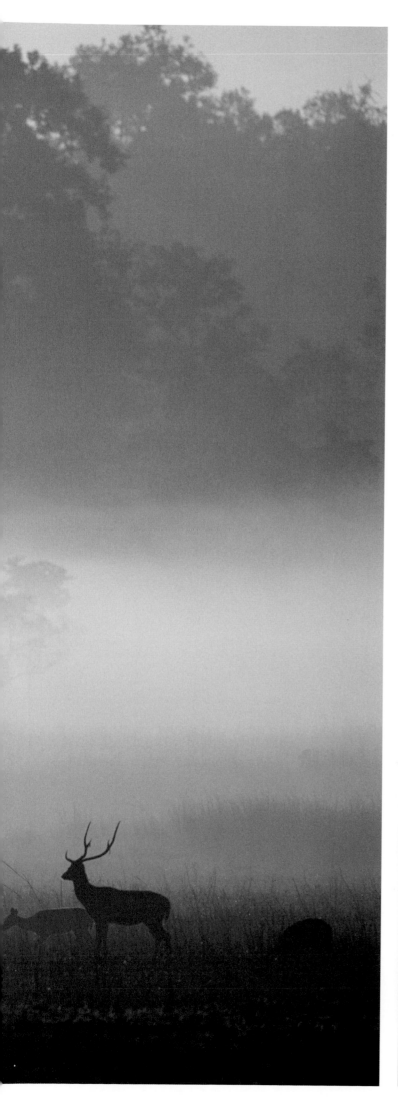

22. The Tigers of Kanha

Located deep in the heart of India, Kanha is one of Asia's finest national parks. Set around a beautiful valley, within which unfolds a rolling patchwork of sal forest, bamboo thickets, scrub-covered ridges and open grasslands, known as *maidans*, it is home to a great diversity of wildlife. This is classic wild India, and the perfect setting for the adventures of Mowgli, Baloo, Bagheera and Shere Khan, as immortalised in Rudyard Kipling's *The Jungle Book*.

Kanha's healthy populations of large mammals are what led to its popularity, first as a hunting ground for the rich and influential, then (in 1933) as a protected area and finally (1955) as a national park. An early focus of conservation efforts was the central Indian race of Swamp Deer (*Cervus duvauceli branderi*) or Barasingha, once reduced to just 66 animals, all of them in Kanha. Barasingha require grassy meadows in which to thrive and so the park's management regime was partly directed at creating and maintaining this habitat. The Barasingha have prospered as a result — there are now over 500 of them in the park, and they can be easily spotted in open areas of lightly forested grassland. These also attract large numbers of other ungulates, notably Chital (*Axis axis*), groups of which often can be seen grazing out in the open in a scene more reminiscent of the East African savannah than India. Few other places in India can offer this spectacle. .

Also present in Kanha, but more often found on the forested ridges on the valley sides, are good numbers of Indian Bison or Gaur (*Bos gaurus*), one of the most impressive species of wild cattle and characterized by their distinctive white "socks", as well as Chowsingha (*Tetracerus quadricornis*), the world's only four-horned antelope, and Sloth Bear (*Melursus ursinus*), which is mostly nocturnal and so rarely seen in daylight.

Predators in Kanha include the Leopard (*Panthera pardus*) and the enigmatic Dhole or Wild Dog (*Cuon alpinus*). Dhole are diurnal hunters, usually moving in small packs and sometimes

LEFT **A group of Chital grazing in the early morning mist in Kanha. Their characteristic alarm call – a shrill whistle – is often the first sign that a Tiger is in the vicinity.**

BELOW **The chance of seeing a Tiger is for most visitors the main reason for travelling to Kanha, but here – as elsewhere in India – the population is falling due to poaching.**

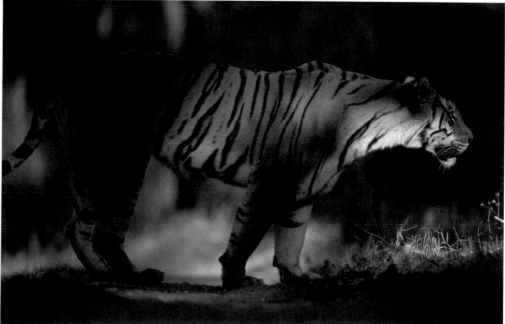

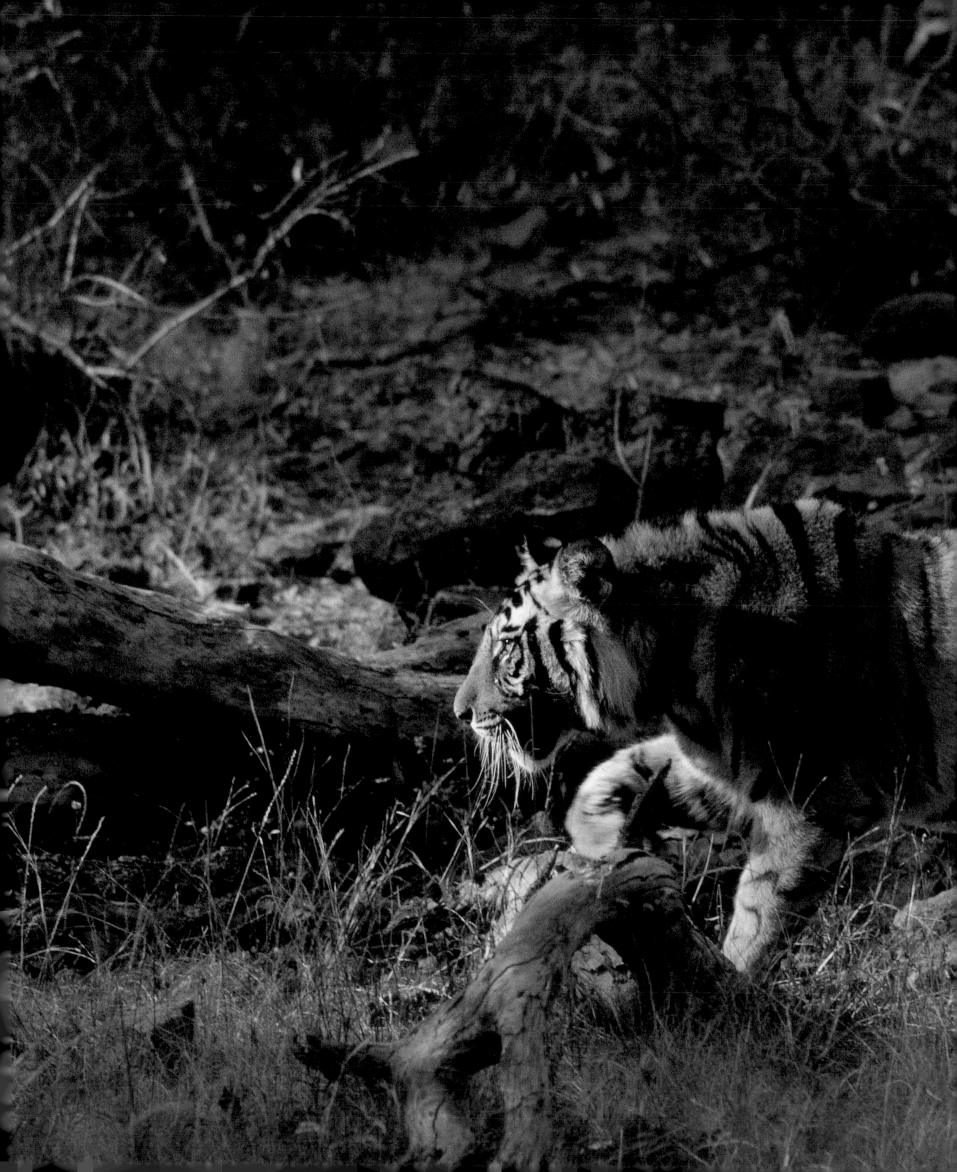

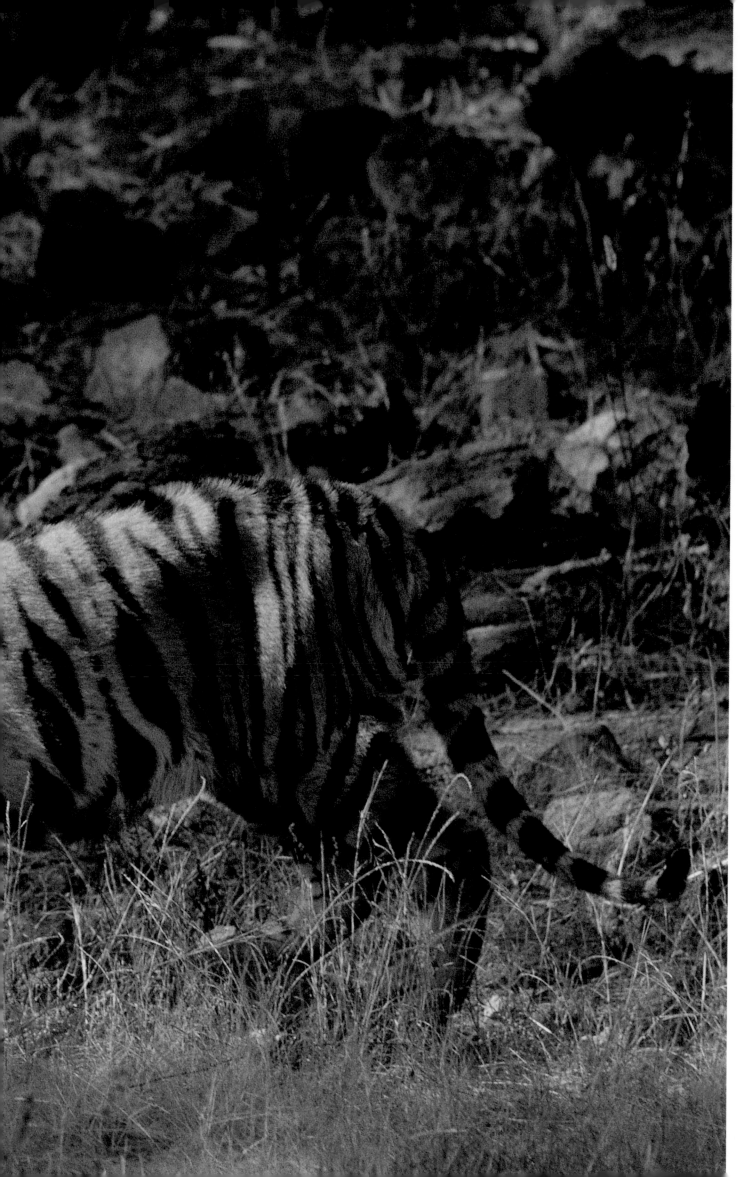

LEFT Tigers usually hunt at dawn and dusk, and if successful will feed from their kill for a day or two. Depending on the size of their prey, they may not then need to eat again for two or three days.

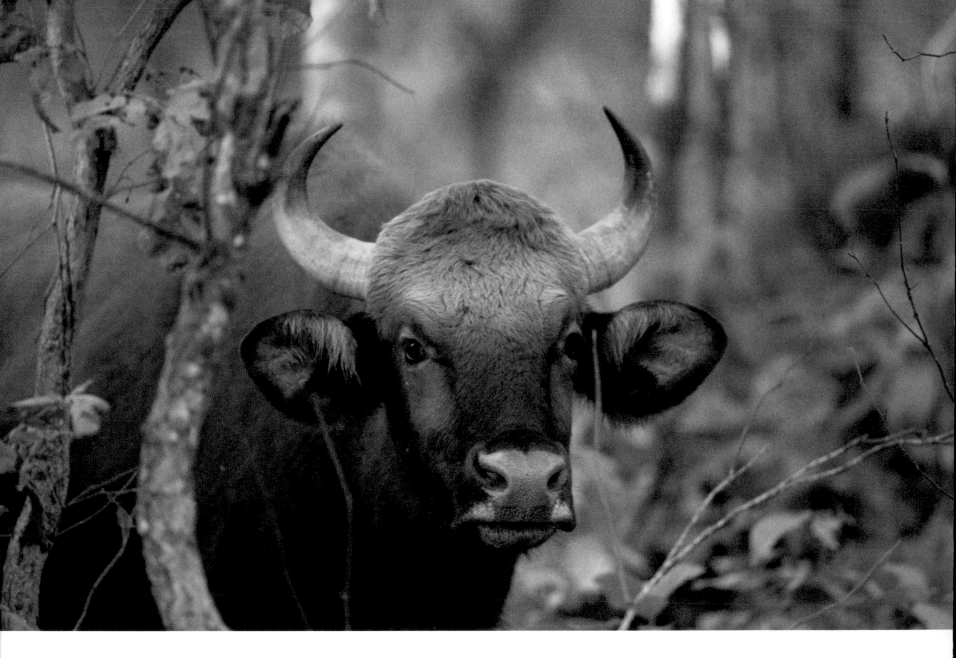

ABOVE **Herds of Gaur are common in Kanha, but they tend to avoid the open areas and are best looked for in the forest and thickets. The largest of all wild cattle, adult male Gaur can weigh up to 1,700 kilograms (3,750 pounds) and can exceed 2 metres (6½ feet) at the shoulder.**

to be found chasing Chital across Kanha's *maidans*. They are capable of tackling much larger prey – even Gaur – and until 30 years or so ago were often persecuted by game wardens on the grounds that they "harassed" other game. Today, the Dhole is accepted as an integral part of the local wildlife scene, but sadly their numbers appear to be declining. They are always difficult to pin down, often frequenting a particular area for a while and then inexplicably moving on and remaining absent for many months. This peripatetic lifestyle adds greatly to their allure, and the sudden sight of these rufous-coloured hunters racing across the grassland, their plumed tails aloft with excitement, is a thrilling climax to any game drive.

However, the highlight of most visits to Kanha is certain to be a sighting of the park's main predator, the Tiger (*Panthera tigris*), seen either moving through the early morning mists that cloak the *maidans*, or resting during the heat of the day in a bamboo thicket in the forest. Along with Bandhavgarh National Park, located to the north-west, Kanha offers the best chance of seeing wild tigers anywhere in the world. The relatively high population – official figures suggested that in June 2006 over 120 animals were living in the park – and open nature of much the Kanha "parkland" habitat makes for premier tiger-watching, and you would be unlucky not to see a tiger here on a three- or four-day visit. Indeed, it is sometimes possible to see as many as four or five different individuals in a day, and a close approach can often be made on elephant-back.

All in all, this makes for superb wildlife-watching, but sadly the situation is not as positive as it may appear. Recent evidence indicates that the real number of tigers in Kanha may be as low as 35–40, and there are worrying signs that the tiger population in other parts of India is in equally poor shape.

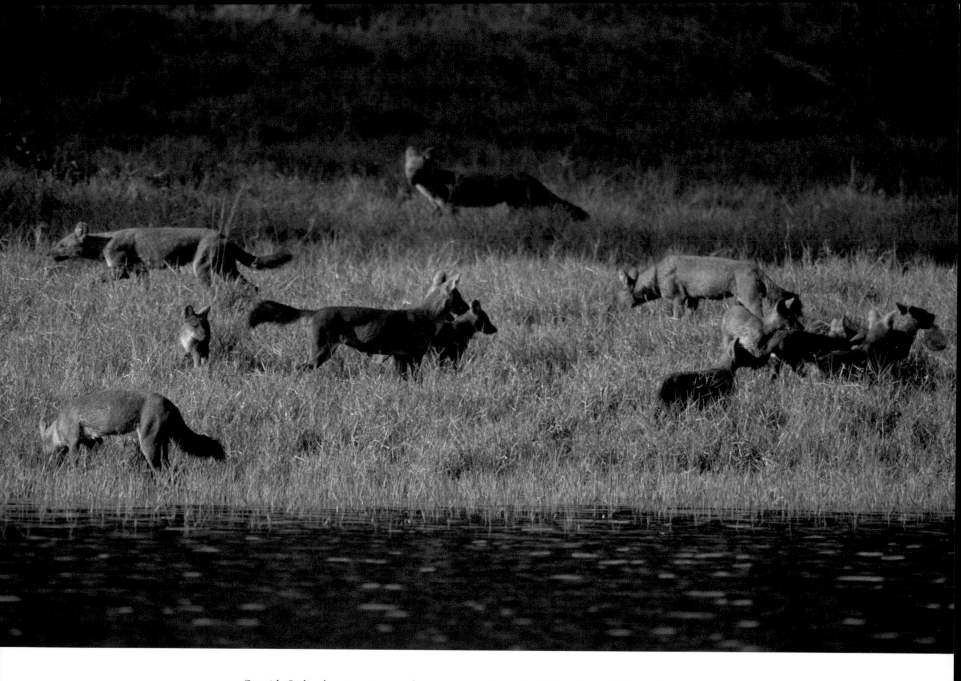

Outside India the situation may be even worse. A total of 13 nations still have tiger populations within their boundaries, ranging from the majestic Siberian Tiger (*P. t. altaica*) in the far east of Russia to the smallest race, the Sumatran Tiger (*P. t. sumatrae*) on its Indonesian island home.

Almost all the populations are suffering from habitat destruction and illegal hunting, and the future for some is bleak indeed. Tigers are under intense pressure on several fronts. Their requirement for extensive tracts of undisturbed habitat sits at increasing odds with rapidly growing populations in almost all the countries they inhabit. Human disturbance, both of the tigers themselves and of the prey animals on which they depend, is helping to fragment tiger populations further and has reduced many to below the point of viability, with too few individuals scattered over too large an area and often "marooned" in pockets of what is often degraded habitat. This is almost certainly the case with the South China race (*P. t. amoyensis*), of which only 25–30 animals may survive.

Meanwhile, the continued poaching of tigers is having a serious impact on their numbers. The precise level of killing remains unclear, but probably an average of at least one tiger per day is lost to poachers and as many as 250 may be killed in India each year. Although tigers are slaughtered primarily for their body parts, used in traditional Chinese medicine, in recent years there has been a resurgence in poaching for skins. This has been driven mainly by demand from Tibet for part of the traditional costume worn at horse festivals there. As a result of a concerted conservation effort, and a call from the Tibetan spiritual leader, the Dalai Lama, for Buddhists not to wear tiger skin, the demand has eased but not been entirely eradicated. Overall, the outlook for wild tigers is looking very bleak indeed.

ABOVE **Usually active by day, Dholes are highly effective hunters and will take a wide variety of prey, from gamebirds to animals as large as Gaur and Water Buffalo. They can be found in a wide variety of habitats, ranging from dense forest to open steppes.**

23. Hanging by a Thread: the Orang-utans of Borneo

Early European visitors to the dense rainforests of Borneo and Sumatra came back with tales of an extraordinary hairy red ape, described by local people as "Orang-utan" – literally, "the wild man of the woods". We now know that this primate, second in size only to the Gorilla (*Gorilla gorilla*), shares over 96 per cent of its genetic material with humans and is therefore one of our closest relatives.

There are two distinct species of the only great ape found outside Africa: the Sumatran Orang-utan (*Pongo abelii*) and the Bornean Orang-utan (*Pongo pygmaeus*). The Sumatran species is thinner than its Bornean relative, with longer hair and a longer face. Each species is endemic to its respective island, and in 1900 there may have been over 300,000 Orang-utans distributed widely across Borneo and Sumatra. Today, fewer than 30,000 survive, in increasingly scattered and vulnerable populations. Living an almost totally arboreal life, Orang-utans rarely descend to the forest floor. They inhabit lowland and mid-elevation rainforest, and are diurnal, sleeping at night in specially prepared "nests". Each animal constructs a new nest each evening, weaving together branches and foliage to create a platform about a metre across on which it will bed down. Orang-utans are mainly solitary, with individuals ranging over large areas in search of food. Their diet consists mainly of fruit, and one of the few occasions when they may be encountered in small groups is when they gather to feed on fruiting trees. Wild figs are a particular favourite.

Two of the best places to watch wild Bornean Orang-utans are in Sabah, in the Danum Valley, and along the Lower Kinabatangan River. Both these sites have ideal Orang habitat, although sightings can never be guaranteed. Even if the Orangs do not oblige, there is plenty of other wildlife on offer at both these sites. The Danum Valley Conservation Area covers 438 square kilometres (169 square miles) and is one of the best remaining tracts of primary lowland rainforest in Borneo. Huge dipterocarp trees, supported by massive buttress roots and bedecked with lianas and epiphytic plants, soar up from the forest floor. Not only do they provide a majestic natural architecture to the forest but they also support thousands of different forms

BELOW The appealing nature of young Orang-utans has contributed to their continued prominence in the illegal pet trade. The mother is often killed in the capture process. Whilst some orphans are rescued and successfully rehabilitated into the wild, many are destined to remain in captivity.

RIGHT The tracts of forest along the Kinabatangan River are home to troops of Proboscis Monkeys, the more adventurous of which can sometimes be seen leaping into the water and swimming across to the other side.

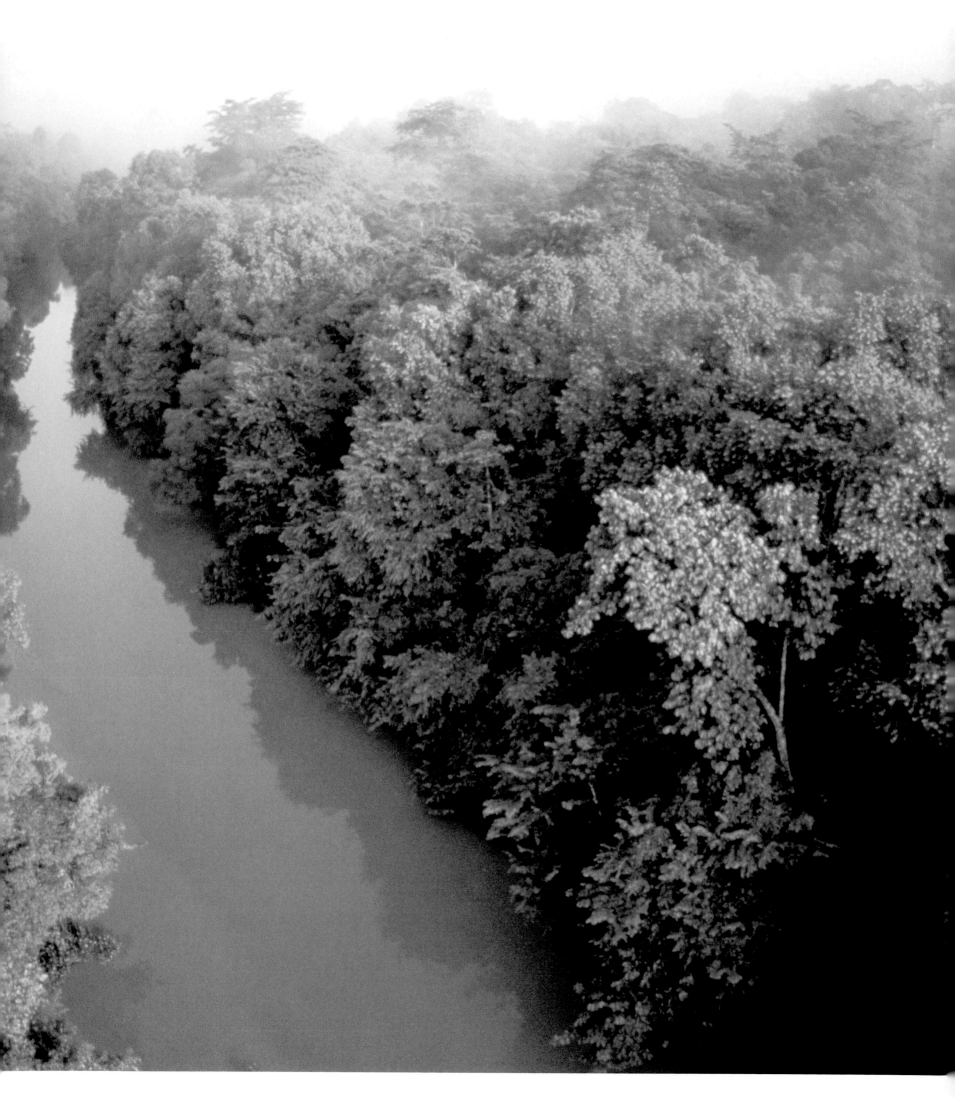

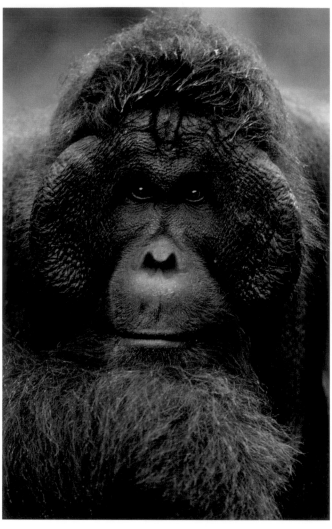

LEFT TOP An adult male Bornean Orang-utan. Male Orangs take 15 years or so to reach maturity, and the older males can be readily identified by their greater weight and bulk and by their prominent cheek pads or flanges.

LEFT BOTTOM The most arboreal of the great apes, Orang-utans spend almost all of their time in trees, and need large areas of forest in which to forage successfully for food. They eat up to 100 types of fruit, as well as bark, nuts, seeds and insects.

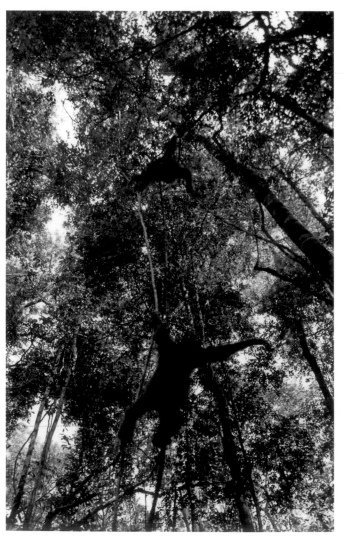

of wildlife. The Danum Valley is home to over 110 species of mammal, for example, including some of Asia's most endangered species. A small population of Sumatran Rhinoceros (*Dicerorhinus sumatrensis*) survives here, alongside such exciting but equally rarely seen beasts as Clouded Leopard (*Neofelis nebulosa*) and Sun Bear (*Helarctos malayanus*).

Much easier to spot are members of the valley's sizeable population of Bornean Gibbon (*Hylobates muelleri*). Waking up in the forest to the whooping of gibbons ringing through the treetops is one of the great Borneo experiences; the rather melancholic "songs" often take the form of duets between male and female, which serve to strengthen their bond and confirm their territory to others. Moving around in small family units, gibbons are highly entertaining to watch as they swing at high speed though the main canopy, 25–45 metres (82–148 feet) up, their acrobatics interspersed with athletic sprints along horizontal branches. Their speed and agility are breathtaking, but getting a good view of one stationary is not an easy proposition.

The Kinabatangan River is the longest in Sabah and its floodplain is one of Borneo's best wildlife areas– a mixture of riparian forest, swamp and mangrove. Wild Orangs are present here, but usually more obvious are troops of Proboscis Monkeys (*Nasalis larvatus*). Characterized by their remarkably large noses, the precise purpose of which remains unclear, these large primates are endemic to Borneo. Usually found in groups of 10–30, they are good swimmers and will readily enter the water and cross to the other side of the river. Indeed, the best views of Proboscis Monkeys are usually to be had from a boat, as they feed in the riverside trees. This is also one of the best ways to try and see the Bornean Pygmy Elephant (*Elephas maximus "borneensis"*), a diminutive race of Asian Elephant. Although elephants also occur at Danum Valley, they are easier to see along the Kinabatangan, although a sighting is by no means a certainty.

However, the future for the elephants, Orang-utans and other forest wildlife of Borneo is far from secure. Commercial logging, much of it illegal and continuing, has destroyed more than 50 per cent of the island's forest habitat in recent decades. At the present rate of destruction it is possible that in Kalimantan (Indonesian Borneo) there will be no primary forest remaining outside of protected areas by 2010. Much of this loss is due to the clearance of forest to make room for palm-oil plantations. In the Lower Kinabatangan area, part of which is ostensibly protected, as much as 90 per cent of the dipterocarp forest has already been cut down, with animals such as elephants increasingly forced out into agricultural plantations, where they come into conflict with humans.

Illicit hunting is a major concern in some parts of Borneo, as is the continued taking of baby Orang-utans for the illegal pet trade, often after their mothers have been killed. Orang-utans are the slowest breeding of all primates and most females normally have no more than three offspring during their lifespan of 45 years or so. This strictly limits their ability to recover their numbers. Yet even if they were able to bounce back more quickly, this would be of little use if their habitat no longer exists. The main conservation priority in Borneo, therefore, is to secure the meaningful protection of sufficiently large areas of suitable habitat to sustain viable populations of the fascinating animals that live here.

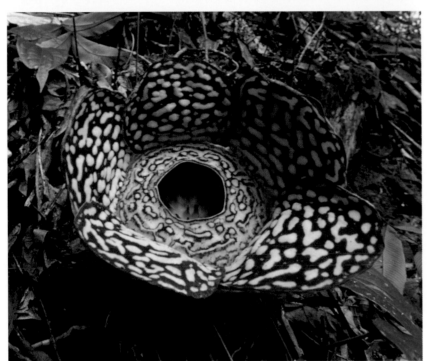

ABOVE **Sequence of *Rafflesia* sp. blooming, from emerging bud (top left) through to fully open flower (bottom right).**

GATEFOLD CENTRE **Found across much of south-east Asia, the Reticulated Python (*Python reticulatus*) is the world's longest snake and specimens in excess of 10 metres (33 feet) have been recorded.**

RIGHT FLAP **The Bornean Gibbon is a highly charismatic – and vocal – member of the rainforest community.**

CLOSING PAGE **Undoubtedly one of the world's most unusual-looking birds, the Rhinoceros Hornbill (*Buceros rhinoceros*) is a fairly common species in the forests of Borneo.**

24. The Rhinos of Kaziranga

Built like an armoured car, the Great One-horned Rhinoceros (*Rhinoceros unicornis*) has more than a hint of the prehistoric throwback about it. Its gun-metal grey skin is folded into what look like a series of overlapping plates, and the head has a definite "dinosaur" profile. By any standards this is a formidable beast, with adult rhinos weighing as much as 3,000 kilograms (6,600 pounds), and standing up to 1.7 metres (5.6 feet) tall at the shoulder. However, a tough hide and a bullish attitude was not enough for India's once sizeable rhino population to withstand the onslaught of the hunting mania that swept the country in the nineteenth century and decimated much of its wildlife. Once common on the grassy floodplains across northern India and into Burma, by the early 1900s the species was reportedly reduced to barely a dozen individuals lurking in the swamps of Kaziranga, along the mighty Brahmaputra River in Assam, in India's far north-eastern corner. Here they hung on, carefully protected, and this area remains the headquarters of the world's population of this still endangered animal. Some 1,500 rhinos live here, out of a total world population of approximately 2,400.

Set against the often hazy backdrop of the snow-capped Himalayas, Kaziranga is classic floodplain country, comprising mainly riverine grassland bordered by forest. During the monsoon season (June to September) the river levels rise dramatically and water spills over the banks, inundating the low-lying grassland and often causing considerable devastation. Beyond the immediate riverside there is much lush and abundant vegetation, characterized by dense stands of rattan cane and tall elephant grass, reaching as high as 5 or 6 metres (16 or 20 feet) through which large mammals such as elephant and rhino think nothing of bulldozing their way. Tracts of evergreen forest extend to the distant foothills. This is wild country, and the atmosphere here is made all the more special by the morning mists that cloak the area. These give the landscape a ghostly, other-worldly feel and provide the perfect setting for watching such primeval-looking beasts as rhinos.

PREVIOUS **Proboscis Monkeys** live in single-male harems, with one male supporting up to half a dozen females. The sexes can be told apart by the male's much larger nose.

ABOVE **Although numbers of the Great One-horned Rhinoceros** have increased in recent decades, there is no room for complacency. A depressing event occurred in early 2007, when six rhinos were killed in Kaziranga by poachers.

RIGHT **Kaziranga's rhinos** spend much of their time grazing on the riverine grass-lands, but they also browse leaves from shrubs and trees. Creatures of habit, they form networks of well-worn rhino "corridors" through the taller vegetation.

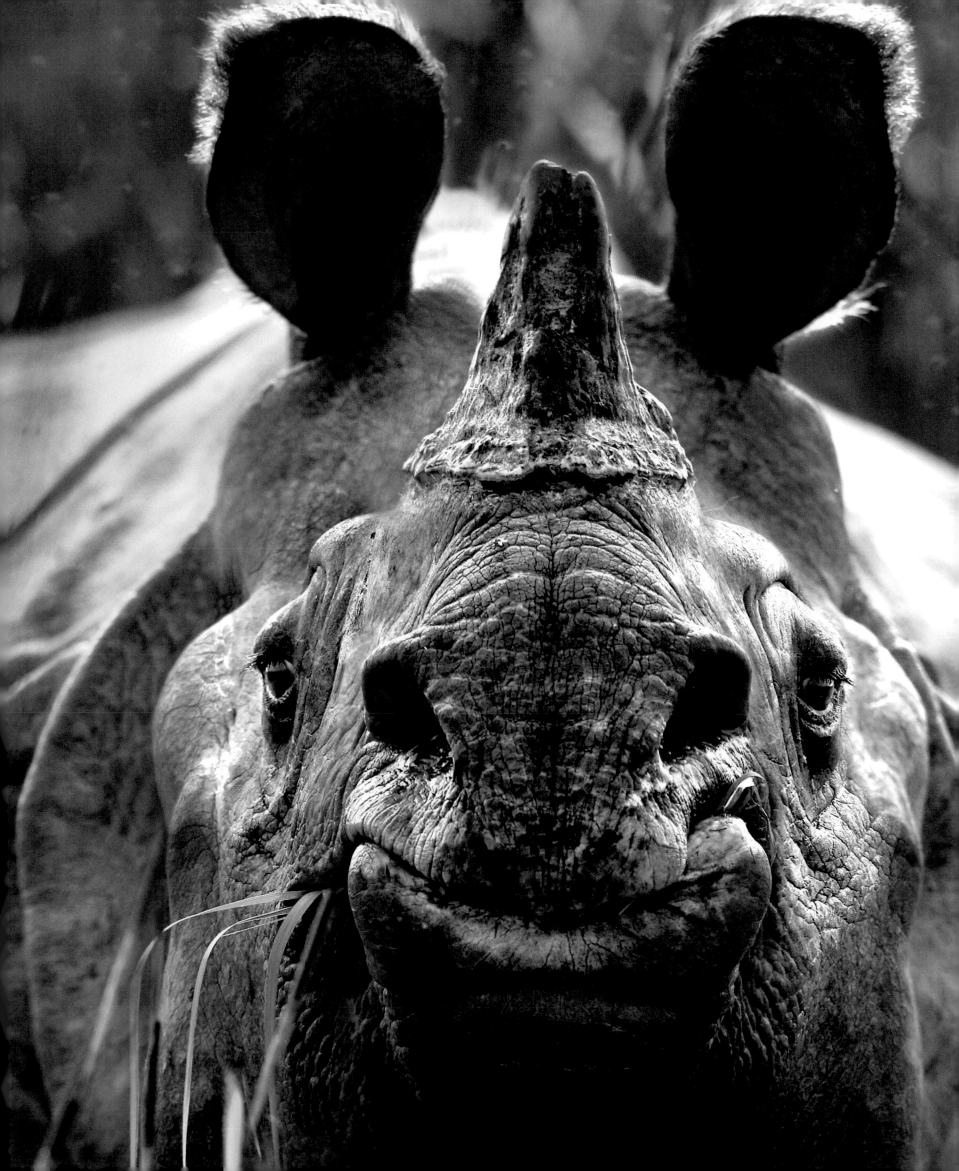

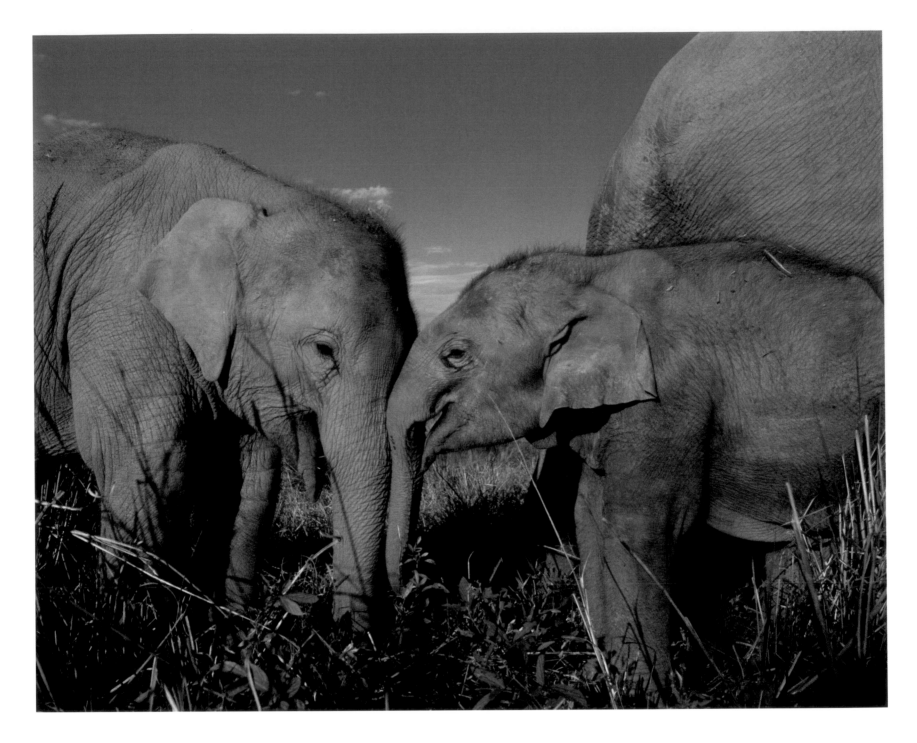

Great One-horned Rhinos are perfectly at home in watery environments, feeding with relish on
aquatic plants and swimming readily when the need arises. The best place to find them therefore is
on the wet, riverine grassland, where they graze, and around the flood-formed lakes or *bheels*, in
which they often wallow to escape the summer heat. Generally solitary, rhinos will tend to gather
in the same favoured locations, and it is not uncommon to see several in a loose – but always wary
– association. Although they have a reputation for being cantankerous and charging unpredictably,
the rhinos at Kaziranga are relatively used to people and vehicles, and a quiet approach will usually
produce good views, especially when it is on elephant-back, which is an option in the park.

Rhinos have only one natural enemy – the Tiger (*Panthera tigris*). Although tigers are not
capable of bringing down a healthy, full-grown rhino, they will occasionally try and sneak a young
calf away from its mother. There is a good population of tigers in the park, but they are seen much
more infrequently here than in some other Indian tiger reserves, due to the nature of the terrain
and the thick vegetation. A much greater threat to the rhinos is illegal poaching. At one time over
30 animals a year were being lost to poaching in the park, but in recent years increased vigilance
and anti-poaching patrols have reduced this figure.

Kaziranga's other star animal is the wild Water Buffalo (*Bubalus bubalis*). Although the
domesticated version of this species is a familiar sight across India, its wild relative is now very

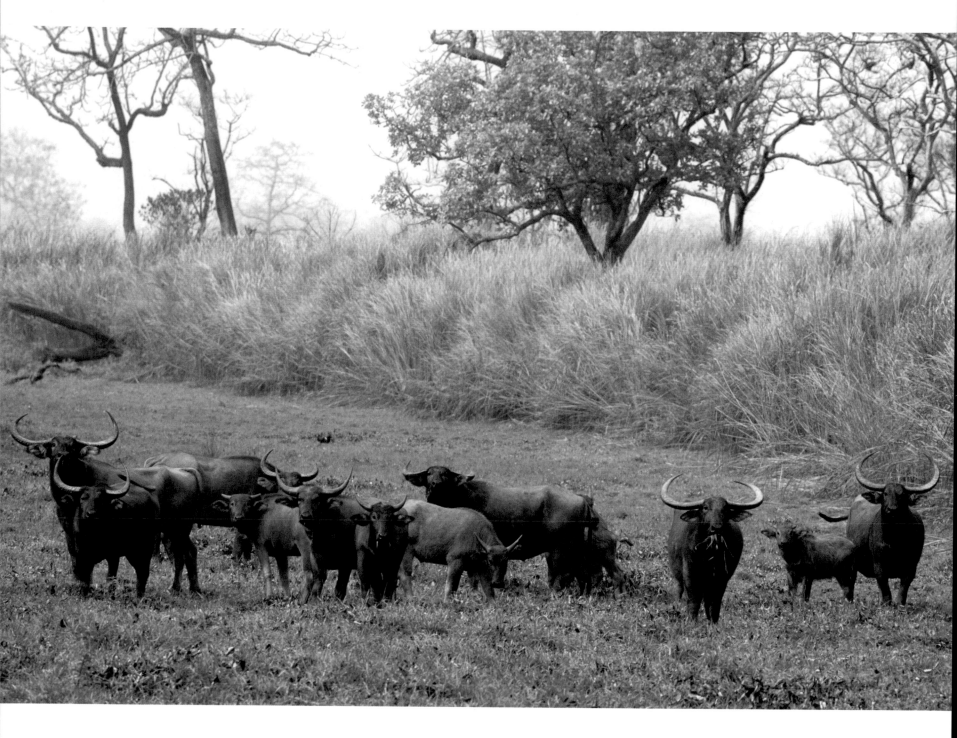

rare and restricted to just a few locations, where it receives protection. A very distinctive animal, with much wider and longer horns than the domestic version, the Wild Buffalo is notoriously shy and unapproachable. However, like the rhino, those at Kaziranga have become habituated to the presence of people and can be approached with care, although the unpredictable nature of the solitary bulls dictates that it is always advisable to give them a reasonably wide berth. The Wild Buffalo's favoured habitat is alluvial grassland, and this has been the source of its undoing, as this land is highly prized in India for its agricultural potential and much of it has been converted into farmland.

Habitat loss is just one threat faced by the surviving Wild Buffalo population. They are also at risk from the dilution of their wild genes by interbreeding with domestic stock which "goes feral" and joins a wild herd. There is no doubt that the population at Kaziranga has been affected in this way, and it may be the case that there are no truly Wild Buffalo left anywhere in India. Be that as it may, the sight of such magnificent animals grazing contentedly alongside rhinos and wild elephants, groups of which regularly move through the park, makes Kaziranga a very special place indeed. The challenge for the future will be to ensure that the integrity of the park's ecosystem is adequately safeguarded. Human pressure on the land outside the park is intense, and changes of land use and infrastructural development are destroying and compromising much of the habitat to which the larger mammals migrate when the park is flooded.

ABOVE **One of India's rarest mammals, the Wild Water Buffalo is facing an uncertain future, due to continuing habitat loss and crossbreeding with its domesticated cousins. Adult Wild Buffalo are not to be trifled with, and have even been known to drive off an attacking Tiger.**

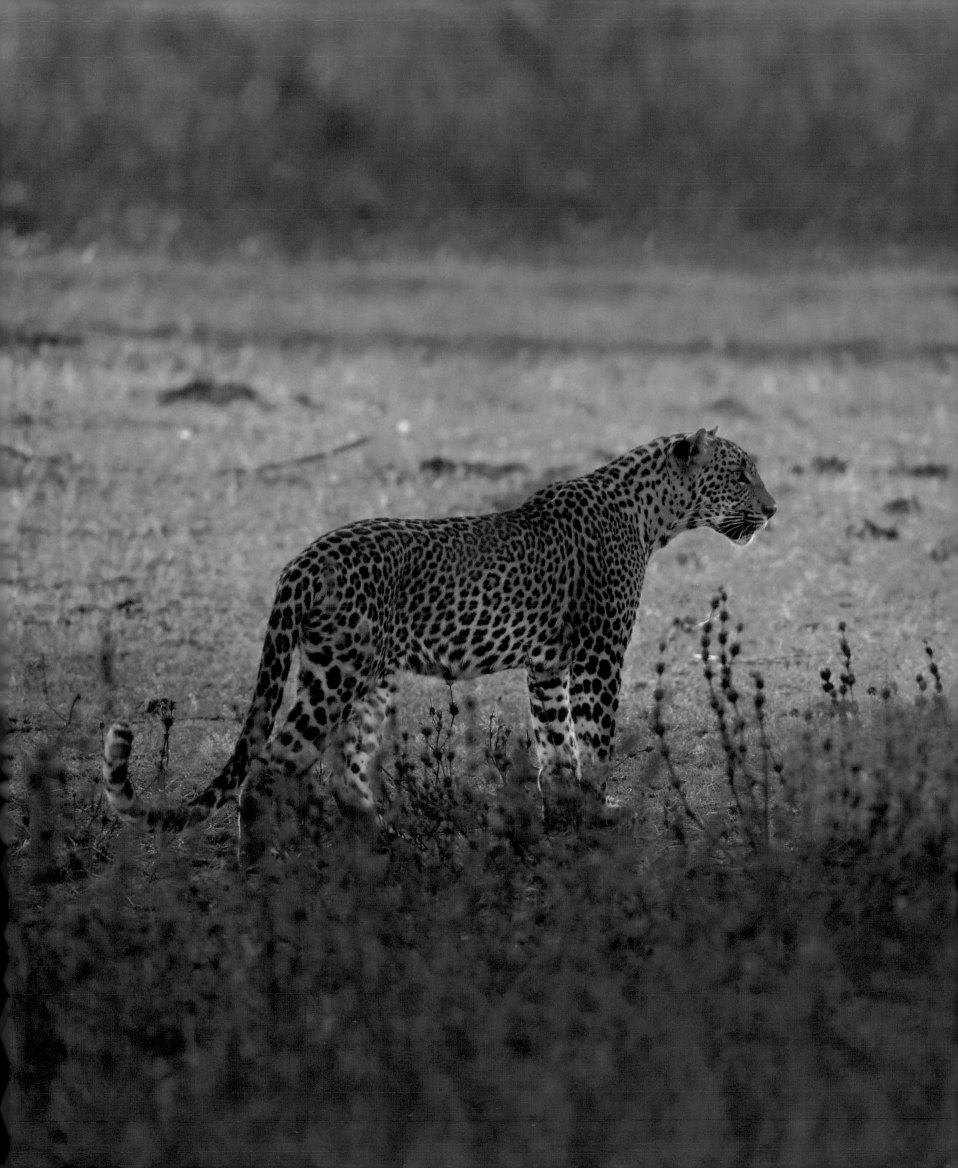

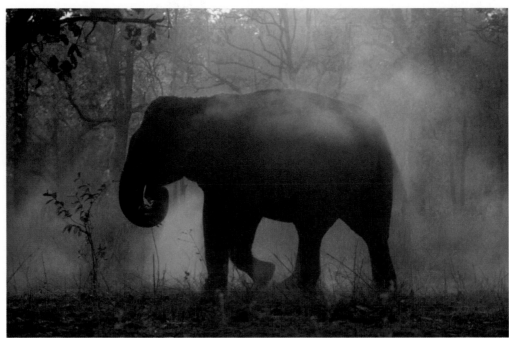

25. Leopards and Elephants in Yala

Yala National Park is perhaps the best place in the world to see Leopard (*Panthera pardus*) in the wild. Up to 40 individual cats live in the park, and because they are the top predator here – unlike in India and Africa, where they are dominated by Tiger and Lion respectively – they are generally bolder and more diurnal in Yala than in other parts of their range. Sightings are never guaranteed, but you certainly stand a better chance of seeing a Leopard here than anywhere else in Asia.

The national park at Yala, also known as Ruhuna, is the oldest on the island of Sri Lanka. Established in 1938, it now covers over 120,000 hectares (296,500 acres) (although there is public access to only a fraction of this area) and features a range of vegetation types, ranging from wet monsoon forest through thorn forest and grassland to both freshwater and saltwater wetlands. The latter offer excellent birdwatching, with the possibility of seeing rare species such as the Black-necked Stork (*Ephippiorhynchus asiaticus*) and Lesser Adjutant (*Leptoptilos javanicus*), as well as a good variety of waders and ducks. The park runs down to the sea and has dramatic sandy beaches along which turtles nest. There is more than just landscape and ecological interest in Yala, for the park contains the ruins of several temples, monasteries and other buildings – evidence of many centuries of human occupation. Overall, it is scenically outstanding.

The Leopard is the most widely distributed member of the cat family, and found from Turkey and other parts of the Middle East across much of southern Asia to China and the far east of Russia, as well as in parts of North Africa and throughout sub-Saharan Africa. In many parts of its range, however, it is seriously under threat from illegal poaching, disturbance and habitat destruction. Indeed, in some areas, such as Anatolia and Israel, the local populations may have already fallen below the point of viability and be doomed to extinction.

Some 13 or so genetically distinct sub-species of Leopard have been identified. Those in Sri Lanka (*Panthera pardus kotiya*) are reputed to be among the largest in Asia, reaching up to 2 metres (6.6 feet) or so in length and are certainly capable of tackling prey as large as a full-grown Sambar (*Cervus unicolor*). Masters of stealth and camouflage, leopards are usually highly secretive, a factor which has enabled them to live undetected in surprisingly close proximity to human settlements. This can, however, bring them into conflict with people when they take "easy" prey, such as domestic animals or pets (they are particularly partial to dogs).

At Yala, however, following decades of protection, it is not uncommon to find a leopard ambling along a sandy track in broad daylight or resting up during the heat of the day in a tree or on top of a shaded rock. As a species, the leopard is highly flexible and able to live in a variety of different habitats ranging from open desert to thick forest. Although found throughout Yala, the local leopards often

LEFT **Yala's relatively large Leopard population, and their often confident behaviour, make it an outstanding place for watching this generally elusive species. Dawn and dusk are the best times for sightings.**

ABOVE **Wild Asian Elephants are common in Yala, which remains one of the best places in Sri Lanka to see them. The island's elephants are the largest of their species, and domesticated animals were traditionally used for carrying timber. However, in recent years the number of working elephants in Sri Lanka has fallen to just a few hundred.**

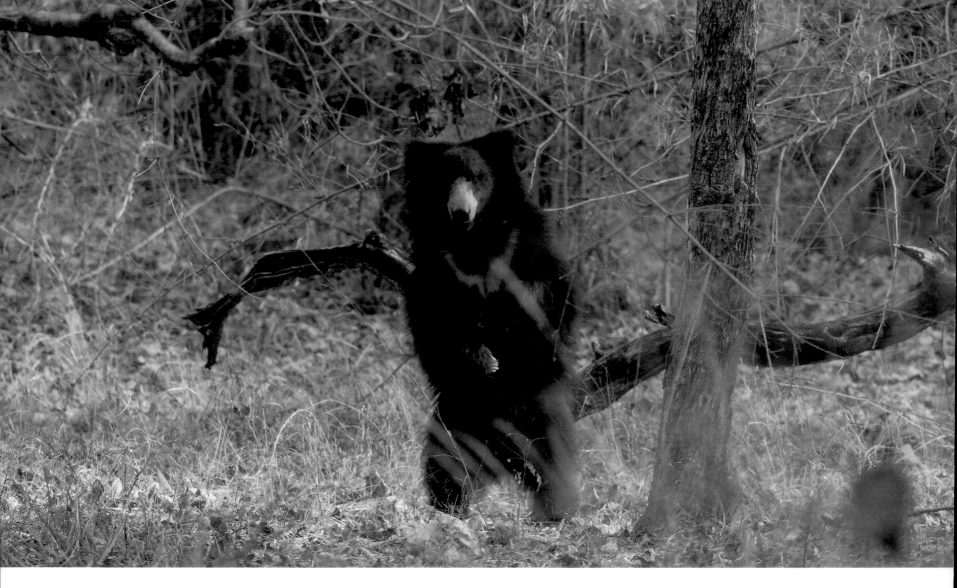

ABOVE Normally seen moving about on all fours, the Sloth Bear (*Melursus ursinus*) will stand up on its hind legs when curious or threatened. Generally nocturnal, this species lives primarily on ants and termites, which it digs out with its long claws.

favour boulder-strewn rocky outcrops and thick scrub along watercourses. Leopard flexibility in habitat is mirrored by an equally opportunistic diet: they will feed on a wide range of prey, from reptiles and birds to monkeys and Wild Boar (*Sus scrofa cristatus*). At Yala their favoured prey is the Chital (*Axis axis*), which they ambush and asphyxiate by clamping their jaws around its neck.

Although a leopard sighting is certain to be the highlight of any game drive at Yala, the park is equally celebrated for its population of Asian Elephants (*Elephas maximus*). Between 3,500 and 4,000 wild elephants survive in Sri Lanka, with 10 per cent of this total roaming Yala in small herds, usually of between five and 15 animals. Elephant society is matriarchal, and the typical leader of a group is a mature female, accompanied by two or three other adult cows and a gaggle of sub-adults and calves. Male (or bull) elephants are usually solitary, although they will occasionally get together in loose "bachelor" parties. For such a large animal, elephants can be surprisingly unobtrusive when in thick forest. However, it is very unusual to spend a day or two at Yala without seeing elephants, and very close views are often possible as the animals move through the landscape grazing, browsing and interacting with one another. They make for compulsive viewing, especially when there are youngsters about.

Yala has a reputation as the home of some notable "tuskers" – mature male elephants with well-developed tusks. Only male Asian Elephants have tusks, and with many of the more magnificent specimens having been poached for their ivory in recent decades, the tusker gene is at risk of dying out. Fewer than five per cent of Sri Lanka's elephants are now estimated to be tuskers. Although poaching for ivory is not too serious a problem in Sri Lanka, elephants have an increasingly uneasy relationship with people outside the protected areas. With many traditional elephant migration routes now disrupted by farmland and expanding settlements, elephants will readily move into agricultural areas and take advantage of cultivated crops when natural food is in short supply. Their prodigious size and appetite can deprive a small-scale farmer of his entire livelihood in an hour or two, and the threat they pose to life and property results in over 100 illegal elephant deaths each year.

OPPOSITE TOP An elephant group bathing. Elephants depend on regular access to water, and when their traditional routes between water sources are disrupted by human activities such as agriculture and infrastructural development such as road-building, conflict inevitably arises.

OPPOSITE BOTTOM Yala is scenically outstanding, and the park's many varied habitats make it one of the Indian sub-continent's best wildlife destinations. The extensive areas of wetland are particularly rewarding for birdwatching.

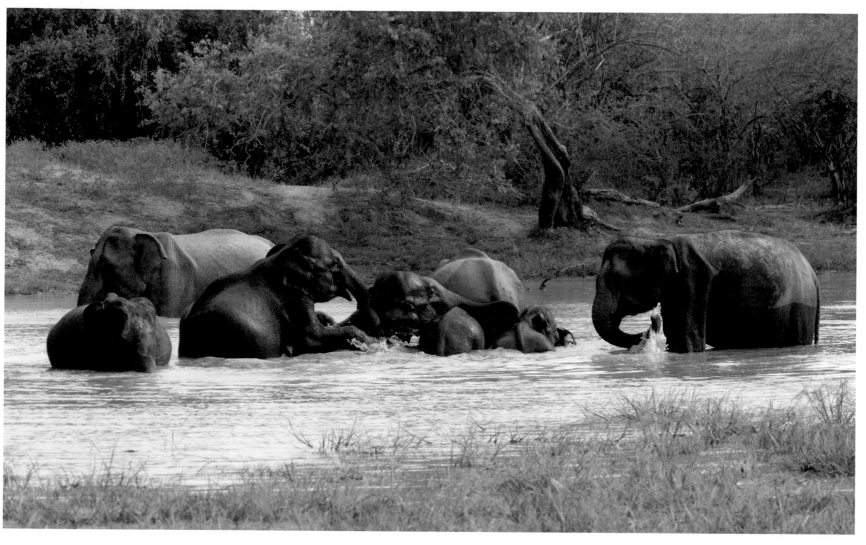

26. The Birds of Bharatpur

Across much of the world, the relationship between hunting and wildlife conservation is historically a strong one; indeed, in some locations the two are inextricably linked. Nowhere is this more apparent than at the remarkable national park of Keoladeo Ghana, more popularly known as Bharatpur. Located in Rajasthan to the west of Agra, and covering a mere 29 square kilometres (11.2 square miles), what is now India's foremost bird sanctuary (around 400 species have been recorded here) started life as a shallow depression in an arid area of scrub, which would flood during the annual monsoon and attract large numbers of waterfowl. For a brief period the site would offer excellent shooting, only for the geese and ducks to leave once the water had dried up.

In the late nineteenth century the Maharaja of Bharatpur decided to develop the area as a permanent shooting ground. He organized the construction of a series of dams and dykes to channel water from a nearby irrigation canal into what became permanent pools or *jheels*. As a result, the waterfowl became both more regular in their visits and more numerous, and it was not long before lavish shooting parties for VIPs were a regular event here. Some of the bags achieved are staggering: the extraordinary death tolls are recorded on an inscription within the park, and the record is held by a 1938 shoot in which the then viceroy, Lord Linlithgow, accounted for 4,273 birds in just one day.

Many thousands of waterfowl continue to visit the lakes at Bharatpur, but shooting ceased here in the 1960s and today's flocks are unmolested. The first waves of wintering geese and ducks arrive in October, with large flocks of Eurasian Wigeon (*Anas penelope*), Northern Shoveler (*Anas clypeata*), Northern Pintail (*Anas acuta*), Common Teal (*Anas crecca*) and Gadwall (*Anas strepera*) arriving from the north, along with gaggles of Bar-headed (*Anser indicus*) and Greylag Geese (*Anser anser*). They join resident species such as Cotton Pygmy-goose (*Nettapus coromandelianus*), Comb Duck (*Sarkidiornis melanotos*), Spot-billed Duck (*Anas poecilorhyncha*) and Lesser Whistling-duck (*Dendrocygna javanica*), and by December the *jheels* of Bharatpur are packed with thousands of waterfowl. Many of them can be watched at close quarters from the paths that lead around the lakes; indeed, there can be few places in the world that offer birding of this quality and diversity.

Alongside the geese and ducks is an impressive array of other waterbirds. These can include three species of pelican (Great White [*Pelecanus onocrotalus*], Dalmatian [*Pelicanus crispus*] and Spot-billed [*Pelicanus philippensis*]), and a bewildering variety of storks, herons and egrets. Although striking enough when stalking around the *jheels*, these birds are at their most impressive when gathered together during the breeding season (July to September). At this time the waterside trees and bushes are teeming with nesting birds, the air full of noise and the acrid aroma of guano, as birds jostle for position and youngsters clamour

to be fed. Seventeen or so species nest in the Bharatpur colonies, and it is not unusual to find up to eight different species occupying the same tree. In total, some 50,000 pairs of large wading bird nest here. These include Painted Stork (*Mycteria leucocephala*), Asian Openbill Stork (*Anastomus oscitans*), Eurasian Spoonbill (*Platalea leucorodia*), Black-headed Ibis (*Threskiornis melanocephala*) and four species of egret; they are joined by two species of cormorant and Darter (*Anhinga melanogaster*).

A vast collection of smaller waterside birds can also be seen at Bharatpur. Common residents include Purple Swamphen (*Porphyrio porphyrio*), White-breasted Waterhen (*Amaurornis phoenicurus*) and Bronze-winged Jacana (*Metopidius indicus*), and many of the migratory waders that drop in here are familiar to birders from Europe. One of the great specialities of Bharatpur in the past was its population of overwintering Siberian Crane (*Grus leucogeranus*). Three other crane species – the resident Sarus (*Grus antigone*), the wintering Common (*Grus grus*) and the irregularly visiting Demoiselle (*Grus virgo*) – still frequent the park, but of the Siberians there has been no sign since 2002. Sadly, it appears that the central population of this species, which nested in western Siberia and was subject to illegal hunting en route to its migration southwards to India, is now extinct (the western and eastern populations are still extant, if endangered).

Although best-known for its waterbirds, Bharatpur is arguably the finest place in India for watching raptors, with over 40 species recorded. Many of these are visitors from northern Asia, which spend the winter here and are best looked for sitting in the trees around the lakes. The areas of woodland and scrub in the park are also very good for passerines, both resident and overwintering. The latter include sought-after species like the Siberian Rubythroat (*Luscinia calliope*), guaranteed to quicken the pulse of any visiting birder from Western Europe or North America.

Bharatpur is not without large mammals, either. Sambar (*Cervus unicolor*), Nilgai (*Boselaphus tragocamelus*) and Chital (*Axis axis*) are all present, and a lone Tigress (*Panthera tigris*) was resident in the park between 2002 and 2005. This is also one of the most likely places in India to see Rock Pythons (*Python molurus*), which are often found hauled out on the banks of the lakes. However, it is for its birds that this amazing place is rightly known and for its waterbirds in particular. In recent years the fluctuating water levels in the park have been a cause of concern, and on occasion the lakes have dried up completely, resulting in the departure of many of the waterbirds. In some cases they relocated to other, unprotected, sites where they were vulnerable to hunting and disturbance. The failure of the monsoon rains in this part of Rajasthan has on occasion prompted the local authorities to divert the River Gambhir – the main water supply to Bharatpur and the source of the fish, fry and invertebrates on which the waterbirds depend – to agricultural areas. The effect on the national park was devastating and a long-term solution to this dilemma is essential to secure Bharatpur's future as a premier bird sanctuary.

OPPOSITE TOP **Whilst the winter months see the arrival of large flocks of migratory wildfowl from the north, there are several resident species of goose and duck. These include Lesser Whistling-duck, a flighty and vocal bird often present in good numbers.**

OPPOSITE BOTTOM **The tallest flying bird in the world, the Sarus Crane is a common sight at Bharatpur. Adult birds stand up to 1.8 metres (6 feet) tall and can be told from juveniles by their crimson heads and grey ear patch.**

RIGHT **Dawn at Bharatpur is one of the best times of day for birding, but for much of the year there are plenty of birds present on and around the water most of the time.**

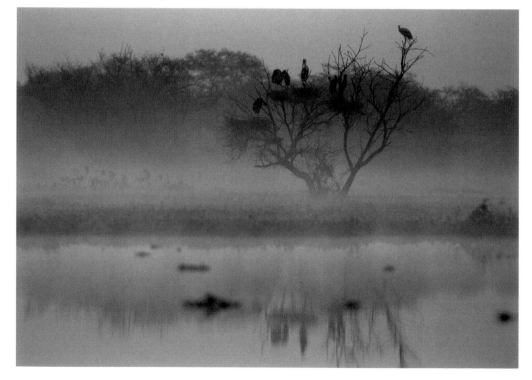

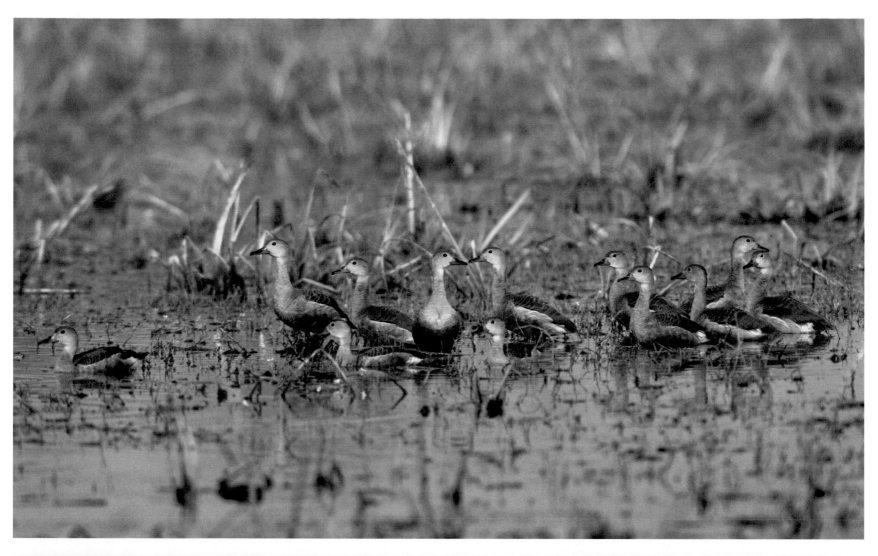

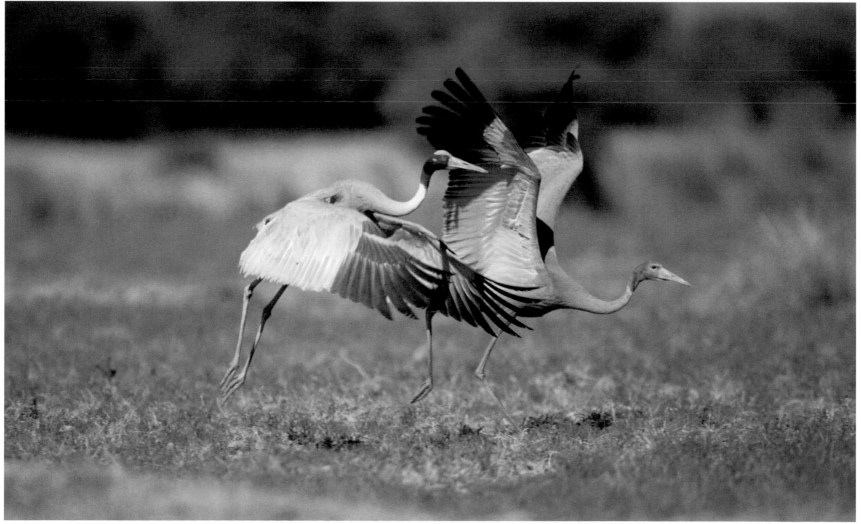

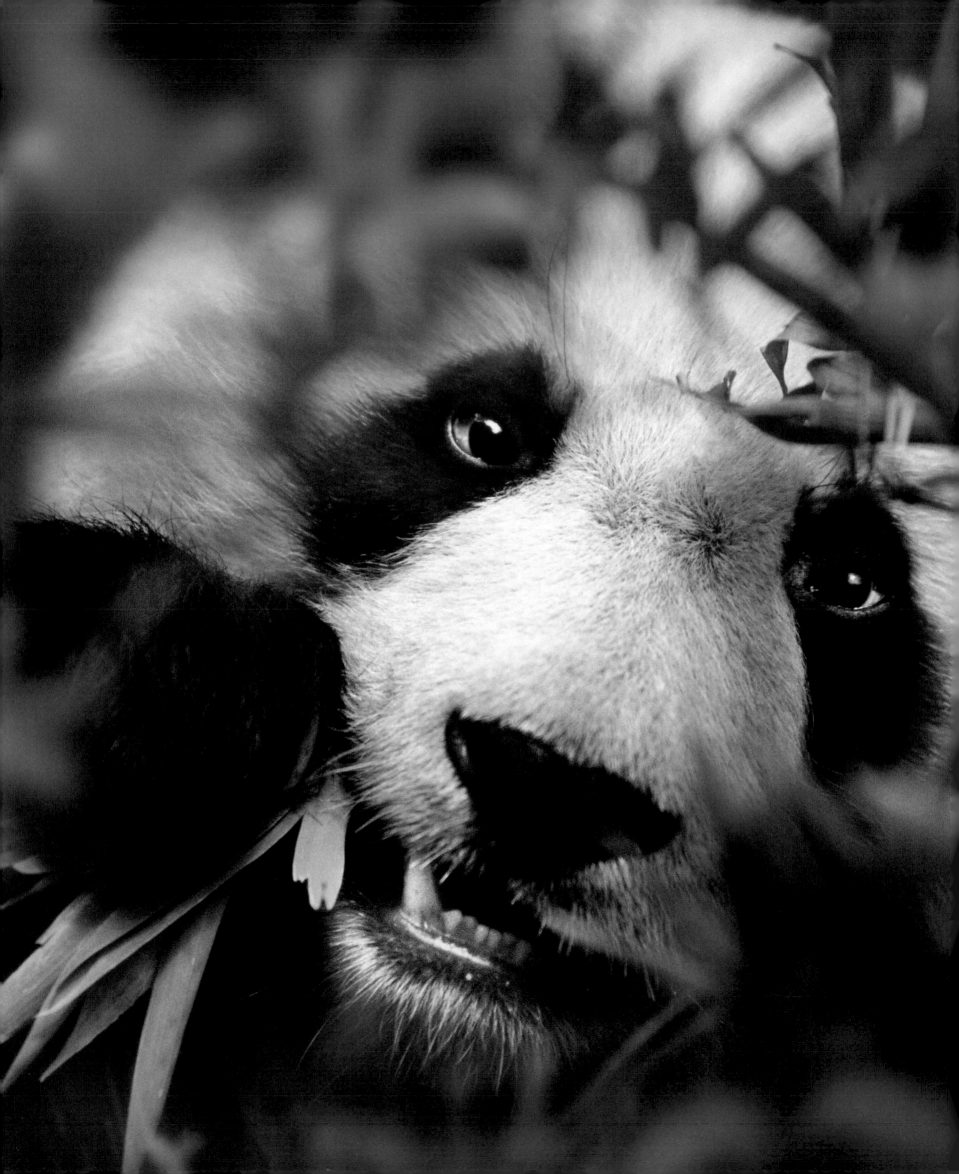

27. Giant Pandas in the Qinling Mountains

Probably the world's greatest conservation icon, the Giant Panda (*Ailuropoda melanoleuca*) is something of paradox. Despite being one of the most immediately recognizable animals, public knowledge of it goes little beyond the facts that it eats bamboo and comes from China. And for such a well-known beast, it remains one of the most difficult to see in the wild. Its legendary reluctance to breed well in captivity – in Western zoos, at least – has not only helped add to its celebrity status but also underlines our failure to understand its ecology fully.

For many years the panda has symbolized the planet's endangered species by virtue of its use on the logo for the Worldwide Fund for Nature (WWF). Endemic to China, in modern times it has always been a localized and little-understood species. Almost entirely dependent on species of bamboo for food, it is restricted to areas where these grow plentifully: temperate mountain forests. Historically the panda's distribution covered much of China and even extended into neighbouring Burma (Myanmar) and Vietnam, but today wild pandas occur only in the Chinese provinces of Gansu, Shaanxi and Sichuan, in six distinct groupings. A comprehensive survey concluded in 2004 revealed an estimated wild population of 1,600 animals, some 40 per cent more than were recorded in the last survey, in the 1980s. It is not clear whether the higher total is due to an actual increase in panda numbers or simply the result of improved survey techniques and more complete geographical coverage. Certainly, in the last survey pandas were found living in areas from which they had not been recorded previously but had probably passed unnoticed.

The plight of the panda during the twentieth century came to prominence as a result of the Chinese government's use of them as "goodwill ambassadors", and its manipulation of the commercial trade in pandas for Western zoos during the 1960s and '70s. It soon became evident that, behind this façade, wild pandas were in real trouble. Poaching and habitat loss were clearly reducing numbers, and the few panda reserves that existed then were inadequately protected and resourced. Since then

LEFT **Its highly distinctive coloration and features have helped make the Giant Panda one of the world's best-known mammals. Traditionally a popular attraction in zoos, it is now possible to observe the species in the wild in China's expanding network of panda reserves.**

BELOW **Pandas are good climbers and readily climb trees. This arboreal habit may partly explain their coloration, for the black-and-white appearance provides good camouflage against the dappled appearance of the tree canopy.**

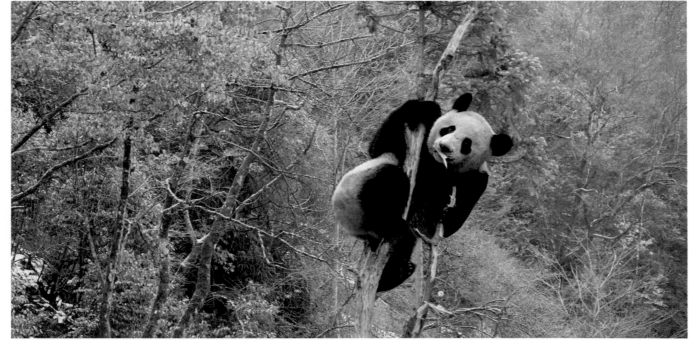

the situation has changed dramatically. In China today there are more than 40 panda reserves, protecting over 10,000 square kilometres (3,860 square miles). This equates to approximately half of the suitable panda habitat remaining in the country, with an estimated 60 per cent of the panda population living within these protected areas.

Seeing wild pandas has not been a viable option for foreign visitors to China until very recently. However, it is now possible to go on organized visits to panda reserves in the Qinling Mountains, in the south of Shaanxi province, This range is the watershed for two of China's major rivers, the Yangtze and the Yellow River, and part of an important eco-region with significant levels of endemism. An estimated 250 pandas live in Qinling, and since 2002 five new reserves have been created here, along with several forested corridors to help connect panda habitat. Further reserves are planned. However, finding a panda is never easy. This is densely forested terrain, and they are usually solitary animals. As with most large, elusive beasts, you need both luck and persistence to see one.

Meanwhile, as China's human population continues to expand and the country's development forges ahead, so pandas are coming into contact with humans more often. This is not always a positive experience for the panda – much of its habitat has become fragmented as a result of deforestation, the construction of new roads and the expansion of farming, which is increasingly moving up from the valley bottoms into panda territory on the forested slopes. Some pandas have become "trapped" in isolated belts of bamboo, unable to connect with populations elsewhere. In such situations their dependence on the bamboo leaves them particularly vulnerable when it goes through one of its periodic die-offs, as they are unable to move to new areas of fresh growth. There is also the serious threat of poaching (for pelts, which command very high black market prices), and illegal snares are commonplace is some areas.

However, conservation awareness in China has grown significantly in recent years and the new network of panda reserves is helping secure the future of the species. A successful captive breeding programme at Wolong was the source of the first captive-bred panda to be released into the wild in 2006, but this is arguably a less important priority than enforcing and extending the protection afforded to pandas and their habitat in the wild. At Liaoxiancheng Panda Reserve, for example, efforts are being made to encourage local people to switch from traditional activities such as forestry in favour of ecotourism, through providing accommodation and guiding for visitors. The Qinling area is well placed for the development of wildlife tourism, as it is also home to an important population of perhaps the world's most beautiful primate, the endangered Golden Monkey (*Pygathrix roxellana*), and accessible to a colony of Crested Ibis (*Nipponia nippon*), rescued from the brink of extinction in the 1980s and found in the wild only in southern Shaanxi.

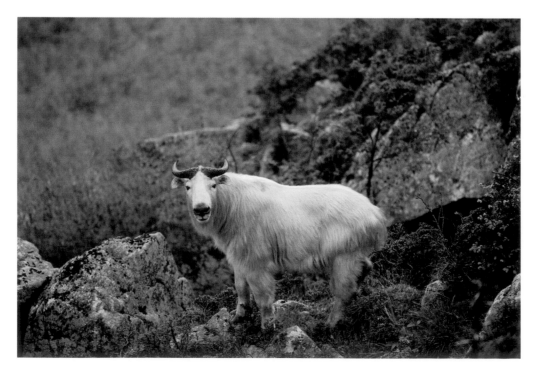

LEFT **The Qinling Mountains are home to the Golden Takin (*Budorcas taxicolor bedfordi*), one of four sub-species of takin, a type of goat-antelope. With short, stocky legs and broad hooves, they are well adapted to life in the rocky terrain.**

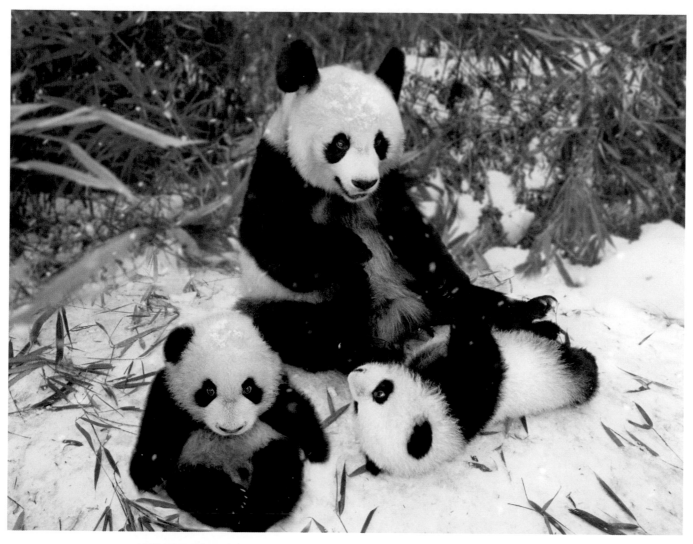

LEFT Although Giant Pandas have an engagingly cute appearance, they can be dangerous and will attack humans if they feel threatened. Females give birth to one or two cubs, but will often abandon one of them shortly thereafter – it is unusual for twins to be reared successfully.

FAR LEFT The Golden Monkey is locally distributed in the mountain forests of central and western China. Its dense, shaggy fur helps it to withstand the region's severe winter weather.

LEFT From a population of just seven birds discovered in Shaanxi in 1981, the last wild group known anywhere, numbers of Crested Ibis in China have now grown to over 500. Captive breeding programmes in both China and Japan are helping to secure the future of the species.

When the first Europeans arrived in Australasia in the late eighteenth century, they were confounded by what they saw. Here was a land inhabited by wildlife that was totally unknown to science and unique to the newly discovered continent. An initial effort to describe and depict these strange creatures was sadly overshadowed by a growing battle with nature, perceived as being hostile and inimical to civilization. Equally tragically, the opportunity to engage with indigenous peoples who lived in close harmony with their environment, and had a profound understanding of its ecology, was also lost. However, the past half century has witnessed a sea change in attitudes, and conservation programmes are now helping to save endangered species and habitats. Australia and New Zealand both offer outstanding wildlife watching, and New Guinea is undoubtedly one of the world's most exciting destinations, with many of its natural riches still awaiting discovery. Meanwhile, one legacy of the European colonization of Australia and New Zealand remains, in the form of a vast array of introduced species, so-called "aliens", which continue to have a serious impact on endemic flora and fauna.

BELOW Kangaroos are synonymous with Australia. The Eastern Grey species is common across much of the south and east of the country, whilst the larger Red Kangaroo (shown here) is more scarce and an animal of the dry interior.

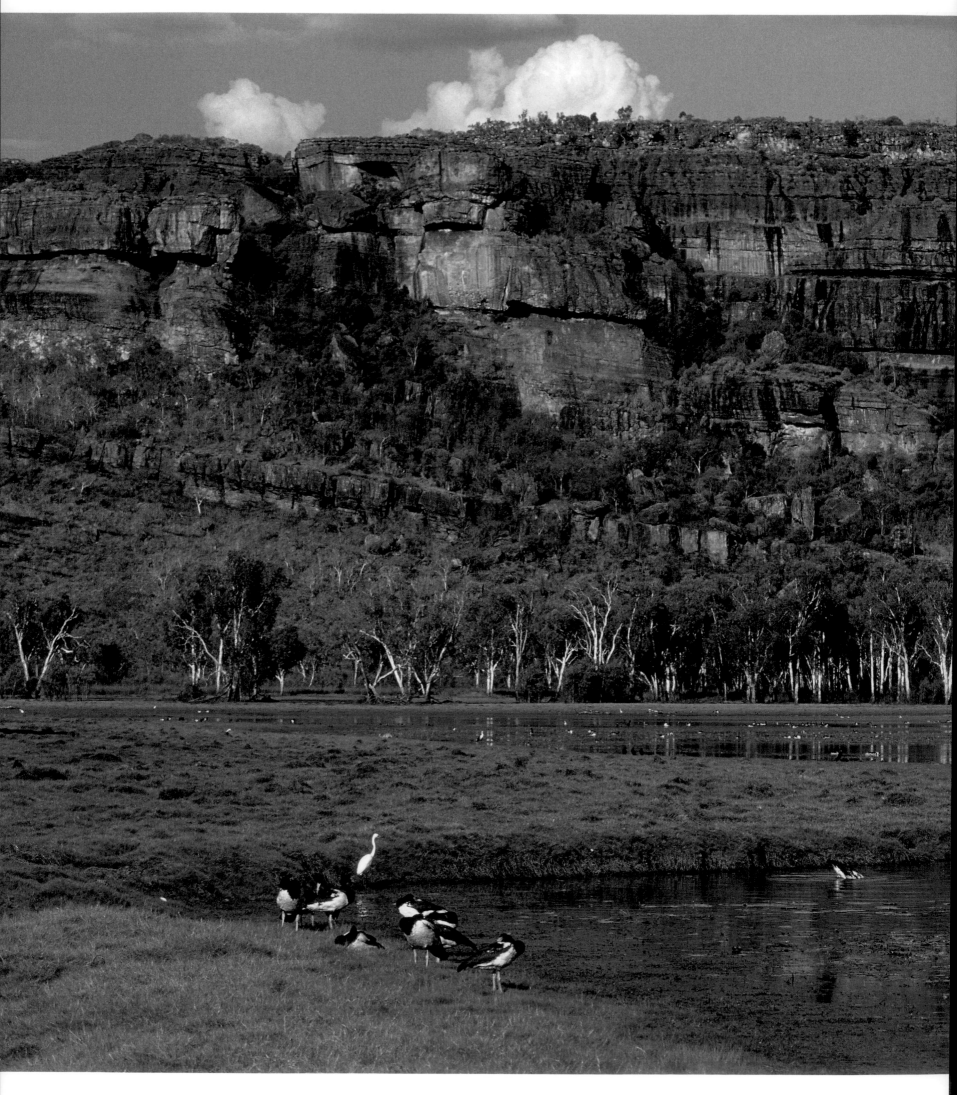

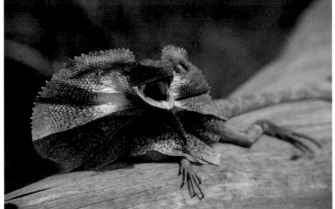

28. Australia's "Top End": Kakadu National Park

An enormous floodplain extending either side of the South Alligator River and running to the Van Diemen Gulf, Kakadu is one of Australia's most important tropical ecosystems and the country's largest national park. Covering over 20,000 square kilometres (7,700 square miles), its wide range of habitats make it a superb place for wildlife: tropical rainforest, open woodland/eucalypt savannah, coastal and riverine wetlands, mangroves and paperbark (*Melaleuca* sp.) swamp are all represented here, along with a variety of micro-habitats. On its eastern flank the floodplain is bordered by a steep sandstone escarpment, which marks the western rim of the Arnhem Land plateau and introduces dry-country flora and fauna to the mix. Kakadu is also extremely significant ethnographically – the area has been continuously inhabited by humans for at least 50,000 years and hosts a variety of archaeological sites, as well as some of the country's best examples of rock paintings and petroglyphs. It is one of the few World Heritage sites that have been listed both for their cultural and natural qualities.

The climate here is monsoonal, with defined wet and dry seasons and high temperatures throughout the year. The wet season (October to March) can be highly dramatic, with much of the rain falling in violent thunderstorms, for which Kakadu is renowned. At this time of year the landscape becomes lush and green, and much of the floodplain proper is transformed into a vast lake. This is the peak season for flowering plants, with spectacular displays of water-lilies in particular, but it is worth remembering that access is usually restricted at this time of year; many areas are accessible only by boat, and some not at all.

The best time to visit Kakadu for wildlife watching is from July to September, towards the end of the "Dry", when the wetland areas are shrinking and waterbirds in particular are increasingly concentrated around those lakes, pools and billabongs that still retain water. Particularly numerous in these situations are Wandering Whistling-ducks (*Dendrocygna arcuata*) and Magpie Geese (*Anseranas semipalmata*). An estimated 1.5 million geese – the world's greatest concentration – use Kakadu during the dry season, and they can be seen almost everywhere, foraging for bulkuru sedge tubers and bulbs. A dawn boat trip on Yellow Water, one of the largest permanent bodies of water in the park, is as good a way to watch birds in Kakadu as any; up to 60 species can be expected here, with regulars including Comb-crested Jacana (*Irediparra gallinacea*), Intermediate Egret (*Ardea intermedia*), Pied Heron (*Ardea picata*) and Royal Spoonbill (*Platalea regia*). Two of the largest birds in Australia are also regularly spotted: Brolga (*Grus rubicunda*) and Black-necked Stork or Jabiru (*Ephippiorhynchus asiaticus*). This is also a good site for White-breasted Sea-eagles (*Haliaeetus leucogaster*), which are often to be found perched in the top of waterside trees.

LEFT **Kakadu National Park can claim some of the most dramatic scenery in northern Australia. The diverse mix of habitats supports a fascinating range of wildlife and merits several days to explore properly.**

ABOVE **A Frill-necked Lizard in full threat display. If a potential attacker continues to come forward, the lizard will usually turn and flee, sometimes running bipedally on its hind legs.**

Although birds are rightly regarded as being among its main attractions, Kakadu is also outstanding for reptiles, with a total of 128 species recorded. These include no fewer than 77 species of lizard and 39 of snakes, including the enigmatic Oenpelli Python (*Morelia oenpelliensis*), which lives on and around the sandstone escarpment in the east of the park and was only described to science in 1977. It has, however, been well known to Kakadu's native people for a very long time, and appears in their rock paintings and carvings. Also notable among Kakadu's reptiles is the remarkable Frill-necked Lizard (*Chlamydosaurus kingii*) which, when hassled, fans out a ruff of orange skin around its neck and opens its mouth to reveal an alarming yellow gape. Much more frightening, however, are Kakadu's largest, and most notorious, reptiles: the Estuarine Crocodiles (*Crocodylus porosus*) – known locally as "salties" – which lurk in the park's watercourses. These can grow up to 7 metres (23 feet) in length, and pose a real risk to human safety if not treated with respect and caution. The largest single population in the world lives in Kakadu, and in times of high water and flood will move into territory that is normally the domain of the Freshwater Crocodile (*Crocodylus johnstonii*), which is also present here.

Over 60 species of mammal inhabit the park, but many are nocturnal and not easily seen. Most visitors see Agile Wallaby (*Macropus agilis*), and Short-eared Rock Wallaby (*Petrogale brachyotis*), and Dingo (*Canis lupus dingo*) are fairly common. In the stone country to the east it is also worth looking out for Black Wallaroo (*Macropus bernardus*), which is endemic to this area. A regular sight in Kakadu 20 years ago were herds of feral Water Buffalo (*Bubalus bubalis*), which were introduced to northern Australia from south-east Asia in the nineteenth century as a regular supply of meat for remote settlements. When the settlements were abandoned, the buffalo roamed free and later proliferated to the extent where they became a pest, damaging vegetation and causing soil erosion. A federal eradication programme successfully reduced the population to manageable levels; in Kakadu alone, the number of buffalo was cut from about 20,000 in 1988 to the few hundred that remain today. However, other undesirable aliens continue to increase. These include a number of introduced and invasive plant species, which out-compete native flora, and the notorious Cane Toad (*Bufo marinus*), which arrived in Kakadu less than a decade ago and is already having a serious impact on certain species, notably Northern Quoll (*Dasyurus hallucatus*), which is likely to become extinct in Kakadu as a result of the toad's presence.

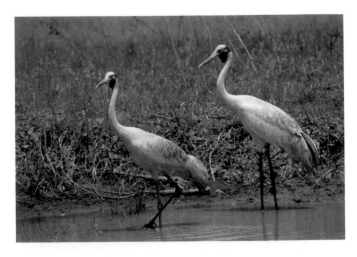

ABOVE **A regular sight at Kadaku, the Brolga is usually found in pairs or small groups. However, larger flocks regularly congregate outside the breeding season.**

BELOW **Vast numbers of Magpie Geese gather on Kakadu's wetlands during the drier months. This species is not a true goose, however, and its feet are only partially webbed.**

OPPOSITE TOP **The Black-necked Stork is one of Kakadu's more conspicuous waterbirds. It is also known locally as the Jabiru, a name it shares with a totally different species found in South America (see page 209).**

OPPOSITE BOTTOM **Estuarine or Saltwater Crocodiles can grow to prodigious sizes and are the main reason why swimming in Kakadu's billabongs is not advisable.**

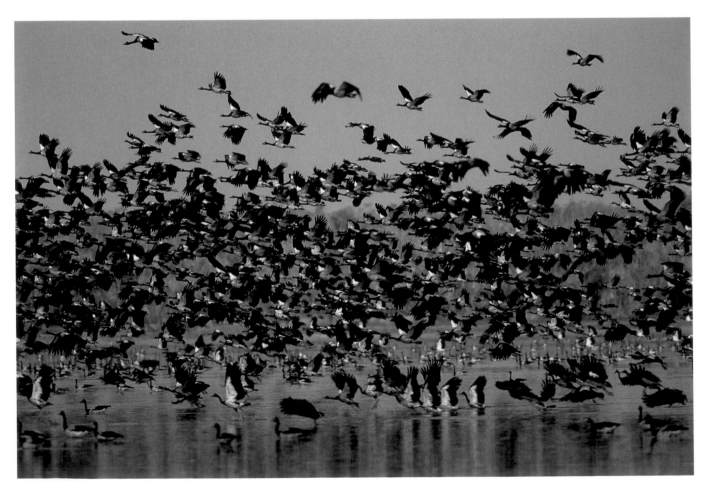

29. The Seabirds and Sperm Whales of Kaikoura

The small town of Kaikoura sits on the east coast of New Zealand's South Island and enjoys a superb setting, with a backdrop of peaks that are snow-capped during the winter months. The coastline is stunning, with crystal-clear waters and an ocean rich in marine life, mainly as a result of the upwelling caused by the Hikurangi Trench, which lies just a few kilometres offshore, reaches a depth of 3,000 metres (9,850 feet) and brings many deepwater species much closer to land than is usual. As a result, the Kaikoura area offers excellent seabird and cetacean watching, which can include large pods of exuberantly playful Dusky Dolphins (*Lagenorhynchus obscurus*), as well as one of the best opportunities anywhere in the world to see Sperm Whales (*Physeter macrocephalus*).

Getting to grips with Kaikoura's wildlife is pleasingly straightforward. For example, since the 1980s New Zealand Fur Seals (*Arctocephalus forsteri*) have been breeding in the area, and are readily seen on and around the peninsular at the end of the town. This is also one of the best places to watch the excellent variety of local seabirds. Depending on the time of year (summer is usually best), it is often possible to see good numbers of Australasian Gannet (*Morus serrator*), Pied Shag (*Phalacrocorax varius*) and Spotted Shag (*Stictocarbo punctatus punctatus*), as well as Hutton's Shearwater (*Puffinus huttoni*), which often passes close offshore (and actually nests in the mountains behind Kaikoura).

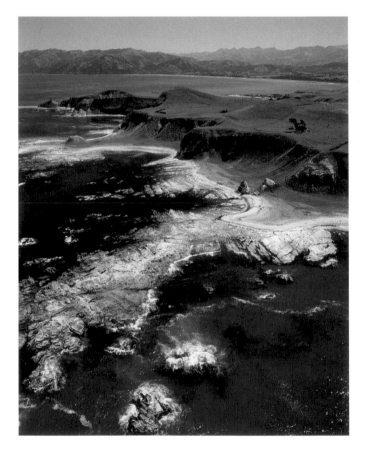

However, to see truly oceanic bird species, the best option is to go on one of the pelagic boat trips that operate from Kaikoura, although this recommendation should perhaps be accompanied by a health warning. It is not so much the roughness of the sea which may disconcert, but the sight and stench of the "chum", a mixture of fish oil and offal which is ladled out onto the sea around the boat. The foul-smelling slick usually proves irresistible to birds like petrels and albatrosses, several species of which will often gather and settle on the water, squabbling over the choicest morsels at distances down to just 2 or 3 metres (6½ or 10 feet). Unbeatable views are usually possible of birds normally seen only at long range, winging over the ocean.

This excellent array of seabirds notwithstanding, for many visitors the main wildlife attraction of the seas off Kaikoura is the large number of Sperm Whales that are attracted here. The reason they are so common is the proximity of the ocean trench, for Sperm Whales are particularly partial to eating large squid, which usually live in deep water. The whales dive to find them, and at Kaikoura usually descend to a depth of 1,000 metres (3,280 feet) or so, and for a duration of approximately 40 minutes. However, Sperm Whales are capable of holding their breath for much longer – a dive of over two hours has been recorded – and at other locations they have been tracked to a depth of 2,200 metres (7,200 feet). Such prowess and stamina easily make them the world's deepest diving mammal.

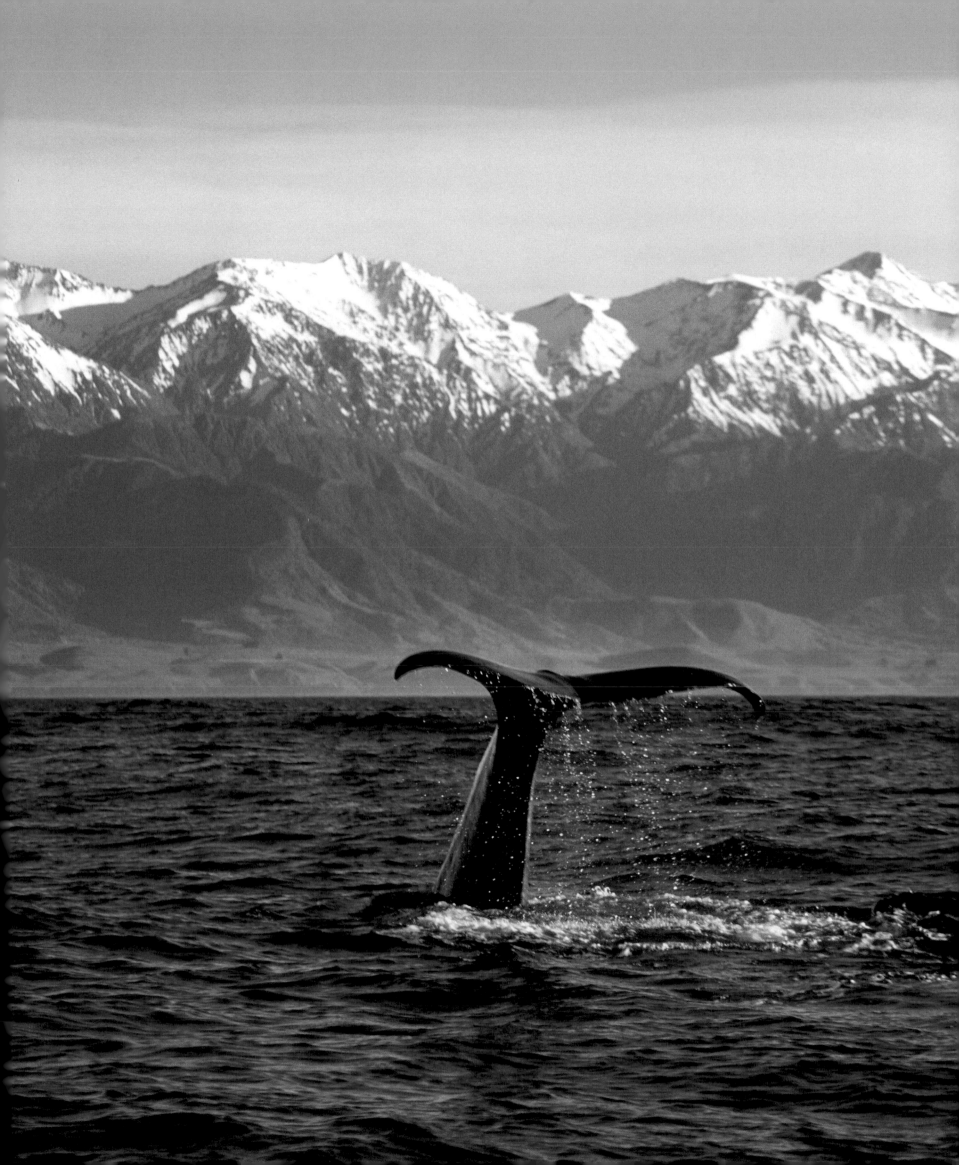

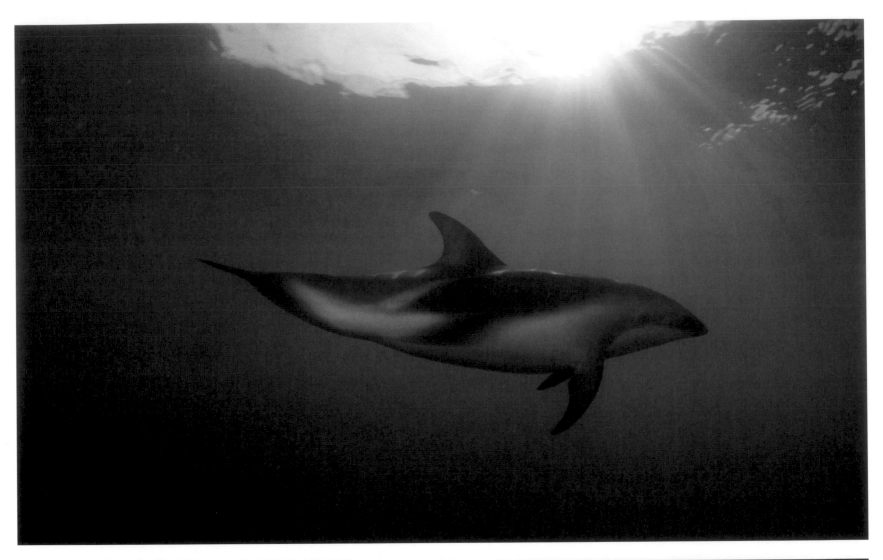

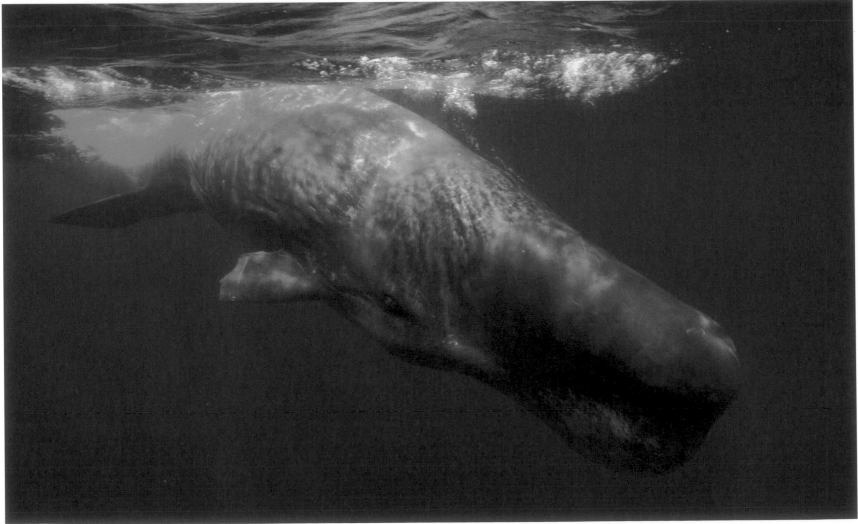

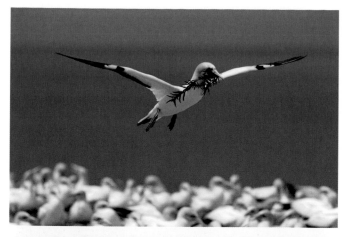

Research has revealed that up to 100 different Sperm Whales may visit the Kaikoura area in any one year; these are a mixture of residents, which are present for most, if not all, of the year, and transient individuals, which move through and may stay only a few hours or days. Based on their size, it appears the overwhelming majority are young adult males, and they are almost invariably travelling alone, although they will sometimes gather in loose "clusters". It is therefore possible to observe several different individuals on one boat trip, with the chances of multiple sightings best in spring and summer. In terms of diet, Kaikoura's whales display a heavy bias in favour of squid – each may consume up to 1,000 squid per day – and this has raised concerns over the whales' vulnerability to a collapse in squid stocks as a result of potential overexploitation by commercial fishing interests.

Somewhat surprisingly, the Sperm Whale is one of the noisiest mammals. When they come up from a deep dive, their first exhalation is so loud that it can be heard up to 1 kilometre (½ mile) away, but even more powerful are the booming clicks – which to human ears often sound like loud knocks – that the whales emit underwater. They use these not only to communicate with each other, but also to detect prey, vocalizing almost the whole time they are underwater, with only short breaks. The clicks are actually sound pulses bouncing between air sacs within the whale's nose – effectively a type of sonar – and are audible to human ears from up to 10 kilometres (6 miles) away.

The resident Sperm Whales at Kaikoura are often close inshore and are generally habituated to boats. Yet an incident involving a Sperm Whale was the inspiration for Herman Melville's celebrated adventure novel *Moby Dick*. In 1820 the whaling ship *Essex*, operating in the South Pacific, was attacked by a large Sperm Whale; it sank, and the sailors on board abandoned ship. In small boats and with inadequate supplies, several of the men died, and the survivors were reduced to eating their comrades' bodies before being rescued later on remote Henderson Island. This sorry episode might be considered as one of the few occasions in the history of man's relationship with whales that the latter actually bit back.

OPPOSITE TOP **The Dusky Dolphin** is one of the cetacean highlights of the Kaikoura area, and swimming with dolphins is a popular attraction here. Such activities are closely monitored to ensure that the animals are not subjected to excessive interaction with humans.

OPPOSITE BOTTOM **Sperm Whales** dive to great depths in search of squid, which make up to 80 per cent or so of their diet. Older whales often bear scars, the result of underwater battles with giant squid resisting capture.

TOP The first Australasian Gannets usually return to their nesting colonies in August, with breeding at its peak during November and December. During the austral autumn and winter the colonies are deserted.

ABOVE **Salvin's Albatross** (*Diomedea cauta salvini*) is one of several species of albatross likely to be seen off Kaikoura.

RIGHT Pelagic boat trips offer the chance to enjoy close views of marine birds. Here several Gibson's Albatrosses (*Diomedea gibsoni*) await the next batch of "chum", along with a single Salvin's Albatross and a few Cape Petrels.

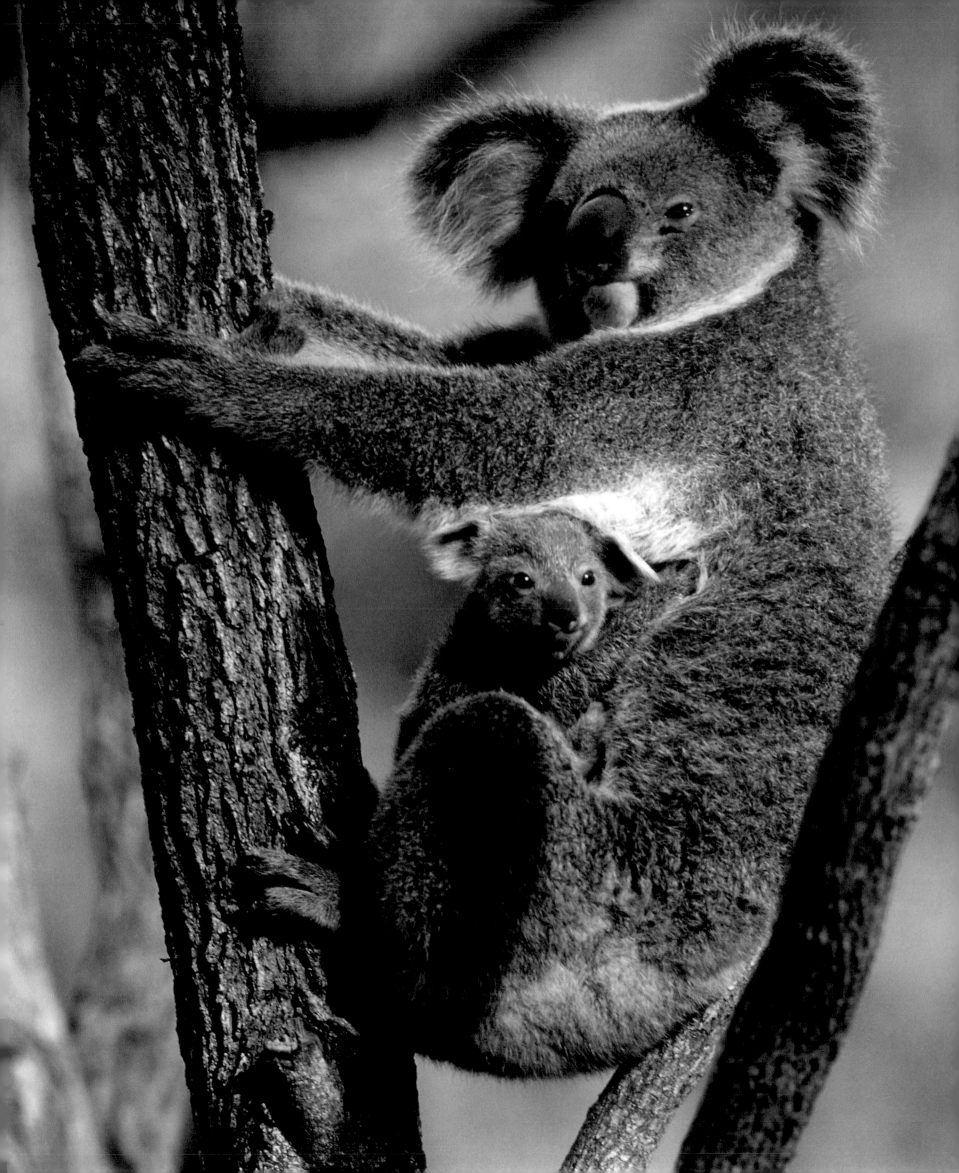

30. The Koalas of Warrumbungle

In a land of iconic animals, the competition for Australia's most distinctive mammal is pretty fierce. Other species may well have the edge in terms of unusual qualities, but the Koala (*Phascolarctus cinereus*) would probably win any competition based on cute looks. However, appearances can be deceptive: Koalas are often irritable, and can be aggressive, and so they should not be approached or handled by the inexperienced. Although they have declined dramatically since the European colonization of Australia, and were hunted for their fur until the 1920s, Koalas remain widely distributed across the eastern side of the country, even if their range is now considerably fragmented. Today, one of the best places to watch wild Koalas – and other classic Australian wildlife – is Warrumbungle National Park, in northern New South Wales.

The spectacular landscape of the Warrumbungle Mountains was shaped by a cataclysmic volcanic eruption about 17 million years ago, and is now characterized by the rocky ridges and jagged pinnacles that tower above the surrounding scrub and woodland. The mountains – and the national park that is named after them – mark the zone in which two distinct ecological regions meet: the wetter, rainforest vegetation of the eastern seaboard, and the drier, Outback-style habitat typical of Australia's arid interior to the west. Since the last Ice Age the rainforest has been in retreat, leaving behind it small pockets of moist vegetation, especially on the wetter, eastern aspect of the Warrumbungle range. This diversity of landscapes supports an unusually wide range of wildlife, with species that are normally found in distinct geographical areas successfully co-existing side by side here. For example, in a few damp, cool corners there are even tree ferns, remnants of a wetter past, growing only a short distance away from flora with a decidedly desert character.

RIGHT **The rugged scenery of the Warrumbungle mountain range was formed by massive volcanic activity and is now a popular destination among rock climbers.**

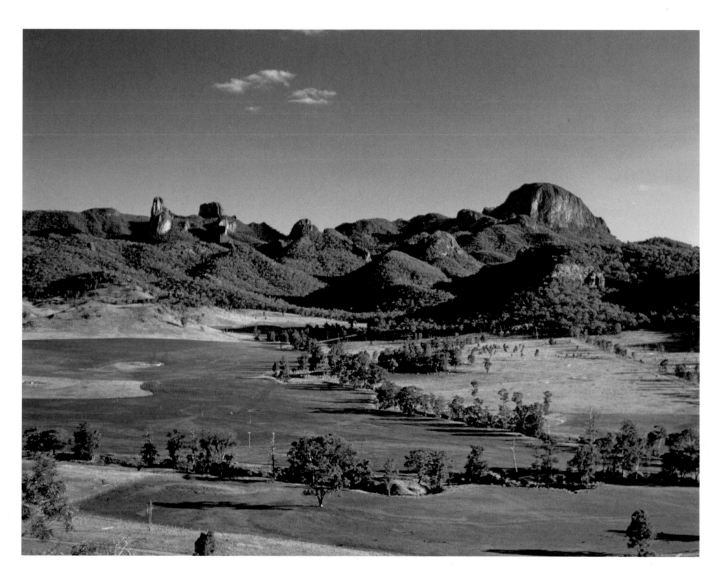

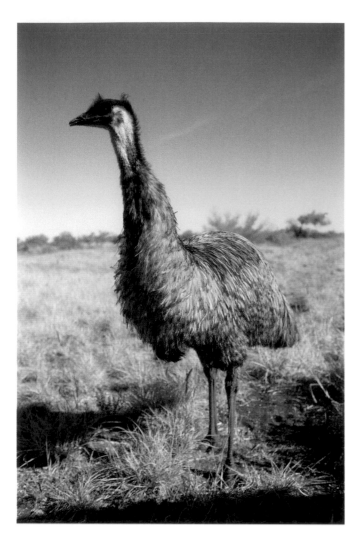

ABOVE The Emu is Australia's largest native bird, and on the world stage is second in size only to the Ostrich (*Struthio camelus*). It is an open-country species and can run at speeds of up to 50 kilometres (30 miles) per hour.

Birdlife at Warrumbungle is excellent and reflects the "east-meets-west" nature of the vegetation. Easy enough to find are Emu (*Dromaius novaehollandiae*), commonly seen stalking about on the flats, and members of the parrot family, of which at least 19 species have been recorded in the park. With a 2.5-metre (8-foot) wingspan, the Wedge-tailed Eagle (*Aquila audax*) is Australia's largest bird of prey and is regularly seen soaring in thermals. Meanwhile, the most immediately obvious large mammals in the park are Eastern Grey Kangaroo (*Macropus giganteus*), Common Wallaroo or Euro (*Macropus robustus*) and Red-necked Wallaby (*Macropus rufogriseus*), all of which are fairly numerous in the more open areas. More unusual, and harder to find, are the park's population of Swamp Wallaby (*Wallabia bicolor*), which tend to keep themselves to thick undergrowth, and the few remaining Brush-tailed Rock-wallabies (*Petrogale penicillata*), a species now endangered as a result of fox predation and habitat loss due to overgrazing goats.

You stand a much better chance of encountering the extraordinary Short-beaked Echidna (*Tachyglossus aculeatus*), which is common in Warrumbungle. Armed with powerful legs for digging, echidnas are best looked for near termite mounds and ant-nests, as they nose about in search of a meal. Those visitors with real luck on their side may even come across an "echidna train", in which a female in season is followed by a queue of up to 10 amorous males, who will bulldoze each other out of the way until an eventual champion triumphs and is accorded mating rights. Like the Platypus (*Ornithorhynchus anatinus*), female echidnas lay eggs directly into their pouch and produce milk, suckling their young for up to seven months.

Finding some of the park's substantial Koala population – there are probably several hundred living here – is not usually too difficult, as Koalas are famously dependent for food and shelter on species of eucalyptus. They are therefore best looked for in gum trees, particularly along creeks and gorges – the Wambelong Creek and Spirey Creek are both especially good spots. Eucalyptus leaves are tough, leathery and low in nutrients, and Koalas are specially adapted to make the most of this apparently unforgiving diet. A very low metabolic rate helps reduce energy requirements, but means that Koalas spend up to 20 hours per day asleep. As some eucalyptuses contain poisons and protein-suppressing tannins, Koalas will rotate between different species to avoid excessive intake of toxins, and they also supplement their diet with minerals, which they take from the soil – one of the few occasions when a Koala will descend from the trees. Although essentially solitary and antisocial, Koalas become much more interactive during the mating season, when noisy and violent confrontations between males can be commonplace.

The conservation of Koalas was traditionally centred on straightforward habitat protection, but the overall picture has become rather complex. As an ecological specialist, the Koala has generally poor recovery potential when its numbers have declined and/or its habitat has been reduced, but on occasions it can do so well that it threatens its own survival. For example, the introduction of Koalas to Kangaroo Island, off the coast of South Australia, has been so successful that there are now at least twice the number present that the habitat can sustain, and the authorities are faced with the task of relocating large numbers elsewhere or – potentially difficult in public relations terms – organizing a cull. Equally problematic are the Koala's notorious health issues. The organism chlamydia appears to be endemic among Koalas, and while it may not manifest itself in healthy animals, in isolated populations living in degraded habitat – and therefore under nutritional stress – it can result in infections and infertility. Clearly, managing a secure future for Koalas is going to be a complicated affair.

OPPOSITE TOP The Echidna or Spiny Anteater is common in Warrumbungle but not necessarily easy to see. Highly specialized feeders, they sniff out ants and termites, which they then harvest with their long, sticky tongue.

OPPOSITE BOTTOM Groups of Eastern Grey Kangaroo are a common sight in Warrumbungle, especially in the cleared areas of the park's central valley.

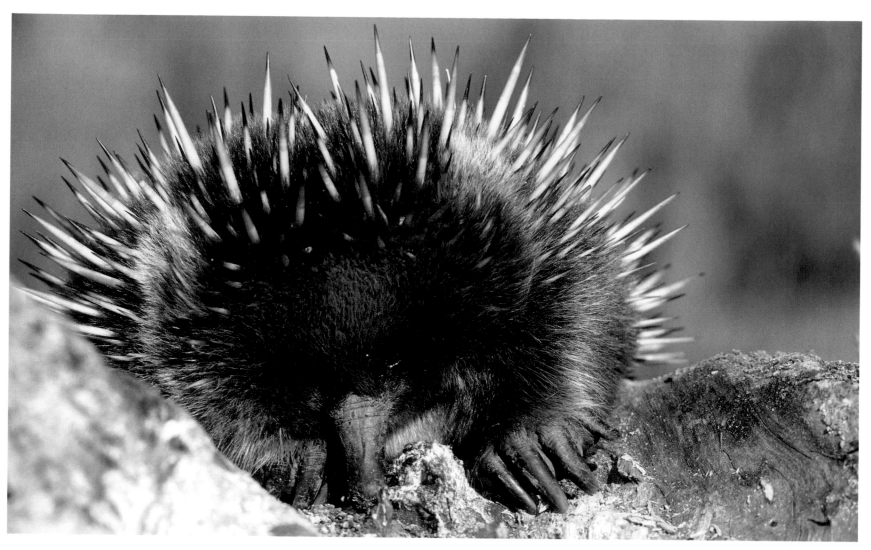

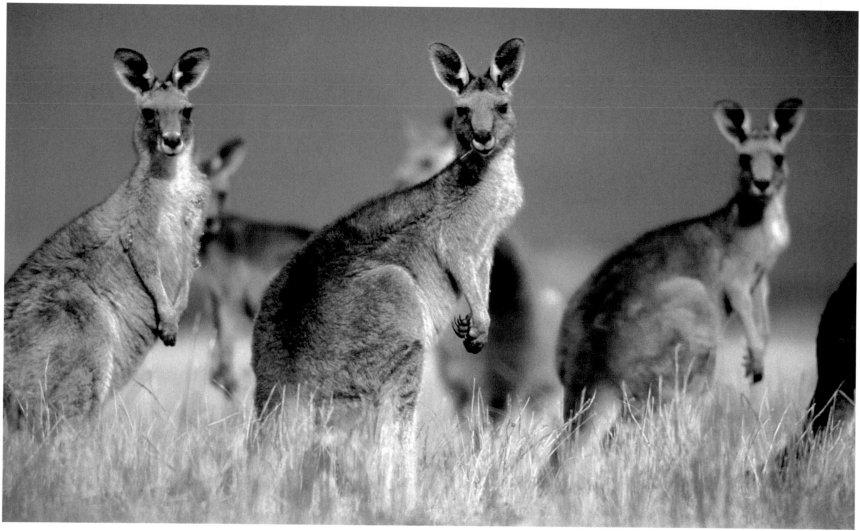

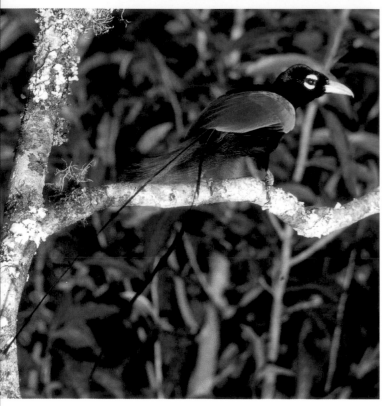

31. New Guinea's Birds of Paradise

The island of New Guinea remains one of the world's last great wildernesses. Large parts of the interior are still uncharted and unexplored by scientists, and as recently as 2006 a team of naturalists discovered a "lost world" in the Foja Mountains that was home to a raft of creatures totally new to science. Despite our incomplete knowledge of the island's flora and fauna, for centuries the forests of New Guinea have been renowned as the home of some of the most beautiful and ornately plumaged birds in the world – the birds of paradise. Rumours of their exotic feathers began to circulate in Europe following the arrival in Spain of bird of paradise skins on board Magellan's ship in 1522. Their beauty was so great that they were believed to be visitors from paradise rather than worldly creatures, and the name has stuck ever since.

Those early skins were often divested of their legs, giving rise to all sorts of fanciful rumours about the birds having celestial qualities, spending all their time on the wing and never alighting. Only in the nineteenth century did proper scientific analysis become possible, and Alfred Russel Wallace was the first naturalist to publish accurate information on the birds and their habits. When he first arrived in New Guinea in the 1850s, he wrote that he could barely contain his excitement knowing that "those dark forests produced the most extraordinary and the most beautiful of the feathered inhabitants of the earth".

It is still possible to feel that same excitement today, for the birds are just as dazzling now as then. And whilst we know more about them than in Wallace's day, much remains to be discovered about their lives and habits. Indeed, it is probable that in the remote heart of the forest there are still species of them known only to the local tribespeople and completely undescribed to science. One of the 2006 discoveries was the first living specimen of a species of bird of paradise hitherto known only from a corpse found in 1897.

There are over 40 different species of birds of paradise, most of which are endemic to New Guinea, with a few found in northern Australia. As a family, they are probably related to crows, but their plumage and coloration could not be more different. In order to attract the generally dowdy females (very few birds of paradise are monogamous) the males are usually equipped with a range of extraordinary plumage devices. These often take the form of elongated and elaborate feathers that extend from the tail, wings or head, and are employed in flamboyant courtship rituals, which range from the repeated display of particularly eye-catching features to hanging upside-down from a branch, and even to dancing around a specially cleared area – or *lek* – on the forest floor. Yet however conspicuous these birds may appear to be, they are often far from easy to find. Many are denizens of the deep rainforest, spending much of their time up in the canopy.

However, there is one place in particular where it is possible to see an excellent range of birds of paradise without too much trouble – the Tari Gap in the central highlands. At an altitude of 2,100 metres (6.890 feet), Tari Gap is located where mid-montane rainforest meets open grassland, and overlooks the stunning Tari Valley below. As well as being an outstanding site for flora, especially orchids, over 200 species of birds have been recorded here. These include up to 13 species of birds of paradise, and the area is equally notable for being the home of the Huli tribe, whose menfolk have a long-established affinity with the birds of paradise, incorporating aspects of the birds' behaviour in traditional ceremonies and wearing their plumes in elaborate head-dresses – the famous Huli "Wigmen".

Among the birds of paradise that can be seen at Tari, in mid-altitude forest, is the King of Saxony Bird of Paradise (*Pteridophora alberti*), which at 22 centimetres (8.7 inches) long is one of the smallest.

TOP The Tari region of New Guinea is probably the best place in the world to watch birds of paradise. Primary forest still covers much of the area, and local guides are skilled at finding the target species for most birders.

ABOVE The Blue Bird of Paradise is found in lower montane forest, and generally sticks to the canopy. It is best looked for in the vicinity of fruiting trees.

OPPOSITE The Raggiana Bird of Paradise (*Paradisaea raggiana*) is the national bird of New Guinea and still relatively common in parts of the country. The male's extravagant tail plumes make it a target for hunters.

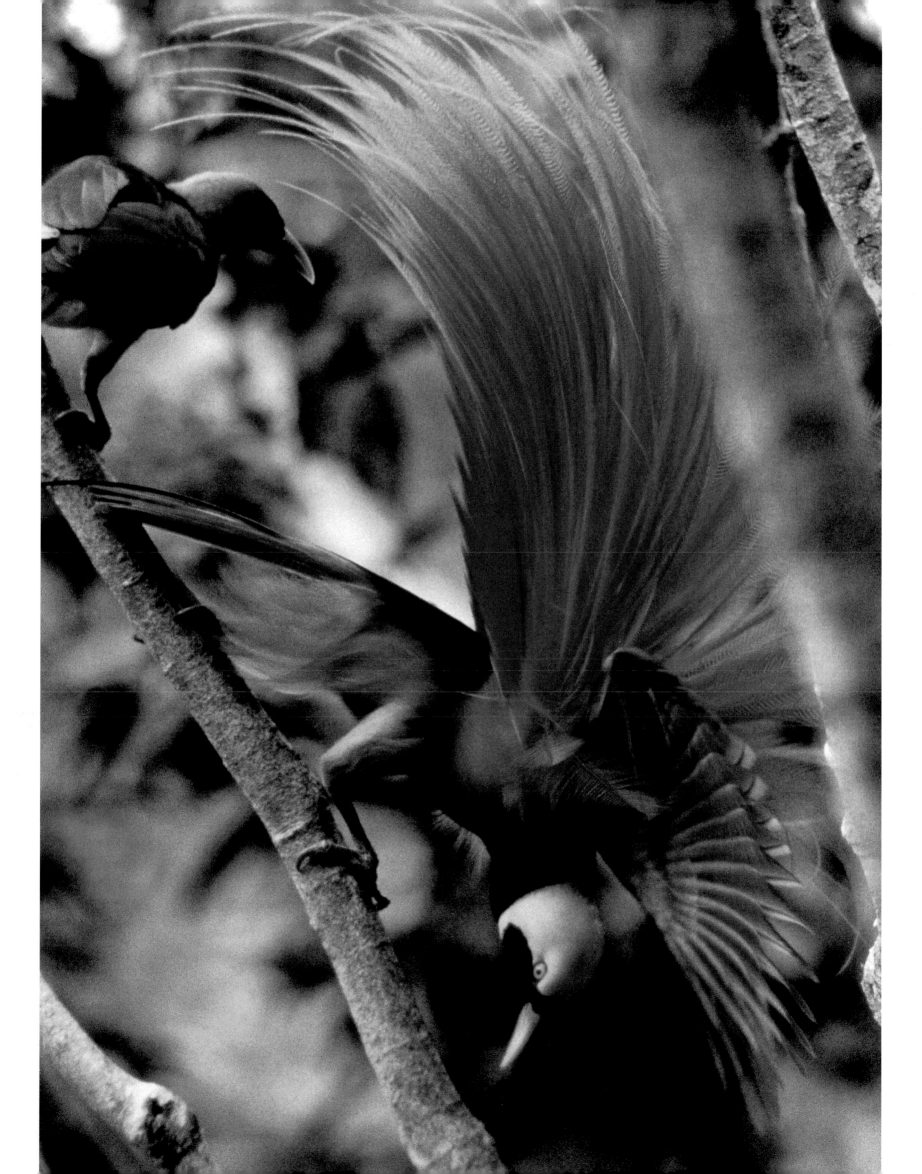

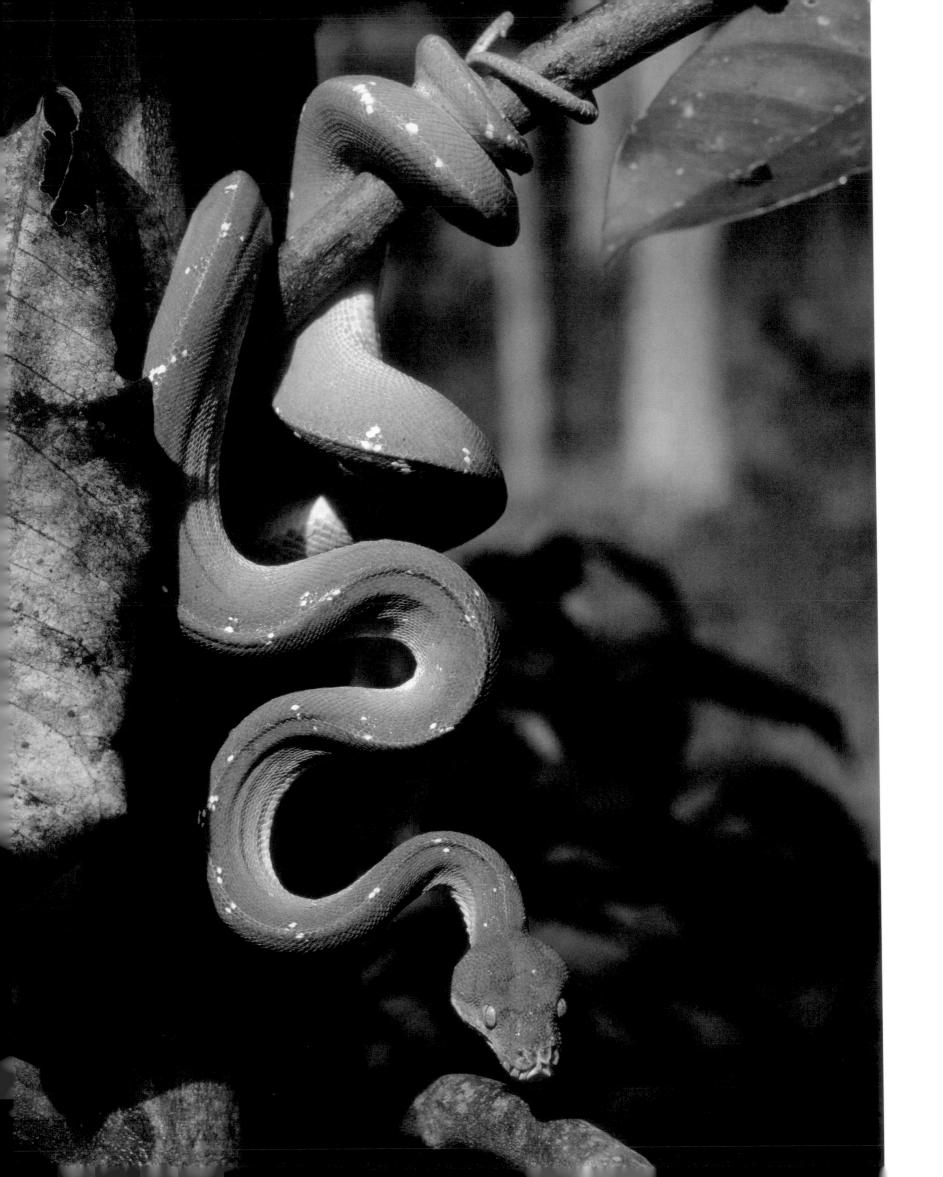

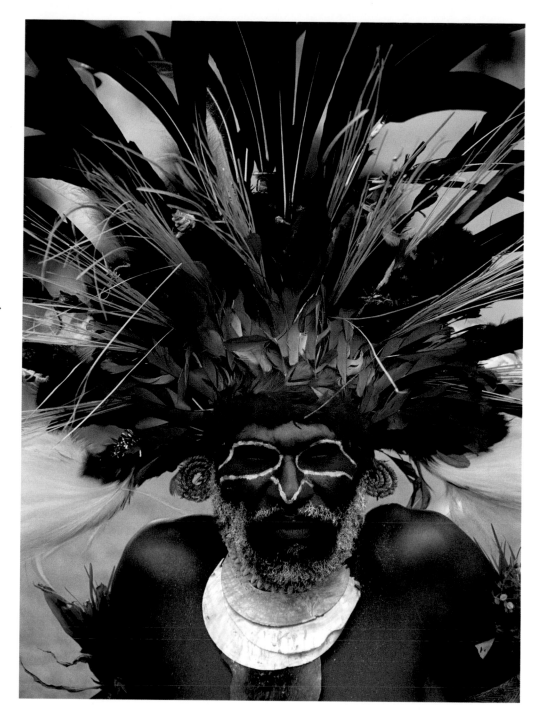

It does, however, win a prize for sheer extravagance, for it possesses two ornamental head plumes that are more than twice its body length and were among the reasons why, when this bird was first brought to the attention of scientists, following the discovery of a skin in a Paris market, some authorities dismissed it as the creation of a hoaxer. Also present at Tari, but at lower elevations down in the valley, is the remarkable Blue Bird of Paradise (*Paradisaea rudolphi*), which stages one of the most magnificent courtship displays in the natural world. With the female close by, the male bird dangles upside-down from a branch, alternately enlarging and contracting the black and red feathers on his chest whilst simultaneously shimmering his spectacular blue wing and back feathers either side of his body as he swings to and fro. He even accompanies this breathtaking performance with a rhythmic "warr-warr" call.

Although many species of bird of paradise have traditionally been hunted for their plumes by the indigenous people of New Guinea, it was the demand of the European millinery trade for fancy feathers that really had an impact in the late nineteenth century. At this time over 50,000 skins were leaving New Guinea each year for the salons of Paris in particular, and although the trade was banned in the 1920s, several species had become very rare by then. Today, the threat comes more from deforestation than from hunting. Although over 80 per cent of New Guinea is still covered by forest, the rate of its removal is increasing rapidly, and with some birds of paradise highly localized in their distribution, there is a serious risk that certain species could come under real pressure in the near future.

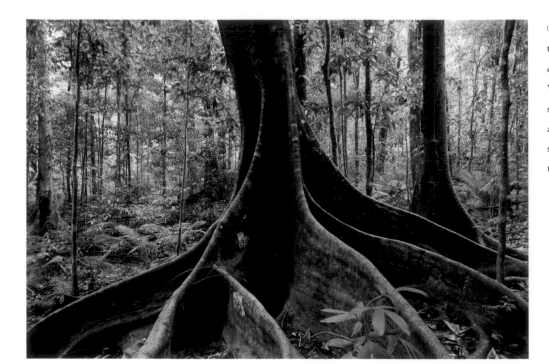

32. Australia's Wet Tropics: Daintree National Park

In 1983 a proposal to drive a new road through pristine rainforest in Queensland caused a public outcry. The affected area – the Queensland Wet Tropics – is home to the greatest concentration of primitive flowering plants anywhere in the world, with some of the highest levels of biodiversity in Australia. Sadly, the road went ahead, but concern over both its impact and the excesses of the regional timber industry, which was systematically stripping areas of primary forest, galvanized local people and conservationists into trying to save this remarkable landscape before more of it was lost. This movement culminated in the listing of the Queensland Wet Tropics as a World Heritage Site in 1988.

The Wet Tropics cover 8,944 square kilometres (3,453 square miles) running immediately inland from the coast from near Townsville to near Cooktown, a distance of some 500 kilometres (300 miles). Large tracts of rainforest cloak the mountain slopes and run right down to the shore, where they look out towards another outstanding World Heritage Site – the Great Barrier Reef. The term "rainforest" really comes into its own in this area, for this is one of the wettest places in Australia – some of the peaks receive an average of 7,000 millimetres (275 inches) of rain annually. The tropical rainforest here is characterized by species of palm, such as the distinctive Fan Palm (*Licuala ramsayi*), and supports an outstanding array of wildlife, including many endemic and highly localized species.

Daintree National Park is one of 19 national parks within the World Heritage Site area. Although much of it consists of largely inaccessible forest-clad highlands, waymarked trails lead through some of the more interesting areas for wildlife. In particular, boat cruises on the Daintree River are excellent for spotting Estuarine Crocodiles (*Crocodylus porosus*), as well as for birding. Several species of kingfisher are possible, along with local specialities such as Black Bittern (*Ixobrychus flavicollis*), Great-billed Heron (*Ardea sumatrana*) and Papuan Frogmouth (*Podargus papuensis*). However, for most visitors to Daintree the "must-see" bird is the Southern Cassowary (*Casuarius casuarius*). This is a secretive inhabitant of the deep forest and its uncanny knack of standing motionless before suddenly crashing off through the undergrowth makes it difficult to get a good view. In any case, with mature adults standing as much as 1.8 metres (6 feet) tall, this is a bird to treat with caution; when cornered, or with young, it is capable of lashing out with its feet, which carry a 10-centimetre (4-inch) long spike on the inside toe. Sadly, cassowary numbers are falling, with continued habitat loss and road casualties among the reasons why fewer than 1,000 survive in Australia today. However, the Cape Tribulation section of the park is a good place to try and find one.

The forests of Daintree are also home to a superb variety of butterflies and moths, including some of the largest species in the world. The electric-blue and black wings of the Ulysses (*Papilio ulysses*), a species of swallowtail, make for a dazzling display as it sails about forest clearings, and in Mossmann

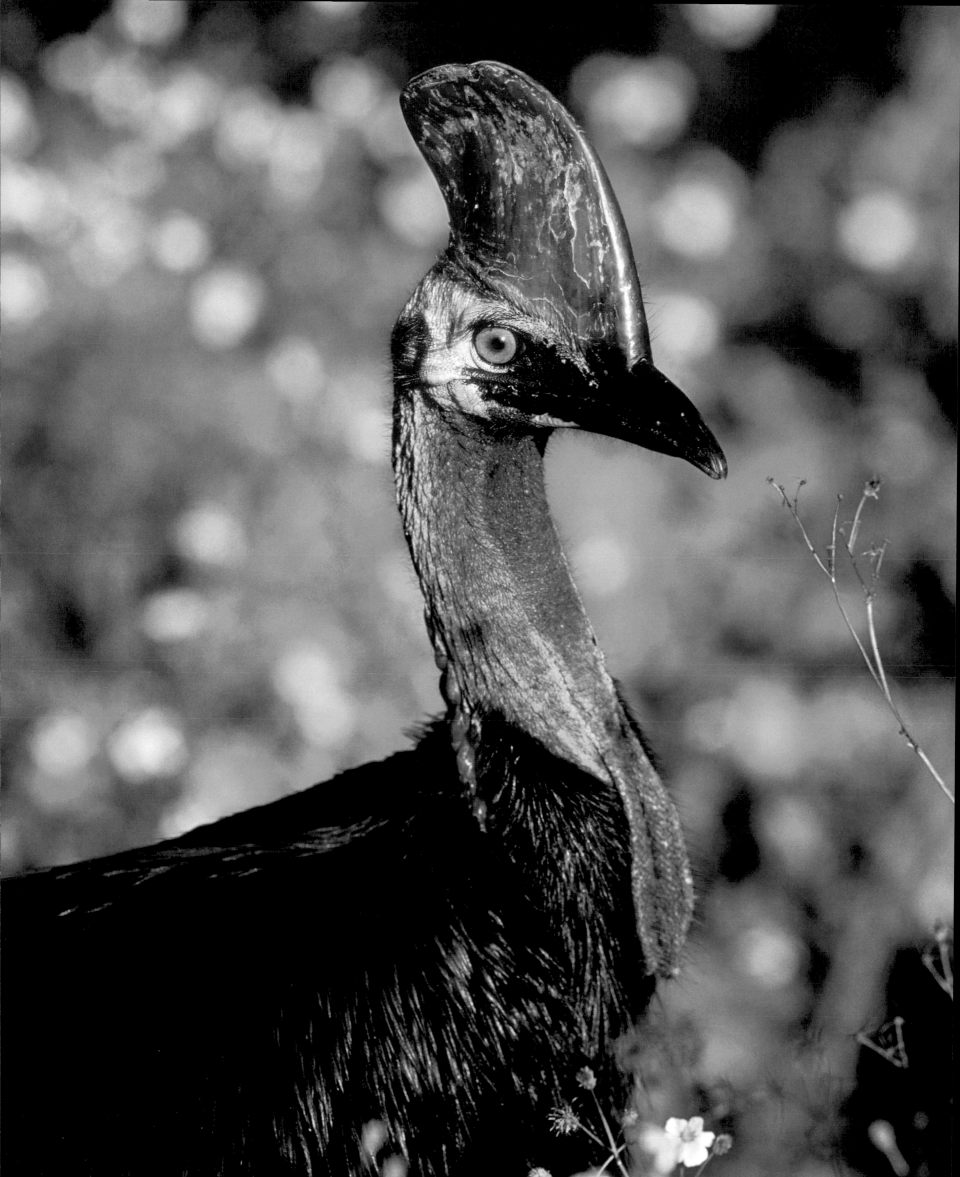

RIGHT In terms of plant species
Daintree is one of the most
diverse places on the planet.
New discoveries are constantly
being made, and it is clear that
some species are highly localized.

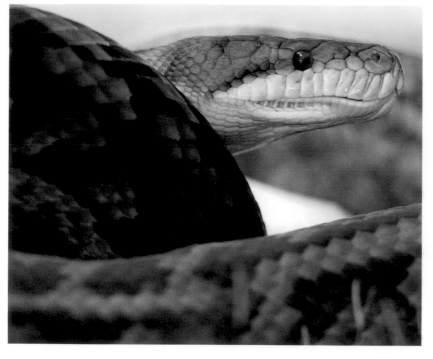

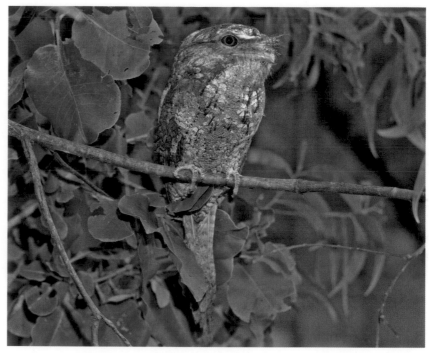

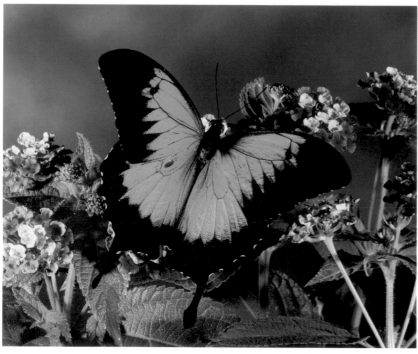

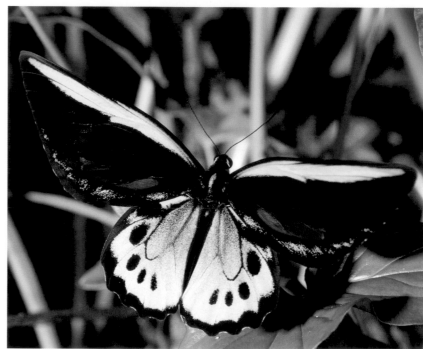

OPPOSITE TOP LEFT The forest-dwelling Amethystine Python is Australia's longest snake. Its name comes from the milky iridescent sheen on its skin.

OPPOSITE TOP RIGHT The Papuan Frogmouth is strictly nocturnal, and preys on frogs, lizards and rodents. It is a north Queensland speciality and found nowhere else in Australia.

OPPOSITE MIDDLE LEFT AND RIGHT The Ulysses (left) and Cairns Birdwing (right) are two of the largest and most dramatic butterfly species found in the Queensland rainforests.

OPPOSITE BOTTOM LEFT Despite its ornate profile and seemingly distinctive coloration, Boyd's Forest Dragon is impeccably camouflaged when resting on tree trunks or among foliage.

OPPOSITE BOTTOM RIGHT The Graceful Tree Frog (*Litoria gracilenta*) is one of a vast number of amphibian species recorded from Daintree.

LEFT A type of possum, the Sugar Glider has skin membranes extending between its forelegs and hindlegs. These enable it to glide for up to 50 metres (165 feet) between trees.

Gorge there is a good chance of seeing the magnificent Cairns Birdwing (*Ornithoptera euphorion*), Australia's biggest butterfly, with a wingspan of up to 18 centimetres (7 inches). Even larger, with a wingspan of up to 25 centimetres (10 inches), is the day-flying Hercules Moth (*Cosinocera hercules*), which is found only in the Wet Tropics and New Guinea. The females attract males by emitting pheromones and, once mated, lay their eggs and die. With no mouth parts, the adults are unable to eat and can live only as long as their fat reserves last – usually a week to 10 days.

One of the most unexpected rewards of exploring a rainforest comes from looking down periodically at your feet, rather than constantly craning your neck to see what may be above you in the canopy. The rotting vegetation and leaf litter on the forest floor is always heaving with life, with thousands of invertebrates and other creatures all busy hunting, gathering and helping to sustain the decomposition process. Beetles, centipedes, millipedes, snails, slugs and spiders are all here in abundance, and careful examination will also reveal the evidence of other birds and animals that have passed by – discarded fruit peel, seed pods or nut shells, for example. A real find is the characteristic pizza-shaped scat of a cassowary, complete with "olives" on the top – actually the undigested seeds and stones of fruit the bird has eaten.

Night is a time of great drama in the forest. Many shyer creatures emerge to seek food, and a torchlit walk is particularly good for finding frogs (especially after rain) and small mammals such as Sugar Glider (*Petaurus breviceps*), often found feeding on sap and nectar, and Striped Possum (*Dactylopsila trivirgata*), which hunts for grubs in rotting wood and prises them out with its specially adapted fourth finger. Also worth looking out for in the dark – but with your torch switched off – are the luminescent fungi that grow on rotting vegetation. However, the highlight of a night walk is often reptilian by nature. Top sightings can include the exquisitely marked Boyd's Forest Dragon (*Hypsilurus boydii*), which often conveniently sits at eye-level on a tree trunk, as well as one of Australia's most beautiful snakes, Amethystine Python (*Morelia amethistina*), which can reach lengths of up to 8 metres (26 feet). Like all pythons, this species is primarily nocturnal and as at home up a tree as on the ground. They are skilled at catching tree-dwelling prey, such as birds and bats, and large specimens are perfectly capable of tackling animals as big as another of the area's nocturnal specialities, Bennett's Tree Kangaroo (*Dendrolagus bennettianus*). Despite their name, these marsupials are only secondarily adapted to arboreal life and can look surprisingly clumsy as they clamber about the canopy. They – and the python – are best looked for around fruiting trees, which act as a magnet for much forest wildlife and are always worth looking at closely.

33. The Whales of Western Australia

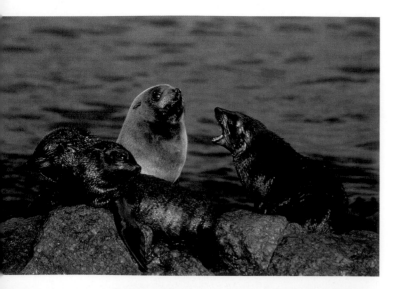

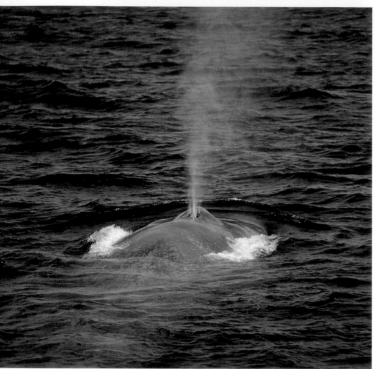

The nutrient-rich waters off the south-western corner of Western Australia are home for part of the year to some of the largest and most diverse congregations of cetaceans found in Australasia. The area offers the opportunity to see up to 20 different species of whale and dolphin, with marine trips leaving from several towns, including Bunbury, Dunsborough, Augusta and Albany. Whale-watching is still relatively new here, and the number of people visiting for this purpose is considerably less than at comparable sites elsewhere in the world – something worth taking advantage of! In addition to several species of large whale, boat trips offer the chance to see the rookeries of New Zealand Fur Seals, and in Koombana Bay, to the north, a school of 100 or so Bottlenose Dolphins (*Tursiops aduncus*) can often be watched at very close quarters.

Not surprisingly, given the high concentration of cetaceans, this part of Western Australia was once a centre for commercial whaling. The industry took off locally following the killing of the first whale off Fremantle in 1837, and whaling operations continued throughout the nineteenth century. Many of the ships that brought out convicts to the expanding colony were whalers, and would revert to whaling on their journey back to Britain. Various whaling stations were established, including one at Frenchman Bay near Albany, which at its peak was processing over 1,000 Humpback and Sperm Whales annually. Such catches were made possible by the invention of the exploding harpoon and steam-powered chaser boats, but their effect on the whale population was such that numbers soon dwindled and the industry became increasingly uneconomic. The last whale was taken in November 1978, after which the station closed down, marking the end of what was probably Australia's oldest industry. Today the site is occupied by an interesting museum on whales and the local history of whaling.

The whale-watching season in this part of Australia begins at the start of the austral winter in late May, when both Humpback Whales (*Megaptera novaeangliae*) and Southern Right Whales (*Eubalaena australis*) begin to arrive in the area from the increasingly rough and colder waters to the south. Attracted here by the more benign conditions, they congregate in sizeable numbers – over 100 Humpbacks have been recorded in the sheltered waters of Flinders Bay and off Cape Leeuwin, for example. The Humpbacks are en route to their breeding grounds, off north-western Australia, and normally remain in this area for only a few weeks, but they are often already engaging in courtship behaviour and several males can sometimes be watched competing energetically for the attentions of a lone female. This can be a rumbustious affair, sometimes incorporating exuberant displays of tail slapping and the spectacular breaching for which this species is famous, but the precise significance of which remains imperfectly understood. In September and October the Humpbacks pass through again, on their journey back south to their summer feeding grounds off Antarctica, the females now accompanied by their newborn calves.

The Southern Rights arrive at the same time as the Humpbacks, but show a more easterly bias and remain in the area for several months, mating and calving in the shallow, sheltered bays along the southern coast before returning south in November. One of the main calving sites is off Point Ann in the Fitzgerald River National Park, east of Albany, where there is a whale-watching platform from which up to 40 animals have been observed at one time. A female will give birth only every two or three years, and will often be assisted in the process by a "midwife" whale. The calf – which can be up to 6 metres (20 feet) long and weigh 1 tonne (1.1 tons) –

TOP **The Australian population of New Zealand Fur Seals has increased substantially in recent decades. The colonies around Flinders Bay and Cape Leeuwin are the most westerly in the world.**

ABOVE **The Blue Whale's exhalation "blow" takes the form of a single vertical spurt, reaching up to 10 metres (30 feet) in height and audible up to 2 kilometres (1¼ miles) away in still conditions.**

OPPOSITE TOP **One of the natural world's most dramatic and exhilarating sights – that of a Humpback Whale breaching.**

OPPOSITE BOTTOM **Bottlenose Dolphins are one of the most widely distributed cetaceans, found in temperate and warm seas worldwide.**

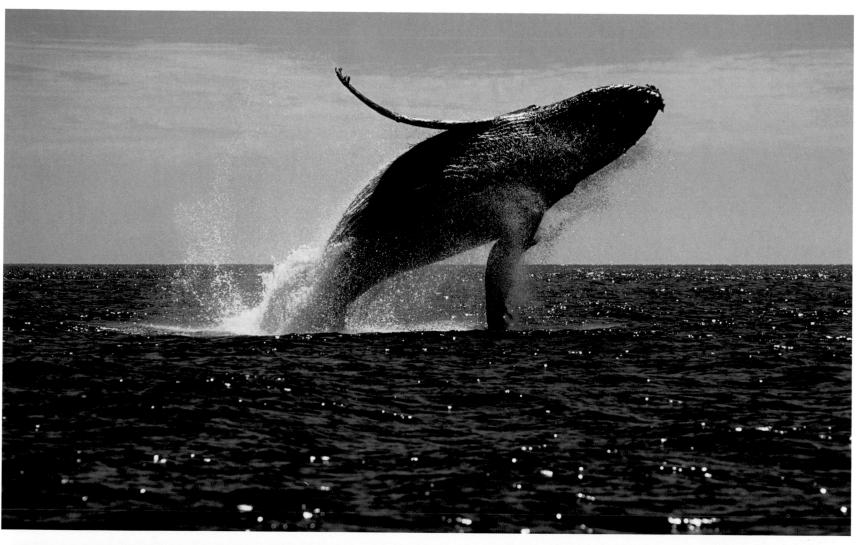

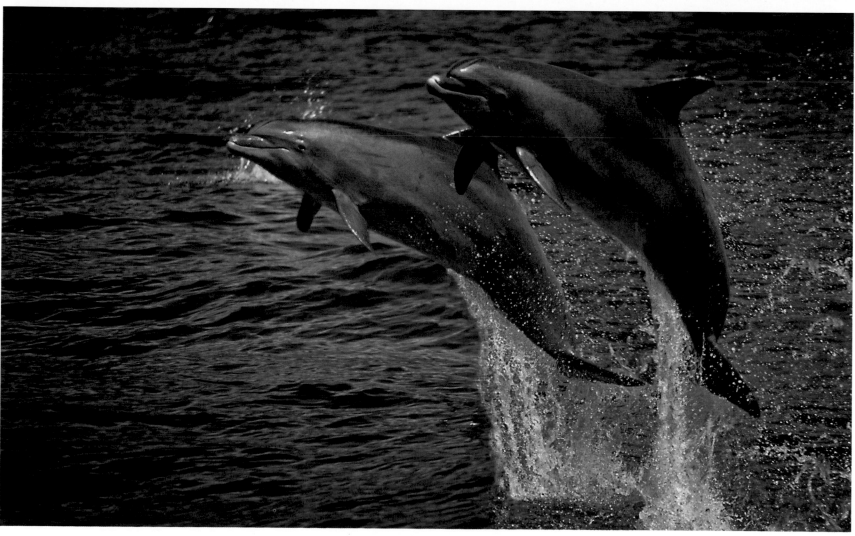

BELOW This aerial view brings
into perspective the great size
of the Blue Whale. After decades
of decline, numbers are now
recovering and the Western
Australian population is in
healthier shape than for
many years.

emerges tail-first and is then gently coaxed to the surface by its mother and the midwife to take its first breath. Those whales that mate locally undergo a gestation period of 12 months, returning to give birth the following year in the same general location.

Southern Right Whales are so named because whalers considered them the "right" whales to hunt, owing to their slow-moving habits and the fact that their body is 40 per cent blubber. This both yields great quantities of oil (formerly much in demand for lighting and heating fuel) and causes the animals to float conveniently when dead, allowing them to be collected easily. Hunting pressure on the species was so intense that the population came close to total extinction. Today, Southern Rights can be found on their calving grounds at several locations on the southern coast of Australia, and are increasing in number, although the total is estimated to be fewer than 1,500.

In recent years, during October and November, there have been regular sightings in Flinders Bay of Blue Whale (*Balaenoptera musculus*), the largest animal ever known to have lived. So reduced were Blue Whale populations by commercial whaling that it is doubtful whether some will ever regain their numbers. Certainly the gene responsible for producing the largest specimens – i.e. those that were particularly targeted by the whalers – appears to have been eliminated, as today's biggest Blue Whales are smaller than the giants of 30 metres (100 feet) and over that were recorded in the past. However, as a result of protection, Blue Whale numbers off Antarctica (and elsewhere) appear to be strengthening, which explains their welcome and increasing occurrence off the West Australian coast.

OPPOSITE A characteristic of Southern Right Whales is the presence on their head of horny growths known as callosities. These give a barnacled appearance but are harmless and may even play a role in sexual selection.

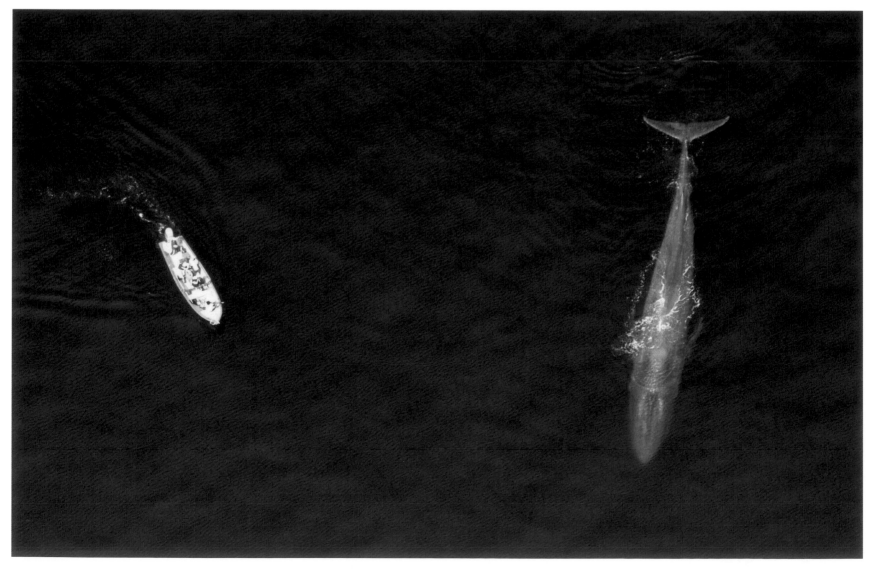

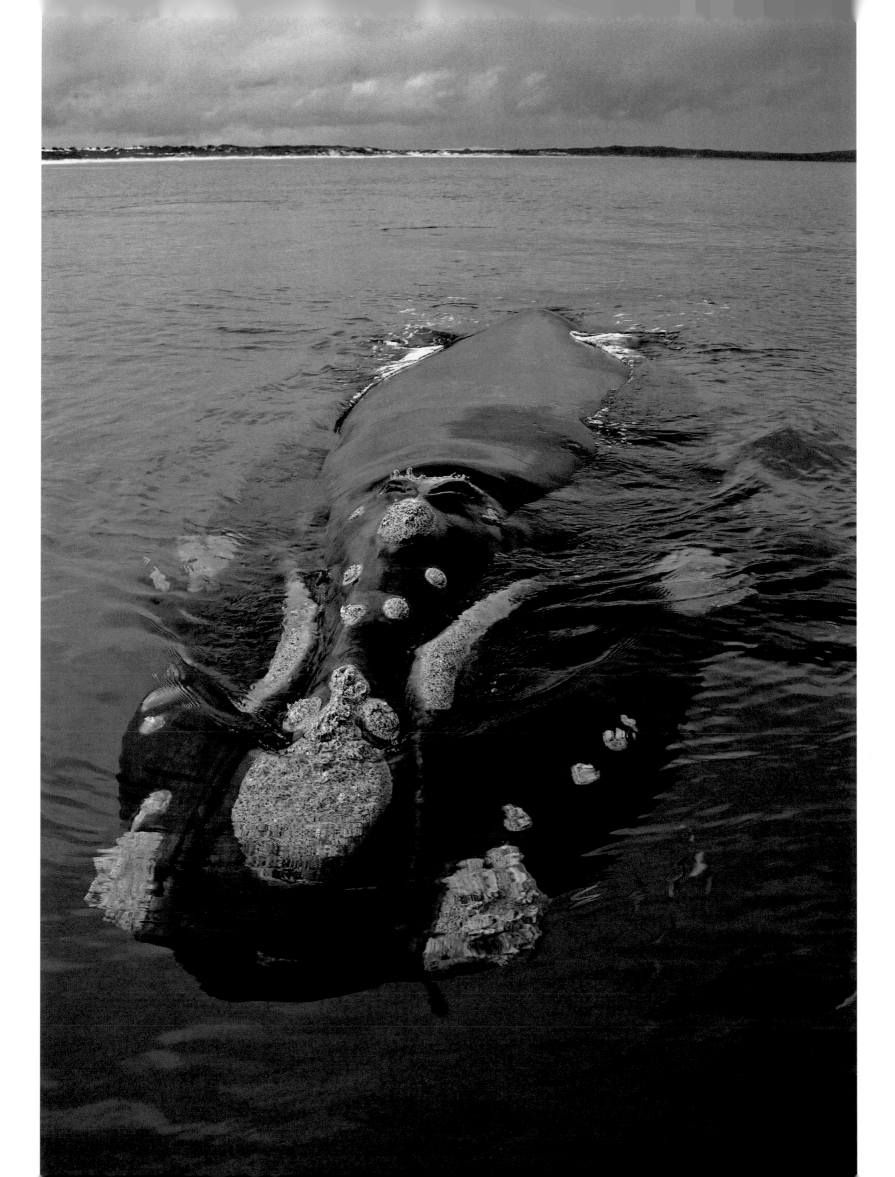

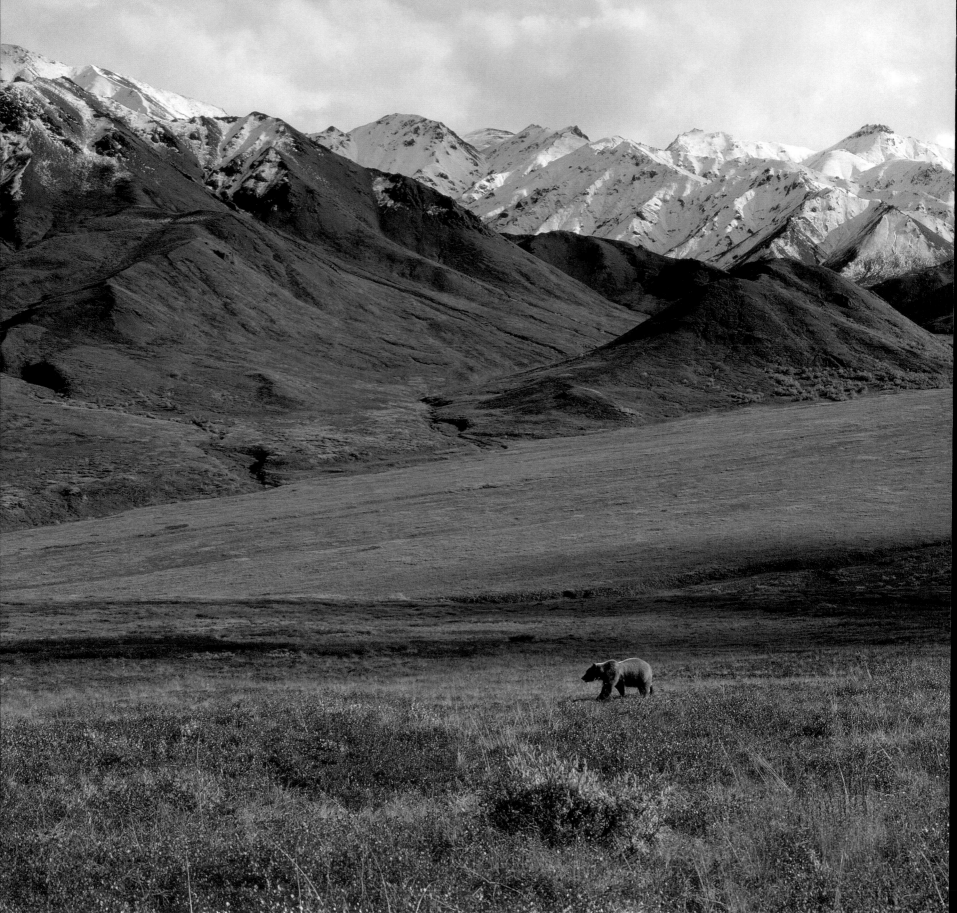

Two hundred years ago, American settlers headed west in their thousands from the eastern seaboard states, astonished by the proliferation of wildlife they found. The woods were thick with deer, bear and wolves, and the plains of the mid-West teemed with millions of ungulates, notably bison. Sadly, two centuries of overhunting and habitat destruction saw the decimation of many of the larger mammals and birds, and the total extinction of some. Today the situation for North American wildlife is much healthier, and from the breathtaking mountain landscapes of Yellowstone to the atmospheric backwaters of Florida's Everglades, there are abundant opportunities to watch exciting wildlife in stunning scenery. Proactive conservation has seen the successful reintroduction of flagship species and the increase of others from the brink of extinction. Yet the hand of man continues to be a threat – the exploitation of the wildernesses of Alaska is a continuing source of concern, and global warming may spell the end of the Polar Bear in the wild.

BELOW A Grizzly Bear roams across the tundra of Denali National Park in search of food. The combination of stupendous scenery and sizeable populations of North America's largest mammals make Denali one of the world's best wildlife-watching locations.

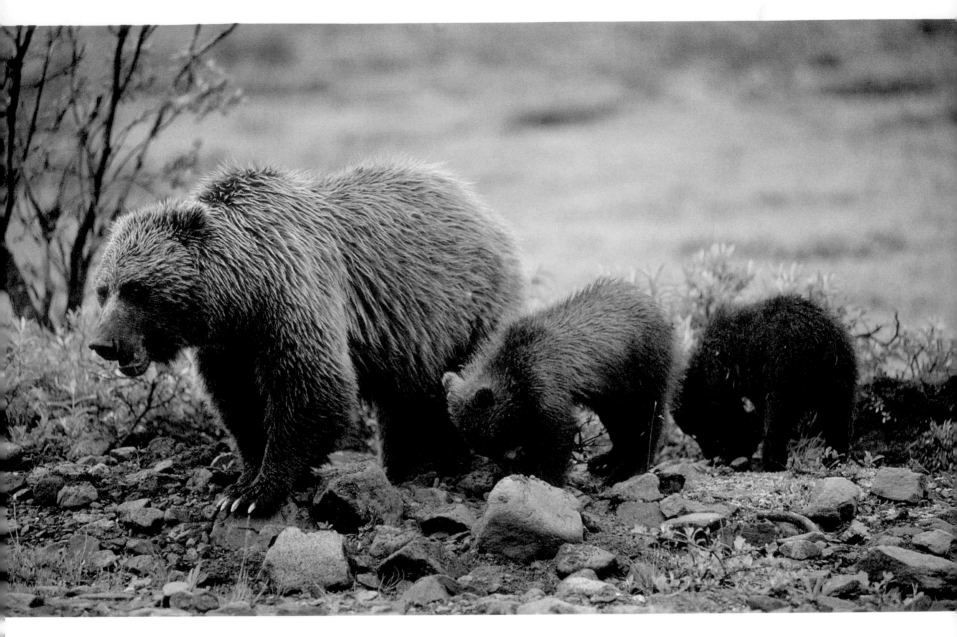

34. The Big Five of Denali

Covering over 24,000 square kilometres (9,250 square miles), Denali National Park and Preserve sit at the heart of wild Alaska on the north flank of the dramatic Alaska Range. This 970-kilometre (600-mile) long chain of permanently snow-capped peaks is dominated by Mount McKinley, which at 6,194 metres (20,322 feet) the highest peak in North America. This is not, however, McKinley's most impressive statistic because, at almost 5,500 metres (18,000 feet) from tundra floor to summit, it can also claim the greatest vertical rise of any mountain in the world. Set against this extraordinary backdrop, Denali cannot fail to impress. At lower elevations there are areas of pristine forest (known as *taiga*), mostly comprising spruce and willow, bisected by rivers and with areas of wetland; as the land rises, the forest gives way to open tundra, covered in mosses, lichens, grasses and other dwarf vegetation, including important berry-carrying species and a host of colourful flowering plants in summer. At higher levels, glaciers, rock and snow take over.

In addition to such stupendous scenery, Denali has abundant wildlife and can even claim its own "Big Five": Moose (*Alces alces*), Caribou (*Rangifer tarandus*), Dall Sheep (*Ovis dalli*), Grey Wolf (*Canis lupus*) and Brown Bear (*Ursus arctos horribilis*), the latter usually known locally as Grizzly Bear. Of these animals, Caribou are the most immediately visible, grazing out on the tundra in loose herds. In the 1920s and '30s there were up to 20,000 living here, but their numbers crashed in later years and today there are fewer than 2,000. It may be that this decline is partly due to natural predation by wolves and bears, although Caribou numbers often fluctuate wildly and can fall sharply, for example in particularly severe winters. Every spring the females migrate to their calving grounds, where they give birth. Some of these places are located on the other side of the Alaska Range from

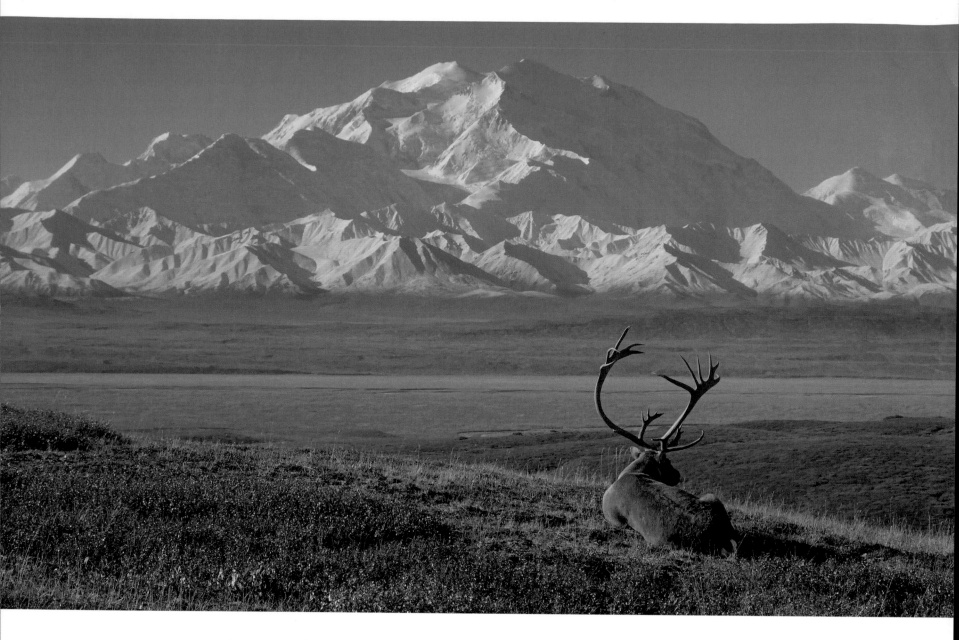

the national park, and to reach them the Caribou cows must overcome natural obstacles such as deep snow and rivers in flood from snow melt.

Moose are restricted to lower elevations and best looked for in woodland next to rivers and lakes: they often venture into the water to browse on aquatic vegetation. Dall Sheep, meanwhile, are animals of the mountains, grazing on the grassy slopes and open ridges and seeking refuge among the rocks and crags from predators. The sheep are something of a park icon, for it was research into these animals that led naturalist Charles Sheldon to visit Denali in the early years of the twentieth century. Recognizing the area's value to wildlife as an intact ecosystem, he lobbied the Federal government for its designation as a protected area. He got his wish in 1917, when an initial section of Denali was gazetted as a national park; this was reaffirmed – and the park extended further – in 1980.

Wolves are undoubtedly the trickiest of the Big Five to find at Denali, and always unpredictable and elusive. Grizzly Bears, however, are relatively easy to see, and this can be one of the best places in the world to watch them. They occur throughout the park, but are more frequently encountered on the open tundra, especially in late summer, when they are on the prowl for berries. Black Bears (*Ursus americanus*) are also present in Denali, but tend to stick to the more forested areas and are rarely seen by visitors. In any case, the two are easily told apart. Whilst Grizzlies are surprisingly variable in coloration, ranging from dark brown to a light tan (and with the darker animals often having blond "highlights" on their head and back), most Grizzlies in Denali are at the fairer end of the scale.

Ambling across the tundra, bears are constantly engaged in a search for food. Highly omnivorous, they are great opportunists and always up for an easy meal. When the heavy winter snow has thawed

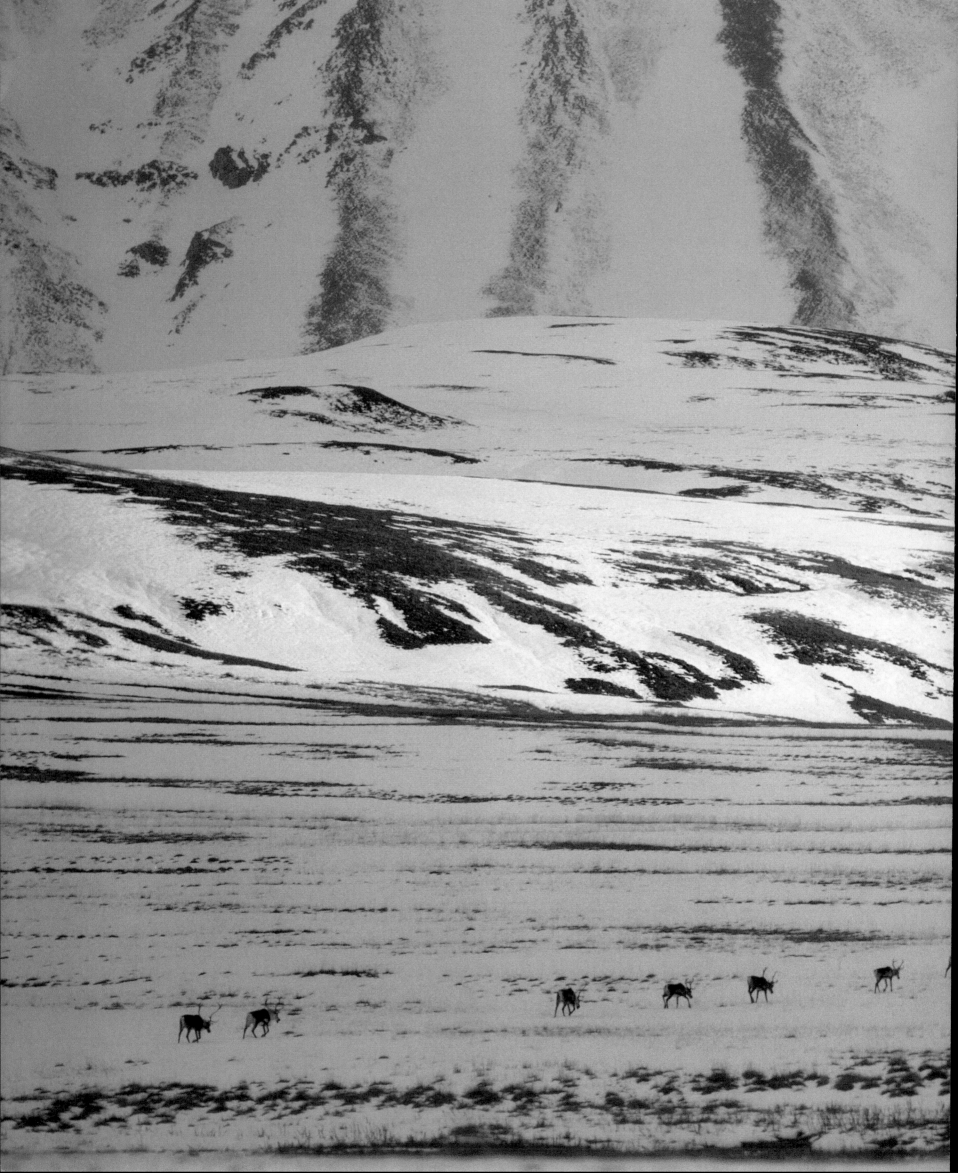

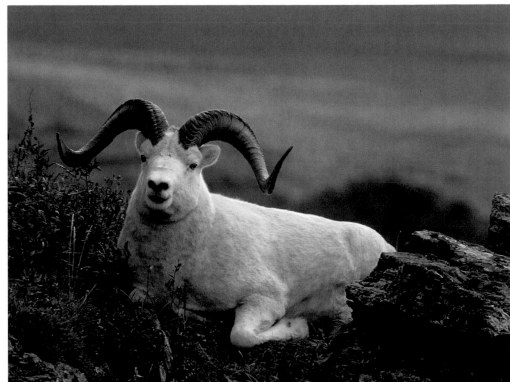

and the bears emerge from their hibernation dens, they will often dig up plant roots or scavenge carrion remaining from wolf kills. As spring progresses, they turn their attention to hunting Caribou and moose calves, before becoming rather more vegetarian in outlook in summer, when there is a plentiful supply of berries and flowering plants. Bears are generally solitary creatures, with the exception of mothers with cubs – these will stay with her for at least three years before parting company. Even then, siblings will often stick together for a further two or three years.

Although it is the larger mammals that inevitably steal the day at Denali, there are good birds here too. In summer the open tundra is home to species such as Willow Ptarmigan (*Lagopus lagopus alascensis*), Lapland Longspur (*Calcarius lapponicus*) and several varieties of nesting wader, whilst the park's wetlands are an important breeding site for Trumpeter Swan (*Cygnus buccinator*). Predators overhead can include Gyrfalcon (*Falco rusticolus*) and Golden Eagle (*Aquila chrysaetos*). However, no species of reptile has ever been recorded in Denali, and only one species of amphibian.

Close interaction between humans and animals in Denali is strictly discouraged (no feeding allowed, for example) and, in order to retain the park's wilderness feel, no private vehicles are allowed. All visitors have to enter by bus along the single access road, which leads from the entrance to just beyond Wonder Lake. Further exploration is permitted on foot, but this is a demanding landscape and not for the fainthearted or foolhardy. Close encounters with bears are not uncommon, for example, but this is one of the world's great wild landscapes and worthy of such excitements. What the future holds for this fragile environment is not clear, however. With the local flora and fauna specially adapted to life in the particular conditions here, it may be that certain species will be significantly affected by climate change, the impact of which is expected to be more exaggerated in mountainous sub-polar regions such as Denali than at lower elevations and latitudes.

LEFT **A line of Caribou makes its way across the snowy wastes. Winter is long and hard in this part of Alaska, and there can be snow on the ground continuously from early October through to late May.**

ABOVE **A Dall Sheep ram. The sheep rely on their ability to move quickly over steep slopes and ledges to escape predators such as wolves.**

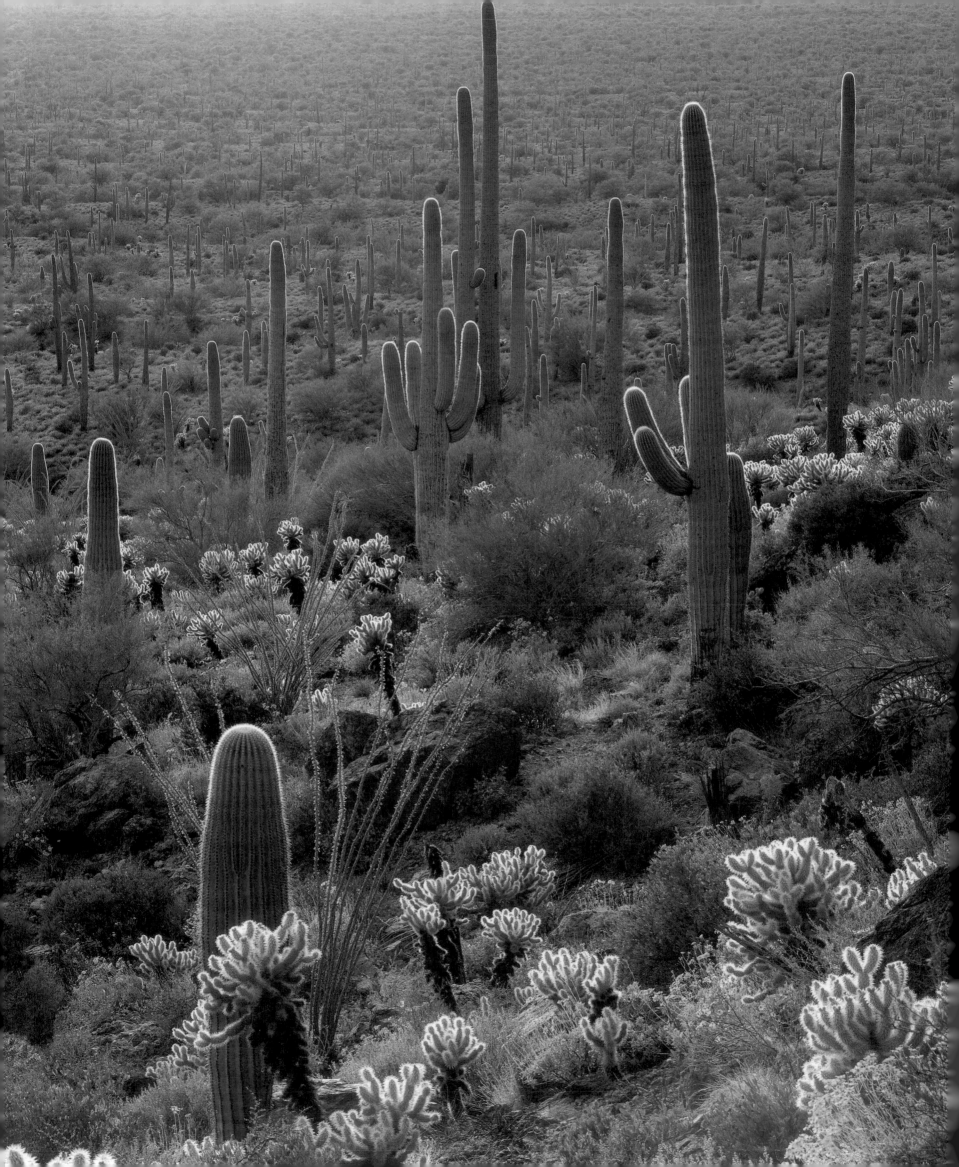

OPPOSITE **Spring in the Sonoran Desert in Arizona. The iconic Saguaro cacti cannot set seed from its own pollen and so relies on pollen transfer by agents such as the White-winged Dove.**

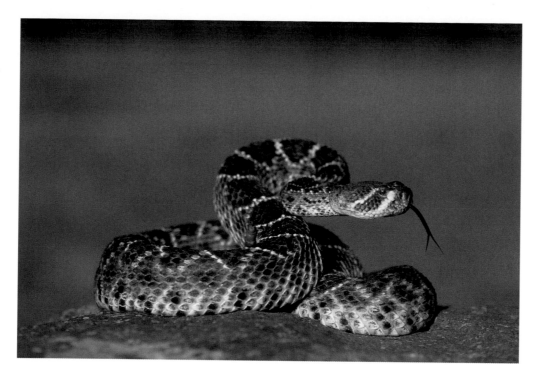

LEFT **Rattlesnakes are usually not fast enough to catch their typical prey of small rodents, so their hunting strategy is to sit quietly waiting for a likely candidate to pass by.**

35. Desert Life in Arizona

Those reared on a mid-twentieth-century diet of television and cinema "Westerns" may be forgiven for viewing the deserts of the south-western United States as little more than a stark backdrop to gun-toting action at the very frontier of civilization. Yet while the deserts are indeed at the limits of human comfort for much of the year, they are very far from being a barren wasteland. The Sonoran Desert eco-region, for example, which covers some 223,000 square kilometres (86,100 square miles) of the south-eastern and south-western sections of California and Arizona respectively, as well as the western half of the Mexican state of Sonora and much of upper Baja California, has the greatest diversity of vegetation of any desert worldwide. Over 550 species of flora have been recorded here, along with an extra-ordinary range of wildlife. However, most natural history enthusiasts come here for three reasons: cacti, birds and reptiles.

Arizona is cacti country par excellence, but one species stands out as an icon of the desert landscape here: the Saguaro Cactus (*Cereus giganteus*). Found on gravelly slopes, rocky ridges and outwash fans up to 1,000 metres (3,280 feet), this is a large, slow-growing plant, and while exceptional specimens can reach heights of more than 13 metres (42½ feet) and a girth of 3 metres (10 feet) plus, it can take them 200 years to do so. Over such a period, a Saguaro will develop several limbs, each one of which contributes to the plant's impressive water-storing capacity. Older specimens are therefore best placed to withstand periods of severe drought, and can visibly increase their size after heavy rain, as they absorb and store precious water. The need to maximize water intake also explains why the Saguaro's spines point downwards, as this helps to direct rainfall towards the base of the plant.

For such a large and unmissable plant, the Saguaro is surprisingly coy about flowering. The rather sickly-smelling creamy white flowers bloom for only one night per year, in May or June. Opening by midnight, they are pollinated by bats and flying insects, and by noon the following day are closed and dying off. However, not all the flowers on an individual Saguaro will bloom at the same time, and so a large specimen can extend its flowering period over a month or more. Vulnerable to theft (the small ones, at least), vandalism and destruction by infrastructure projects such as road-building and new housing, Saguaros are now protected by law. One of the best places to see these magnificent plants in their full sculptural glory is the Saguaro National Park, near Tucson.

The desert regions of Arizona are among the richest in the United States for birds, with over 40 per cent of America's terrestrial bird species making an appearance here at one time or another. There are two endemic species of sparrow to keep the keenest of birders contented, as well as a host of other distinctive desert-related species. Several of these enjoy a strong ecological association with

the Saguaro, including Gila Woodpecker (*Melanerpes uropygialis*), Gilded Flicker (*Colaptes chrysoides*) and White-winged Dove (*Zenaida asiatica*). The first two species excavate nest holes inside the cactus; the woodpecker rarely causes a problem, but the larger size of the cavities created by the flicker can cause problems for the Saguaro, and even the death of the plant in extreme cases. The situation is exacerbated by the fact that both birds create new holes each breeding season, although this does leave residential opportunities for others, such as the diminutive Elf Owl (*Micrathene whitneyi*). The largely migratory White-winged Dove feeds extensively on Saguaro flower pollen, nectar, fruit and seed, and therefore times its arrival in the Arizona desert with the Saguaro's flowering season. One of the most famous desert birds is the Roadrunner (*Geococcyx californianus*), a largely terrestrial member of the cuckoo family, and one capable of reaching speeds of 27 kilometres (17 miles) per hour when on the run. It feeds primarily on insects and reptiles, and will even tackle scorpions and rattlesnakes.

There are almost 60 species of reptile in the Arizona deserts, and whilst the most likely reptilian encounter for a human visitor will be with species of smaller lizard, there are some local specialities to look out for. These include Desert Tortoise (*Gopherus agassizii*), a much-declined species that is now the subject of various conservation programmes, and, if you have great luck, one of the most remarkable desert creatures of all: Gila Monster (*Heloderma suspectum*). Like many other desert reptiles, the Gila spends up to 95 per cent of its time in underground burrows, emerging to hunt in the cool of the night. Slow-moving and unaggressive, it is one of the world's only two species of venomous lizard, subduing its prey with venom delivered from grooves in its teeth. Remarkably, research has recently revealed that this venom may be of value in the treatment of diabetes through its ability to stimulate insulin production.

Discoveries such as this underline the urgent need to protect the landscapes and wildlife of this fascinating ecosystem. The Sonoran Desert is a fragile environment, and subject to a range of pressures, including a rapidly growing human population, greedy for land and water resources. The encroachment of agriculture, especially along river valleys, is already a major problem, and the introduction of the non-native and invasive Buffel Grass (*Cechrus ciliaris*) for cattle grazing is threatening indigenous plants and overall biodiversity. Pressure from tourism also requires careful management, as many desert plants in particular are vulnerable to uncontrolled access. Also of great concern around the early part of 2007 was the US federal government's plan to construct a 1,100-kilometre (684-mile) long fence along the country's border with Mexico to prevent the influx of illegal immigrants. If constructed, this will also serve to inhibit the traditional cross-border movement of large mammals, including wolves and big cats, such as Jaguars (*Panthera onca*), extinct in Arizona but with the potential to recolonize from Mexico.

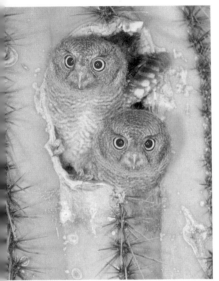

TOP The desert is home to tarantulas (*Aphonopelma* sp.), whose size and fearsome appearance belie a generally placid nature. They are mostly crepuscular, spending the heat of the day underground.

ABOVE The best chance of seeing the nocturnal Elf Owl comes from identifying a likely nesting hole and then waiting quietly until dusk falls. The birds usually soon appear, in this case two youngsters.

OPPOSITE TOP Although most large Saguaro cacti are able to withstand the hole-creation activities of birds such as the Gila Woodpecker (shown here), the excavated cavities can weaken individual limbs.

OPPOSITE BOTTOM The expansion of cities such as Phoenix and Tucson into the surrounding desert is a major conservation issue. However, some wildlife species are more adaptable than others. Roadrunners, for example, can be counted as a garden bird in some areas.

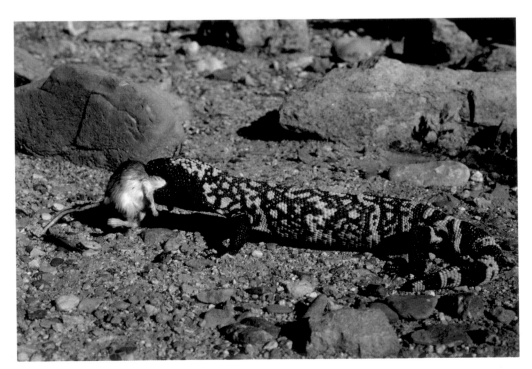

LEFT Gila Monsters feed on rodents and other reptiles. Although generally sluggish in their movements, they move their head with lightning speed when seizing prey.

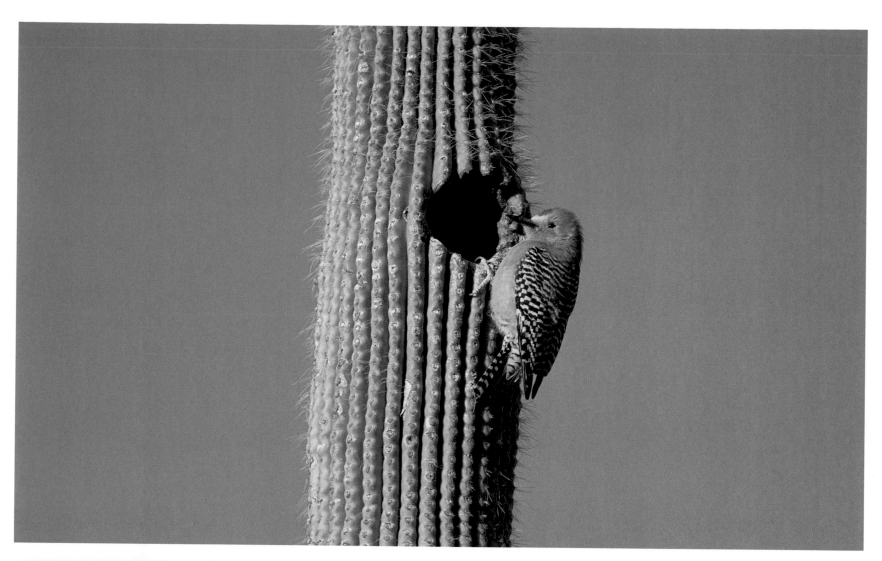

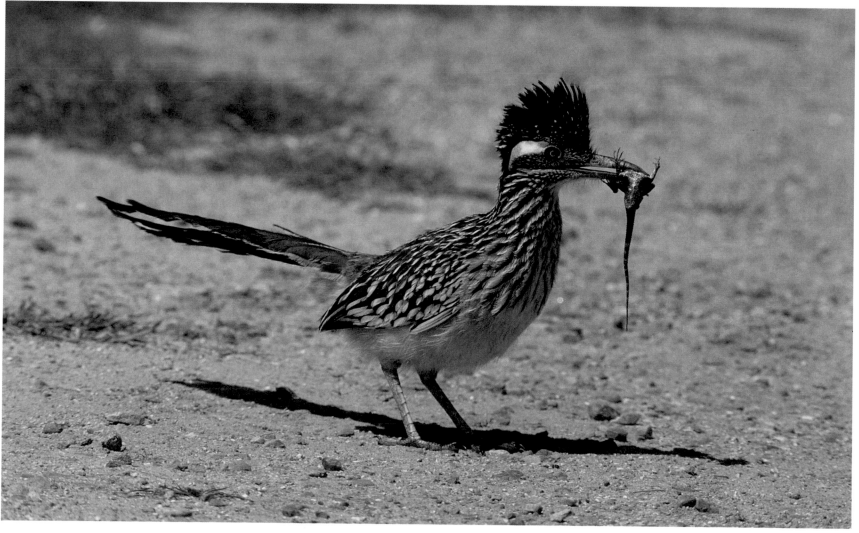

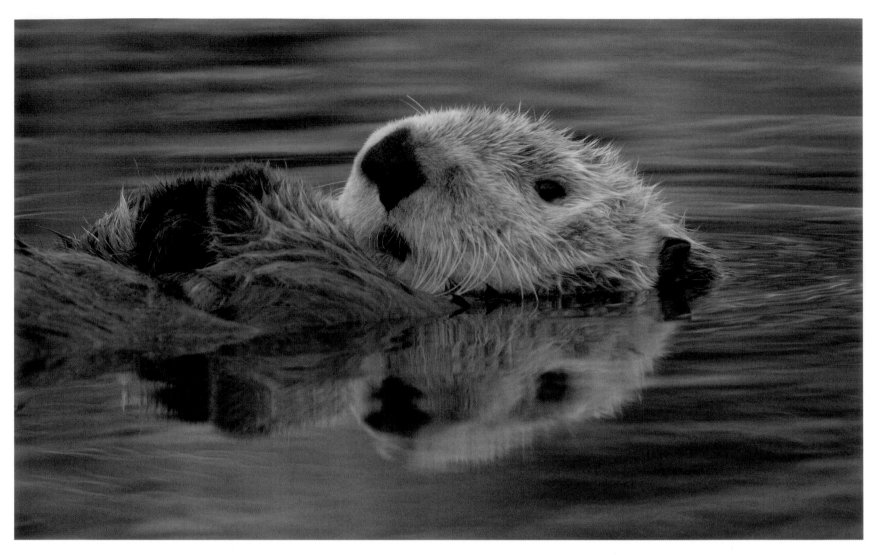

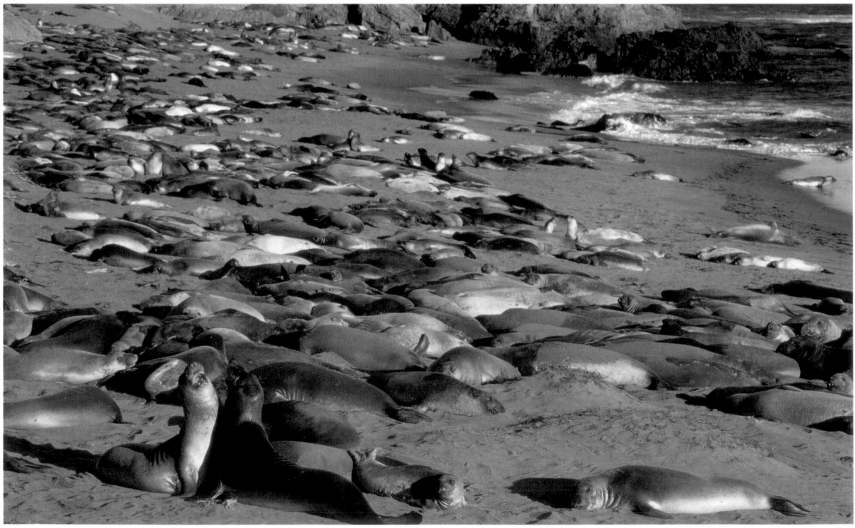

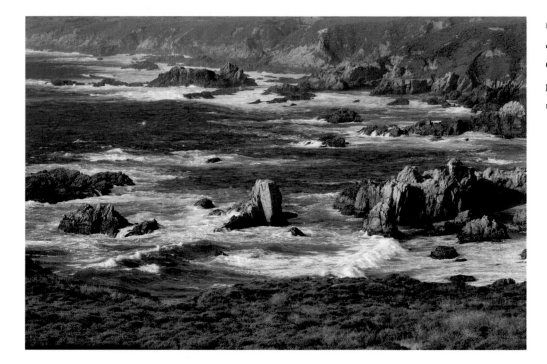

36. The Sea Mammals of the California Coast

California is home to some of the best wildlife-watching in North America. One undoubted
highlight is the variety of sea (or pelagic) mammals that frequent the waters of Monterey Bay and
the coastline that runs south from here to Big Sur, where the Santa Lucia Mountains meet the rocky
Pacific coast. This 150-kilometre (93-mile) stretch of dramatic country has always been remote
and thinly populated, and a combination of environmentally-aware landowners and protected state
parkland has helped keep it that way. Wildlife abounds here, and the offshore presence of deep
underwater trenches causes a nutrient-rich coldwater upwelling in the ocean, which attracts vast
numbers of seabirds and marine mammals. Wet winters, equable year-round temperatures and thick
summer fogs are characteristic of the area and reflected in the local flora; for example, Big Sur is the
most southerly stronghold of the tallest tree species in North America, the giant Coast Redwood
(*Sequoia sempervirens*).

For much of the year the easiest sea mammal to see here is the California Sea Lion (*Zalophus
californianus*), often found lolling around marinas and harbours, such as on the jetty in Monterey.
For other species, a little more effort is required. One of the most popular is the Southern Sea Otter
(*Enhydra lutris nereis*), which was once found right along the western coast of the United States and
Canada. Endowed with the densest fur known of any mammal, the otters were intensively hunted
for their luxuriant pelts, to the point that by the 1920s only a few small isolated groups remained.
Indeed, the species was believed extinct in California, but in 1938 a small group was discovered living
in the kelp forests south of Carmel. Under careful protection, their numbers have grown to more
than 2,000 and otters have recolonized many of their former haunts. One of the best spots to find
them now is around the Monterey Peninsula; they favour shallow waters, and seldom stray more
than a kilometre or two from the shore.

Sea Otters are particularly engaging creatures. They are most often seen lazing around in groups
– known as rafts – on the surface of the water, usually on their backs with their head slightly raised
and, if dozing, with their paws folded across their chest. One of the more interesting aspects of their
behaviour is their ability to use tools. When eating, for example, they will use their chest as a table
and often position a flat stone on it, against which they smash open crabs, shellfish and sea urchins.
Favourite rocks or food items are sometimes stowed in pouches of skin under their forelegs, to be
retrieved later. At night, Sea Otters are even known to wrap themselves in strands of kelp, to avoid
being carried away by the current.

Another West Coast marine mammal, the Northern Elephant Seal (*Mirounga angustirostris*),
also took a hammering at the hands of man during the nineteenth century. Hunted for the oil that

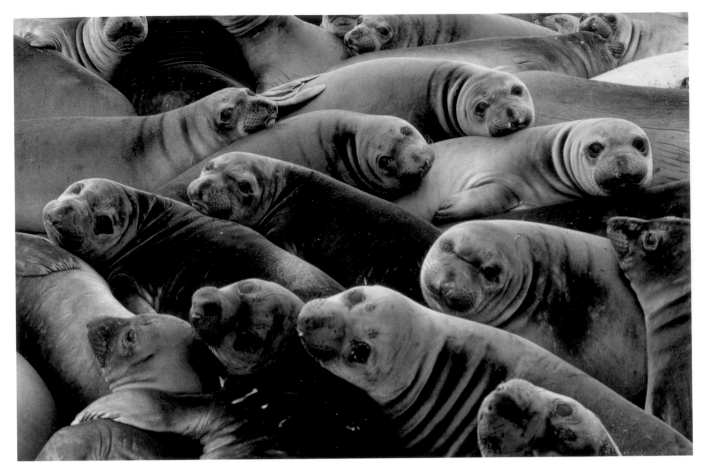

ABOVE A group of Elephant Seal pups at Año Nuevo. Once at the brink of extinction, the species has recovered well under protection.

could be made from its blubber, the seals were virtually wiped out, and by the early 1900s only one surviving rookery was known. Since then, the seals have made a great comeback, thanks to strict protection, and the two largest mainland breeding sites for this species anywhere in the world are here – at Año Nuevo Point, north of Monterey, and Piedras Blancas, at the southern end of the Big Sur coastline.

Big Sur is also one of the best places in North America to watch Grey Whales (*Eschrichtius robustus*). Almost the world's entire population migrates past the coastline here twice a year, as they undertake their remarkable migration from Baja California, where they overwinter and the females calve, to their summer feeding grounds in the Bering Sea, and thence back south again. An approximately 20,000-kilometre (12,500-mile) round trip, this probably represents the longest migration of any mammal. Favouring shallow water and travelling in small groups, the whales pass close to the shore, giving excellent sightings from viewpoints along the coast. Watching them is particularly rewarding in spring, when the females carefully escort their new calves on the journey north, often taking care to keep the youngsters on the landward side, possibly to reduce the risk of attack by sharks and Orcas (*Orcinus orca*).

In addition to top quality mammal action, Big Sur has another natural history ace up its sleeve – North America's largest landbird, the California Condor (*Gymnogyps californianus*). As a result of persecution and habitat destruction, by the early 1980s fewer than 25 condors remained in the wild. These were captured to form the basis of a captive breeding programme, with a view to reintroducing a viable population to the wild. The first releases took place in 1992 and today there are over 120 condors flying free over California and Arizona. Some of these majestic birds can be seen regularly soaring above Big Sur, and a pair that nested here in 2006 was the first to do so this far north in California for over a century. That they should do so on this wild stretch of the Golden State is testament to the area's special value as a refuge to species brought back from the very brink of extinction. With most local marine mammal populations currently secure, and condor numbers continuing to grow, the outlook is bright, even if vulnerability remains – oil from a single tanker spill could wipe out the entire local Sea Otter population, for example, and released condors have died as a result of lead poisoning and collision with overhead cables.

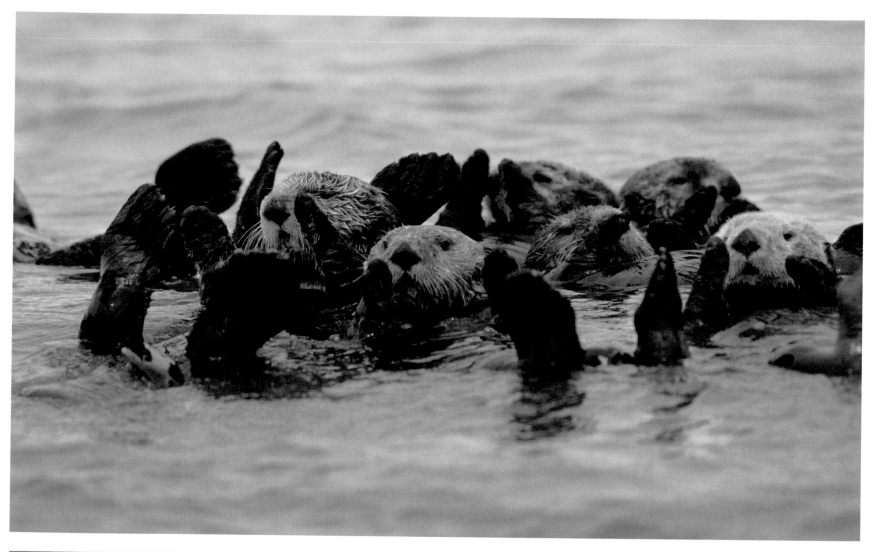

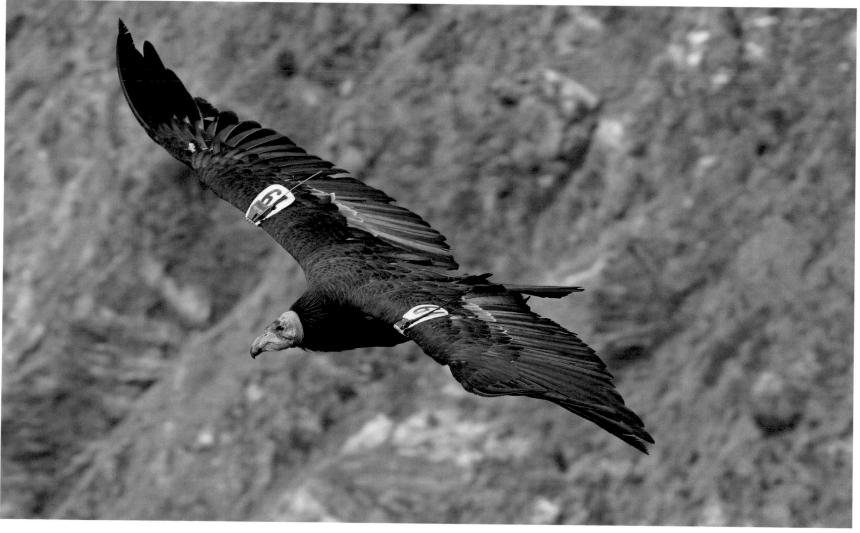

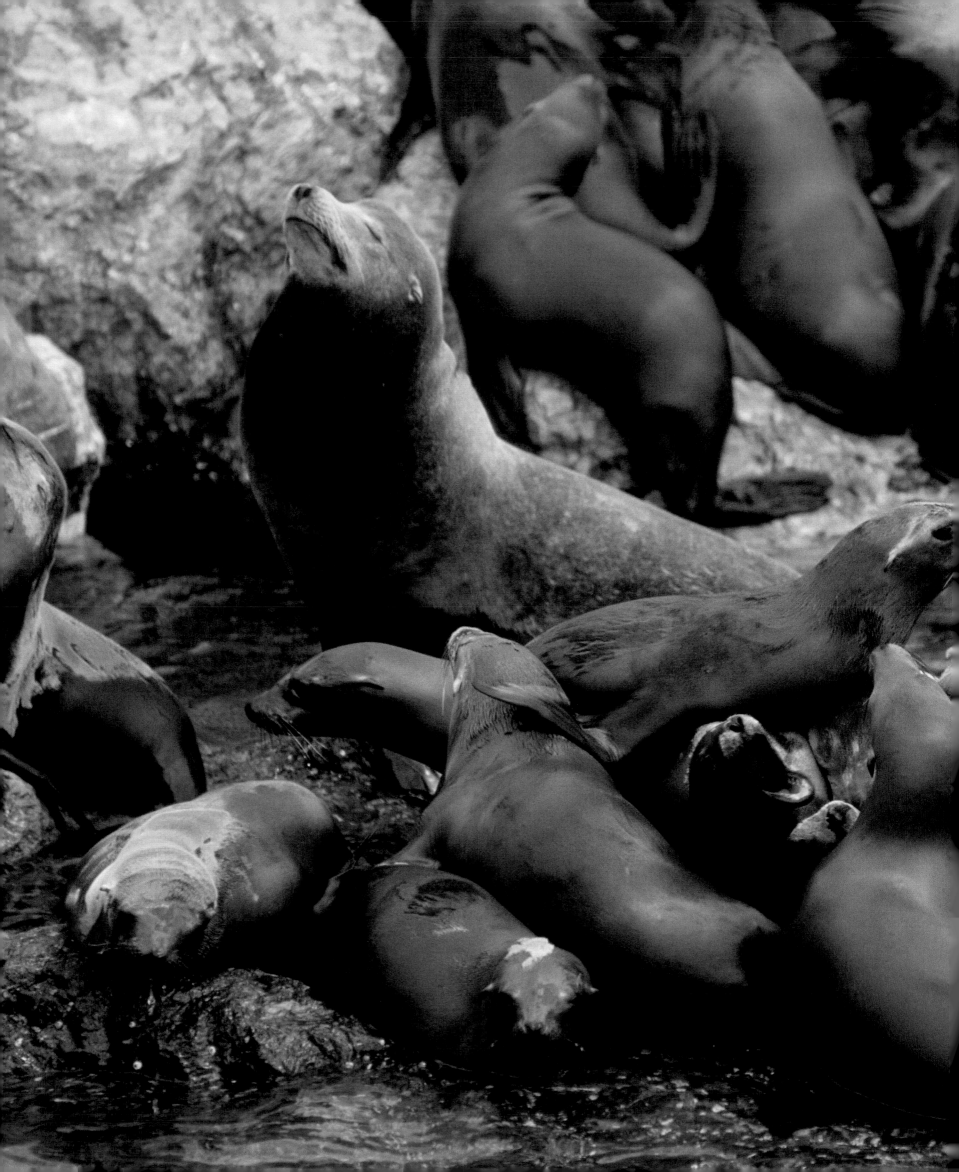

LEFT A bull California Sea Lion
sitting among his harem. Sea lions
usually have little fear of man,
and can on occasion be dangerous.

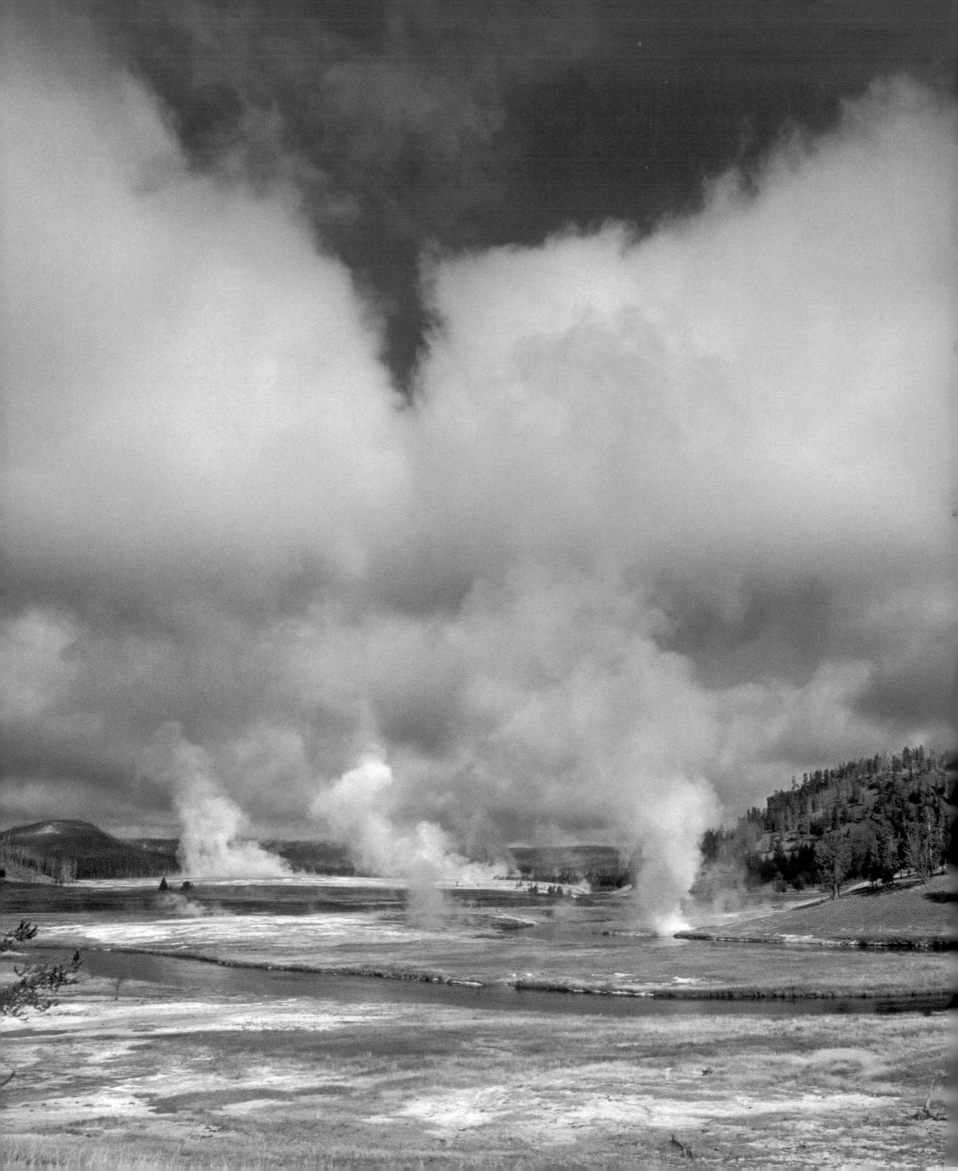

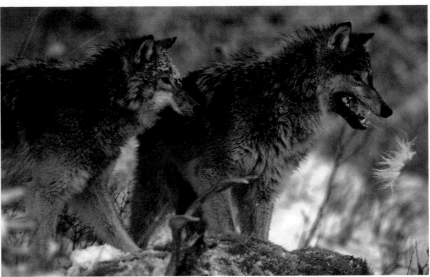

37. The Return of the Wolf to Yellowstone

Established in 1872 as the world's first national park, Yellowstone was initially valued for its outstanding scenery and dramatic geological formations, including the geyser "Old Faithful". Today it rightly receives top billing as an outstanding site for wildlife, and is home to the largest concentration of land mammals in the United States outside Alaska. Located mainly within Wyoming, but extending into neighbouring Idaho and Montana, the Yellowstone ecosystem includes large tracts of undisturbed habitat – ranging from mixed forests through river valley wetlands to open grass-land – and supports over 60 different mammal species. These include both Grizzly and Black Bears (*Ursus arctos horribilis* and *U. americanus*), Grey Wolf (*Canis lupus*), American Bison (*Bison bison*), Pronghorn Antelope (*Antilocapra americana*), Moose (*Alces alces*), Elk or Wapiti (*Cervus canadensis*), Mule Deer (*Odocoileus hemionus*) and Bighorn Sheep (*Ovis canadensis*). The diversity and number of animals, combined with the epic landscape, make this area a wildlife reserve on a very grand scale indeed.

One of the most significant developments in Yellowstone in recent years has been the reintro-duction of the Grey Wolf. Originally native to the area, wolves were systematically persecuted, both within the park and outside, as part of a "predator control" programme. By the 1930s they were extinct locally. However, the removal of the ecosystem's top predator caused problems. Among these was a big increase in the local population of Elk, which grew to the point that overgrazing was having a serious impact on the park's vegetation, especially key tree species such as aspen and willow. This in turn led to a loss of habitat for American Beaver (*Castor canadensis*), the numbers of which declined, leading to a degradation of the park's wetland habitats. It became increasingly clear that, without wolves, important aspects of the Yellowstone ecosystem were falling out of kilter, and so the decision was taken to reintroduce them.

In 1995–96 a total of 31 young wolves were captured in Canada and relocated to Yellowstone. They prospered, and today an estimated 120 wolves inhabit the park, moving around in 13 packs, although the number and size of pack formations changes regularly. The wolves prey mainly on Elk, which make up 75 per cent or so of wolf kills, but they will also take Bison and even small mammals such as Skunks! Watching wolves hunt is a very rare treat indeed, and seeing them at

LEFT **Up to three million visitors come to Yellowstone each year, lured by its fabulous wildlife, breathtaking scenery and celebrated volcanic activity.**

ABOVE **Still demonized in many regions of the world, the Grey Wolf has been given a second chance at Yellowstone. However, it remains on the hunted list in other parts of North America.**

RIGHT Black Bears very rarely
interact with Grizzlies and are
more likely to come into close
contact with humans. Their
penchant for raiding rubbish
bins continues to cause conflict.

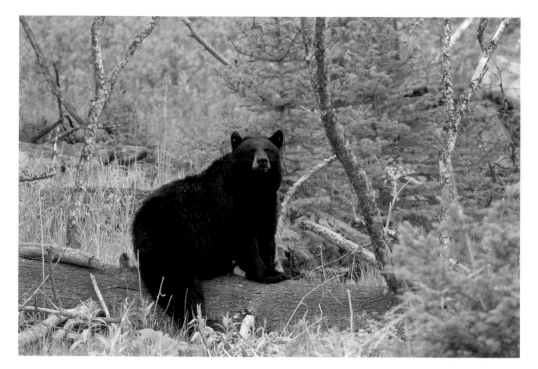

OPPOSITE TOP The Pronghorn
Antelope is North America's
fastest mammal, able to reach
speeds of almost 100 kilometres
(62 miles) per hour when
running flat out.

OPPOSITE BOTTOM Two male Elk
lock horns. Sparring between
males is commonplace, and
ferocious battles over access
to females can sometimes
result in the death of one
of the protagonists.

all in Yellowstone is far from guaranteed. They are usually shy and wary, but the park's Lamar Valley
offers the best chance of catching up with them, either as a large pack or, more usually, in smaller
groups or even lone individuals out on an opportunistic forage. Winter is the best season for finding
wolves, and an excellent time for wildlife-watching generally in Yellowstone. Although bears are
hibernating at this time, all other large mammals are active and often conveniently congregated near
supplies of food and water. One of the great wildlife sights in the area is the winter gathering of
between 6,000 and 7,000 Elk in the National Elk Refuge adjacent to the park's western boundary.
The snow-covered scenery here provides one of the finest backdrops anywhere in the world.

With the wolf now restored to Yellowstone, all the key players in the network are back in place.
This makes Yellowstone one of the best locations in the world for ecosystem study, and has helped
fuel the development of the "Yellowstone to Yukon" concept, also known as "Y2Y". Central to this
vision is the creation of a web of protected wildlife centres and connected wildlife movement
corridors, leading from Yellowstone right up to the Yukon in northern Canada. This exciting idea
of "re-wilding" – of establishing large-scale conservation systems rather than piecemeal reserves –
is galvanizing conservationists elsewhere in North America, as well as in Europe.

However, the immediate way ahead is fraught with problems. Among these are the commercial
interests of the gas and oil sectors, which are lobbying fiercely for an expansion in the sinking of
trial wells in the area. In some places, where drilling has already started, Mule Deer numbers
have declined by almost half and traditional migration routes have been disrupted. There is also
opposition from the livestock industry to the idea of extending the wildlife envelope, and specifically
to the potential expansion outside the national park boundaries of the bison population. In harsh
winter weather some bison already wander across the northern and western boundaries of the park
in search of forage at lower elevations on public land. This has always been contentious, not least
because of fears that migrating animals will infect domestic cattle with brucellosis (even though
the risk of direct infection is very low). For this reason, bison straying from the park – members of
the last continuously wild herd in the United States – have been hitherto rounded up and culled.
The latter has in recent years partly taken the form of a licensed hunt, and the pressure from some
quarters to "manage" bison in this way is intense.

Furthermore, just as wolf numbers have recovered, some old demons are reappearing. In early
2007, the US federal government was actively considering the delisting of the Grey Wolf as a
protected species in several states, including Idaho, Montana and Wyoming, on the grounds that
the population had grown too large. This act will enable public hunts to take place, and of particular
concern already is Idaho's proposal to kill no less than 80 per cent of its resurgent wolf population –
some 550 animals out of a total of 650 – little more than a decade after an expensive reintroduction
programme to bring wolves back to the region.

OVERLEAF An undoubted
conservation success story,
the American Bison now
appears to be secure after
almost having been wiped
out in the nineteenth century.

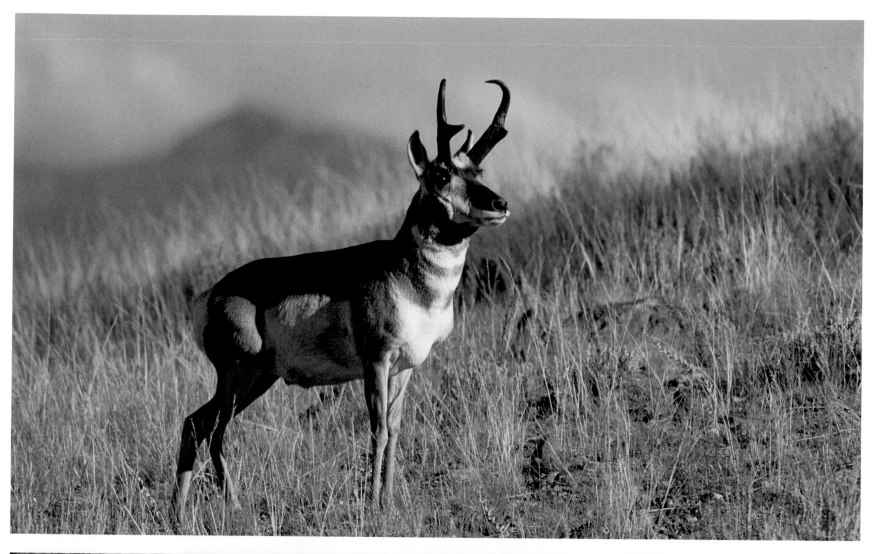

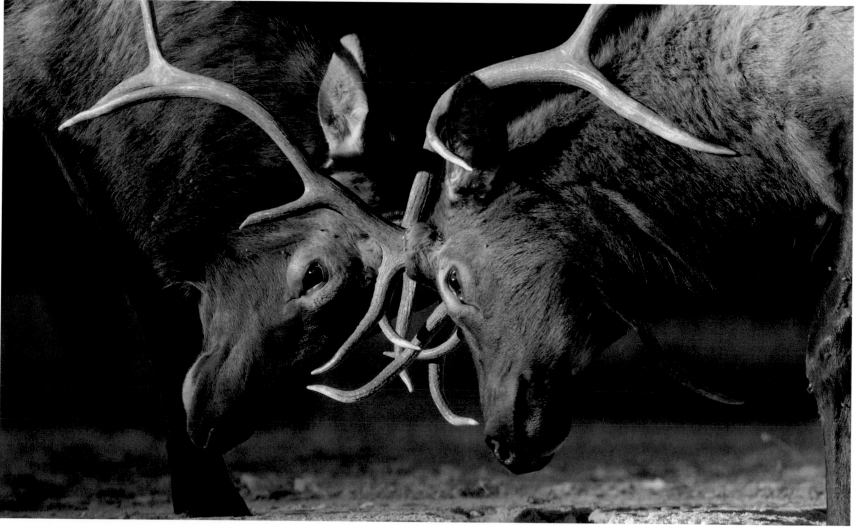

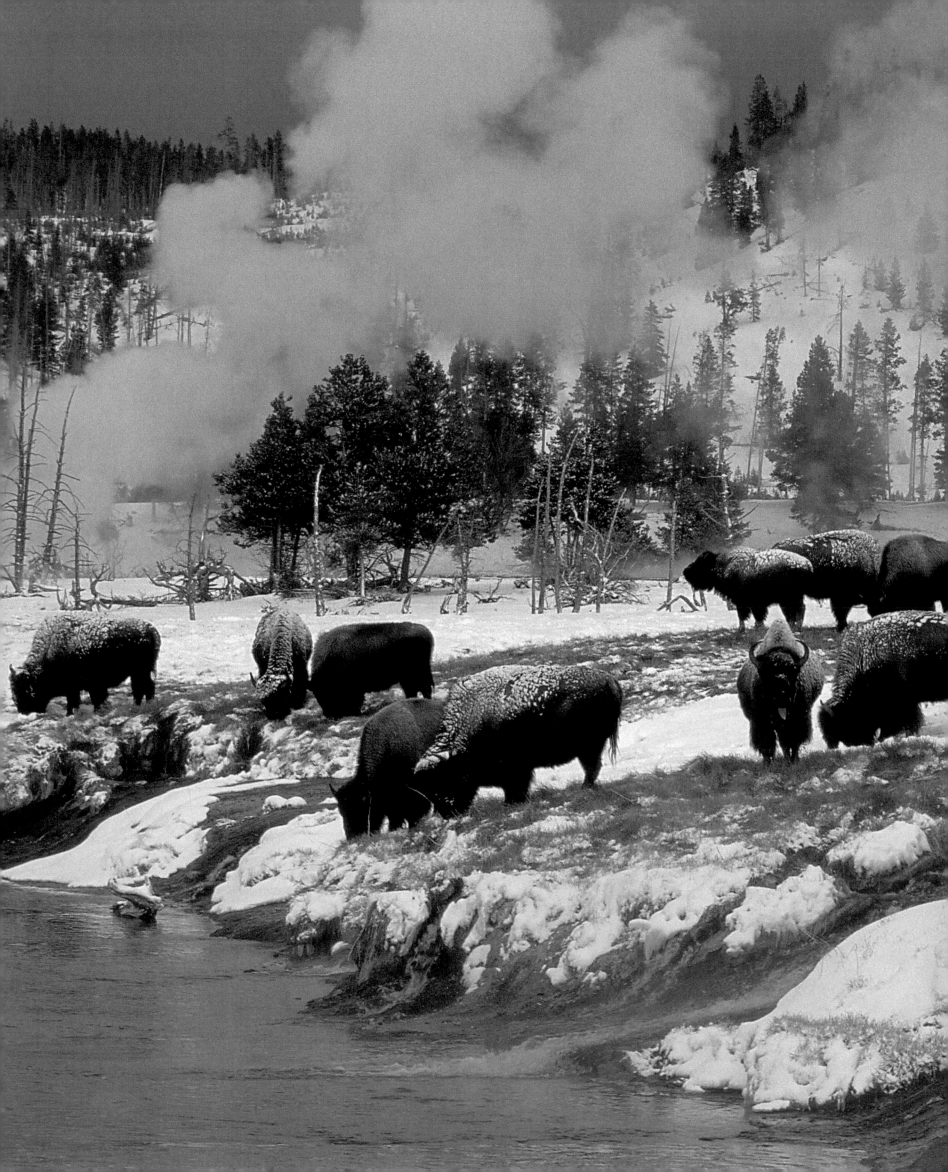

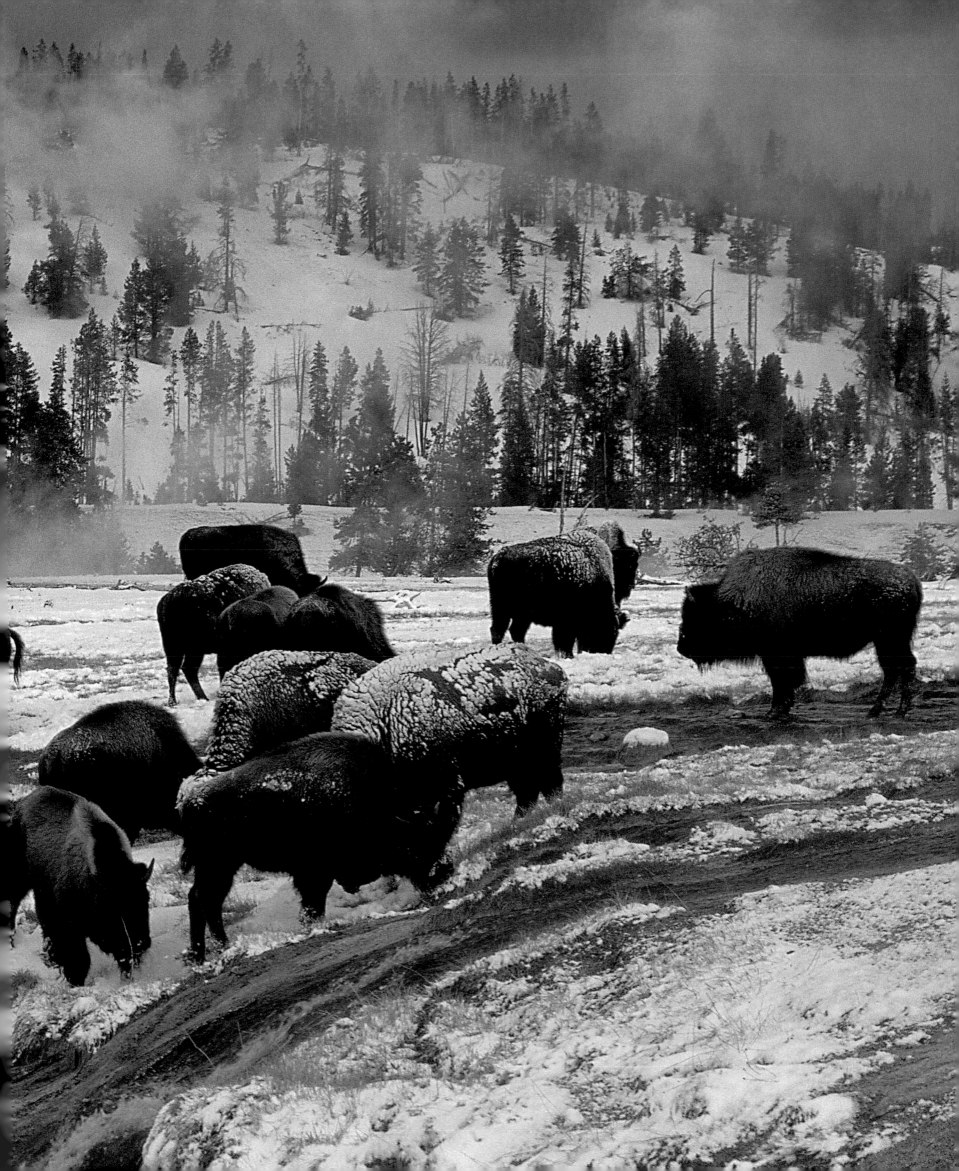

38. America's Tropics: the Everglades

Florida's reputation as a tourist destination and a landing-ground for retirees from colder northern climes is well established. With a rapidly growing human population, developmental pressure on land and resources is intense, but the Sunshine State also has a wilder side. Its sub-tropical climate makes it home to a variety of interesting wildlife for which it represents the only toehold in North America, and a network of protected areas help conserve what survives of once extensive tracts of forest and wetlands. Foremost among these are the Everglades – once regarded as a useless swamp and largely reclaimed for agriculture, save for an important section that was established as a national park in 1947 and as a World Heritage Site in 1979.

The national park occupies the southern portion of the surviving Everglades and covers a little over 6,000 square kilometres (2,300 square miles), constituting the largest wilderness area in the eastern USA. At first sight, much of this landscape may not necessarily fire the imagination – a seemingly endless sea of Saw-grass (*Cladium jamaicense*), relieved by occasional tracts of open water and clumps of trees. However, this first impression belies a much more complex and diverse picture. The Everglades are actually a highly dynamic ecosystem, with their health depending heavily on events to the north, and in particular at Lake Okeechobee. Heavy summer rains have traditionally filled the lake and then headed slowly south, seeping through the Everglades before finally draining into the Gulf of Mexico.

These wetlands are therefore a landscape "on the move", the local wildlife highly dependent on the seasonal ebb and flow of the water. Many waterbirds, for example, breed during the dry winter, a time of plenty when their prey is concentrated in the few surviving pools of water and therefore easier to pick off. The subtleties of the flooding pattern are also reflected in the variety of habitats, which equally respond to the slightest change in elevation. Although the freshwater marshes and "sloughs" dominate the landscape, there are drier limestone ridges supporting areas of pine woodland, and "hammocks" or tree islands in the middle of the marshes, carrying stands of hardwoods such as mahogany, oak and maple. Also dotted about the marshes are dense clumps of cypress, a tree which can survive in standing water and are often festooned with the characteristic Spanish moss. In the coastal channels are important mangrove forests, which give way to beds of Sea-grass in the shallow waters of the Gulf.

For most visitors, the Everglades mean two things: birds and alligators. Both are common and easy enough to see, but it was not always thus, certainly with regard to alligators. During the first half of the twentieth century, the American Alligator (*Alligator mississippiensis*) was hunted so intensively for its hide that it was at risk of extinction and was accorded federal protection in 1961. Numbers built up

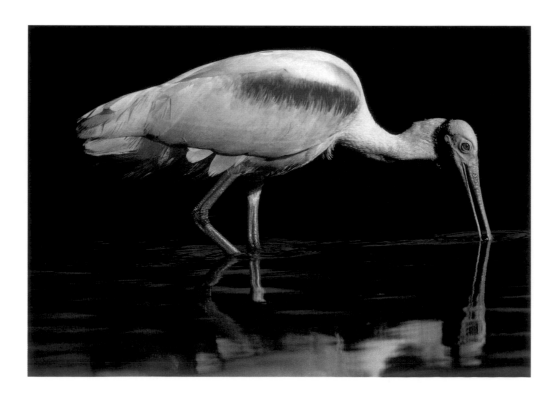

RIGHT The presence in Florida of birds such as the Roseate Spoonbill helps emphasize the state's sub-tropical credentials.

OPPOSITE Many parts of the Everglades are virtually impenetrable to humans, and partly under water for some or all of the year. Such habitats support many varieties of wildlife, much of it found nowhere else in North America.

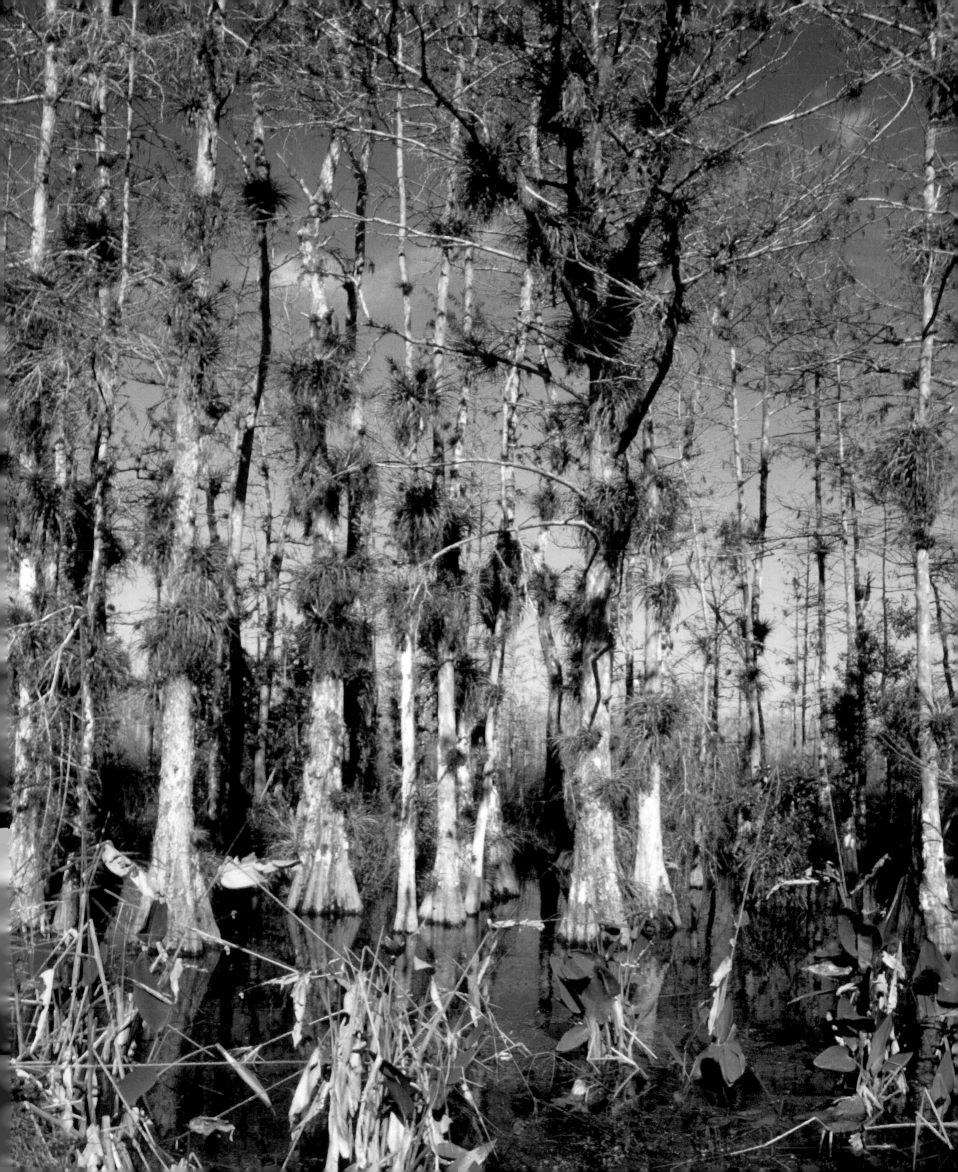

FAR LEFT The Purple Gallinule (*Porphyrio martinica*) is a migratory bird across much of the United States, but resident all year round in the warmth of the Everglades.

LEFT The highly specialized Snail Kite is essentially a South American bird, but maintains a toehold in the south of Florida.

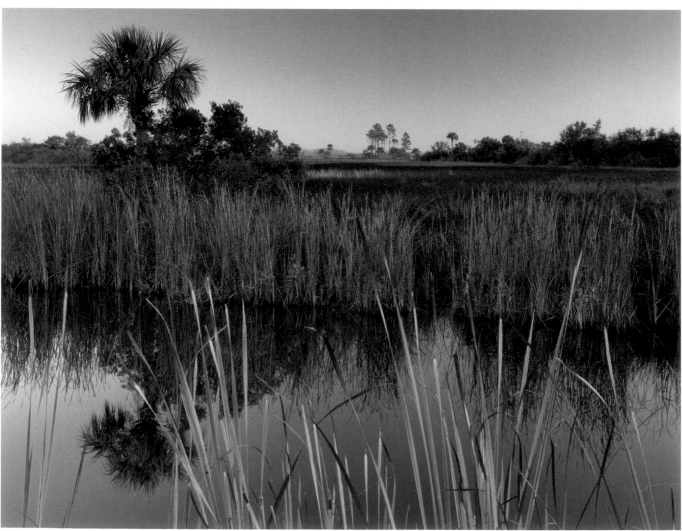

LEFT The Florida wetlands are a complex mix of habitats, as here in the Fakahatchee State Preserve, an important component in the wider Everglades ecosystem.

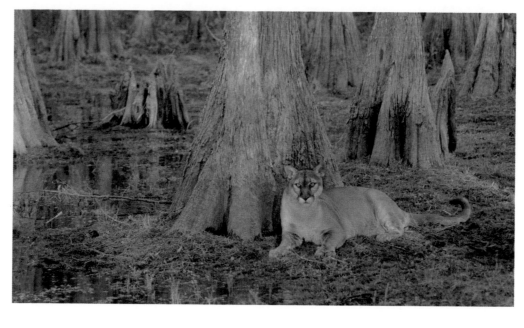

quickly as a result, and the species is now off the endangered list and potentially reaching pest proportions in some places. Although the park's top indigenous predator, with large individuals even known to take on Puma (see below), in recent years there have been instances of fully-grown alligators being predated by escaped – or illegally released – non-native pythons. Much shyer and rarer than the alligator, and distinguished by its narrower snout and the fact that its lower teeth are always visible, is the American Crocodile (*Crocodylus acutus*). Again decimated by hunting in the past, fewer than 1,500 survive in the United States, with the Everglades holding a sizeable percentage of this population.

Some 400 species of bird have been recorded in the Everglades, and these include several exotic species guaranteed to turn a birder's head. Top of the list are waterbirds such as Wood Stork (*Mycteria americana*), Limpkin (*Aramus guarauna*), Roseate Spoonbill (*Ajaja ajaja*) and Reddish Egret (*Egretta rufescens*), but one of the most interesting local birds is actually a raptor – the Snail Kite (*Rostrhamus sociabilis plumbeus*). Totally dependent for its food on apple snails (*Ampullariidae* sp.), which it breaks into with a specially adapted beak, this elegant bird hangs on in southern Florida.

The Everglades are also among the last haunts of a subspecies of Puma (*Felis concolor coryi*), known locally as the Florida Panther. Pumas – also referred to as Cougars and Mountain Lions – were once widely distributed across much of North America, but human persecution and loss of habitat resulted in their effective extinction east of the Mississippi River. Although there have been definite Puma sightings from various eastern States in recent years, the Florida population is the only confirmed sustaining population. However, their long-term viability is in doubt: although numbers have picked up from their lowest ebb, when just 30 individuals remained, the population is still fewer than 100, and continually threatened by habitat loss and fragmentation, poor genetic health and collisions with motor cars. In an attempt to boost genetic diversity, in 1995 eight female Pumas from Texas were released in southern Florida. Five of them bred successfully with native Floridian males and were later removed from the area to reduce over-exposure to outside genetic material. Meanwhile, the hybrid kittens that had been born as a result showed a better survival rate than purebred offspring, and their presence will hopefully reduce the incidence of genetic defects in the native population and thereby help augment numbers further.

Although there are various challenges facing those responsible for conserving the Everglades, such as the impact of non-native plants (of which at least 221 species have been recorded in the park), the biggest issue of all is – not surprisingly – water management. Basically, the Everglades are drying up. In the days when the seasonal waters flowed unhindered from north to south, the Everglades were a paradise for breeding waterbirds; an estimated 300,000 birds nested here in the 1930s. Today less than 10 per cent of that number remains – the result of water being diverted to meet human requirements in Florida's cities and farmland. When too little water reaches the park, the tiny aquatic organisms that underpin the whole food chain are not produced in adequate quantities to sustain those creatures above them. For example, with apple snail numbers depleted through lack of water, the Snail Kite is now in decline – a beautiful if poignant indicator of how the ecosystem is starting to unravel.

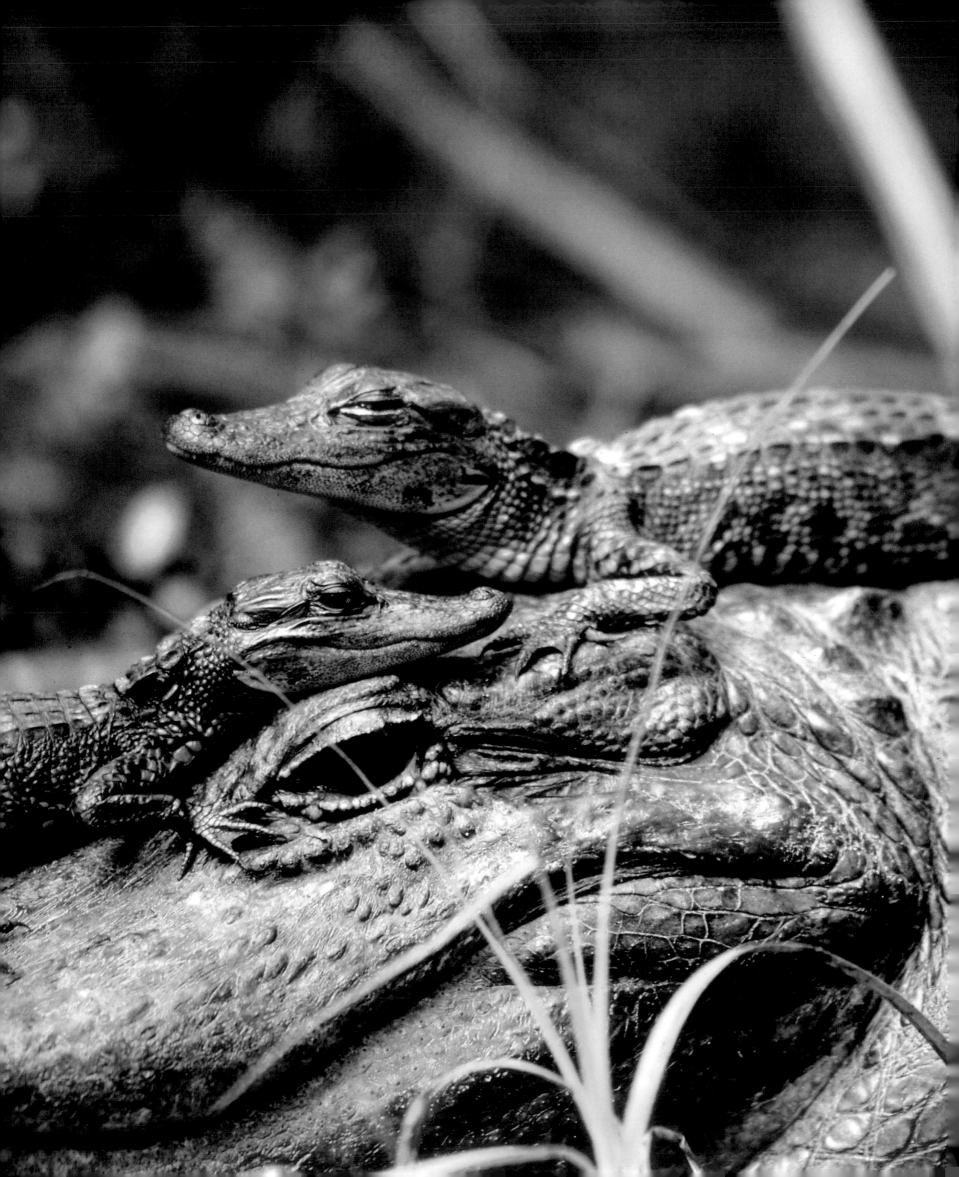

LEFT Once slaughtered remorselessly for their skins, alligators have come back in style and are now very numerous. Southern Florida is one of the few places in the world where species of alligator and crocodile live in close proximity to one another.

39. The Polar Bears of Churchill

Since the late 1970s, the Canadian town of Churchill has become famous as the easiest place in the world to watch Polar Bears (*Ursus maritimus*). Located at 58 degrees north, the Churchill area is actually too far south to qualify as true Arctic, but the cooling effect of Hudson Bay confers on the local landscape, climate and wildlife a character more typical of that further north. Here it is possible to view a range of essentially Arctic wildlife that normally requires much greater effort – and expense – to enjoy. While it is to Churchill itself that most visitors head, the town lies less than 50 kilometres (30 miles) from the boundary of Wapusk National Park, one of Canada's largest. The park was established in 1996 to protect the Polar Bears of this section of western Hudson Bay, and lies in the transition zone between tundra and taiga. Home to the world's most southerly population of Polar Bears, Wapusk is particularly significant as a denning area; many female bears give birth here, and some of the dens appear to have been in use for many decades, if not centuries.

The natural habitat of Polar Bears is open pack ice. Supremely adapted to life in such testing conditions, this is where they hunt their favoured prey – seals. Although the bears are strong swimmers, the seals are too fast for them to catch in the open sea, and so they rely on ambushing their prey when it is either resting out on the ice or coming up for air via breathing holes. Ringed Seal (*Pusa hispida*) are the bears' prey of choice, but they will eat virtually anything that comes their way, including a variety of other mammals, birds, crustaceans and fish, as well as carrion. Hudson Bay's bears spend more than half their year out on the ice, but by July this has almost completely melted and so they are forced to come ashore, gathering in large numbers on the open tundra and rocky shores around Cape Churchill. Here they potter about and loaf around, providing one of the world's great bear-watching opportunities. During this period the bears fast, losing weight and condition continuously until the bay freezes again – usually in November – and they are able to head out over it again and resume hunting.

Even when not in top shape, adult Polar Bears are formidable animals. A mature male normally weighs between 300 and 450 kilograms (661 and 992 pounds) and (the largest recorded in the Churchill area tipped the scales at 700 kilograms [1,543 pounds]) and stands over 2.5 metres (8 feet)

BELOW A female Polar Bear and her cub crossing the ice. For much of the year Polar Bears live in conditions that few other mammals could withstand. Indeed, the warming of their environment may even threaten them with extinction.

OPPOSITE A close up of a male Polar Bear. During the 1960s and '70s unregulated sport hunting, including the shooting of bears from helicopters, took out many of the larger males.

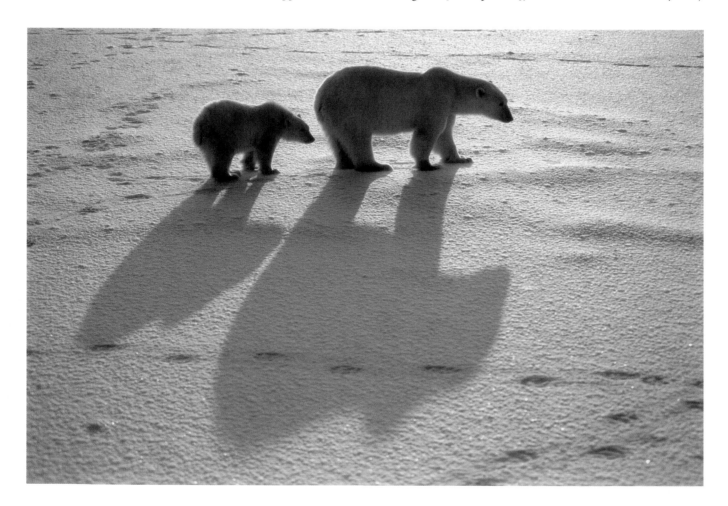

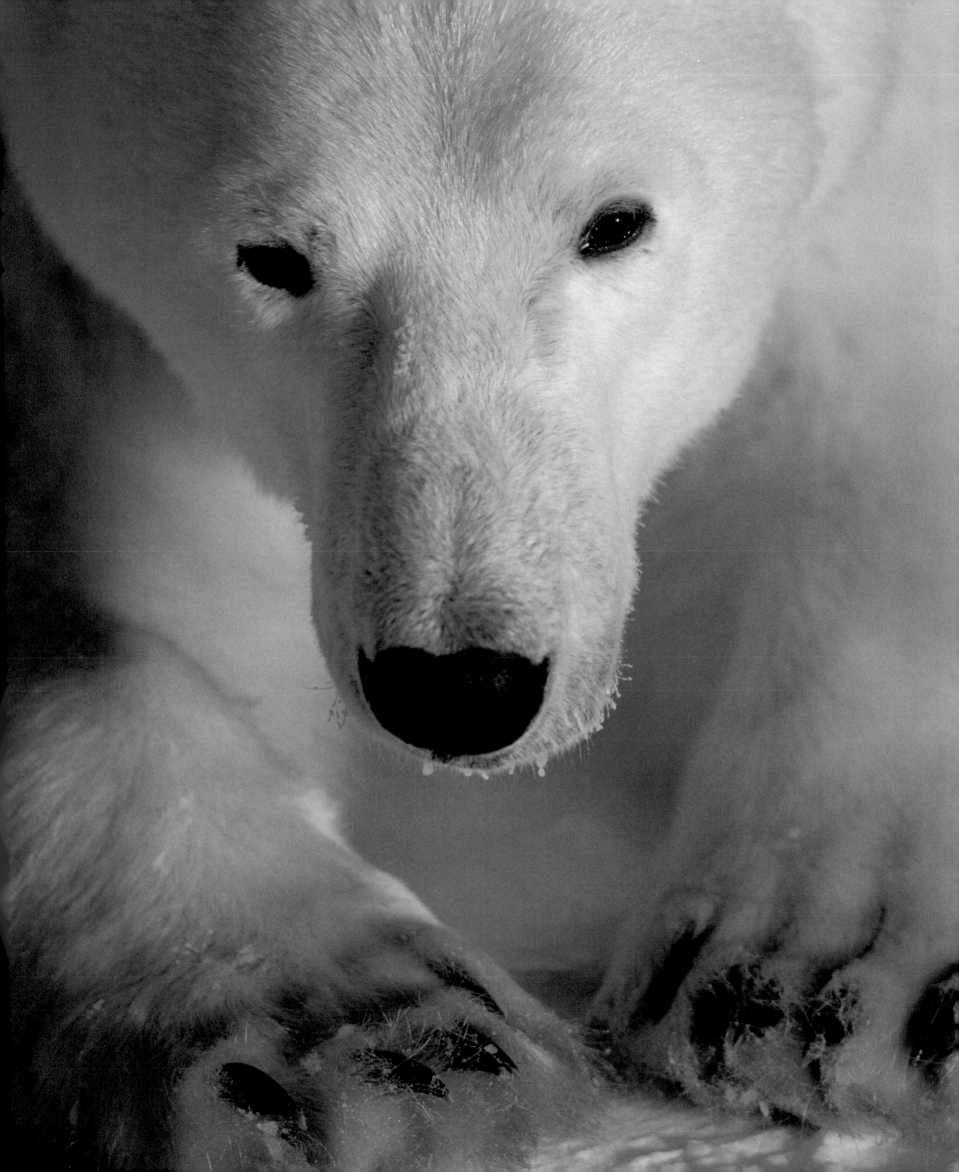

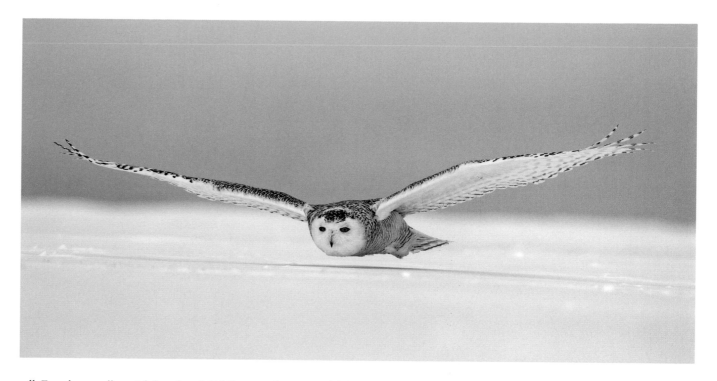

tall. Females usually weigh less than 300 kilograms (661 pounds), but both sexes are highly dangerous and should be treated with the utmost respect and caution at all times. Highly unpredictable, and the most predatory of all bear species, they can easily outrun a human, and should never be approached on foot. The thousands of people that come to Churchill every year to view the bears therefore do so from the comfort and safety of specially designed "tundra buggies". Even so, bear–human contact does sometimes take place in Churchill on a more direct and potentially alarming level. Polar Bears will on occasion wander into town, posing great danger to the human inhabitants. In such cases, the bears are darted and transported away from the area, but the relationship is always a delicate one and under constant review.

Bears are not the only wildlife attraction in the Churchill/Wapusk area. Arctic Fox (*Vulpes lagopus*) is a common and attractive sight, and in late spring the tundra is home to hundreds of thousands of breeding ducks and waders. July and August bring a blaze of floral colour, with Lapland Rosebay (*Rhododendron lapponicum*), Mountain Avens (*Dryas octopetala*) and Purple Saxifrage (*Saxifraga oppositifolia*) all in bloom. This is also the best time of year to see Beluga Whale (*Delphinapterus leucas*), with over 3,000 gathering in the Churchill River estuary. Intelligent, inquisitive and highly vocal, they can be approached closely by boat, and there can be few better places in the world to enjoy this delightful cetacean. By autumn, when most bear-watching visitors turn up, there is less other wildlife about, but there are still some quality birds to look out for. These include Snowy Owl (*Nyctea scandiaca*) – quite a common sight – and that other avian predator of the Arctic, Gyr Falcon (*Falco rusticolus*), which is less dependable but still regular. Other birds reliably present at this time of year include Willow Ptarmigan (*Lagopus lagopus*), Rock Ptarmigan (*Lagopus mutus*) and Snow Bunting (*Plectrophenax nivalis*).

As if Polar Bears, Belugas and Snowy Owls were not incentive enough to visit Churchill, for up to 300 or so nights of the year the extraordinary Aurora Borealis is also visible here. Yet this northern paradise is in trouble. With a warming climate, Hudson Bay is freezing over progressively later each autumn, and the Polar Bears are marooned for longer on the land, unable to resume hunting and therefore more likely to wander into Churchill and scavenge a meal at the town's garbage dump, for example. As the weeks pass, they are at greater risk from starvation and associated illness, and then struggle to regain peak condition during their shortened hunting season. Numbers are already falling; the Polar Bear population on Hudson Bay's west coast declined from 1,200 individuals in 1987 to 950 in 2007, and – most worryingly – cub survival rates are down. Evidence suggests that for every three cubs that made it past their first year in the early 1990s, fewer than two do so now. Average weaning ages are appreciably later now, and the average weight of fully grown adults is showing signs of reduction. All in all, the outlook is bleak. Indeed, if these worrying trends continue we could witness the total extinction of the Polar Bear before the end of this century.

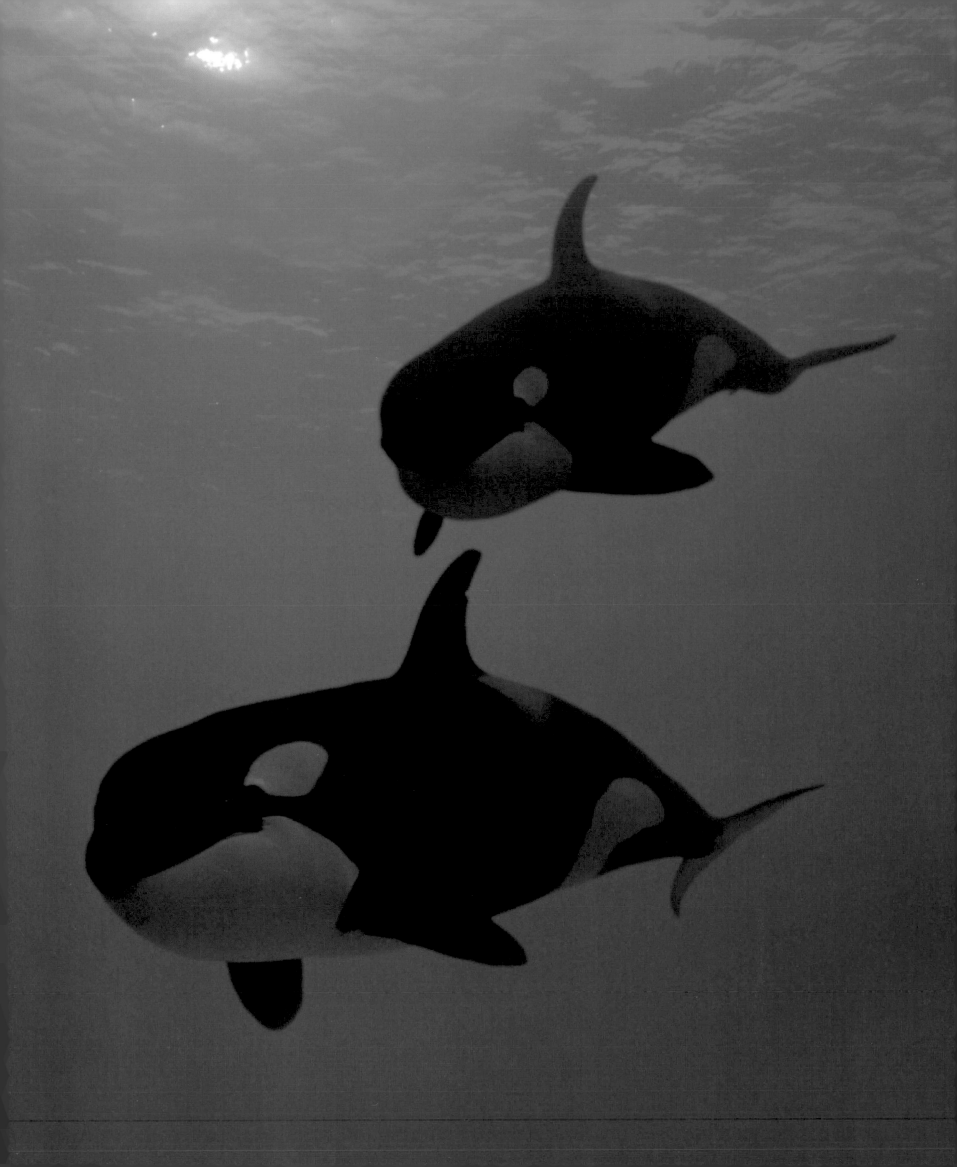

OPPOSITE Orcas are always
dramatic and impressive animals
to watch. Intelligent and curious,
they will often approach divers
to within a few metres.

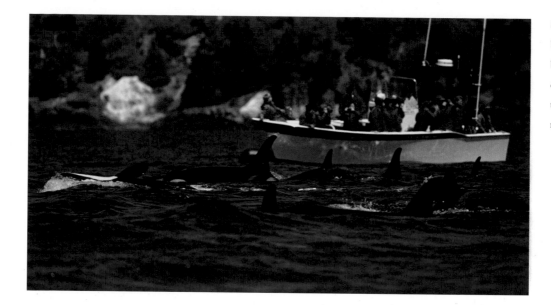

LEFT Orca-watching from
boats is undoubtedly exciting,
but its popularity is such that
careful monitoring is required
to ensure that the animals are
not unduly disturbed.

40. The Orcas of the Haro Strait

Also known as the Killer Whale or Grampus, the Orca (*Orcinus orca*) is one of the most immediately recognizable sea mammals. Widely distributed across the world, Orcas are equally at home in polar seas and in tropical and equatorial waters, and their characteristic black-and-white body pattern makes them highly distinctive. However, the fame of the species is due almost entirely to the popularity of Orcas in marine parks and aquaria, rather than to the fact that many people see them in the wild. Thankfully, the capture of wild Orcas to satisfy the demand of the animal show industry has decreased in recent years, and opportunities to see them in their natural environment are growing. One of the best places to watch Orcas is around the San Juan Islands and the Haro Strait, between the mainland of Washington State and the southern end of Canada's Vancouver Island.

Orcas are not whales at all, but the largest species of dolphin. Highly social animals with a complex and sophisticated system of behaviour, they live in family groups known as pods, usually composed of several generations and led by the oldest female. Some individuals are known to be at least 80 years old, and so a pod can include many generations. Indeed, Orcas of both sexes will often spend their entire lives with their mother, until she dies. Although pod size varies from 5–50 and averages at about 18–20, "superpods" of up to 150 animals have been recorded. There is a high level of pod individuality, with particular pods demonstrating different types of behaviour and, most significantly, each pod emitting a unique set of calls. Known as pod dialects, these enable pod members to recognize each other at a range of several kilometres.

The Orcas that live off British Columbia and Washington are probably the most studied in the world. Although Orcas all look similar, individuals can be distinguished from one another by the size and profile of their dorsal fin and by the saddle patches behind the fin, as well as by scars and marks. Research in the Haro Strait area has revealed that there are three different types of Orca occurring here – resident, transient and offshore – and that these are sufficiently distinct genetically to be considered as separate races. For example, the resident Orcas, of which three pods have been identified, have rounded dorsal-fin tips and feed primarily on fish, mainly salmon; the transient population lives on a diet of sea mammals and has more pointed dorsal tips; while the offshore Orcas, which spend almost all of their time far out at sea, have curved fins and eat fish and turtles.

Capable of swimming at speeds of up to 55 kilometres (35 miles) per hour, Orcas are the ocean's top predator and have no natural enemies. They feed on a wide variety of animals, from squid to whales, and will hunt cooperatively to overcome large prey. However, there have been no confirmed records of wild Orcas deliberately attacking a human, and only isolated cases of attacks in captivity. The most usual behaviour shown to people by Orcas is one of curiosity. The three resident pods of Orca in the Haro Strait (named "J", "K" and "L" pod respectively) collectively number 80–90

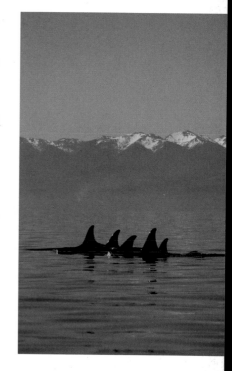

ABOVE The tall dorsal fin of the Orca is a diagnostic feature and in adult males can reach a height of 1.8 metres (6 feet).

individuals, and although present in the area throughout the year, they are most readily seen from late May through to October, when they feed on the migrating salmon that move through the strait. Passing Orcas can often be viewed well from the west coast of San Juan Island, but most visitors take advantage of the many boats that go out into the Strait and surrounding waters especially to find the animals.

Other marine mammals that can be seen readily in this area include Dall's Porpoise (*Phocoenoides dalli*), Harbour Seal (*Phoca vitulina*), Minke Whale (*Balaenoptera acutorostrata*) and Steller's Sea Lion (*Eumetopias jubatus*), which winters here in increasing numbers. Birdlife is varied and interesting, and includes several species of auk, such as both Ancient and Marbled Murrelets (*Synthliboramphus antiquus* and *Brachyramphus marmoratus*), which winter here, and Rhinoceros Auklet (*Cerorhinca monocerata*), which breeds locally. The San Juans are particularly significant for Bald Eagle (*Haliaeetus leucocephalus*), and are home to more than 100 pairs, one of the largest single populations in North America. These impressive birds can often be seen working their way along the cliff edges or around the saline lagoons, perched in trees along the shoreline, or swooping down to pluck a dead fish from the surface of the water.

There is no doubt that watching the huge dorsal fins of a pod of Orcas as they rhythmically cleave their way through the water is one of the great wildlife experiences. Indeed, such is the appeal of these magnificent animals that a sizeable whale-watching industry has developed around the Haro Strait, to the extent that at peak times of year the water is dotted with marine craft, intent on locating and then following the pods as they hunt. Whilst all such whale-watching is bound by guidelines specifically devised to ensure there is no undue disturbance to the Orcas, the volume of traffic has raised concerns that the animals' natural hunting behaviour may be affected by the numbers and movements of those watching them. Meanwhile, the Orca population of the Haro Strait area has declined in recent years. The reasons why are unclear, but may be related to a reduction in the amount of prey available, and possibly to the accumulated effect of toxins such as lead, mercury and polychlorinated hydrocarbons (PCBs), to which the Orca's position at the top of the food chain makes it highly vulnerable.

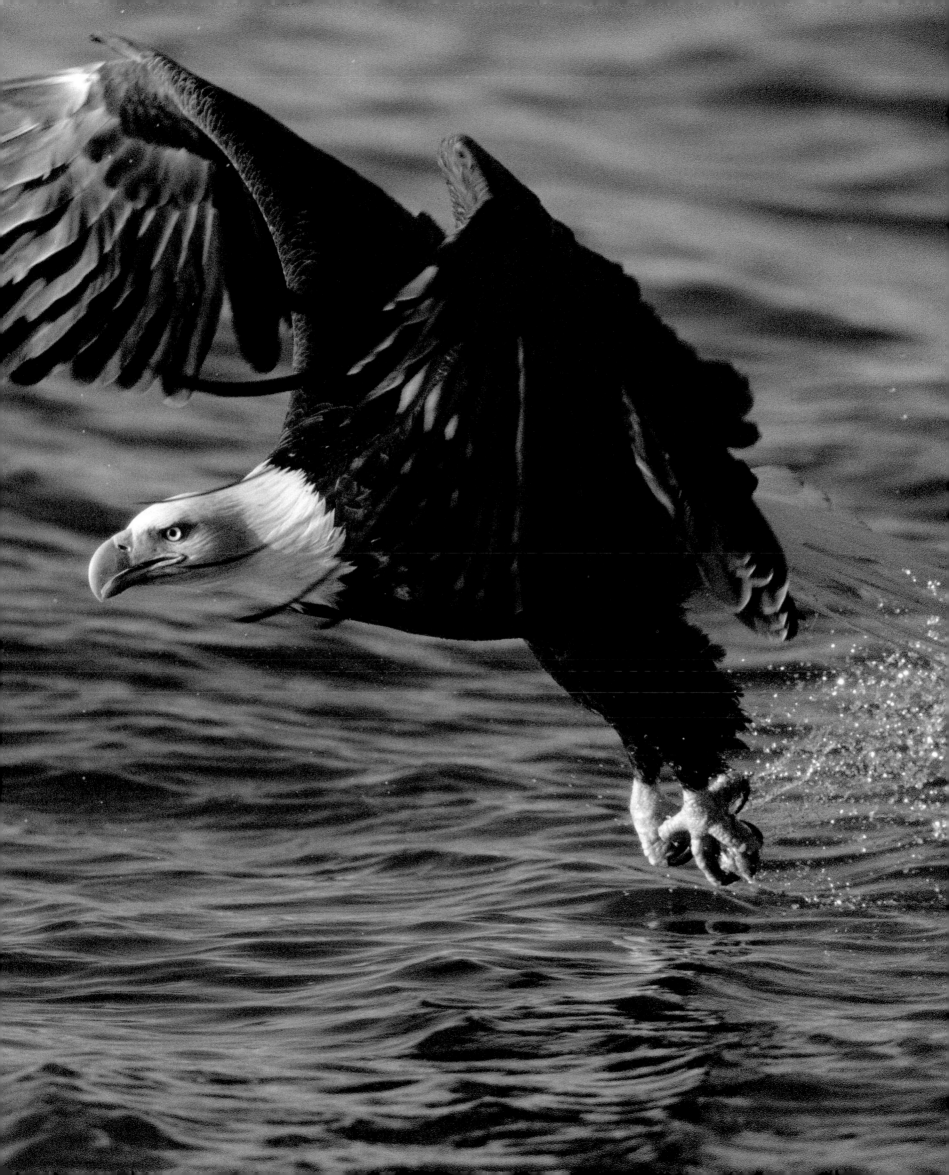

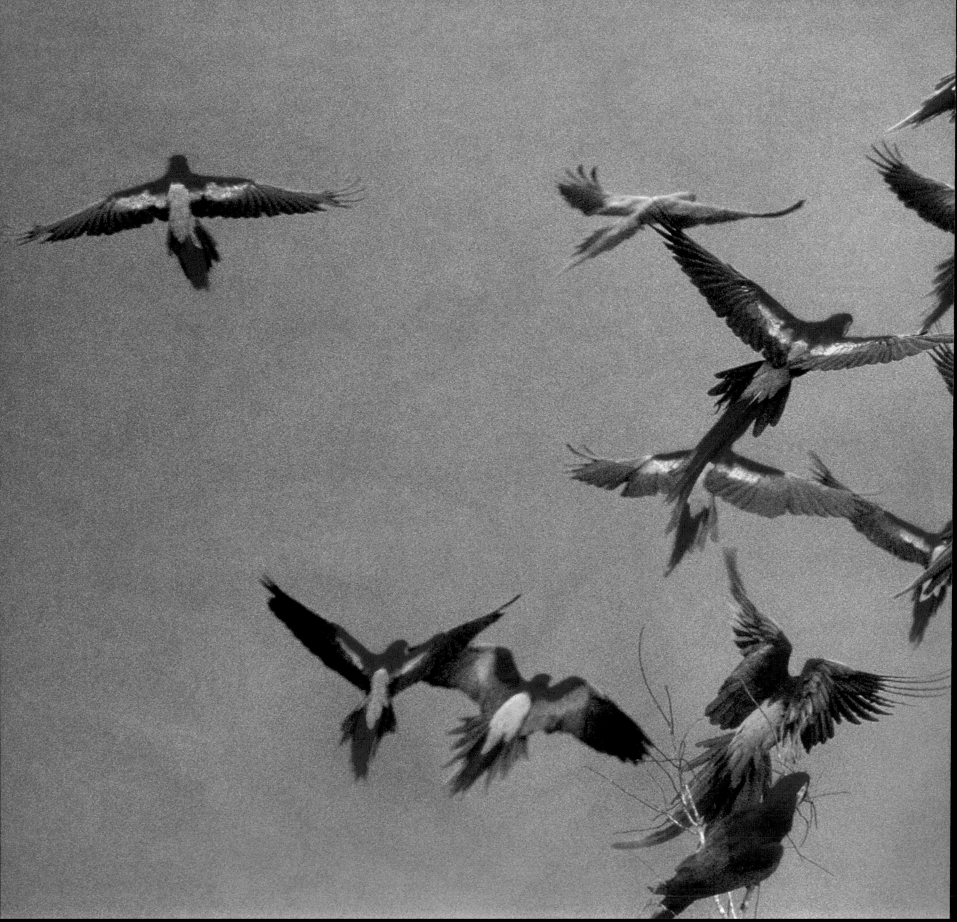

With a dramatic variety of wildlife-rich habitats and a bewildering range of flora and fauna, Latin America is home to some of the most bio-diverse places on the planet. From the deserts of Mexico to the glaciers and snowfields of the High Andes, there are unparalleled opportunities for top-quality wildlife watching right across the continent. The scale of the sights on offer is overwhelming at times: Brazil's Amazon basin contains the world's largest continuous tract of lowland rainforest, for example. Meanwhile, Peru can claim to be the country with the greatest number of recorded bird species – over 1,870 in total – while the congregations of nesting turtles along the coasts of Costa Rica comprise one of the highest densities of reptiles anywhere in the world. Such richness and diversity is, however, under threat. Habitat loss, pollution and global warming are all taking their toll, and stringent conservation measures are required to ensure that this unique natural heritage is not lost.

BELOW Few birds sum up the exotic qualities of Latin American wildlife more than macaws, particularly when seen in flight.

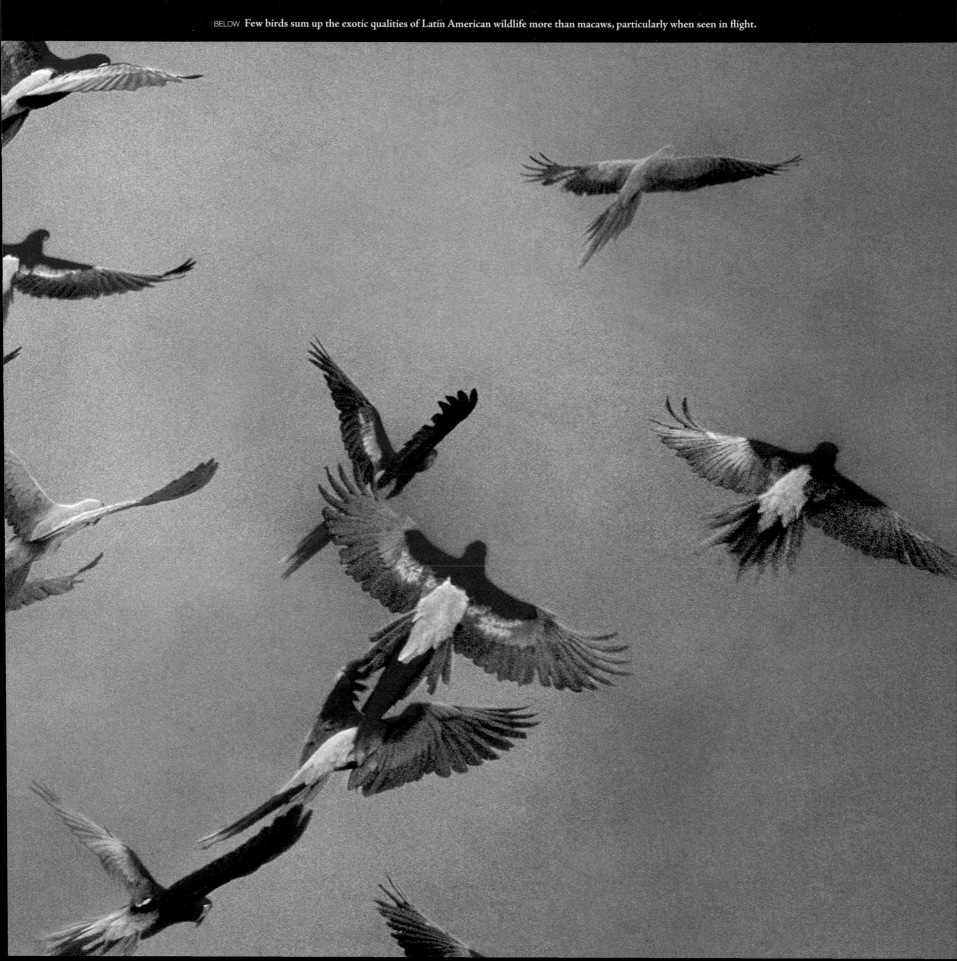

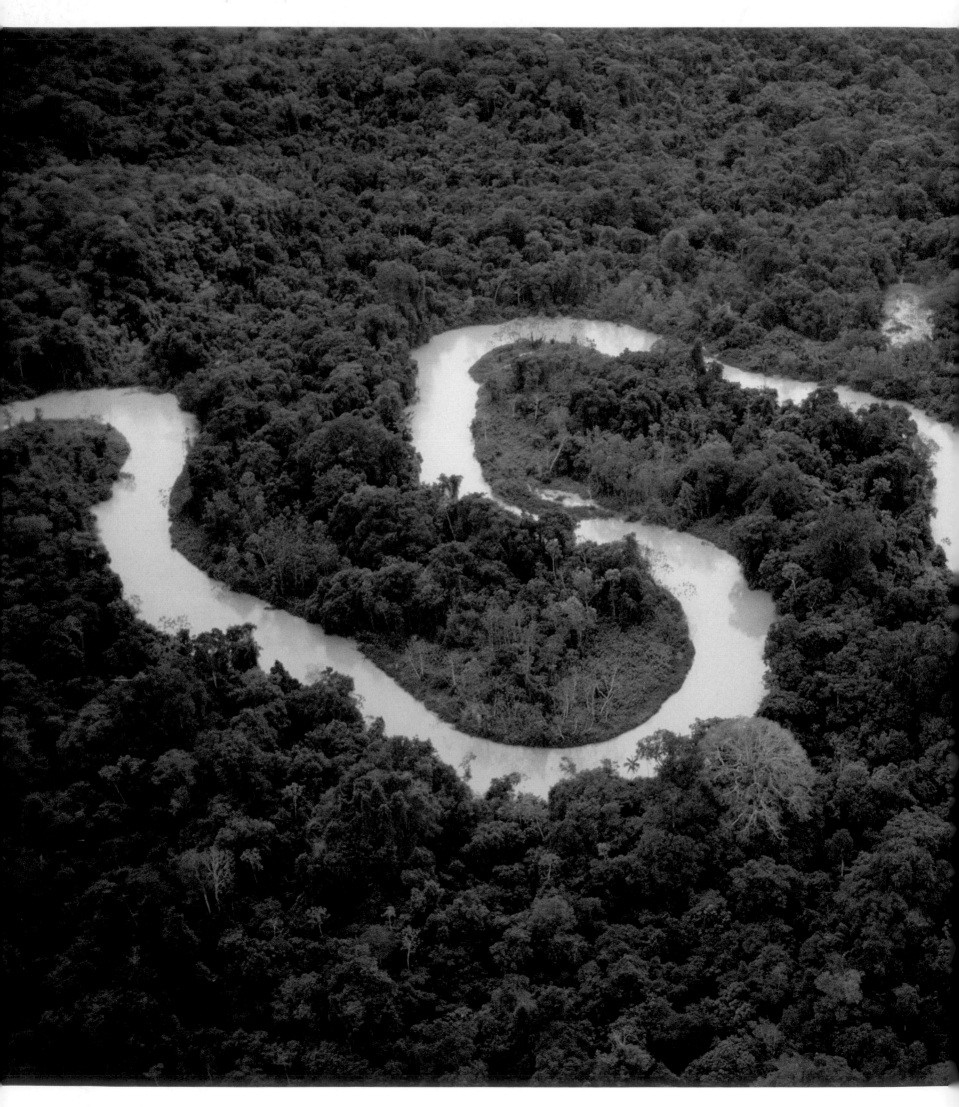

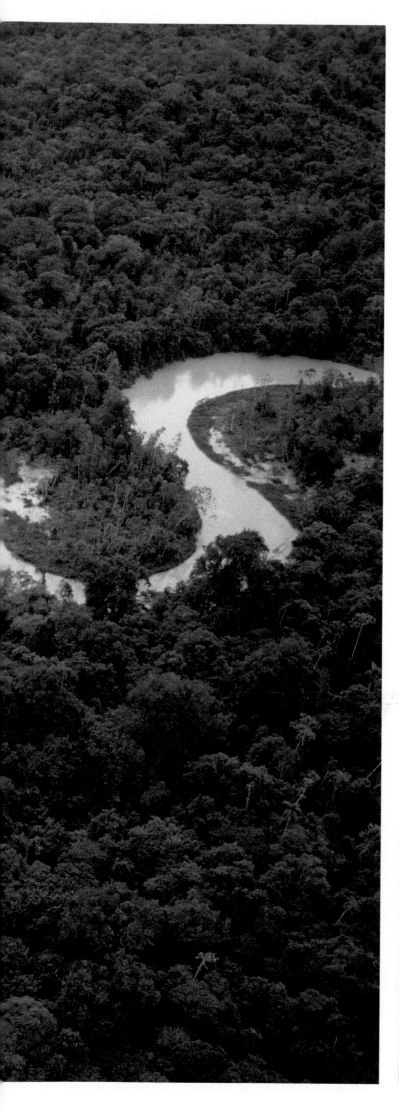

41. The Flooded Forests of the Amazon

At 5.5 million square kilometres (2.1 million square miles), the Amazonian rainforest is the largest single expanse of lowland rainforest in the world, and probably the best-known wild landscape of any type. For several decades, the rate of its destruction has been extensively publicized and has served as a symbol of the wider environmental damage being wrought around the globe. Yet despite the rainforest's prominence as one of the great conservation *causes célèbres* of our time, much of this vast but infinitely intricate and subtle ecosystem remains under threat, both real and potential. This is all the more worrying as we still understand so little of what the forest contains and how it works, although it is clear that human actions in the region may already have resulted in the extinction of species before they have been "discovered".

Our lack of knowledge is exacerbated by the fact that, although the Amazonian forest is classic tropical rainforest, it is anything but a monotype and contains a surprisingly vast and complex range of smaller habitat types, each of which supports a wealth of diverse wildlife. Another of the more unexpected aspects that strike newcomers to the rainforest environment is how different much of it looks from the "inside". Most visitors travel at least part of their way into the Amazon by boat, and from the water the forest looks impenetrable, a frothing mass of tangled vegetation strung with vines and lianas. Yet once you are ashore and have wandered a short distance in among the trees, it becomes a very different place.

Immediately noticeable is how surprisingly open the forest can be at ground level – where it is often perfectly possible to walk without constantly having to hack your way through dense foliage. All around you are imposing buttress-rooted trees, which create a great sense of natural architecture, but the canopy – 30–40 metres (98–130 feet) above your head – is largely closed, with very little sunlight penetrating down to the understorey. The relative darkness results in poor ground flora and a forest floor covered mostly by huge leaves that have tumbled down from above. At intervals, individual trees known as "emergents" break through the canopy, reaching as high as 50 metres (165 feet).

LEFT Threaded by waterways, the Amazonian rainforest is one of the most bio-diverse habitats on the planet. Vast tracts remain virtually inaccessible other than by boat.

BELOW The forest canopy is generally very dense, allowing little sunlight to filter through. The conditions typical of the flooded forest habitat are exploited by many forms of wildlife, and new discoveries are being made all the time.

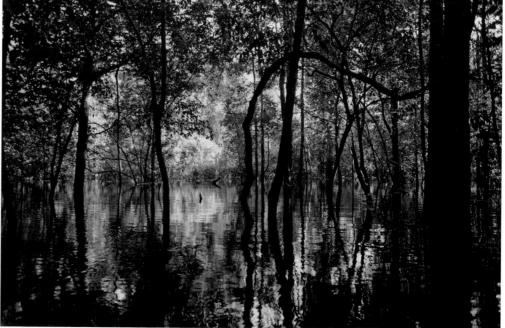

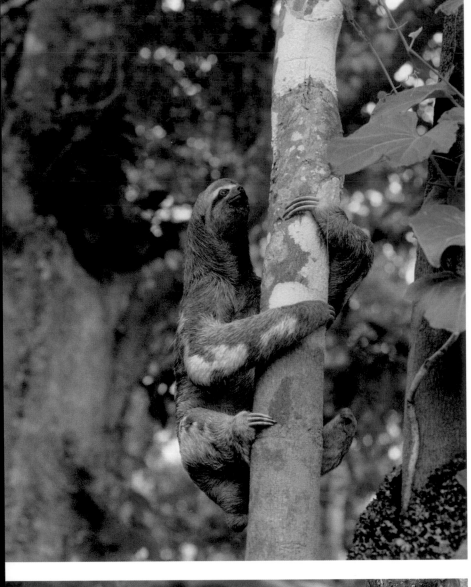

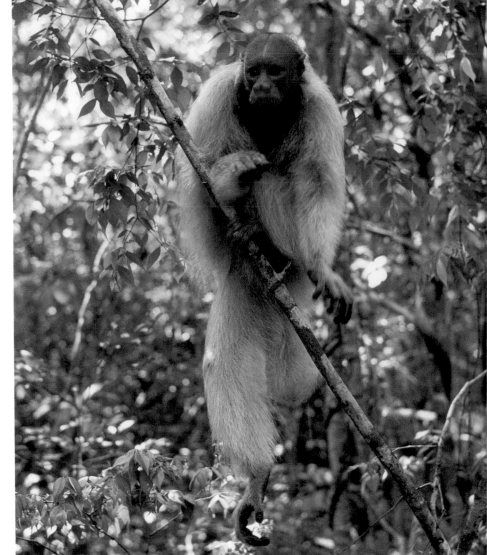

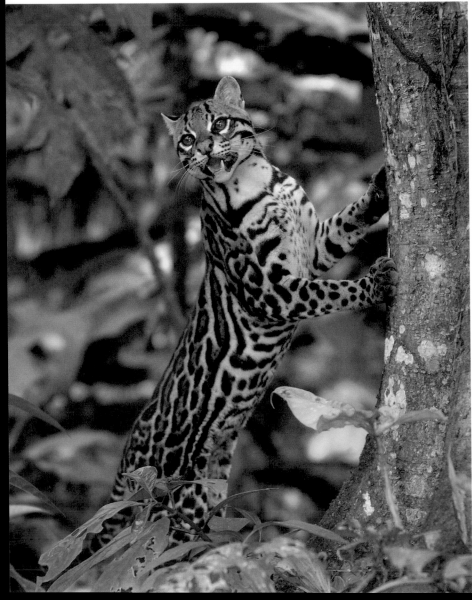

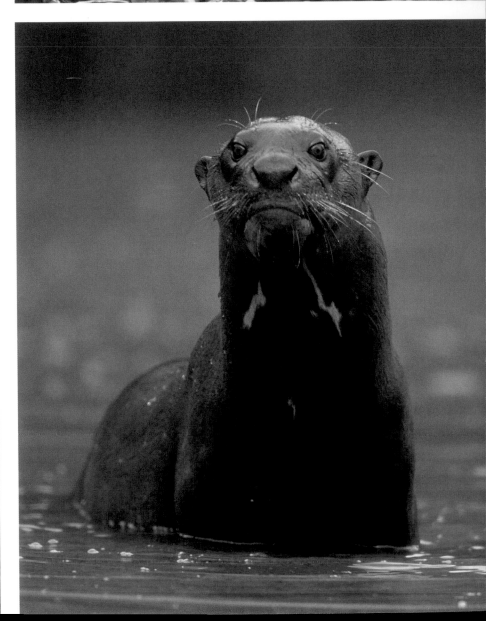

About 90 per cent of the Amazon lowlands is covered by *terra firme* forest, i.e. forest that is never flooded. However, the remaining 10 per cent is very different terrain and includes one of the most remarkable ecosystems of all – flooded forest. This unique habitat is able to survive several months of submergence, when water levels in parts of the Amazon river system rise by as much as 15 metres (50 feet) and can cover the tops of the trees. In the western Amazon this is the result of seasonal rains in the Andes, which carry down fine-grained silt from the nutrient-rich montane soils and create the "white-water" character of the Amazon River in this region. The flooded forest here is known as *várzea*, and its trees have evolved particular methods of dealing with this annual inundation – their leaves have water-resistant cuticles, for example, and their bark is often protected by cork tissue. Aerial roots assist with respiration, and some tree species appear to be able to close down their metabolism to the bare minimum during the flood. Furthermore, the seed dispersal of certain trees is designed to be carried out by the fish that become abundant in the area at this time – the seeds are swallowed whole and then passed into the water; they sink down to the silt at the bottom and, when the waters recede and the land dries out, they germinate.

The best place to experience unspoilt *várzea* is the Mamirauá Sustainable Development Reserve, Brazil's first such area, located 600 kilometres (375 miles) (and a 12-hour powerboat journey!) west of Manaus. Sandwiched between Amanã Reserve and Jaú National Park, with which it forms a vast protected area covering some 22,000 square kilometres (8,500 square miles), Mamirauá has a superb patchwork of habitats, created by the erosion and deposition actions of the annual flood process. The mixture of forest, scrub, swamp and lake is home to a range of fascinating wildlife, and with over 300 species recorded this is probably one of the Amazon's best locations for fish. These attract huge concentrations of waterbirds and caimans, particularly when the floodwaters have receded and the increasingly isolated pools can seethe with trapped fish. The river itself and its associated channels are also home to the Pink River Dolphin or Boto (*Inia geoffrensis*), a common sight following boats.

The signature wildlife species of the flooded forest – and endemic to the Mamirauá area – is the extraordinary White Bald-headed Uakari (*Cacajao calvus calvus*), one of nine species of primate found here. Uncannily human-like in appearance, Uakaris live in groups of up to 30, foraging on the ground for seeds and fruit during the dry season and becoming more arboreal when the waters rise. They can be seen relatively easily at Mamirauá, as can two species of sloth, the Two-toed (*Choloepus didactylus*) and the Brown-throated Three-toed (*Bradypus variegatus*). Mammal watching is usually best here during the flood (April–August), when the animals are more concentrated and can often be approached quite closely by canoe. For many species the floodwater presents no impediment to movement – sloths in particular are excellent (if unlikely) swimmers.

Mamirauá's human inhabitants have traditionally practised subsistence fishing and hunting, as well as the seasonal cultivation of crops such as cassava. Ecotourism is offering new opportunities for them, and the prospect that this extraordinary area can be securely protected in the future. Meanwhile, across the Amazon basin, rates of deforestation are still increasing, and the quality of more and more of the forest and its associated habitats is becoming compromised or adversely affected by activities such as illegal colonization, ranching, logging, mining, poaching and commercial fishing. How to reduce the rate of destruction of the world's most species-rich biome – more than one-third of all known species live in the Amazon – will continue to be one of the great environmental challenges of the twenty-first century.

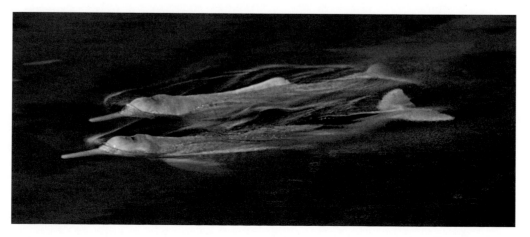

LEFT Endemic to the Amazon–Orinoco river systems, Pink River Dolphins are usually seen in pairs and small groups. Despite their name, they are highly variable in colour and different individuals range from bright pink to dull grey.

RIGHT **Giant Otters** are highly vocal and their noisy calls are often the first clue to their presence.

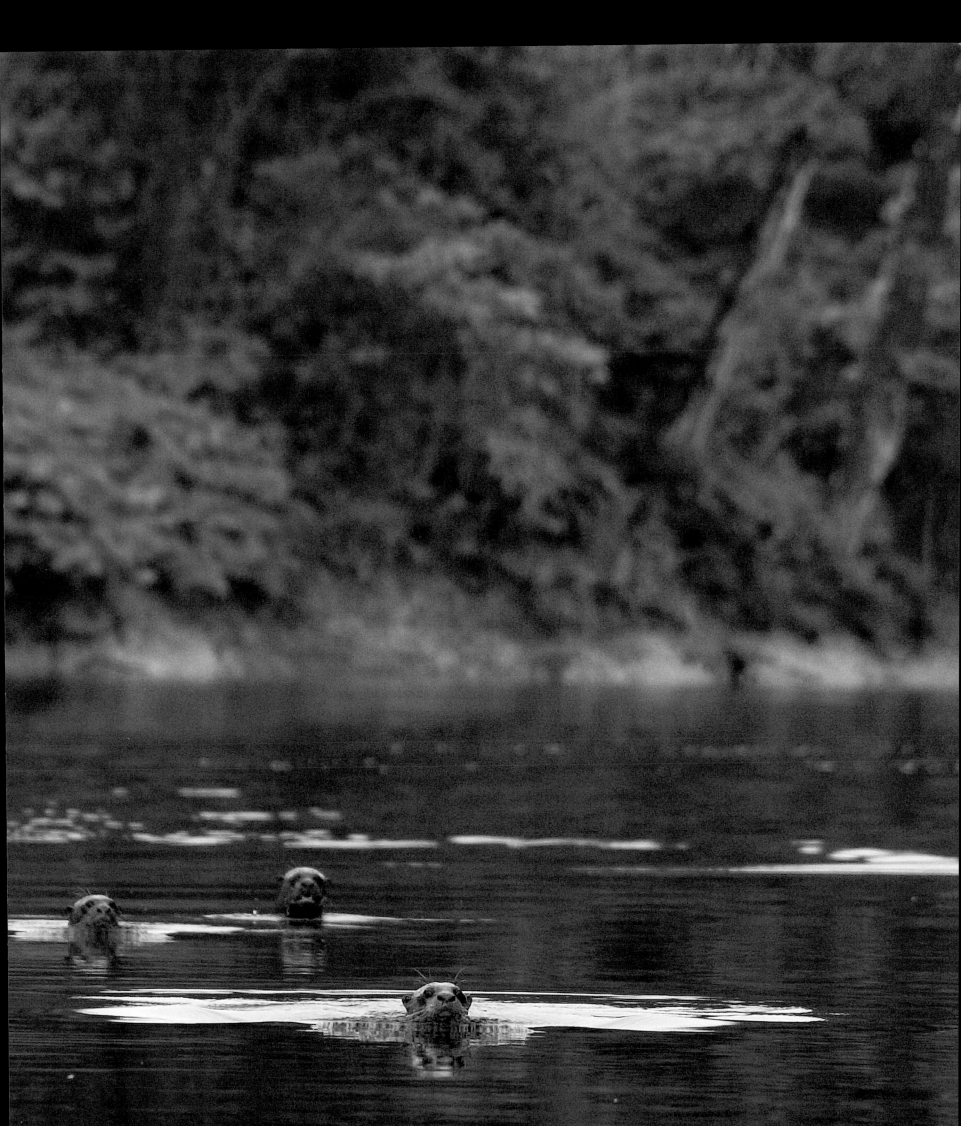

42. The Wintering Monarch Butterflies of Mexico

A common butterfly across much of North America, the Monarch (*Danaus plexippus*) is also one of the largest and most distinctive. Its gaudy orange and black coloration makes it fairly unmistakable, and hints at the probable tropical ancestry of the species. It is thought that Monarchs evolved from butterflies originating in Central or South America, which spread north as the prevailing climate warmed. The inability of Monarchs to endure persistent low temperatures further supports this theory about their origins; instead of hibernating during cold weather, as some North American butterflies do, the last generation of Monarchs to hatch during the northern summer heads south in autumn. In one of the world's great wildlife migrations, hundreds of millions of butterflies travel thousands of kilometres before gathering in massive numbers at a small number of specific roost sites. Here they pass the winter months before returning north again in spring.

North America's Monarchs have two distinct winter quarters. Those spending the summer west of the Rockies head south and pass the winter around Pacific Grove and Santa Cruz, in southern California. Those living east of the Rockies – the majority of the North American population – migrate south to a range of hills in the state of Michoacán, in south-central Mexico. For some, this can mean a round trip of over 5,000 kilometres (3,100 miles), the longest regular migration of any insect. Monarchs can actually travel distances even greater than this and appear regularly as vagrants in Europe, having somehow crossed the Atlantic Ocean. Although some individuals are considered to have been "ship-assisted", i.e. having hitched a ride on board a boat, there is no doubt that some actually make it under their own steam.

In both wintering grounds the Monarchs congregate on and around trees. In California these are mostly Eucalyptus (although some other species are used), whereas in Mexico they are to be found only on Oyamel Firs (*Abies religiosa*). However, evidence suggests that it is not so much the species of tree that is important to the butterflies, but the precise environmental conditions and microclimate afforded by the trees and their location. The dozen or so Mexican sites, which are on steep, southwest-facing slopes some 3,000 metres (9,800 feet) above sea level and within an area of some 800 square kilometres (300 square miles), were only made known to scientists in the mid-1970s; until then they had been a closely guarded secret among local villagers. Several reserves have since been established to protect the overwintering butterflies, and together these harbour the entire population of eastern North American Monarchs. They offer a uniquely exhilarating wildlife experience.

The best time to observe the Monarchs in their winter forests is on a sunny day, in the morning, just as they become active after roosting overnight on the trees. At night, and in cold or cloudy weather, the butterflies are inactive, and remain tightly clustered on every available surface of the trees, hanging from the leaves and branches and covering the trunks, often to such a density that it is all but impossible to see the precise structure of the tree beneath. Despite the inconsequential weight of each individual butterfly, the total number gathered is so vast that their combined weight can snap off branches. However, as the sun climbs and the temperature rises, so they become active, flexing

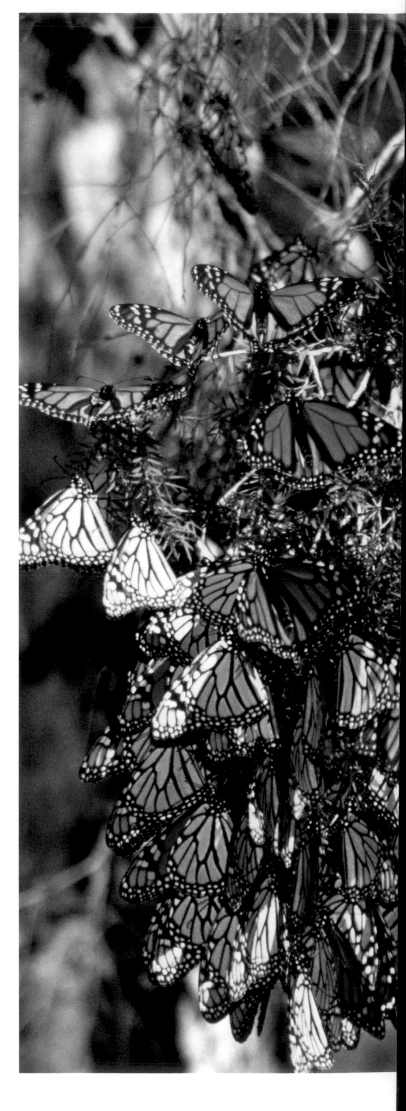

RIGHT **Although each butterfly weighs only a few grams, the wintering Monarchs gather in such vast numbers that their collective weight can be enough to break off tree branches.**

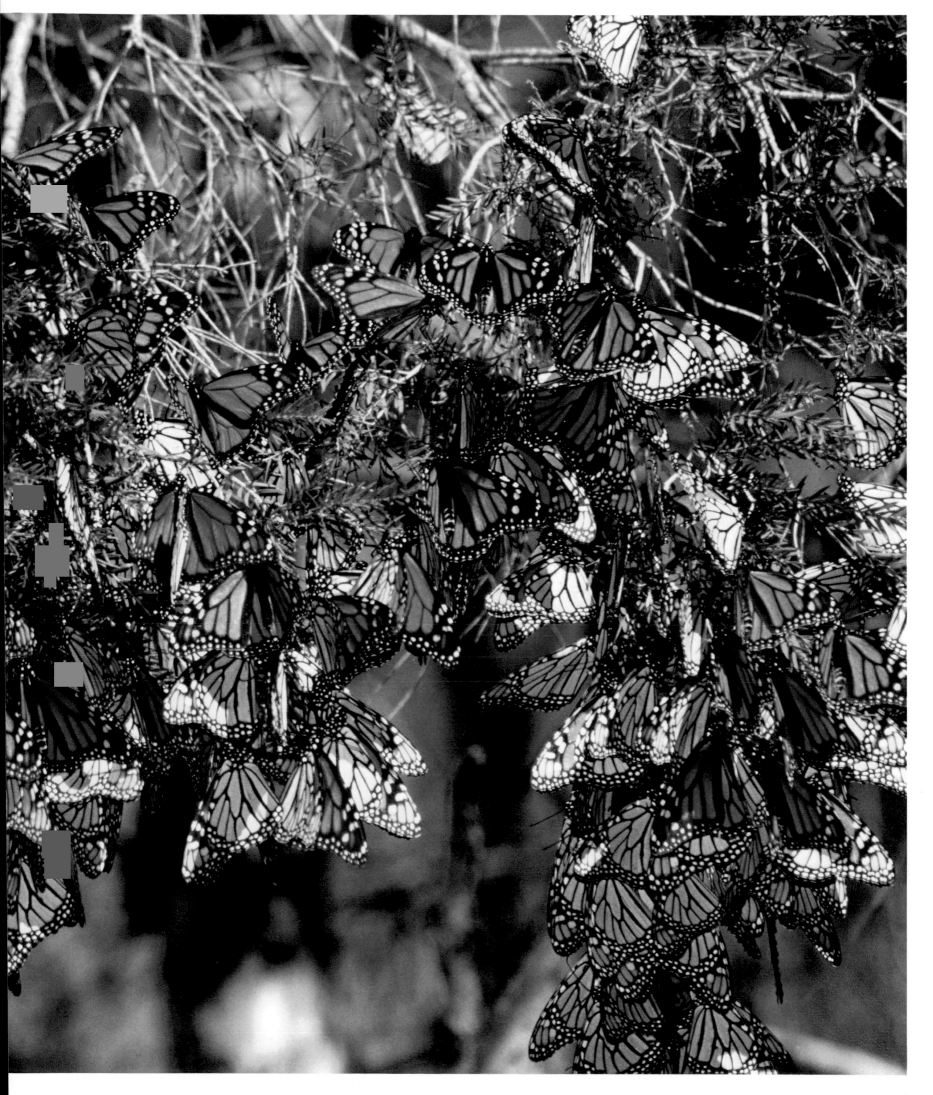

their wings and starting to flutter about. In especially sunny weather they will make short trips, particularly down to sources of water, where they will drink. The sight of so many butterflies, especially as they splutter into life when a ray of sunshine reaches them through the tree canopy, is quite unforgettable. For many visitors, the most remarkable aspect of all is the noise made by the countless millions of wings all beating simultaneously – this ranges from a light patter when only a few butterflies are active to an extraordinary hum when the gathered hordes are preparing to leave *en masse*.

By March, the Monarchs become more purposefully active as they prepare to make the journey back north. The returning butterflies, which have lived for several months, as opposed to the few weeks' lifespan of all other generations of Monarch, arrive in the southern United States, where they lay their eggs and die. The ensuing generation of adults continues the migration northwards as far as southern Canada, and as many as three more generations may hatch as the summer progresses. The last of these will be the one that continues the migratory cycle back south again in autumn.

Although Monarchs require cool temperatures during the winter, so that they do not metabolize too fast and use up valuable reserves, they are vulnerable to prolonged cold weather. In January 2002 a severe snowstorm hit the Monarch wintering grounds in Mexico and at two of the main sanctuaries, El Rosario and Sierra Chincua, over 75 per cent of the butterflies perished – an estimated 250 million insects in total. The scene that met the first naturalists to reach the colonies was one of devastation, with poignant accounts of the ground being littered with dead and dying Monarchs in deeply packed drifts up to 30 centimetres (1 foot) deep. Despite such catastrophes, Monarchs can usually rebound quickly because, like most insects, they have a high reproductive rate, with a single female capable of laying hundreds of eggs. However, the fact that the entire population is concentrated in just a few locations in winter inevitably makes the species highly vulnerable.

BELOW AND OPPOSITE **When the temperature rises and rays of sunshine fall on the clustered hordes of Monarchs, they start to flutter about, steadily taking to the air in ever greater numbers until the sky appears to be full of them.**

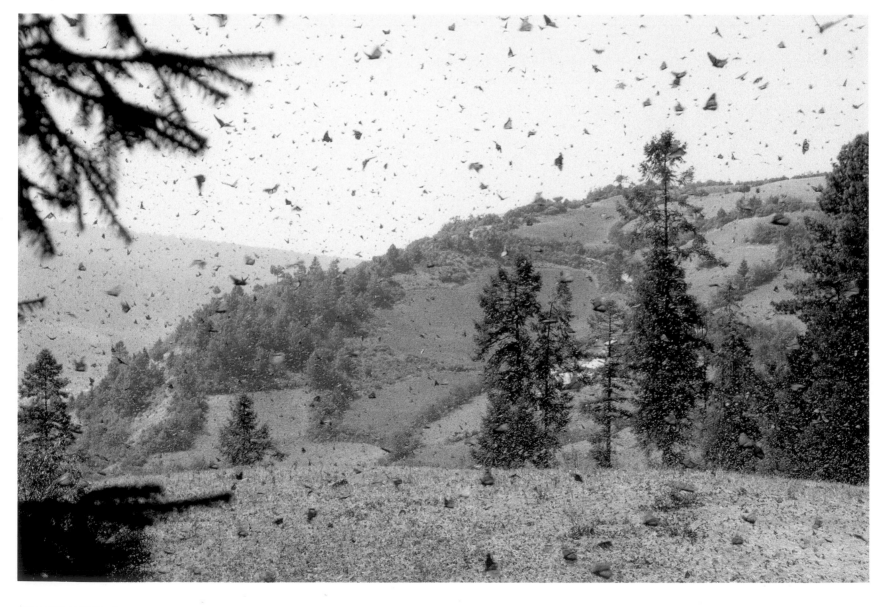

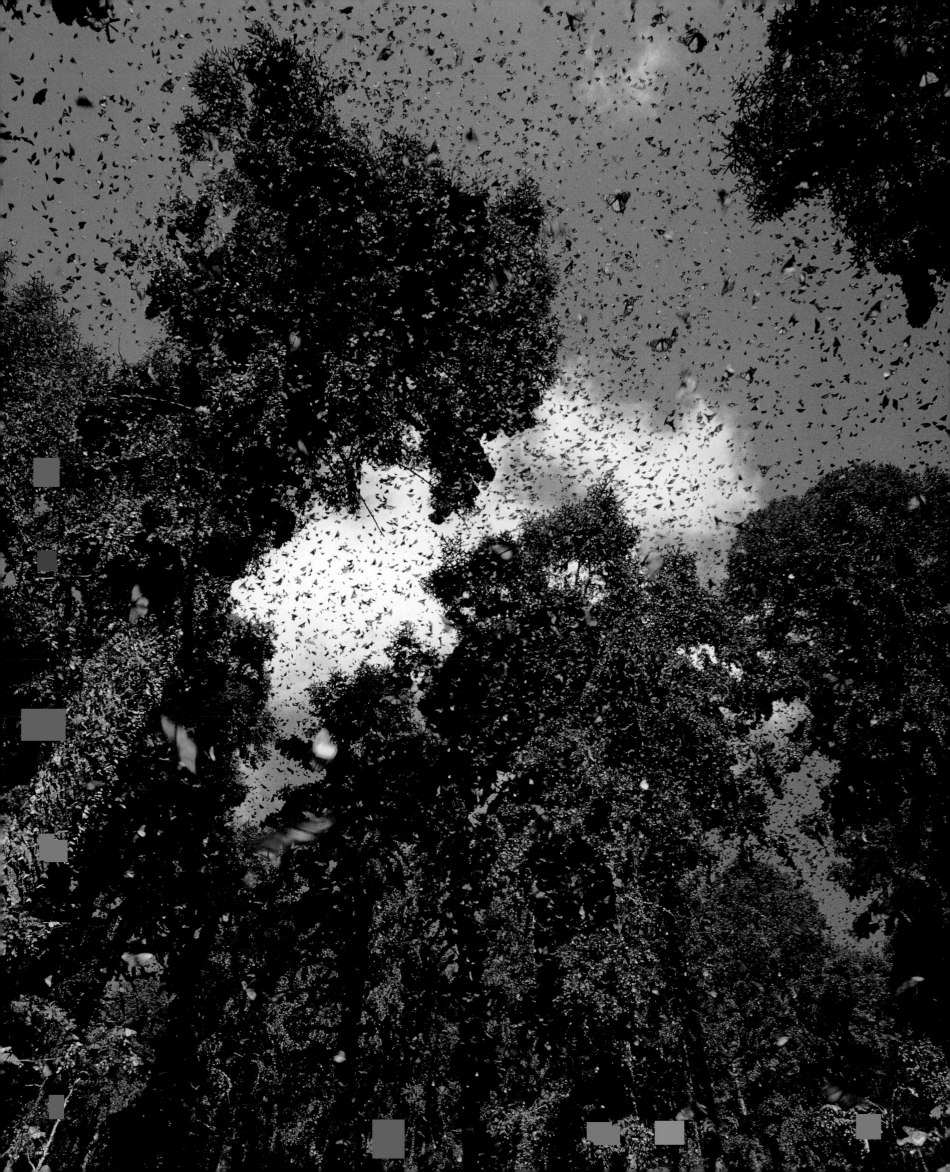

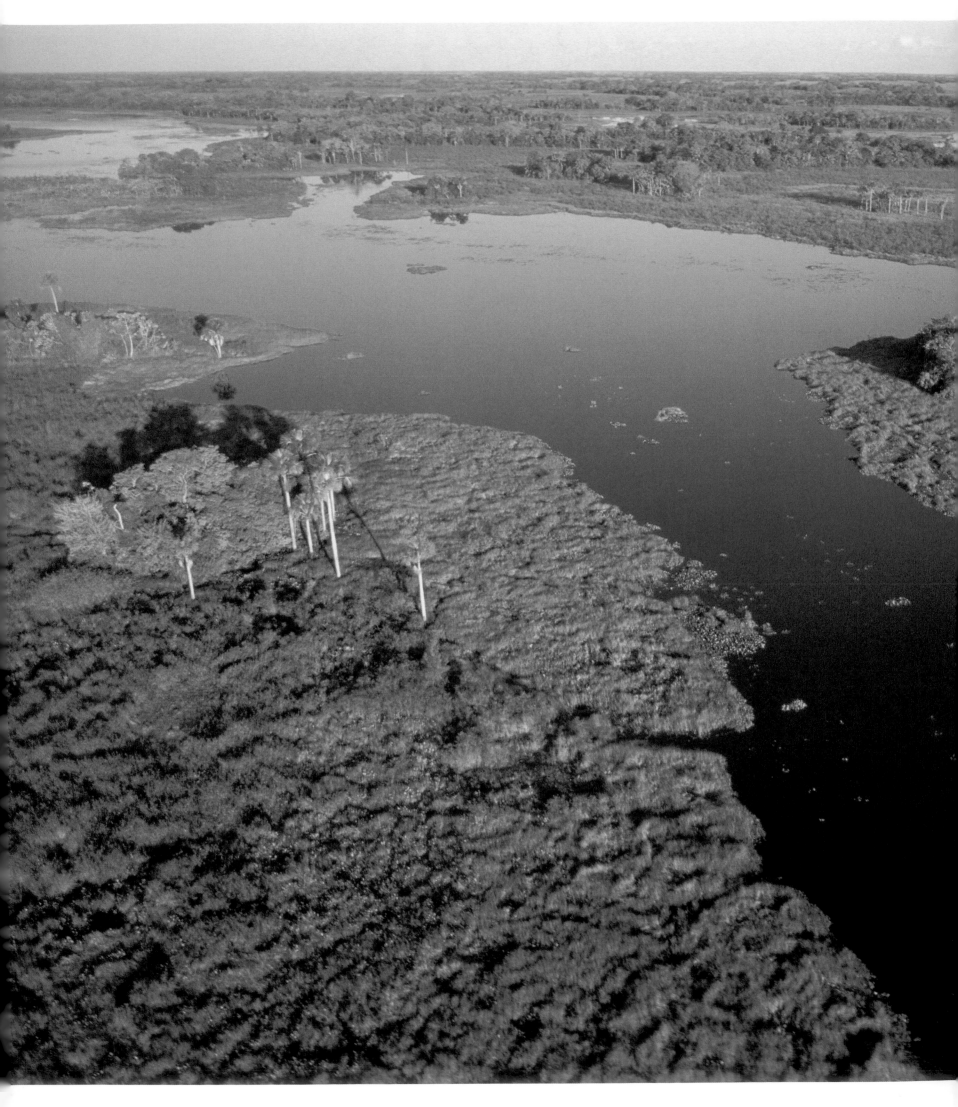

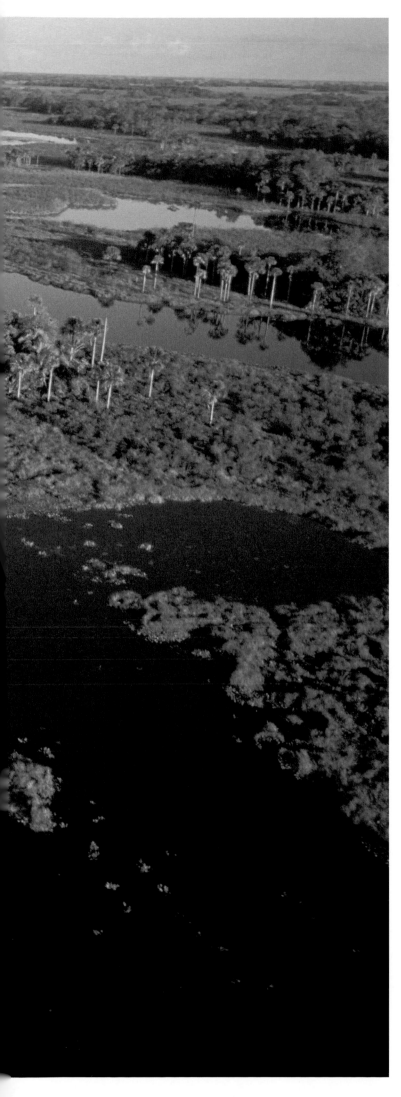

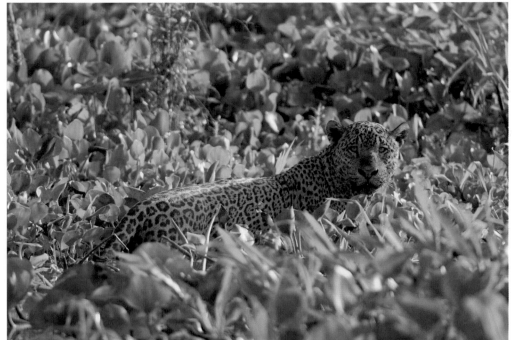

43. A Water Wilderness: the Pantanal

The remarkable Pantanal is the largest contiguous wetland on the planet. Mostly contained within Brazil, but extending into parts of Bolivia and Paraguay, this vast inland floodplain covers almost 200,000 square kilometres (77,250 square miles) in total, an equivalent area to England and Scotland combined, or roughly half the size of California. A flat but diverse landscape of astonishing beauty, the Pantanal is a vast mosaic of rivers, oxbow lakes, swamps, seasonally flooded woodland and savannah (the latter known as *cerrado*), scrub and forest of various types. It is an outstanding site for wildlife, and has been rightly compared with the more famous and equally remarkable Okavango Delta in Botswana (see page 65). Although little known to outsiders until the 1970s, the Pantanal is now recognized as one of South America's most important ecosystems, and its wildlife riches are attracting increasing attention.

Running along a north–south axis in the valley of the Upper Rio Paraguay, the Pantanal works as a huge sponge, absorbing the flow and runoff from the river headwaters in the highlands that surround it. During the rainy season, which usually lasts from November until April, as much as 70 per cent of the area can be submerged to a depth of up to 3 metres (10 feet). Sometimes the waters arrive quite suddenly, provoking a wildlife frenzy as smaller creatures struggle to escape the flood, and the area's huge population of waterbirds – including many species of heron and egret, along with the unmistakable Jabiru (*Jabiru mycteria*) – gathers to pick them off. Indeed, the Pantanal's birdlife is one of its major attractions and, while the number of species found here (about 650 or so) may not rival the totals recorded at other locations in this extraordinarily bird-rich continent, this is more than compensated for by the sheer numbers of birds that can be observed here.

One of the best vantage points is the Transpantaneira, a 148-kilometre (92 mile) long raised dirt road which, linked by a sequence of over 100 wooden bridges, cuts across part of the delta and offers some of the best roadside birding in the world. From here it is possible to see a huge variety of species, as many as 120 in a day, including many raptors and two of the Pantanal's most stately

LEFT **A superb mosaic of different habitats – wet and dry – makes the Pantanal one of the world's great wildlife locations. The congregations of birds and animals certainly rival more famous sites in Africa.**

ABOVE **The Pantanal is now regarded as the world's premier site for Jaguar watching. Although local ranchers have traditionally hunted this beautiful but shy animal, there is still a sizeable population in the area.**

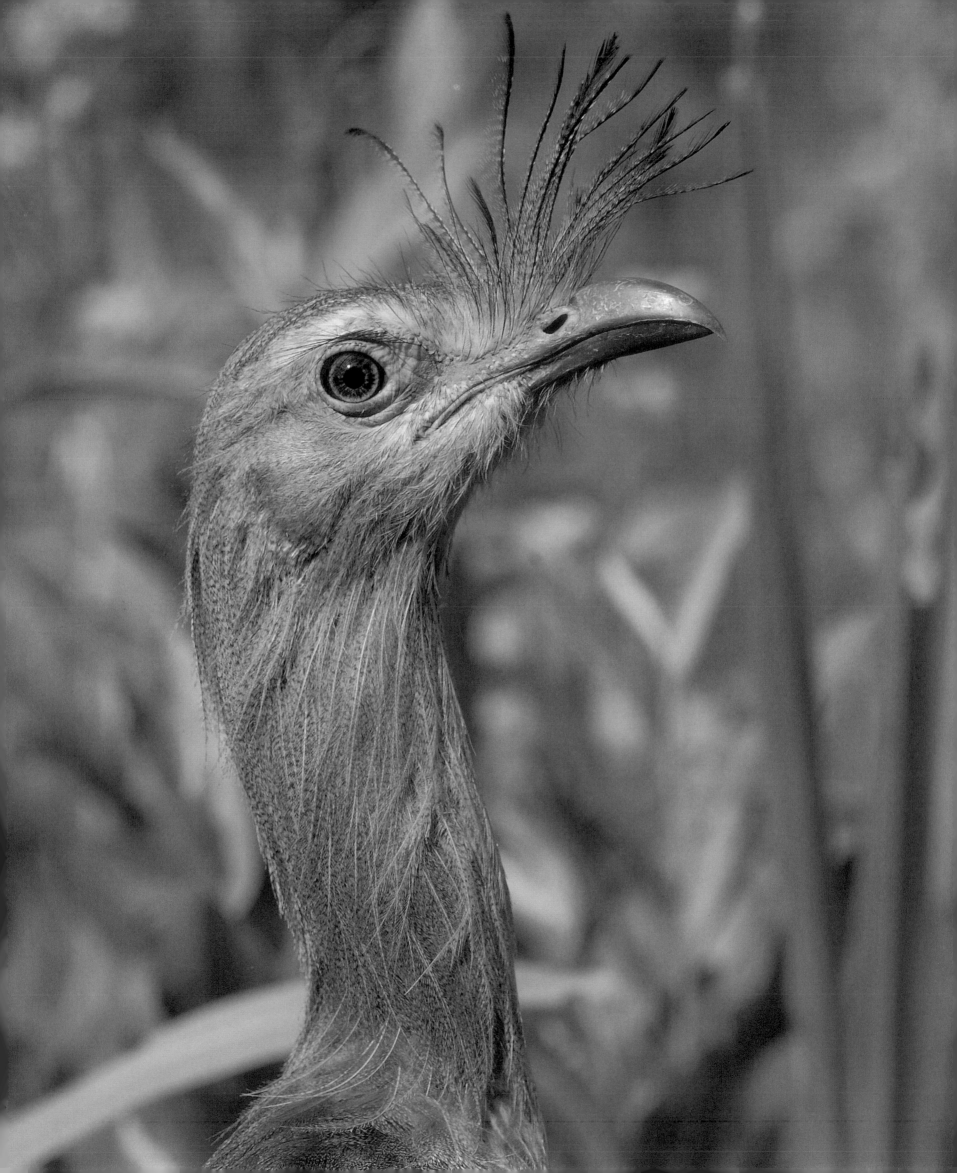

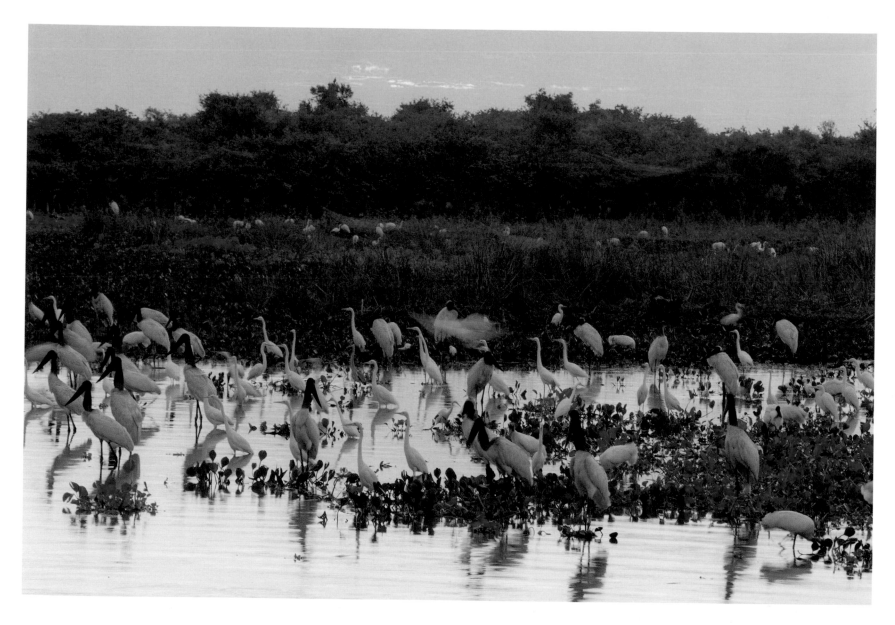

landbirds, Greater Rhea (*Rhea americana*) and Red-legged Seriema (*Cariama cristata*). The "highway" can also be productive for spotting parrots, for which the Pantanal is outstanding. Almost 30 species have been recorded here, including a sizeable percentage of the world's surviving wild population of the endangered Hyacinth Macaw (*Anodorhynchus hyacinthinus*). Birds of this species are faithful to particular trees, and with the help of a local guide can usually be found without too much difficulty.

Although not all of the Pantanal is inundated annually and water levels vary from year to year, the floods generally mean that in the wet season much of the Pantanal's wildlife is concentrated on scattered patches of higher land, where it can be easily observed. Equally, during the dry season the birds and animals necessarily congregate around the surviving areas of open water, where they can both drink and feast on the fish and invertebrates that are trapped in the ever-shrinking pools or baias. This means that throughout the year there are always parts of the Pantanal able to offer the sort of high-density wildlife-watching more normally associated with Africa. While birds are the most immediately numerous, there are over 80 species of larger mammals (i.e. excluding bats and small rodents) in the Pantanal; among the most readily seen are Collared Peccary (*Tayassu tajacu*), Coati (*Nasua nasua*) and the world's largest rodent, the Capybara (*Hydrochoerus hydrochaeris*), large family herds of which gather on the grassy areas next to water. Less ubiquitous but still common are Marsh Deer (*Blastocerus dichotomus*), one of four deer species occurring in the Pantanal, with Giant Otter (*Pteronura brasiliensis*) and Brazilian Tapir (*Tapirus terrestris*) also regularly seen. The drier areas of *cerrado* are the most likely spots to find two Pantanal specialities, Giant Anteater (*Myrmecophaga tridactyla*), which is relatively common here, and the beautiful but largely nocturnal Maned Wolf (*Chrysocyon brachyurus*). However, it is a glimpse of the Pantanal's top predator, the Jaguar (*Panthera onca*), which is really guaranteed to get the spine tingling. In recent years the Pantanal has become the best place in the world to see this elusive cat, which – contrary to the traditional view of its preferred habitat as thick forest – clearly thrives in the open

OPPOSITE **The Red-legged Seriema is a bird of the *cerrado*, where it hunts for invertebrates and reptiles. With a raucous call, and more willing to run from danger than to fly, this species is surprisingly elusive and more often heard than seen.**

ABOVE **The Pantanal is home to thousands of waterbirds, including several species of egret and the Jabiru, easily identified by its black head and neck, and red pouch below.**

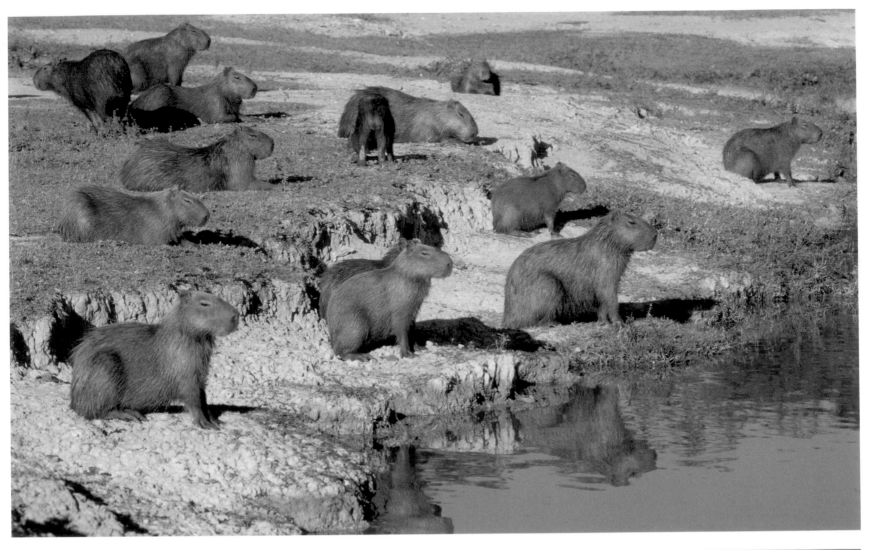

terrain of the Pantanal. Kilo for kilo, Jaguars are the most powerful of the big cats and the Pantanal Jaguars are amongst the largest of their kind; they readily take cattle, which is a continuing source of friction with local landowners.

Reptiles are well represented in the Pantanal, the most prominent undoubtedly being the Yacare Caiman (*Caiman yacare*). Although seriously affected by overhunting during the twentieth century, they remain numerous, despite continued poaching. Snakes are also common, and this region is one of the few places where it is possible to see two species of anaconda – the Yellow (*Eunectes notaeus*) and the Green (*E. murinus*). The latter is one of the biggest snakes in the world, with specimens recorded in excess of 9 metres (29½ feet) and with a girth of almost 1 metre (3½ feet). Not surprisingly, such huge serpents are capable of tackling very large prey; on occasion this can include humans, although such cases are very unusual.

The astonishing diversity of wildlife and habitat found in the Pantanal today reflect the low-level impact of the historical land-use patterns in the area. For two centuries these have revolved around cattle ranching, and the local ranches or *fazendas* have traditionally tolerated wildlife alongside their livestock, with one exception – the Jaguar. The hunting of Jaguars was once widespread in the Pantanal and, while some illegal killing continues, schemes to compensate owners for their losses, and to encourage them to diversify into ecotourism, are making encouraging progress. With over 90 per cent of the Pantanal in private ownership, such initiatives are essential if this unique ecosystem is to survive, especially as threats to the area are growing. Pesticide run-off from agricultural land is affecting the quality of the waterways, as is pollution from mineral extraction and the clearance of forests in the mountains that feed the Pantanal with water; stripped of its tree cover, the soil there has been washed down into the Pantanal, silting up watercourses and disrupting traditional flooding patterns. Poaching for hides and the illegal pet trade continue to be serious problems in many areas, and grandiose schemes to create extensive navigational waterways in the region to boost trade could also be disastrous. With less than three per cent of the Pantanal under statutory protection at present, there is a desperate need to do more to save its future.

44. The Parrots of Tambopata

Few countries can rival Peru when it comes to birds and birdwatching. More species of bird have been recorded here than in any other country: a total of 1,800-plus and rising. Remarkably, this amounts to almost 20 per cent of the world's bird species, and it includes no fewer than 300 endemics. The highest number seen anywhere in the world in one day – 361 – was in Peru, in Manu National Park; and over 40 species of bird totally new to science have been discovered in Peru in the last three decades. The reason why Peruvian avifauna is so extraordinarily rich is the great diversity of landscapes and ecological opportunities that occur here, and while exciting birds can be found right across the country in virtually every type of habitat niche, it is clear that some habitats are more productive for birds than others. Top of the list is undoubtedly lowland rainforest, and it is therefore no surprise that one of Peru's other world-beating records – that for the most species recorded in a single locality (650) – comes from the vast forests of eastern Peru's lowlands, and from a site just upstream from Tambopata specifically.

The Tambopata–Candamo Reserve Zone was established in 1990 and extends over 1.4 million hectares (3.5 million acres) of mostly lowland rainforest habitat, much of it in pristine condition. The reserve covers most of the basins of the Tambopata and Heath rivers and, in 1995, part of it was combined with the Pampas del Heath National Sanctuary to form the Bahuaja–Sonene National Park; this, together with Madidi National Park across the border in Bolivia, is now recognized as one of the most bio-diverse regions in the world. Almost 1,000 bird species have been recorded here, with 20,000 species of plant and 1,200 species of butterfly also found in this superb wilderness of forest, grassland and swamp.

Access to these outstanding wildlife areas is generally via Puerto Maldonado. This oddly atmospheric town has a decidedly frontier-like feel, and a chequered history. It first developed as a point through which the resources of the Peruvian Amazon forests – primarily rubber and timber – could be exploited, and historically had a reputation for Wild West-style lawlessness. There are certainly local stories of traders and settlers fighting with the indigenous Amazonian tribes, and one of the so-called rubber barons was the infamous "Fitzcarraldo", who explored parts of the area by means of a steamship, which he had transported, piece by piece, over the mountains. A hint of this historical quirkiness remains in Puerto Maldonado, but today the town does good business as a centre for ecotourism, and thousands of tourists pass through it every year on their way to the growing number of wildlife lodges located along the Tambopata River.

There is plenty of wildlife here, but accessing the depths of the forest proper is hard work, and potentially less fruitful than spotting the birds and animals that present themselves readily along the river. Boat trips offer excellent opportunities to see Giant Otters (*Pteronura brasiliensis*) and monkeys (the dawn chorus of the Black Howler Monkeys (*Alouatta caraya*) is one of the defining forest sounds here), but it is mainly the outstanding variety of birds that draw the crowds, and particularly the area's parrots. For it is here, on the eroded cliffs and banks of the Tambopata River, that the best parrot-watching in the world is possible, as thousands of them gather at dawn each day at the famous "collpas" (a Quechua name) or clay-licks along the river. Arriving in a mixture of pairs, small groups or sometimes in flocks hundreds strong, parrots of up to 15 different species fly in and gather cautiously in the riverside trees. Once certain that no predator is near, they descend to the exposed cliffs and banks below and start grabbing beakfuls of mineral-rich clay. Noisily crowding

OPPOSITE **Scarlet Macaws and Blue-and-yellow Macaws gathered at a *collpa*. These riverside clay-licks are best approached by boat, invariably the most effective way of getting close to the birds without disturbing them.**

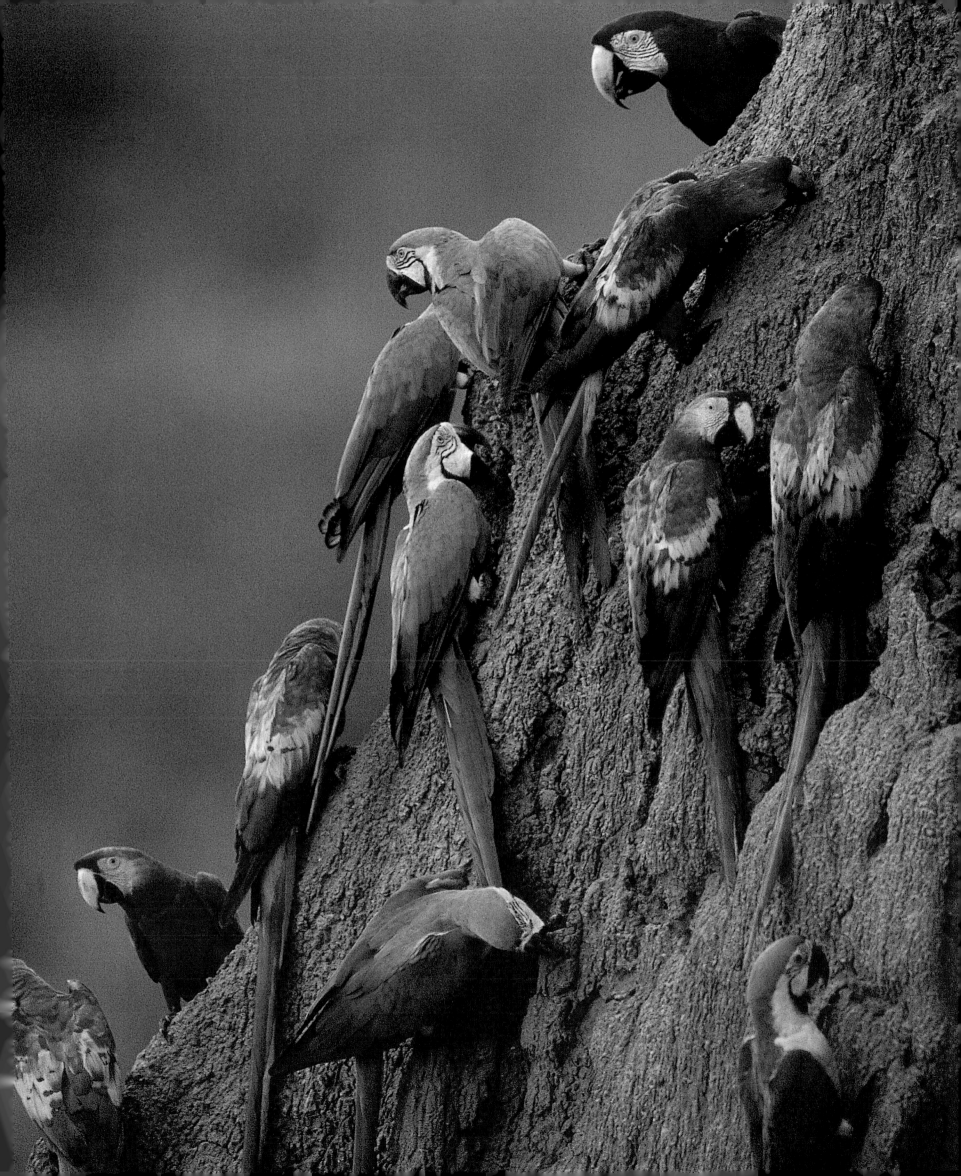

on to the vertical cliff-faces, squabbling, squawking and chattering, and flashing rainbow-coloured feathers, they present a dazzling and entertaining spectacle. First to arrive are usually the smaller parrots, such as Blue-headed (*Pionus menstruus*), Dusky-headed (*Aratinga weddellii*), Mealy (*Amazona farinosa*) and Orange-cheeked (*Pionopsitta barrabandi*), along with Cobalt-winged Parakeet (*Brotogeris cyanoptera*), followed by up to six species of macaw – Blue-and-yellow (*Ara ararauna*), Blue-headed (*Primolius couloni*), Scarlet (*Ara macao*), Red-and-green (*Ara chloroptera*), Chestnut-fronted (*Ara severa*) and Red-bellied (*Orthopsittaca manilata*). Every so often, the mixed congregation will explode into raucous, multi-coloured flight, spooked perhaps by a Harpy Eagle (*Harpia harpyja*) drifting overhead. The parrots will then circle around screeching, before dropping back down on to the slopes.

At particularly busy times as many as 500 parrots may be gathered at a single collpa, and there are several excellent sites along the river where arrangements are in place to observe the birds without disturbing them. The viewing experience does vary from place to place, as some parrot species visit collpas more frequently, and in larger numbers, than others, while certain species only visit particular collpas. Other creatures also obtain minerals in this way, including monkeys and butterflies, and clay-licks located deep in the forest doubtless attract large mammals such as tapirs. How far, and how often, the parrots fly to visit the collpas is not clear, but many appear to travel for at least several kilometres on a daily basis. Precisely why they come is also not totally understood, but either they are seeking out the minerals to supplement their diet of fruit, or – as some scientists believe – the minerals are actually essential to counteract the toxic qualities inherent in certain types of fruit consumed by the parrots. Whatever the reason, hundreds of parrots jostling side-by-side, their colours suddenly illuminated by the first golden rays of the sun, are a sight worth travelling a very long way to see.

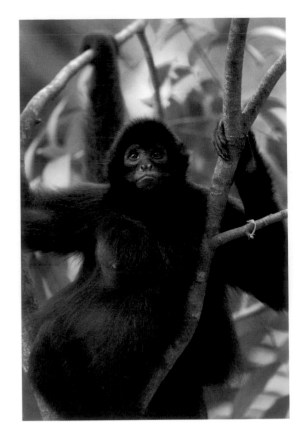

ABOVE **Black Howler Monkeys are** one of the more obvious mammals in Tambopata, their hollow roars usually betraying their presence long before they can be spotted in the tree canopy. The prehensile nature of their tail can be seen clearly in this photograph.

LEFT The forest habitat here is as diverse as anywhere, with thousands of plant species, and important communities of palms in particular. The large number of micro-habitats means that some wildlife, especially invertebrates, are highly specialized and only occupy certain niches.

OPPOSITE TOP LEFT **With a wingspan** of up to 2 metres (6½ feet), the King Vulture (*Sarcoramphus papa*) is the largest South American vulture after the Andean Condor. A forest inhabitant, it feeds primarily on carrion.

OPPOSITE TOP RIGHT **One of the** world's most extraordinary birds, the Hoatzin (*Opisthocomus hoazin*) is usually found in small colonies in riverine forest. Rather ungainly, and with a particularly laboured flight, it is always a target species for birdwatchers visiting the Tambopata area.

OPPOSITE BOTTOM **Mealy Parrots are** common visitors to Tambopata's collpas, and usually among the first species to arrive.

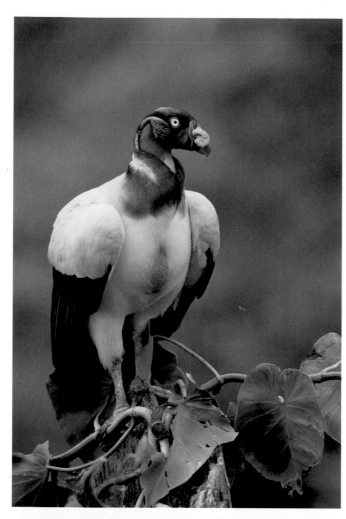

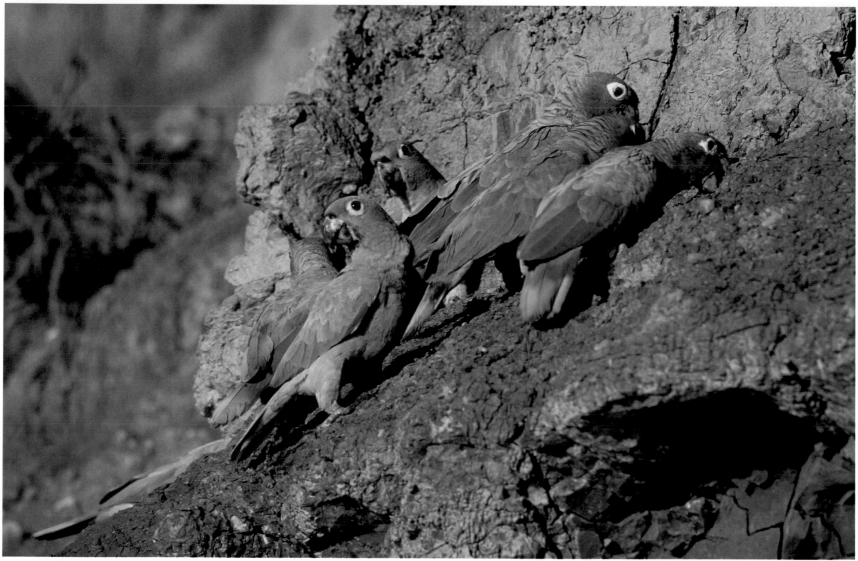

RIGHT The Giant Tortoises of the Galapagos are among the most iconic animals in the world. The older specimens are estimated to be at least 150 years old, and most tortoises make their centenary.

RIGHT The Giant Tortoises of the Galapagos are among the most iconic animals in the world. The older specimens are estimated to be at least 150 years old, and most tortoises make their centenary.

FAR RIGHT **Marine Iguanas** spend much of their day lounging about in the sun, warming up after their frequent dives into the cold waters that surround the islands.

45. Island Life: the Galapagos

Although they were first visited by European voyagers in the sixteenth century, the fame of the Galapagos Islands stems overwhelmingly from a much later visit, that of British naturalist Charles Darwin, in 1835. He visited four of the 13 main islands, recording the flora and fauna and developing theories on natural selection which he was later to present, most controversially, in *The Origin of Species* (1859). As a result, the traditional science of the day was turned on its head, and the conclusions drawn by Darwin from his Galapagos studies have continued to shape our understanding of evolution and the nature of biodiversity ever since.

Located in the Pacific Ocean about 1,000 kilometres (620 miles) off the coast of Ecuador, the Galapagos Islands are the result of uninterrupted volcanic and tectonic activity going back more than five million years. The constantly shifting plates upon which the archipelago sits ensure that it is in a perpetual state of movement, with older islands being edged ever eastwards and sinking below the waves, while to the west, new islets are regularly created by convulsive seafloor activity. This constant geological upheaval has produced a range of habitat niches across the islands, each of which supports particular forms of flora and fauna. It is this biodiversity – and the high levels of endemism resulting from the islands' isolation from the nearest landmass – that has helped make the wildlife of the Galapagos so unusual and so exciting.

Visitors to the islands are faced with extraordinary wildlife encounters at every turn. Whether it is the sight of a pair of Waved Albatrosses (*Diomedea irrorata*) performing their enchanting courtship dance, a whole crowd of Galapagos Sea Lions (*Zalophus californianus wollaebacki*) sprawled on a beach in the sunshine, or Marine Iguanas (*Amblyrhynchus cristatus*) launching themselves off a rocky headland into the chilly water below, the Galapagos are quite unlike anywhere else. Most visits to the archipelago take the form of cruises which, in addition to landing at some of the best wildlife sites, also offer the opportunity to see some of the area's superb marine creatures – cetaceans, sharks and rays all abound here – as well as watching seabirds such as boobies in dramatic action as they plunge-dive in search of food.

Isabela, the largest island, is famous as the home of several thousand Giant Tortoises (*Chelonoidis nigra*). Despite their size, these can be surprisingly difficult to locate in the scrub and forest that covers parts of the island, and the best place to find them is in the Alcedo caldera, where groups will gather in shallow pools of water, presumably as a way of divesting themselves of parasites and of coping with the heat. There are at least eight races of Giant Tortoise across the archipelago, with considerable variations in terms of size (the largest can be 1.5 metres (5 feet) long and weigh more than 300 kilograms [660 pounds]), shell profile and habitat preference. One subspecies –

RIGHT The seas around the Galapagos are teeming with marine life. Among the more dramatic sights are schools of Cownose Rays (*Rhinoptera steindachneri*), which cruise about in search of molluscs, which they grind up with their plate-like teeth.

BELOW On the island of Isabela, Giant Tortoises gather in pools to help them cope with the heat and to protect themselves against parasites. They sometimes spend several hours in such locations, usually resting, but occasionally partaking in more strenuous activity.

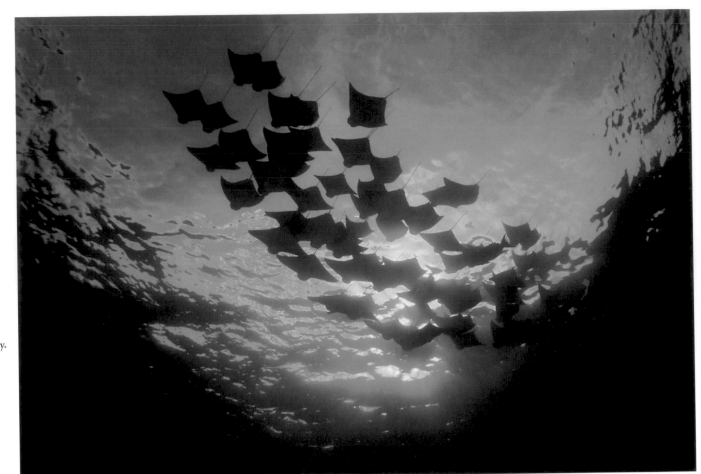

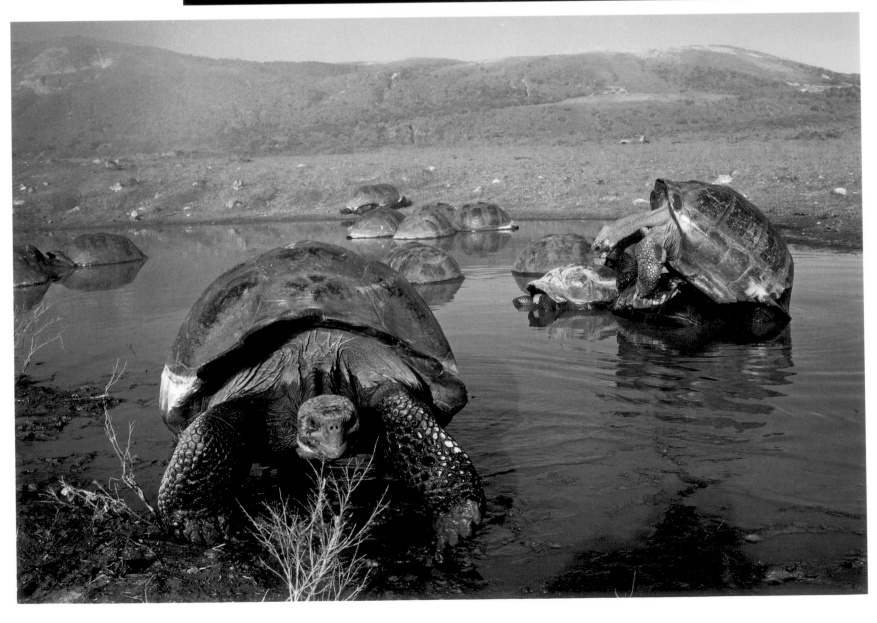

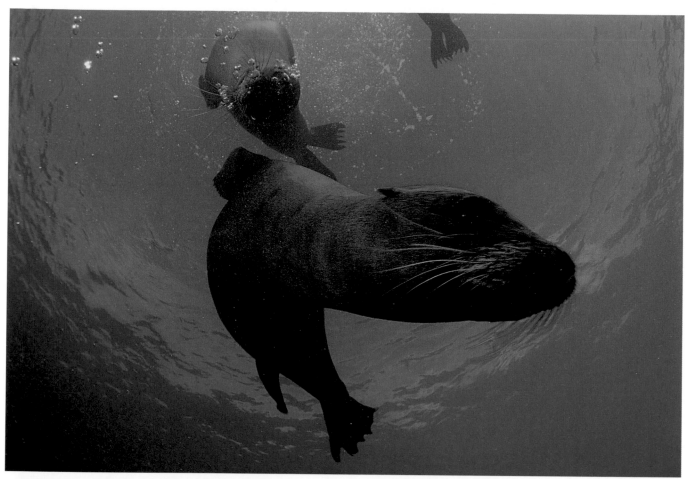

LEFT The Galapagos Fur Seals and Sea Lions is supremely equipped as underwater predators and can swim at up to 40 kilometres (25 miles) per hour.

BELOW A wildlife icon of the Galapagos, Blue-footed Boobies are at their most engaging during courtship. The male dances in front of his prospective mate, displaying his colourful blue feet to best advantage, in an attempt to form a mating bond.

OVERLEAF In the absence of any land-based predators, the Flightless Cormorant's wings ceased to be essential and are now just withered appendages. The vulnerability of this species and other forms of wildlife on the islands has led to a re-examination of the level of human impact on the Galapagos.

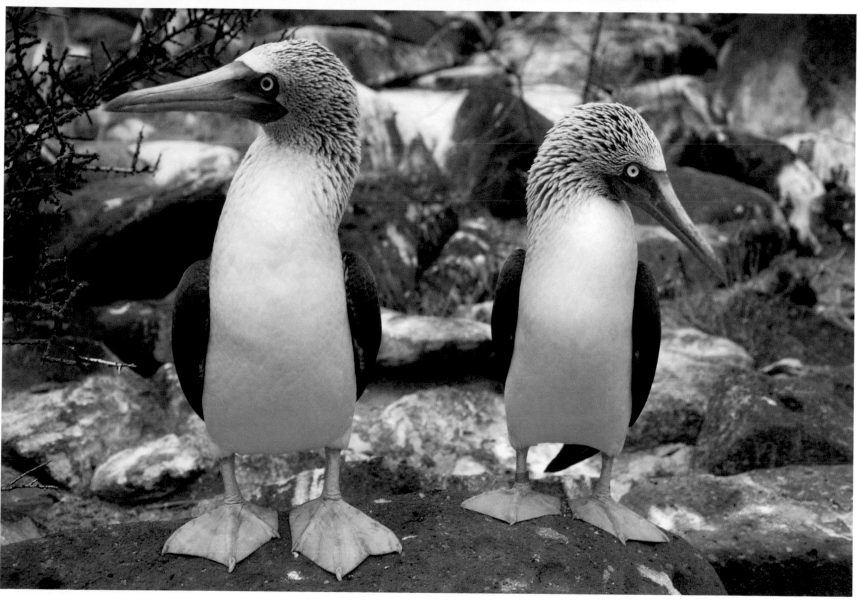

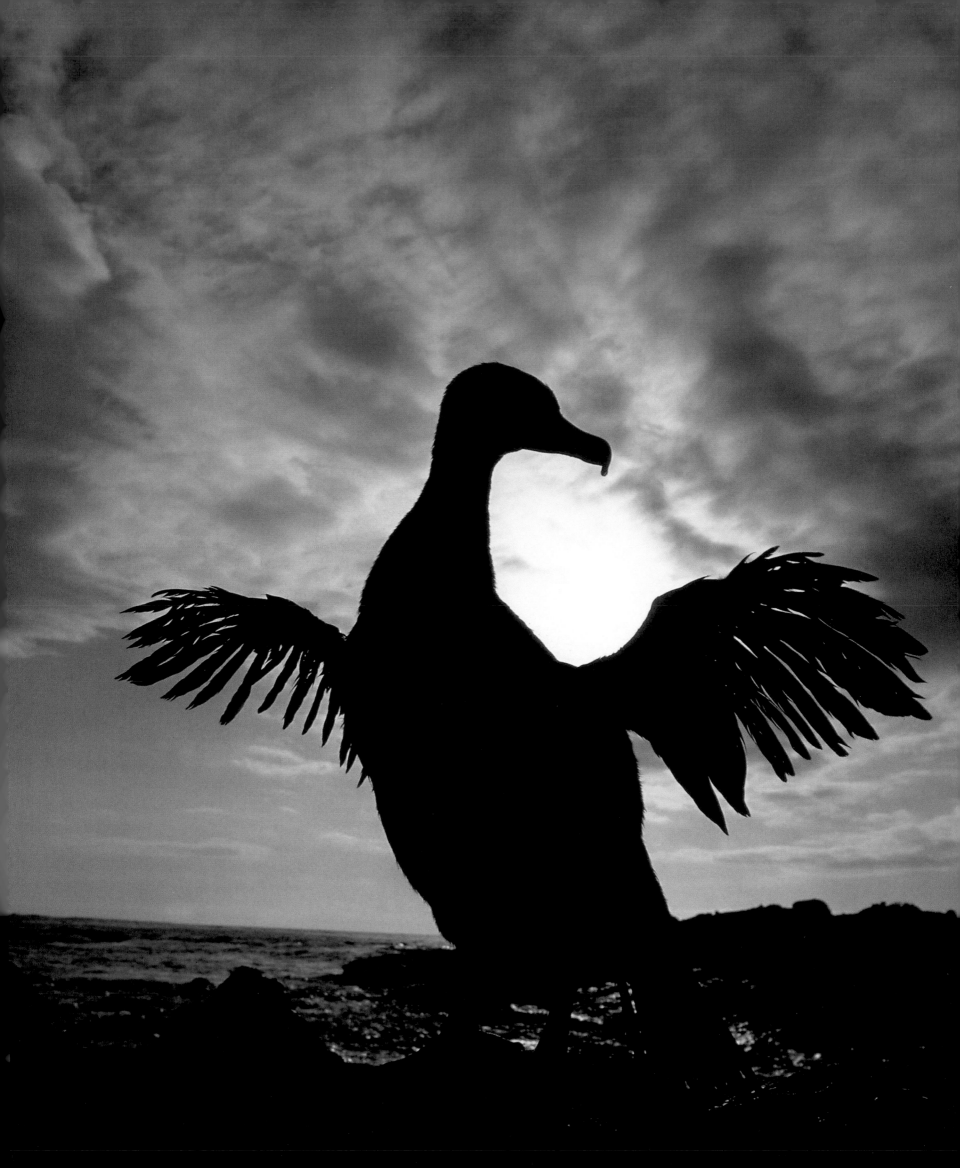

ABOVE **Giant Tortoises** gave the Galapagos Islands their name, in the sense that "galapago" is Spanish for saddle, a reference to the shape of the shell.

LEFT FLAP **American Flamingos** (*Phoenicopterus ruber*) at their breeding colony on the island of Floreana. Their characteristic pink coloration is caused by the carotene present in the shrimps on which they feed.

GATEFOLD CENTRE **Marine Iguanas** are typically seen sprawled across the rocks, resting and sunbathing between dives in search of food

RIGHT FLAP The male **Magnificent Frigatebird** has an extraordinary scarlet throat pouch, which inflates with air during courtship and mating.

CLOSING PAGE **Giant Tortoises** have an eclectic diet, and although they will normally browse on vegetation, when times are hard they will turn to other options, including carrion.

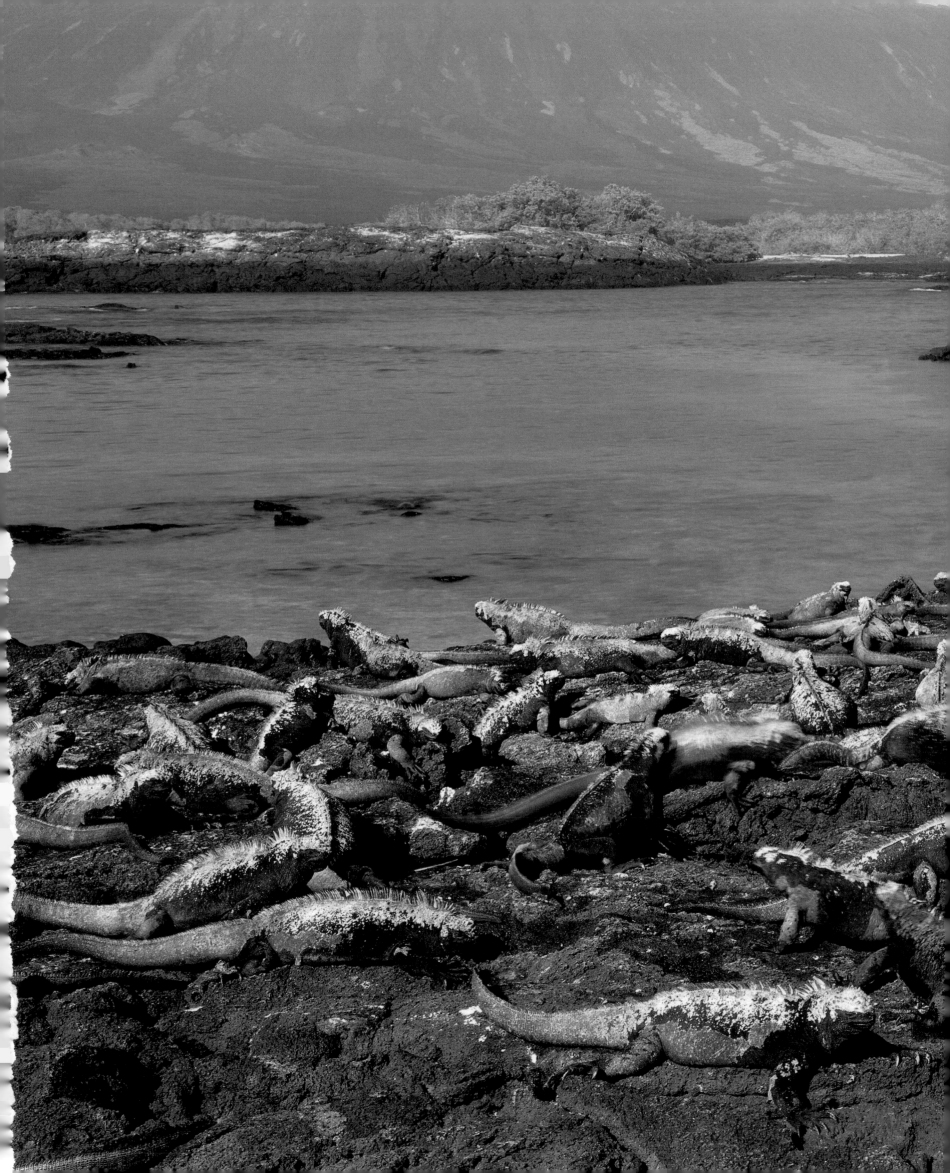

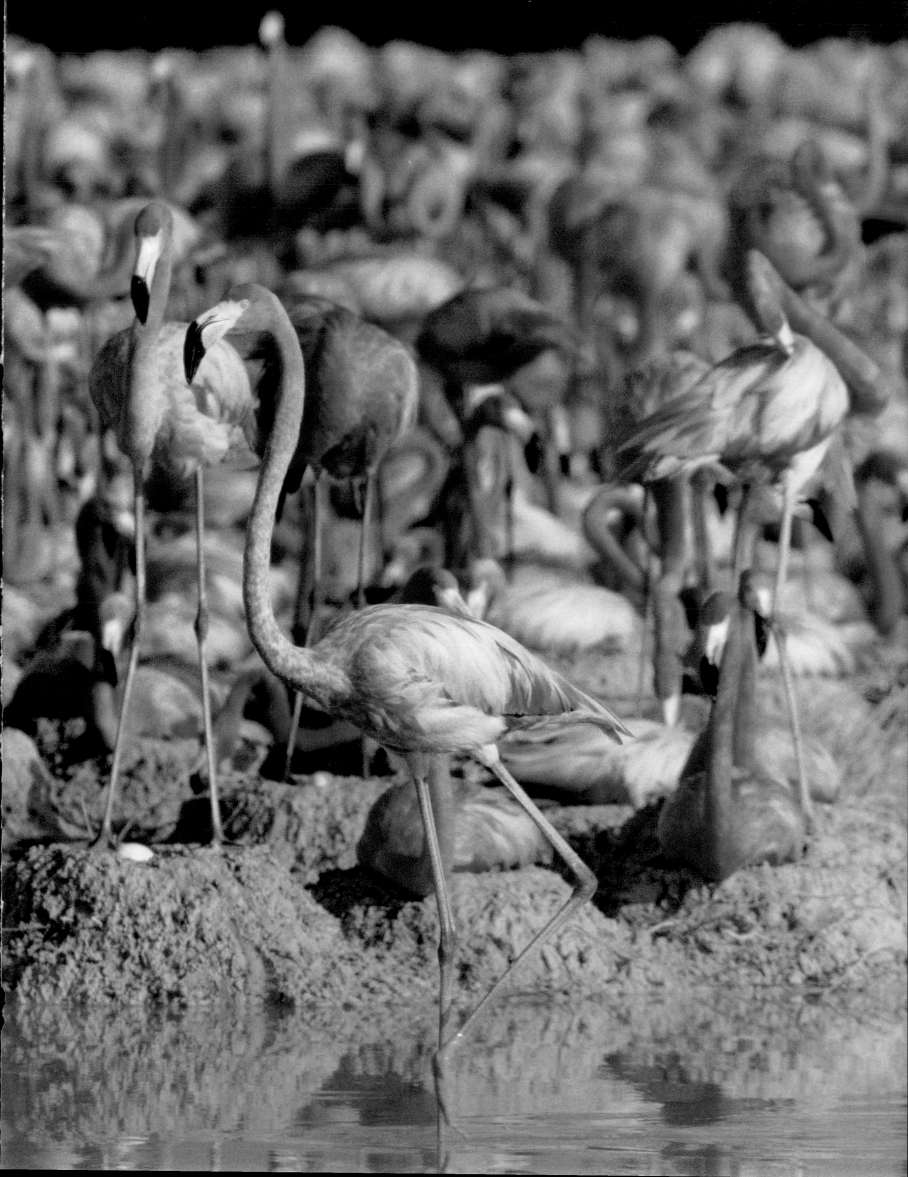

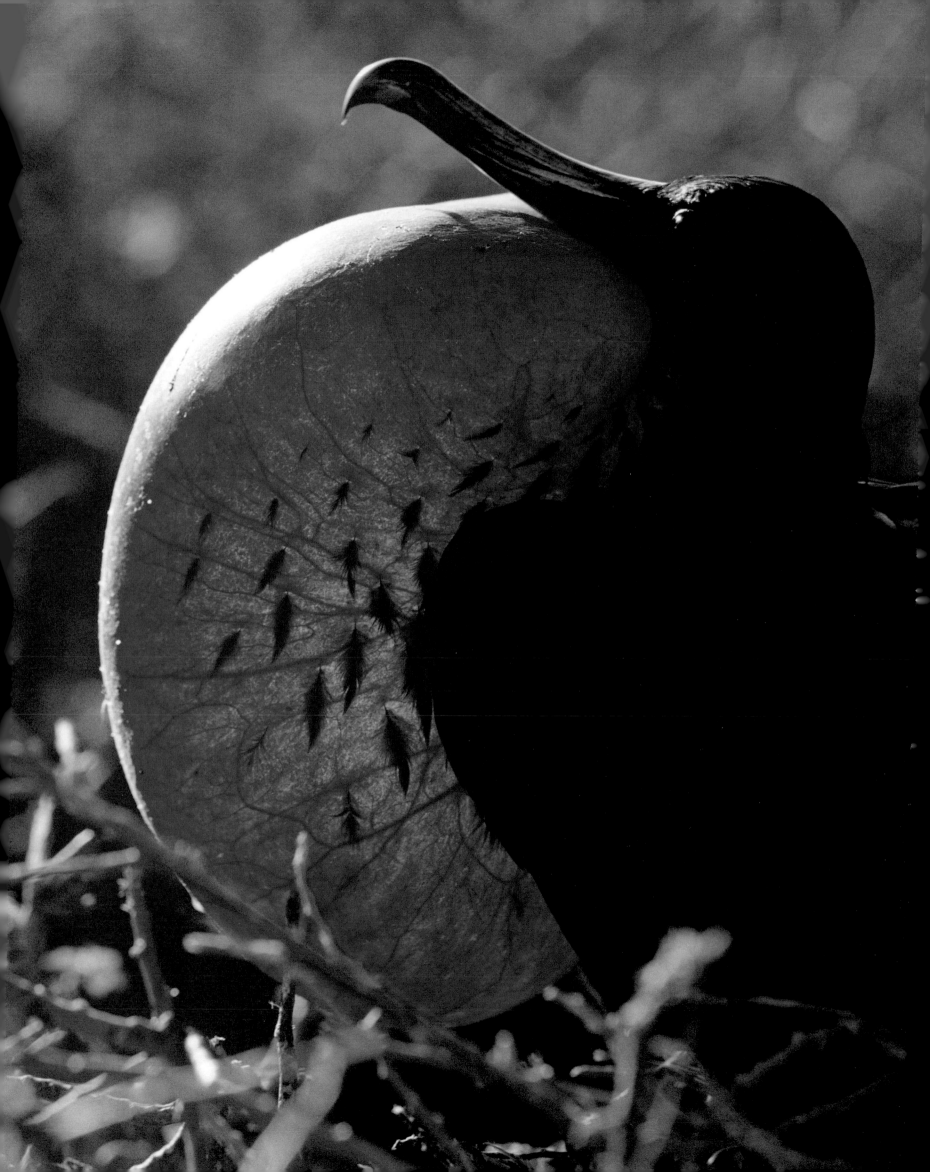

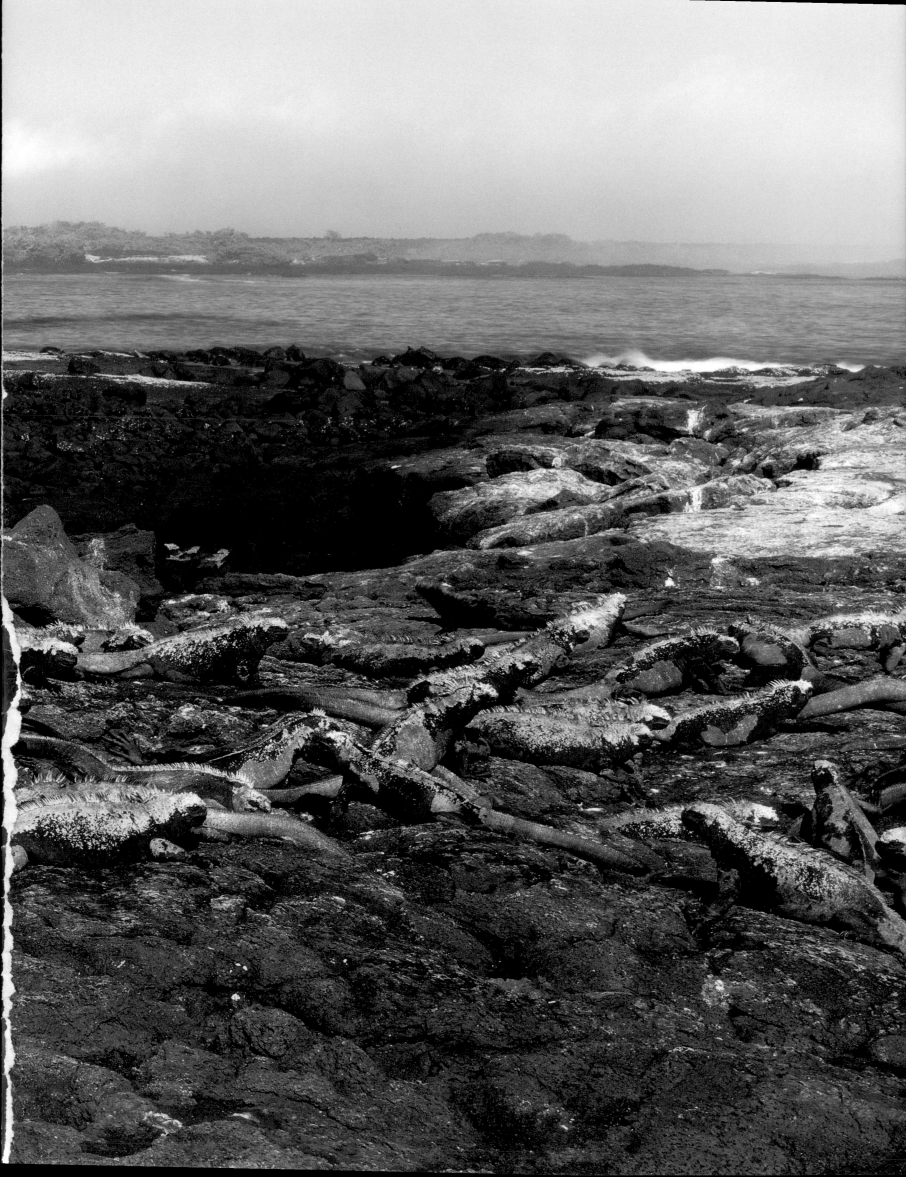

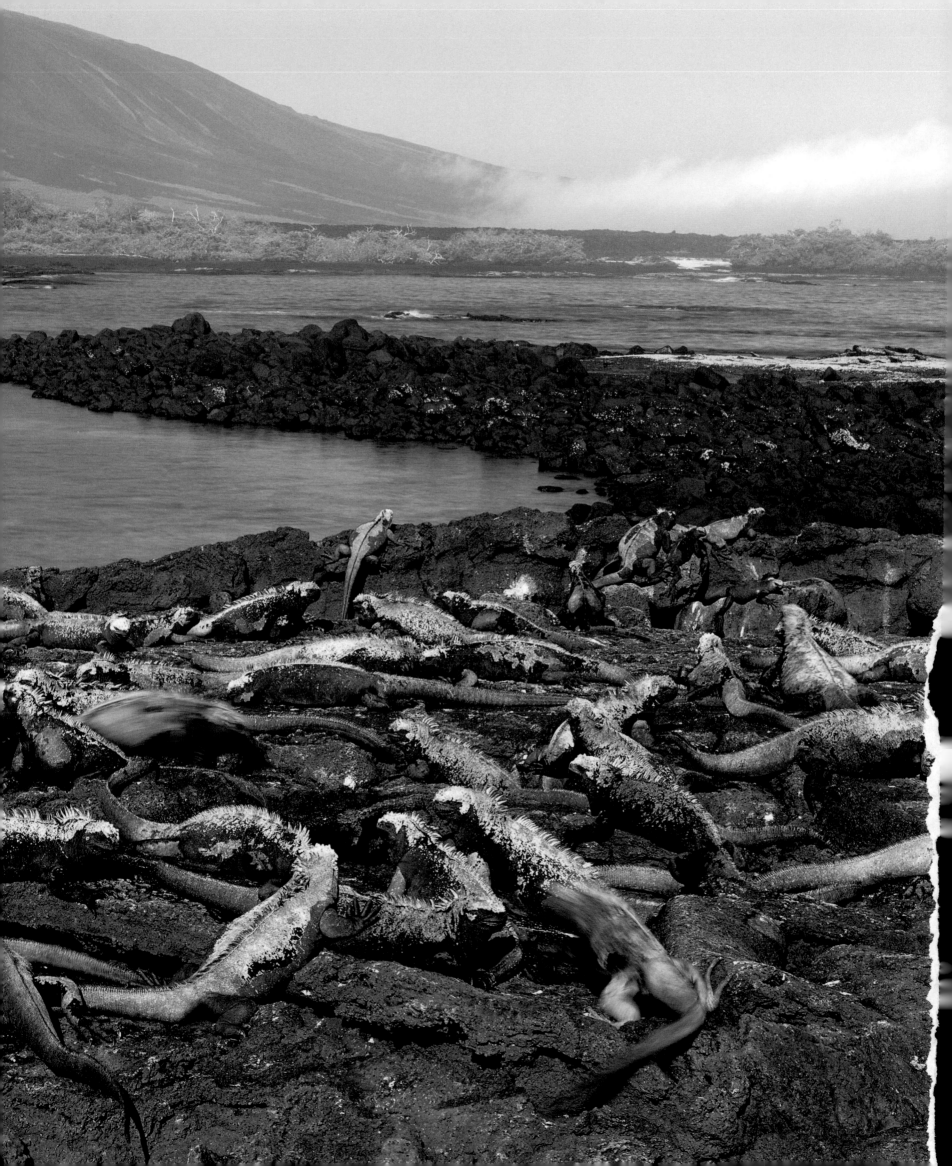

C. nigra abingdonii – is sadly doomed, for there is only a single male left, understandably nicknamed "Lonesome George".

The other "must-see" reptile on Galapagos is undoubtedly the world's only sea-going lizard, the Marine Iguana. There are two species of land iguanas here too, but the marine species steals a march on its relatives by virtue of its ability to dive underwater in search of seaweed and algae. Among its evolutionary adaptations is a special gland, connected to the nostrils and through which it secretes excess salt. There may be as many as 300,000 Marine Iguanas across the Galapagos, and they are impossible to miss, always to be found loafing around in large numbers along the rocky coasts.

It is typical of the ability of the Galapagos to surprise and challenge our preconceptions about wildlife that there are penguins here, despite the fact that this is the heart of the tropics. Galapagos Penguins (*Spheniscus mendiculus*) are found mainly in the westernmost islands, where particularly cool currents keep water temperatures low and boost levels of marine life, on which the penguins feed. Their inability to fly is shared by the equally endemic Flightless Cormorant (*Phalacrocorax harrisi*), which has relinquished the power of flight in response to an absence of predators. Other seabirds breeding here include Magnificent Frigatebirds (*Fregata magnificens*) and three species of booby – Blue-footed (*Sula nebouxii*), Masked (*Sula dactylatra*) and Red-footed (*Sula sula*). Landbirds are less numerous on the islands than their seafaring peers, but almost all the species present are endemic. They include the celebrated "Darwin finches", a group of closely related species which were studied in detail by the scientist, both when on the island and subsequently from specimens he collected whilst here. Each has evolved to exploit a particular niche, with highly specialized feeding strategies and beaks that have developed accordingly.

One of the most remarkable aspects of Galapagos wildlife is its approachability. Within minutes – often seconds – of arriving on the islands, you are face-to-face with some of the tamest wildlife on the planet, and able to get within a few centimetres of tortoises, iguanas and nesting seabirds. This lack of fear of man is all the more surprising given that, in the past, some animals – especially the Giant Tortoises and Fur Seals – were harvested here in large numbers. In more recent times man's involvement with the local wildlife has been far more sensitively managed and geared around ecotourism, although there are worrying signs that what has always been a delicate balancing act may be starting to fall out of kilter.

One significant change in the Galapagos Islands in the last few decades has been a large increase in the human population. When the national park was first declared in 1959, between 1,000 and 2,000 people lived here. As a result of immigration, this total has since risen to around 30,000, many of the new arrivals having little or no tradition of living alongside wildlife or understanding of how fragile the local ecosystem is. There has been an increase in the illegal killing of animals such as tortoises, and the impact of introduced creatures such as goats – which strip huge areas of indigenous vegetation but have been successfully eradicated on several islands – remain of great concern. The special qualities of the Galapagos are also under threat from climate change, and in particular from the more frequent occurrence of El Niño, which results in a warming of the ocean around the islands, thereby reducing the amount of marine life on which much Galapagos wildlife depends.

46. The Cloudforest of Monteverde

In 1972 concern over the fate of a small amphibian – the Golden Toad (*Bufo periglenes*) – helped lead to the creation of what has since become one of Costa Rica's most important protected areas: the privately owned Monteverde Cloudforest Reserve. Only ever observed during its brief annual breeding season, the toad was restricted to just a handful of ponds in the cloudforest of Monteverde in the Tilarán Mountain Range. Cloudforest is essentially a montane version of rainforest, marked by cooler temperatures and the presence of low cloudbanks, which frequently cloak the mountains and vegetation in a drenching mist. At such times humidity levels rise to as much as 100 per cent, the abundance of moisture in the air promoting the growth on the forest trees of spectacular communities of epiphytes, such as bromeliads, orchids, ferns and mosses. Over 878 epiphytic species have been recorded at Monteverde, including a remarkable total of 450 different orchids.

Swathed in mist and drizzle, at first impression the cloudforest can seem a rather gloomy place, its interior dark and dank, with conditions underfoot frequently wet and muddy. What can be spectacular views often remain largely unseen, hampered by cloud. Yet this is a beguiling and atmospheric landscape, and one that soon works its unusual magic on visitors. As one of the world's biodiversity hotspots, there is certainly plenty to see and enjoy. The figures speak for themselves: 3,000 species of vascular plants, 750 types of tree, over 400 varieties of bird, 120 mammal species, and many thousands of different invertebrates. A good starting-point for understanding the cloudforest at Monteverde must be the trees themselves and the luxuriant epiphytes that festoon their trunks and branches, often at a density that obscures the profile of the tree beneath. A characteristic feature of Monteverde is the large number of strangler fig trees (*Ficus* sp.). These start life as epiphytes on other trees, but then grow roots that descend to the forest floor and begin taking in water and nutrients in a more conventional manner. Eventually the strangler becomes a freestanding

LEFT **Strangler fig trees are rapacious epiphytes, their roots eventually depriving the host plant of all sustenance and thereby causing its death.**

RIGHT **The cloudforest has a strong claim to be one of the most atmospheric places on the planet. Luxuriant vegetation abounds, and the variety of plant species is quite bewildering.**

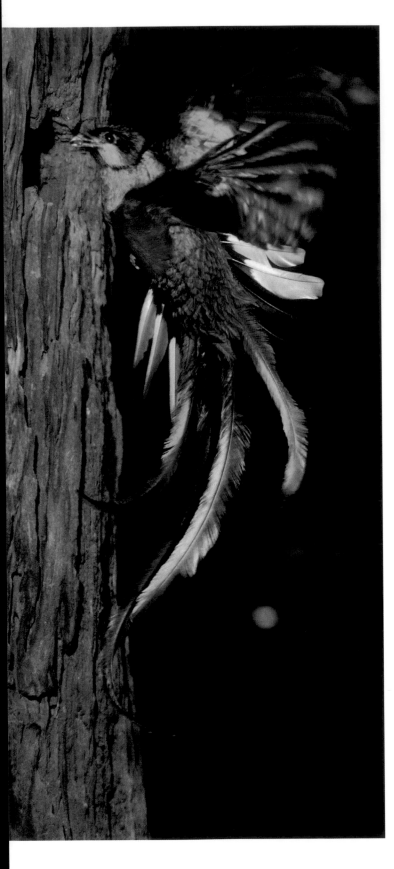

tree, having slowly suffocated its original host within the closed mesh of its above-ground root system.

Most visitors to Monteverde explore the area known as "The Triangle", via a network of 13 kilometres (8 miles) of different forest trails, which start at the reserve entrance. Just outside the entrance it is worth stopping at the Hummingbird Gallery feeders, which regularly attract several species of "hummer", their names as flashy as their plumage. Species to look out for include Violet Sabrewing (*Campylopterus hemileucurus*), Green-crowned Brilliant (*Heliodoxa jacula*), Purple-throated Mountain-gem (*Lampornis calolaema*), Striped-tailed Hummingbird (*Eupherusa eximia*), Magenta-throated Woodstar (*Calliphlox bryantae*) and Coppery-headed Emerald (*Elvira cupreiceps*), the latter being one of Costa Rica's few endemic birds. However, even the most glamorous hummingbird might struggle to compete with Monteverde's avain speciality: the Resplendent Quetzal (*Pharomachrus mocinno*). A member of the trogon family, the Quetzal was revered by both the Aztecs and the Maya on account of the male's dramatic breeding plumage – his iridescent green tail feathers, which can grow up to 60 centimetres (24 inches) long, were used in their ceremonial headdresses. For such a showy bird, the Quetzal can be surprisingly inconspicuous for much of the time, but during the mating season (April–May) the males call noisily and launch into spectacular display flights above the tree canopy, sometimes giving dazzling views.

Quetzals are hole-nesters, either commandeering an old woodpecker cavity or excavating their own in a dead tree. They will also use nest boxes. Once the young have fledged, generally in July, the Quetzals leave Monteverde for the lower elevation of the Pacific slope, where they spend three months before migrating across to the Atlantic slope, where they remain until returning to the cloudforest the following January. This unusual pattern of movement is doubtless related to food supply and the Quetzal's dependence on wild avocados. It does, however, make the conservation of the Quetzal a more complicated affair, as three distinct areas of habitat need to be protected to ensure the bird's survival.

The particular requirements of the Quetzal highlight the complex nature of the forest ecosystem. However, few episodes underline the fragility of the cloudforest environment more than the demise of the Golden Toad. In 1987 some 1,500 adult toads were recorded at Monteverde, but numbers subsequently crashed and none have been seen since 1989. As this was their only known location in the world, the species is now presumed extinct. At the same time, populations of many other amphibian species at Monteverde also collapsed, and some vanished completely. The reasons remain unclear, but the drier and warmer weather patterns that followed the El Niño event of 1986/87 may well have been responsible, as some ponds dried out completely and the water temperature in those remaining rose slightly, possibly beyond what certain amphibians could support.

That a relatively modest change in climate could have such devastating consequences is ringing alarm bells in the context of the more general global warming now taking place. The cloudforest amphibians may prove to be the "canary down the mine", an early warning of impending environ-mental problems and ecological disruption. If the climate does become permanently drier and warmer, the future of the cloudforest ecosystem is at stake. There are already signs that this may be happening. The climate at Monteverde has become slightly drier in recent decades, and certain lower-elevation bird species are already extending their ranges up the mountain, presumably as conditions become suitable for them. What this means for those living in the cooler, wetter conditions at the top of the mountain, with nowhere left to go, is a sobering thought indeed.

ABOVE **There is no denying the Resplendent Quetzal's glamour factor. The Aztecs greatly valued its plumes for royal ceremonial garb, and would trap the birds, remove their tail feathers and then release them, so the feathers would grow back at the next moult.**

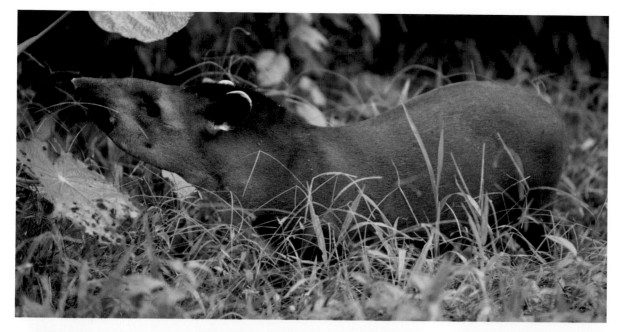

LEFT The enigmatic Baird's or Lowland Tapir (*Tapirus terrestris*) is the largest mammal species in Monteverde after the Jaguar. Essentially nocturnal, they remain largely unseen by human visitors, but finding their tracks is relatively easy.

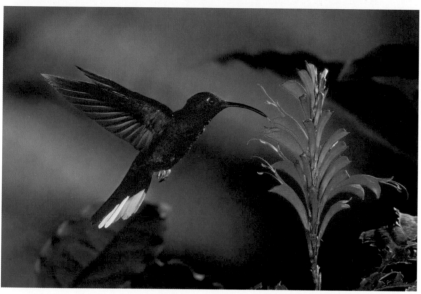

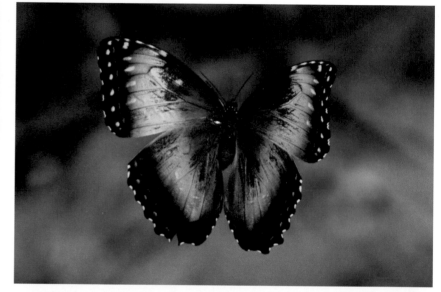

MIDDLE LEFT The Violet Sabrewing is one of several hummingbird species regularly attracted to the feeders near the entrance to the Monteverde reserve.

MIDDLE RIGHT Butterflies can be spectacular in the cloudforest, with sunny clearings often attracting many different species. The Blue Morpho (*Morpho peleides*) is one of the most eye-catching and largest, with a wingspan of as much as 20 centimetres (7½ inches).

BOTTOM LEFT Costa Rica's poison-dart frogs, such as *Dendrobates auratus* (shown here), are found in the lowland forests rather than the highlands, but like their higher-altitude relative the Golden Toad, they are highly sensitive to changing environmental conditions.

BOTTOM RIGHT Only ever recorded from the Monteverde cloudforest, the Golden Toad is now presumed extinct, a victim of subtle but deadly changes in climate. Monitoring amphibian populations may be one way of understanding more about the impact of global warming.

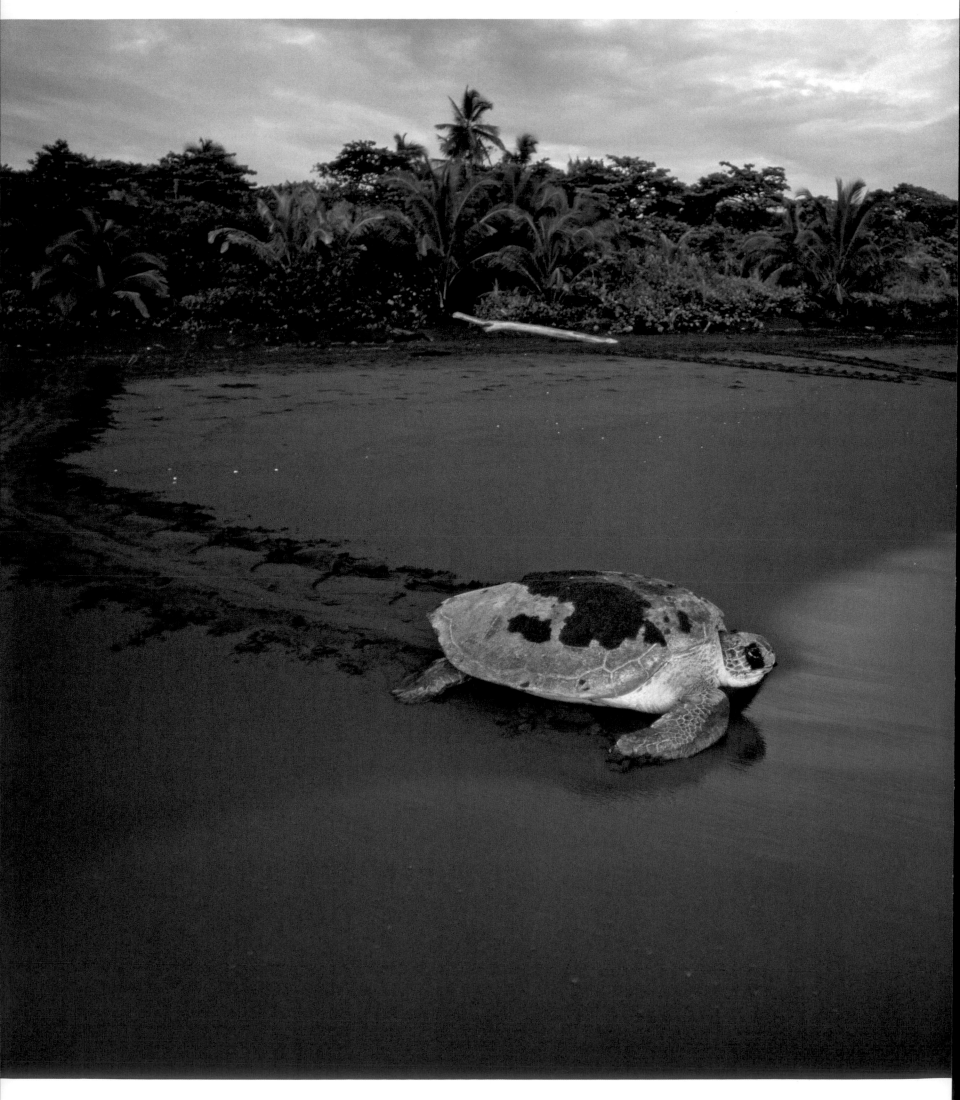

47. The Turtles of Tortuguero

Sandwiched on the Central American isthmus between the Pacific Ocean and Caribbean Sea, Costa Rica is a nation that takes wildlife and environmental conservation very seriously – over a quarter of its land area is protected within an impressive network of 161 national parks, reserves and refuges. For its size, the country has an exceptionally wide range of habitats and landscapes, and biodiversity levels are among the highest in the world. With a good infrastructure and stable political scene, this is without doubt one of the world's premier wildlife-watching destinations. Among Costa Rica's best sites is Tortuguero National Park, covering almost 19,000 hectares (46,950 acres) of Atlantic coast lowland rainforest and *Raphia* palm swamp, through which a series of canals and creeks cut their way before reaching the sea via stands of mangrove and coastal lagoons.

Tortuguero is the local name for turtle-catcher, and the protection of breeding turtles on the area's beaches was the main catalyst behind the creation of the park in 1970. At that time the turtles were threatened with extinction by overhunting, with almost every female that arrived back on its natal beach to try and nest being killed and sent to the export market for turtle soup. Most visitors today come to watch the turtles, as well as to explore the rainforest and swamp via the network of navigable waterways that are such a delightful feature of the park. Often carpeted in water hyacinths, these offer the chance to explore quietly by boat – one of the most exciting ways of getting up close to animals. It is usually possible to see a wide range of birds here, as well as reptiles such as iguanas and basilisks, which often sunbathe in the vegetation overhanging the water. Mammals to look out for include River Otter (*Lontra longicaudis*), Three-toed Sloth (*Bradypus variegatus*) and three species of monkey.

This is also one of the best places in Central America to see the West Indian Manatee (*Trichechus manatus*), now endangered across almost all of its Caribbean range. Manatees, which can be up to 3 metres (10 feet) long, favour shallow coastal waters, although they will often wander up estuaries and rivers. Mainly vegetarian, they graze on seagrasses and other aquatic plantlife, and have traditionally been hunted for their meat and hide. Although this illegal activity still continues on a small scale, a much greater threat to the surviving manatee population is collision with speeding motorboats – many Manatees bear the scars of such accidents.

Much of the park's 40-kilometre (25-mile) stretch of coastline comprises gently shelving beaches of black sand, and from July to October these are the main nesting sites in the western Caribbean for Green Turtles (*Chelonia mydas*), over 2,000 of which visit each season to lay their eggs. Smaller numbers of breeding Hawksbill (*Eretmochelys imbricata*) and Leatherback Turtles (*Dermochelys coriacea*) also occur here. What is undoubtedly one of the world's most remarkable and moving spectacles starts after dusk, when female turtles – some weighing in excess of 100 kilograms (220 pounds) – start appearing in the shallow waves offshore and then slowly emerge on to the land, sometimes for the first time in several years. They then haul themselves laboriously up the beach towards a likely nesting location above the high-tide line, where they set about digging a hole into which to lay their eggs.

This process is painstaking slow and highly fatiguing for the turtle – every few moments she will stop and rest before continuing, using her left and right back feet alternately until a hole of up

LEFT **Exhausted and vulnerable after laying her eggs on the beach above the high tideline, a female Green Turtle drags herself back to the relative safety of the sea.**

to 1 metre (3½ feet) deep is created. During the latter stages of this process all that is visible above ground level from a distance are the plumes of excavated sand shooting into the air. Having dug the hole, the female turtle will then rest for a few minutes before starting to lay her eggs. Green Turtles nest only every 2–4 years, but may lay around 100 rubbery golf ball-sized eggs in one nesting, and several clutches in a breeding season. When she has finished laying, the female turtle backfills the hole and moves around repeatedly over the nest site, camouflaging the precise spot where she has laid the eggs. Exhausted, she then drags herself back down the beach to the sea.

The whole process can take up to two hours, and is necessarily undertaken under the cover of darkness to avoid predators. Not only are the turtles vulnerable when out of the water, but a female who risks laying late in the night – and is still in the nest hole at first light – will attract a host of attendant birds, who will literally gobble up the eggs as they are laid. Outside the protected areas, turtle eggs are still regularly harvested by people for food. Even once out of the shell, the odds are stacked against the turtle hatchlings, with only one in every 2,000 or so making it to maturity. Their life is full of hazards – on the inaugural scramble from their birthplace to the sea, newly-emerged baby turtles risk being picked off by predators such as coyotes, herons and gulls, and life in the open ocean remains fraught. Many turtles die through becoming entangled in fishing nets or in collisions with boats, and they are also killed for food. Some species, like the Hawksbill, continue to be hunted to supply the demand for tortoiseshell. However, careful protection – much of it thanks to the teams of volunteers active in countries like Costa Rica – is helping to ensure that at least some turtle populations have a fighting chance of survival.

OPPOSITE **The placid and slow-moving Manatee can, with luck, be spotted in the coastal waters of Tortuguero. The animal's prehensile upper lip resembles a truncated elephant's trunk and is used both to gather aquatic vegetation and for social interaction.**

OPPOSITE BOTTOM **Costa Rica's Pacific coast also offers excellent turtle-watching opportunities. During August each year the beach at Ostional is visited by up to half a million Olive Ridley Turtles (*Lepidochelys olivacea*), the largest known nesting congregation anywhere in the world.**

BELOW **An aerial view of the forest-lined waterways that are such a characteristic feature of Tortuguero and which offer top-quality wildlife viewing by boat.**

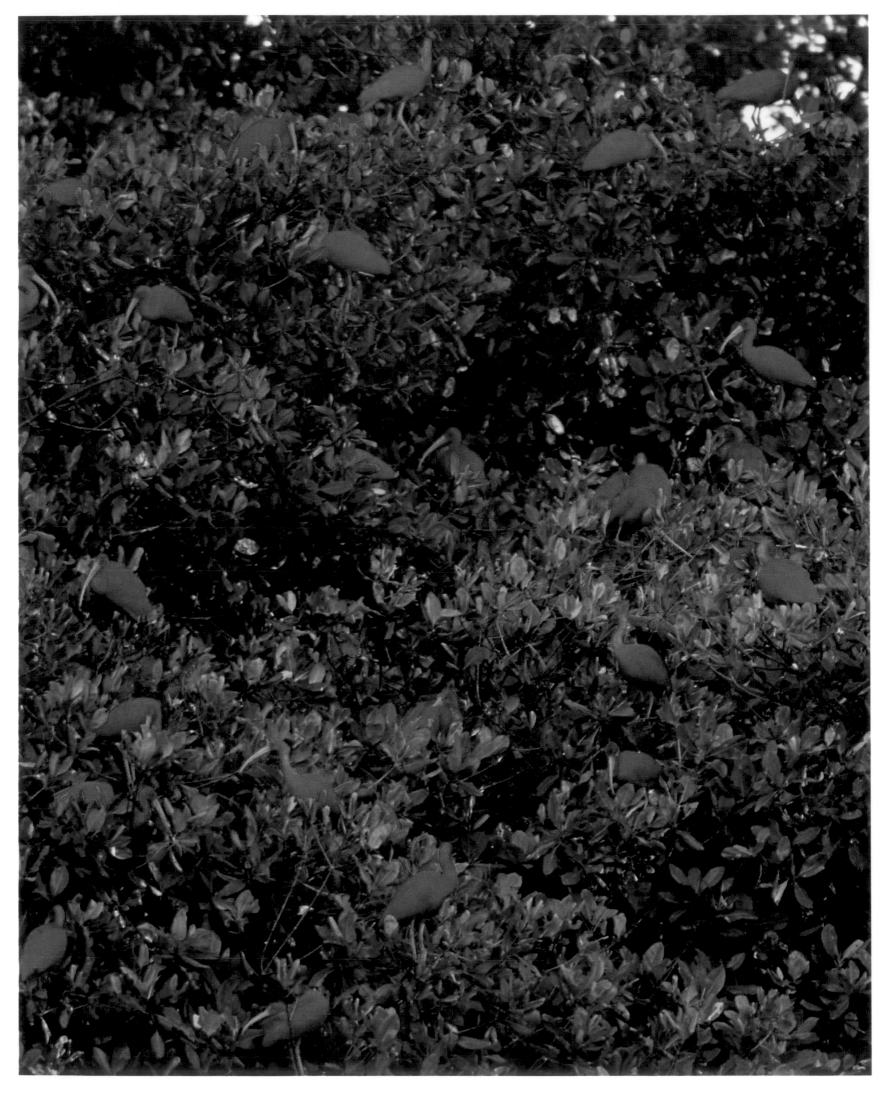

48. Tropical Birding on Trinidad

The southernmost island in the Caribbean Sea, Trinidad sits only 12 kilometres (7½ miles) off the coast of Venezuela. It was once connected to the mainland via a land bridge, which allowed a range of typically South American wildlife to colonize what later became an island when sea levels rose at the end of the last ice age, some 10,000 years ago. As a result, the flora and fauna of Trinidad are particularly rich by regional island standards and have much in common with the continental landmass next door. Indeed, among the Caribbean islands it is only on Trinidad that it is possible to find classic continental mammals such as the Agouti or Paca (*Agouti paca*), Red Howler Monkey (*Alouatta seniculus*), Ocelot (*Felis pardalis*) and Silky Anteater (*Cyclopes didactylus*). The island's appeal as a wildlife-watching destination is further strengthened by the diversity of its habitats and plant communities; there are tracts of lowland and montane rainforest, as well as savannah grassland, semi-deciduous woodland and freshwater and saltwater wetlands.

For an island of such relatively modest size – it covers slightly over 4,700 square kilometres (1,800 square miles) – Trinidad supports a particularly impressive number of insects. There are 650 types of butterfly, for example. The island's birdlife is also outstanding, not just in terms of abundance and diversity (over 460 species have been recorded), but also because Trinidad's avifauna has a decidedly Amazonian character. This makes the island especially appealing to bird enthusiasts, because here is a welcome chance for the less experienced to make sense of the often complex and frustrating art of tropical forest birding. This is not always easy at mainland South American locations, some of which boast bird lists in excess of 1,000 species, the variety on offer being both bewildering and overwhelming, and with many of the birds hard to see well in the dense tree canopy. In Trinidad the birding scene is decidedly more user-friendly, and made even more so by excellent establishments such as the renowned Asa Wright Nature Centre, located in the foothills of the Northern Range near the town of Amina. A former coffee–cocoa–citrus plantation, the Centre sits within secondary rainforest, with some areas of primary forest at

higher levels. This makes for excellent birding locally, but the beauty and interest of this place is as much to do with the avian spectacle, which is on view every day from the Centre's verandah, as with forays into the forest proper.

The verandah offers armchair birding at its very best; bird-tables piled high with fruit, and with sugar-solution feeders for the nectar-loving species, help ensure a constant traffic of birds of great variety and beauty. Many venture within a few metres of the gathered human visitors, and even the shyer birds are regularly lured in close by the delicacies on offer. This makes identification unusually straightforward and even offers unusual opportunities for the side-by-side comparison of similar species. Overall, there can be few better places to get to grips with some of the classic forest birds of South America. Up to 40 species can be seen in just one hour's observation from the verandah, including various tanagers and honeycreepers, woodpeckers, antshrikes, orioles, and several species of hummingbird, whirring busily around the feeders and flowers. Also characteristic of the Centre's grounds are the noisy and unmissable Crested Oropendolas (*Psarocolius decumanus*), a colony of which nests near the main building, and the unremitting, metallic "bong" of the Bearded Bellbird (*Procnias averano*), a particular feature at dawn.

However tempting it might be just to sit on the verandah and enjoy the avian theatre taking place before you, only the laziest visitor could resist exploring the trails that lead through the surrounding forest and countryside. Especially popular are visits to the remarkable leks of the White-bearded Manakin (*Manacus manacus*). After clearing a small area on the forest floor, the male manakin launches into a hyperactive display, jumping from a series of perches to the ground and back again, snapping and whirring his wings and making a variety of trilling and cracking noises. Several males will often perform simultaneously, in an attempt to attract the watching females into mating. One other local excursion worth making is to see the world's only readily accessible colony of the bizarre and enigmatic Oilbird (*Steatornis caripensis*). Up to 80 pairs of this remarkable species, the only nocturnal fruit-eating bird in the world, nest in a cave within the centre's grounds. At night they leave the cave on forays in search of fruit (particularly that of the Oil Palm), which they locate mainly by using their acute sense of smell. Returning by dawn, they navigate their way around the cave's interior by means of echo-location, much as bats do.

Whilst Oilbirds would win few prizes for beauty, one of the most striking of all birds is also found on Trinidad. Every evening at the Caroni Swamp, a few kilometres south of the island's capital, Port of Spain, birders gather for one of the greatest bird spectacles of all – the arrival of thousands of Scarlet Ibises (*Eudocimus ruber*) as they fly in to roost. Known locally as "flamingoes", during the day these birds forage for crustaceans out on the mud flats at low tide, some making daytrips as far away as the Venezuelan coast. In the hour or so before sundown they drift back in a constant stream of small groups of 5–20, to spend the night perched in the mangroves at Caroni. As many as 3,000 may gather here, congregating in such numbers as to turn the mangroves fluorescent red. There are few sights to beat it anywhere in the world.

ABOVE LEFT **Hummingbirds like this Tufted Coquette (*Lophornis ornatus*) are a delight to watch. Outstanding aerial acrobats, their flying skills are made possible by extraordinary breast muscles that comprise nearly 30 per cent of their total body weight.**

ABOVE **An Oilbird with its chicks. This bird's English name comes from the unfortunate historical practice of harvesting and boiling down the plump young birds for oil. Thankfully, the species is now strictly protected.**

OPPOSITE **A male Ruby Topaz Hummingbird (*Chrysolampis mosquitus*) at a hibiscus. Hummingbirds usually need to feed every quarter of an hour or so, and with most flowers only containing a small amount of nectar, some 2,000 visits are required by each bird every day.**

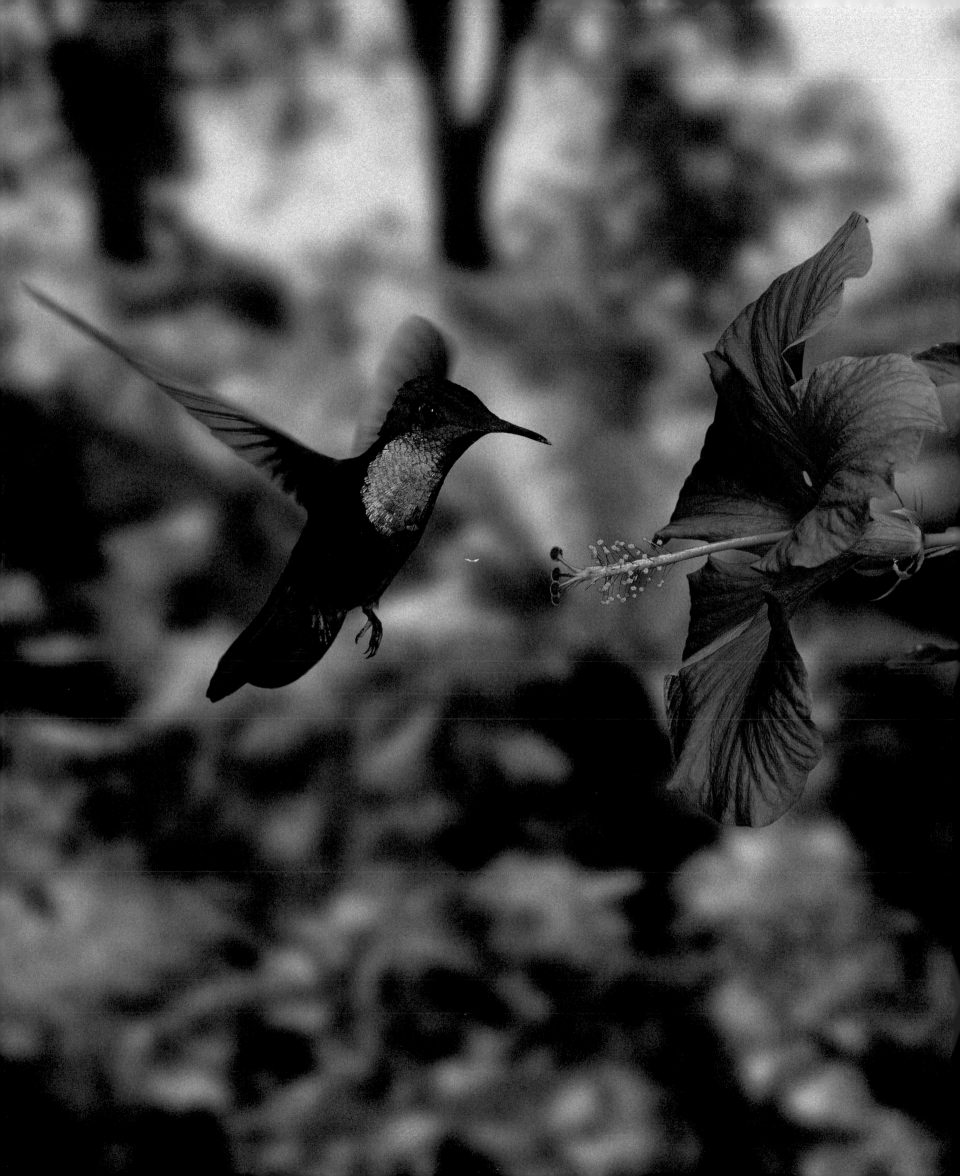

49. Life at the Top: Huascarán National Park

The diversity of landscapes and habitats in South America is never less than astonishing, and some of the most extraordinary ecosystems of all are undoubtedly those associated with the Andean mountain range. Extending for over 7,000 kilometres (4,350 miles) down the western side of the continent, the Andes are home to a variety of high-altitude wildlife that would otherwise be unable to maintain a foothold in South America. This is largely a land of cold, windswept plateaux, glaciers and permanently snow-capped peaks, and life here is tough for man and beast alike. The severe climate, with frequent snow and temperatures as low as −30°C (−22°F) at higher levels, determines the character and distribution of the local flora and fauna, and the inaccessible nature of much of the terrain makes this exciting territory for those in search of interesting wildlife – it is, after all, virtually certain that species as yet unknown to science await discovery in a hidden valley or on a remote scree slope.

A major component of the Andean system is the Cordillera Blanca which, with 27 peaks in excess of 6,000 metres (19,685 feet), is the world's highest tropical mountain range. At its heart sits El Huascarán, the highest mountain in Peru at 6,768 metres (22,205 feet), and the fourth highest in South America. Its twin peaks dominate the vast surrounding national park to which it lends its name. Declared a World Heritage Site in 1985, Huascarán National Park covers 3,400 square kilometres (1,300 square miles) of breathtaking Andean scenery, with rugged mountainous terrain dissected by steep-sided valleys and fast-flowing rivers. Azure-blue mountain lakes contrast with the panorama of snow-covered peaks behind. With almost the entire park located above 2,500 metres (8,200 feet), the local habitats are largely montane in character, but there is a surprisingly diverse range of vegetation within the park boundaries. About 800 different species of plant have been identified here, with many highly specialized communities – including forests of *Polylepis* spp., the highest altitude trees in the world – and an interesting variety of mountain orchids.

Particularly iconic among Huascarán's flora is the Puya or Cunco (*Puya raimondii*), undoubtedly one of world's most spectacular plants. The tallest bromeliad of all, the Puya is fairly common in the park at altitudes between 3,200 and 4,800 metres (10,500 and 15,750 feet). It grows on dry, stony slopes and is a hard plant to miss, with rosettes of leaves (which are covered in unforgiving thorns) standing up to 3 metres (10 feet) tall. Like many high-altitude species, it is slow-growing and individual plants can take 100 years or so to reach maturity. They then send up an extraordinary flower spike, reaching as much 10 metres (33 feet) high and capable of bearing up to 8,000 blossoms; but once flowering is over, the plant dies. Such a long life cycle, combined with the Puya's specific ecological requirements and restricted distribution – it is only found in parts of Peru and Bolivia – make it potentially vulnerable should conditions in its native habitat become unfavourable.

Owing to the harsh nature of the local climate and terrain, Huascarán is home to a rather limited number of wildlife species by South American standards. However, the relative lack of quantity is more than compensated for by the quality of what is here. Mammals include Vicuña (*Vicugna vicugna*) and White-tailed Deer (*Odocoileus virginianus*), herds of which graze the montane grasslands and both of which are potential prey for the local population of Pumas (*Felis concolor incarum*). Two smaller members of the cat family have also been recorded in the park, the Pampas Cat (*Leopardus colocolo*) and the Andean Cat (*Leopardus jacobitus*). The latter is South

TOP The remarkable Puya is one of the emblematic plants of Huascarán and very much a feature of the park's stunning landscapes. The thorns on the Puya's leaves probably evolved to deter browsing by mammals.

ABOVE The striking Torrent Duck (female in foreground, male behind) is supremely adapted to life in fast-flowing Andean rivers, but is usually found at low densities and appears to be declining across much of its range.

OPPOSITE The magnificent Andean Condor invariably stays well above the tree line, scavenging carrion. Females lay a single egg, usually in a cave or on a cliff ledge, and the chick will take five or six years to reach maturity.

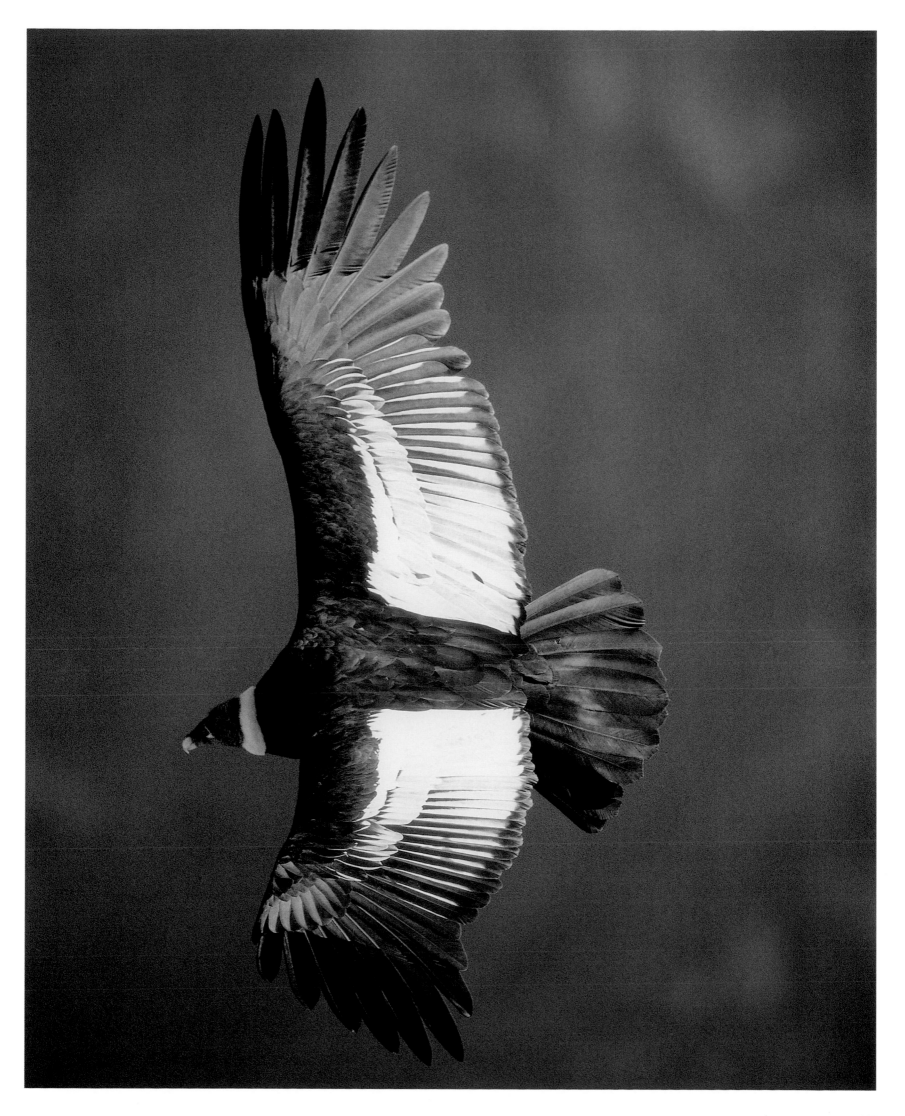

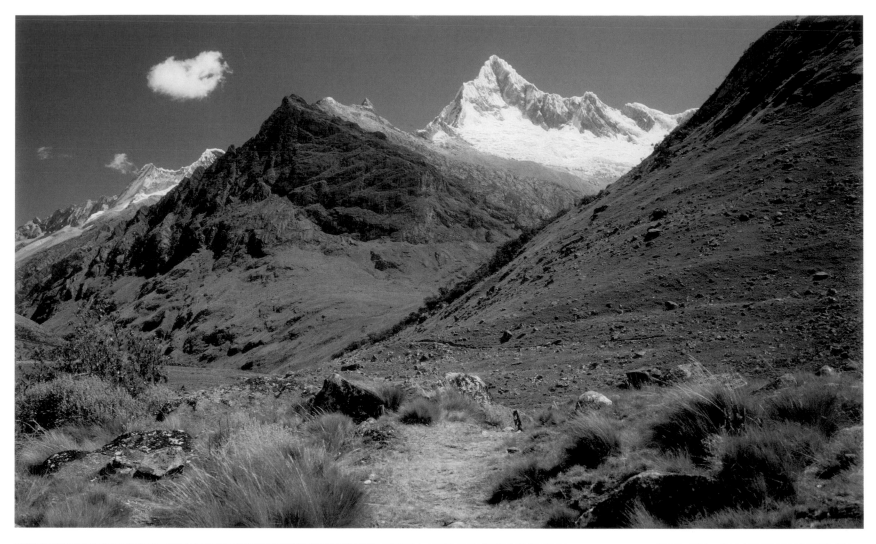

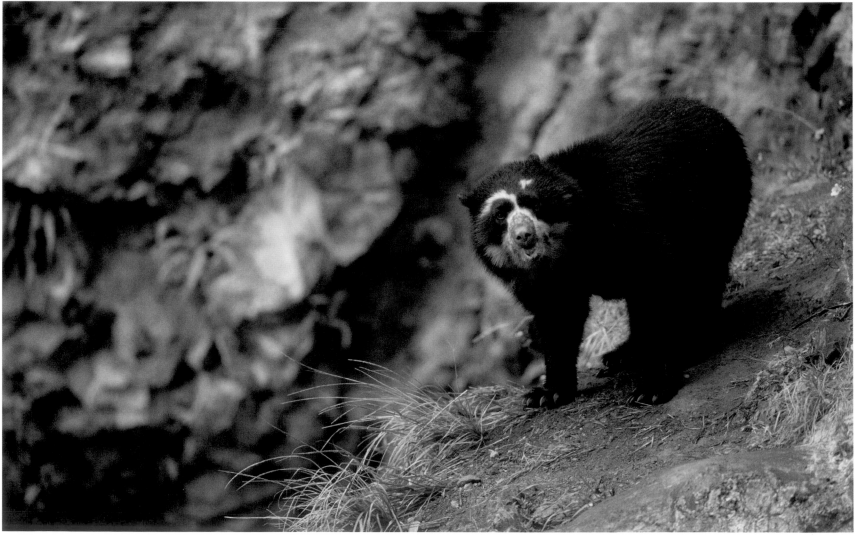

OPPOSITE TOP The valleys and peaks of Huascarán offer trekking of the highest standard, but this is wild country and best tackled by using local expertise and guides. Wildlife can be less immediately apparent than in other types of landscape, but some of South America's greatest wildlife attractions are found here.

OPPOSITE BOTTOM Spectacled Bears are widely but thinly distributed through the northern two-thirds of the Andean chain, but appear to be declining almost everywhere and are now extinct in some parts of their former range.

America's rarest felid, highly adapted to its mountain environment and, whilst considerably smaller, it bears more than a passing resemblance to the equally elusive Snow Leopard of Asia (see page 91). The ecology and habits of the Andean Cat remain little understood; sightings are exceedingly infrequent, which only adds to its mystique.

Huascarán is also significant as a refuge for Peru's increasingly fragmented population of Spectacled Bears (*Tremarctos ornatus*). South America's only bear, and the world's rarest, this species was named on account of the characteristic facial markings, the pattern of which is unique to each individual. Widely but thinly distributed throughout the Andes, it is – like all bears – highly omnivorous, preying opportunistically on a variety of foodstuffs from fruit to bromeliads and invertebrates. Spectacled Bears are good climbers and so are often best looked for in tracts of forest, but being shy and mainly nocturnal, this is not an easy animal to find. Outside of protected areas, the bears are vulnerable to habitat destruction and poaching, and it is unlikely that the total world population exceeds 5,000.

Birdlife in Huascarán is highly specialized. Over 110 species have been recorded in the park, including several Peruvian endemics, and a number of classic Andean specialities. Largest of these, and a popular sight among visitors to the park, is the mighty Andean Condor (*Vultur gryphus*). Regular scouring of the skies will often reveal one or more birds, sailing effortlessly in thermals on a wingspan of 3 metres (10 feet) or more. As carrion eaters, they are constantly engaged in a search for carcasses, often gathering around a particularly inviting specimen and gorging themselves to excess. Another species on most birders' hit list is the colourful Torrent Duck (*Merganetta armata*), which is fairly common along the foaming white-water rivers of the park.

Huascarán National Park is well known as a destination for mountaineering and trekking, but its wildlife interest remains relatively undeveloped. It has great potential as a focus for sensitively managed ecotourism, but the long-term future of some of its more fragile habitats may be affected by global warming. High-altitude ecosystems such as those found in the Andes are likely to be sensitive to the slightest increase in average temperature, and with evidence that some of the region's glaciers are already in a state of constant melt, research is underway to try and understand what the implications may be for the wildlife that lives in this stark but beautiful environment.

RIGHT The smallest of the camelid family, the Vicuña was once so intensively hunted for its soft fur that by the 1970s it was considered at risk of extinction. Numbers have since partially recovered, and today family groups are a common sight in Huascarán.

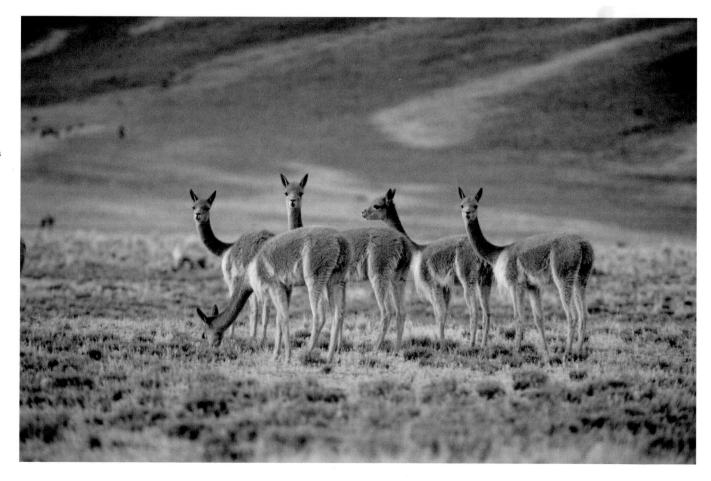

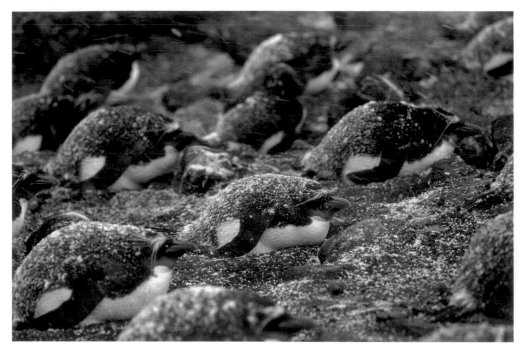

50. The Penguins and Seals of South Georgia

By any standards South Georgia is a remote place. The largest of a chain of rocky outcrops that also includes the South Sandwich Islands, it sits out in the vastness of the South Atlantic Ocean, beset by wind, snow and ice for much of the year. While technically sub-Antarctic in terms of its location and latitude, the climate, mountainous terrain and wildlife of South Georgia are decidedly Antarctic in character – a result of the island's being located south of the point at which the northward-flowing cold currents from the Antarctic sink below the warmer waters of the Atlantic. Half of South Georgia is covered by glaciers, and ice regularly freezes over the smaller bays and inlets around its coast. In particularly cold winters the Antarctic pack ice has extended as far north as the island.

Despite its remoteness – the nearest continental landmass is South America, over 2,000 kilometres (1,240 miles) to the west – South Georgia is far from desolate, at least in terms of its wildlife. For here are some of the largest populations of birds and animals known anywhere; in fact, possibly the greatest density of wildlife on the planet. The numbers speak for themselves – over 20 million Antarctic Prions (*Pachyptila desolata*), nearly four million Common Diving-petrels (*Pelecanoides urinatrix*) and 2.7 million Macaroni Penguins (*Eudyptes chrysolophus*). And those are just the most numerous bird species. Several others are present in totals running into many thousands, and there are also large colonies of both Antarctic Fur Seal (*Arctocephalus gazella*) and Southern Elephant Seal (*Mirounga leonina*). All in an area 170 kilometres (106 miles) long and never wider than 40 kilometres (25 miles).

The main explanation for these mind-boggling numbers is the abundance of food. The seas around South Georgia are teeming with marine life, including masses of krill, squid and fish, and this ensures a plentiful, nutritious supply of food for young birds in particular. With the local wildlife showing little or no fear of humans, some astonishing encounters are virtually guaranteed. One of the most dramatic is surely at the island's colonies – usually known as rookeries – of King Penguin (*Aptenodytes patagonicus*). The second-largest penguin (after the Emperor, *A. forsteri*), the Kings gather here in vast numbers to breed. There are 400,000 or so on South Georgia in total, and their main nest site is at St Andrew's Bay, where

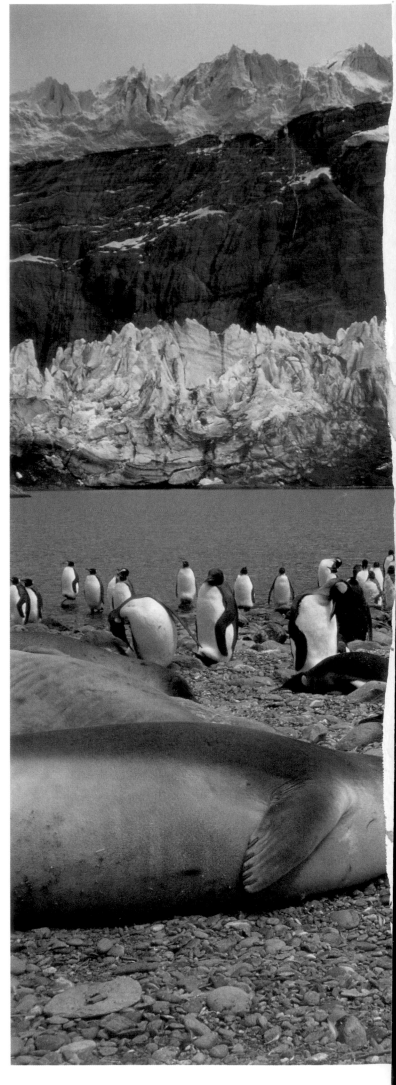

ABOVE **Macaroni Penguins hunkered down in a snowstorm. The species takes its name from the term "Macaroni", used to describe eighteenth-century London dandies who wore gaudy Italian plumes.**

RIGHT **A typical South Georgia scene. Large numbers of King Penguins gathered on a beach, with lounging Elephant Seals in the foreground and a dramatic glacier backdrop.**

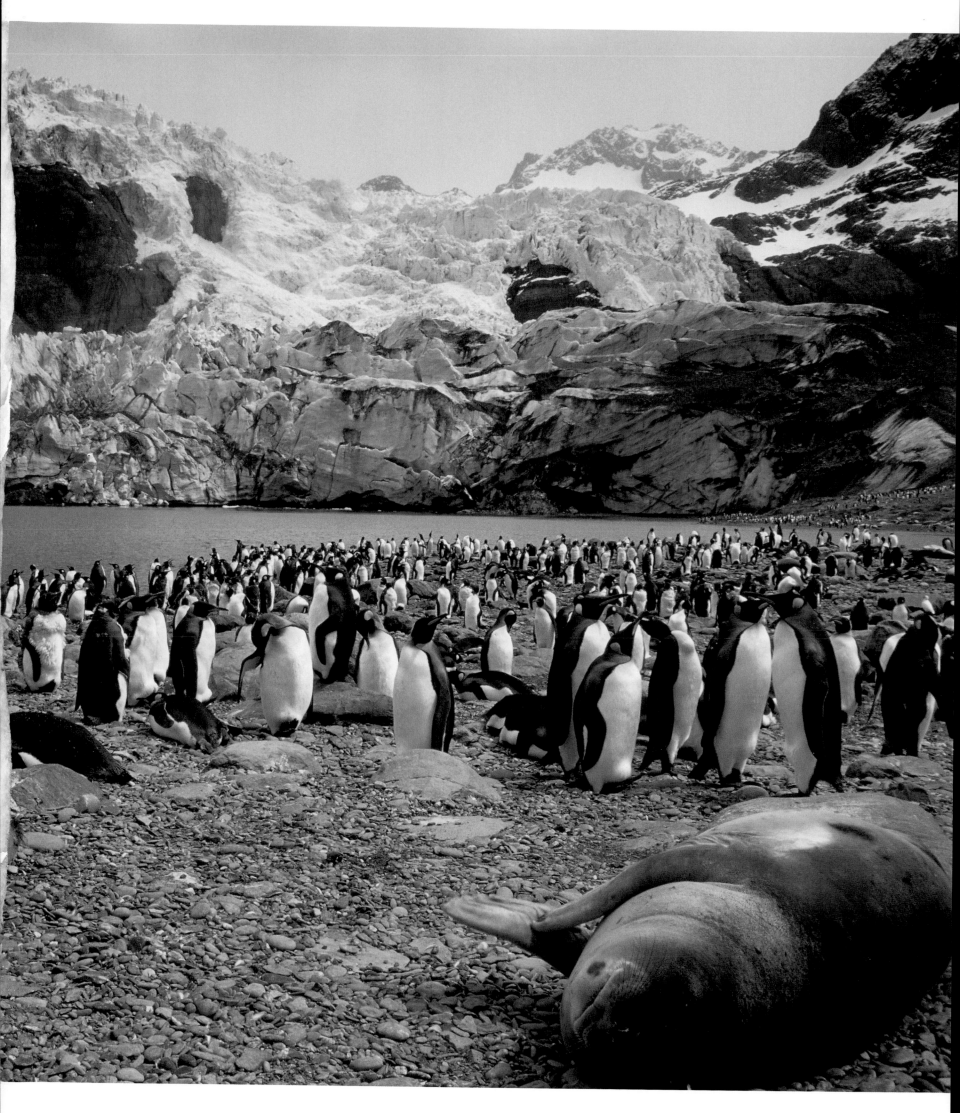

OPPOSITE **A King Penguin with a young chick. The parent bird supports the youngster on its feet, so that it is not in contact with the icy ground below, and will cradle it among its belly feathers.**

more than 250,000 birds gather alongside many thousands of Elephant Seals – an amazingly populous, noisy and smelly congregation, and without doubt one of the world's most remarkable wildlife experiences.

Whereas King Penguin rookeries elsewhere are occupied only during a defined breeding season, the birds on South Georgia have a staggered 18-month-long breeding cycle, and so the rookery site is full of birds all year round. A successful pair will rear two chicks every three years, the first early in the Antarctic summer and the second at the end of the summer the following year. They then skip a season, to regain condition, before breeding again early in the next summer. Consequently it is sometimes possible to watch various adult birds incubating their (usually single) egg and feeding chicks of different ages, as well as older young gathered together in creches and moulting their down, all at the same time.

King Penguins occupy 1 square metre (10 square feet) of space per couple, and their rookeries are arranged accordingly. This contrasts with the 30 square metres (325 square feet) or so required by each pair of Wandering Albatrosses (*Diomedea exulans*) which, with a wingspan of over 3 metres (10 feet), necessarily lengthy take-off distances and various elaborate greeting ceremonies, need a considerably roomier domain. Four thousand pairs nest on three small islands off South Georgia, but their numbers are down by a third since 1984, almost completely due to the impact of long-line fishing. Although they can live for at least 50 years, Wandering Albatrosses may only make 10–15 successful breeding attempts during their lifetime, and so the population will always struggle to recover after a decline.

The biggest mammals on South Georgia, and the largest seal in the world, the Elephant Seals arrive on their breeding beaches in September and October. The males soon set about trying to establish dominance, sparring in what often turn into bloody battles resulting in injury and, very occasionally, the death of one of the protagonists. The most successful male will become "beachmaster" and enjoy mating rights with a harem of as many as 40–50 females, but the efforts required to attain this role – and, perhaps, to fulfil it – are such that his life expectancy is less than half that of a female. Fur Seals breed later, during November and December, and on different breeding beaches, but these are also occupied to such a density – and defended by the bulls with such vigour – that it is impossible to land there without causing huge disruption and risking an incident. Territorial bull Fur Seals will not hesitate to drive off human interlopers and can inflict a nasty bite! Far less intimidating is the population of Reindeer (*Rangifer tarandus*) that also lives on the island. Introduced in the first quarter of the twentieth century, these have thrived in the absence of any local predators.

Finally, South Georgia can also claim the world's most southerly passerine (or perching bird) – the South Georgia Pipit (*Anthus antarcticus*). Endemic to the island, it is believed to have descended from a South American pipit that got blown off course here and subsequently evolved into a separate species – evidence, if any more were needed, of just what a remote but extraordinary spot this is.

BELOW **To the south west of South Georgia, off the Antarctic Peninsula, lie the South Shetland Islands. Millions of Chinstrap Penguins (*Pygoscelis antarctica*) nest there, seen here in a huge colony behind a group of Antarctic Fur Seals.**

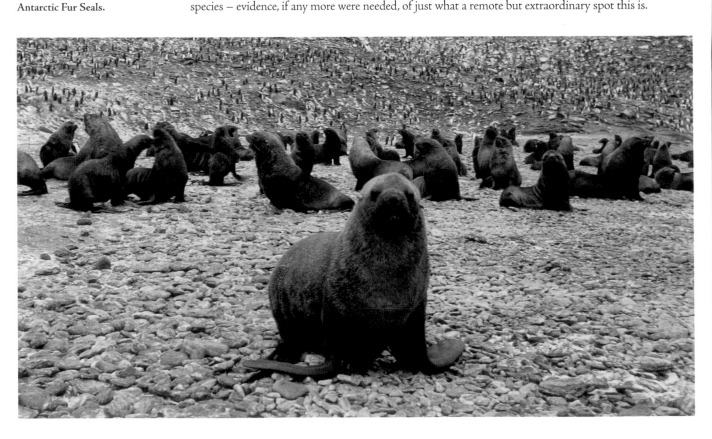

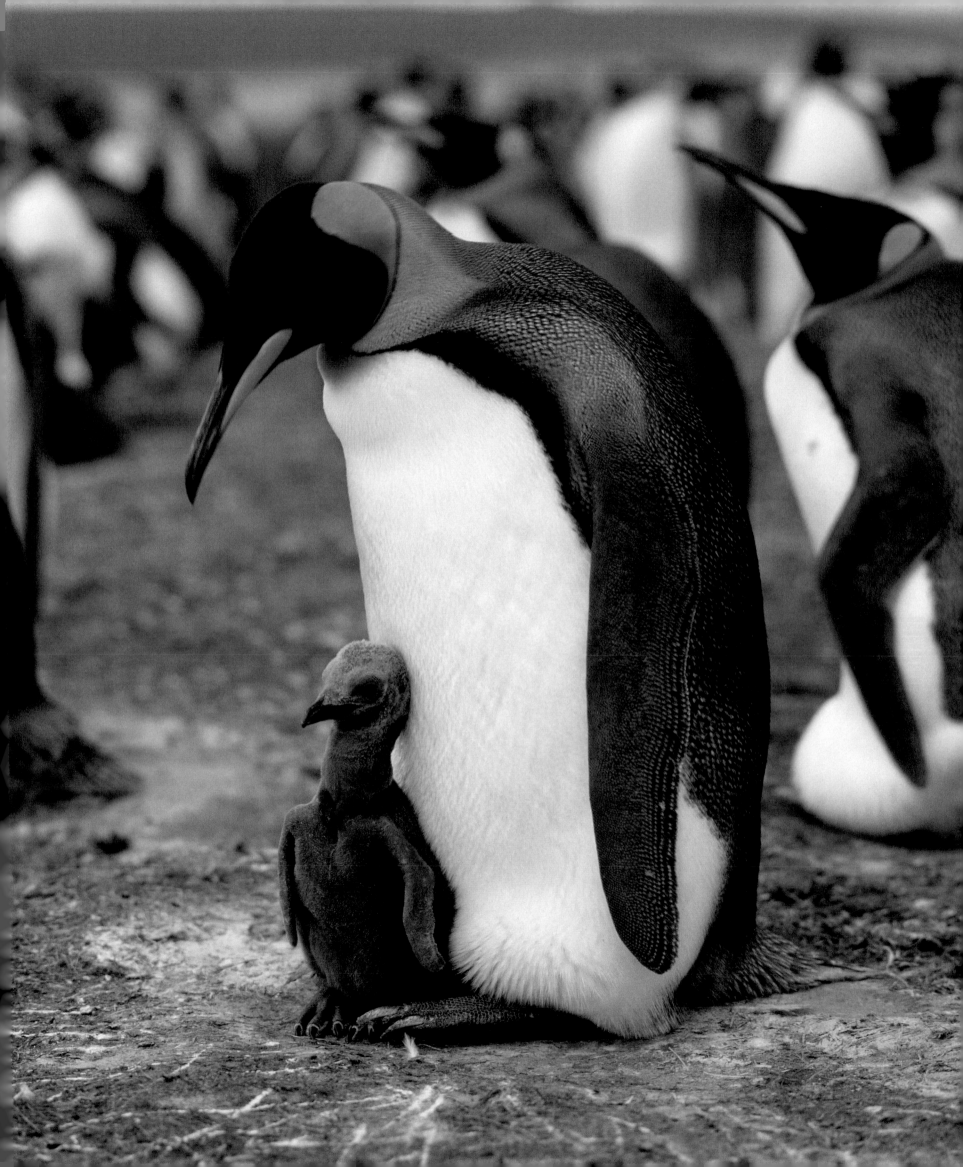

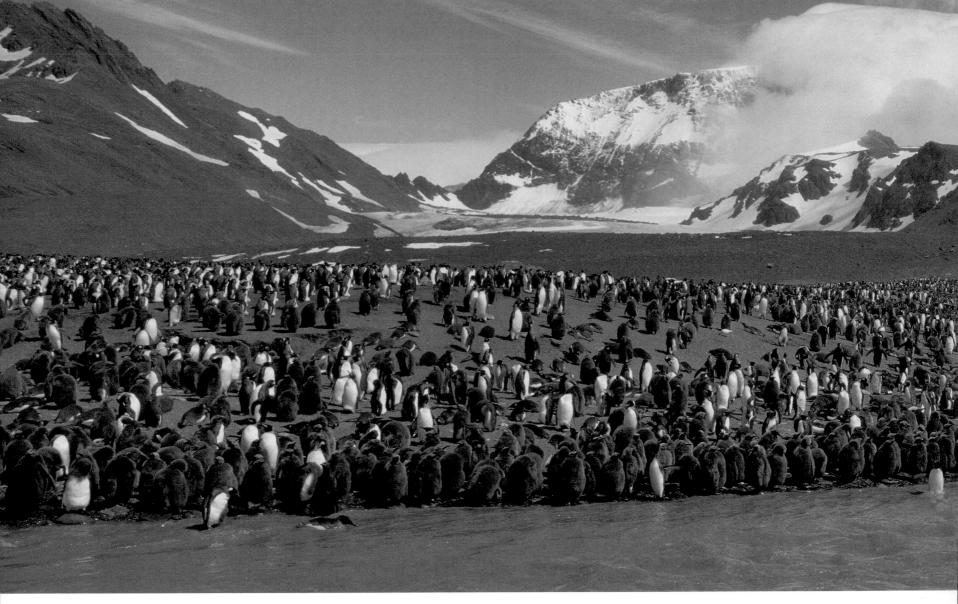

ABOVE Just one section of the King Penguin colony at St Andrew's Bay. The chicks are distinguished by their thick brown coats, which help protect them against harsh winds and sub-zero temperatures.

RIGHT A bull Antarctic Fur Seal calling. Ninety-five per cent of the world population of this species, currently estimated at 1.5 million, breeds on South Georgia.

FAR RIGHT Male Elephant Seals can weigh as much as 4,000 kilograms (8,800 pounds) and reach up to 1.8 metres (6 feet) in length.

OPPOSITE Wandering Albatrosses displaying. These birds pair for life, and reaffirm their bond through an elaborate series of greetings, vocalizations and courtship gestures.

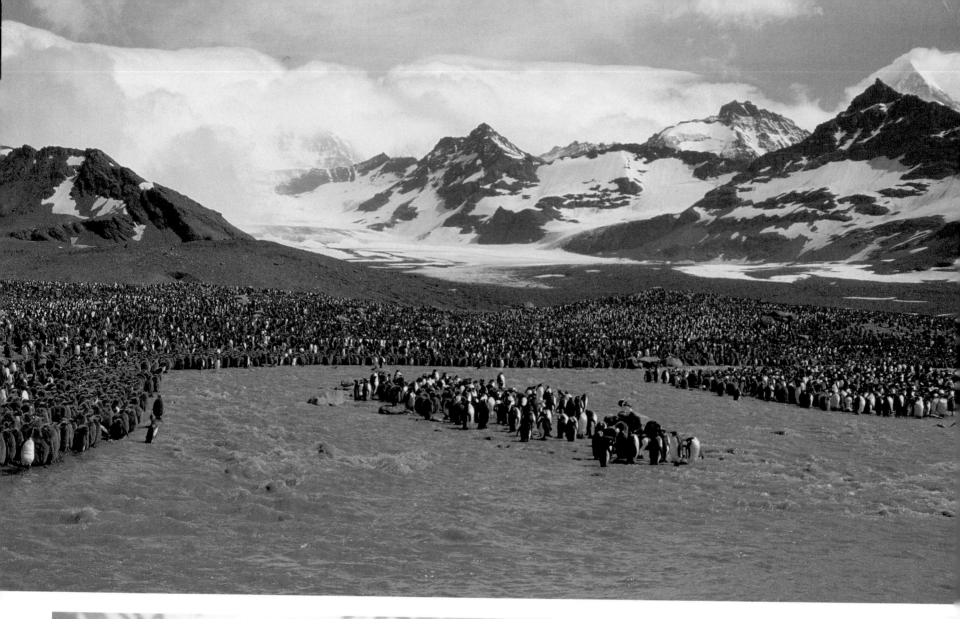

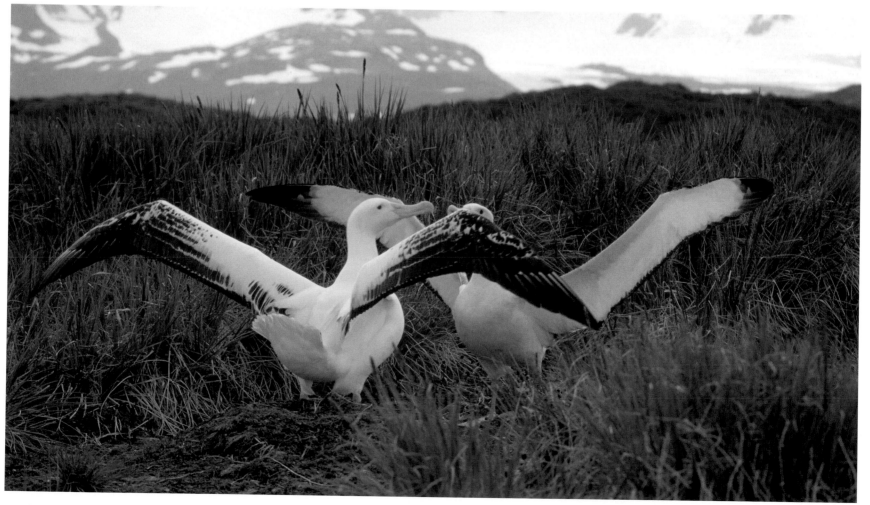

SITE GAZETTEER

AUSTRALIA	Sites 28, 30, 32 and 33 (pages 134, 142, 150 and 156)
BOTSWANA	Site 12 (page 64)
BRAZIL	Sites 41 and 43 (pages 198 and 208)
CANADA	Site 39 (page 188)
CHINA	Site 27 (page 128)
COSTA RICA	Sites 46 and 47 (pages 224 and 228)
ECUADOR	Site 45 (page 218)
FRANCE	Site 5 (page 32)
GABON	Site 14 (page 72)
GERMANY	Site 5 (page 32)
ICELAND	Site 7 (page 40)
INDIA	Sites 18, 20, 22, 24 and 26 (pages 90, 98, 106, 116 and 124)
ITALY	Site 5 (page 32)
KENYA	Sites 11 (page 60)
MADAGASCAR	Site 10 (page 56)
MALAYSIA	Site 19 and 23 (page 94 and 112)
MALI	Site 16 (page 80)
MEXICO	Site 42 (page 204)
NAMIBIA	Site 13 (page 68)
NEW ZEALAND	Site 29 (page 138)
OMAN	Site 21 (page 102)
PAPUA NEW GUINEA	Site 31 (page 146)
PERU	Sites 44 and 49 (pages 214 and 236)
POLAND	Site 2 (page 18)
ROMANIA	Site 4 (page 26)
SOUTH GEORGIA	Site 50 (page 240)
SPAIN	Sites 3 and 6 (pages 22 and 36)
SRI LANKA	Site 25 (page 120)
SWITZERLAND	Site 5 (page 32)
TANZANIA	Sites 8, 9 and 15 (pages 46, 50 and 76)
TRINIDAD AND TOBAGO	Site 48 (page 232)
UGANDA	Site 17 (page 84)
UK	Site 1 (page 14)
USA	Sites 34, 35, 36, 37, 38 and 40 (pages 162, 166, 170, 176, 182 and 192)

LEFT Once over-hunted for
their skins, following protection
alligators in the southern
United States have regained
their numbers.

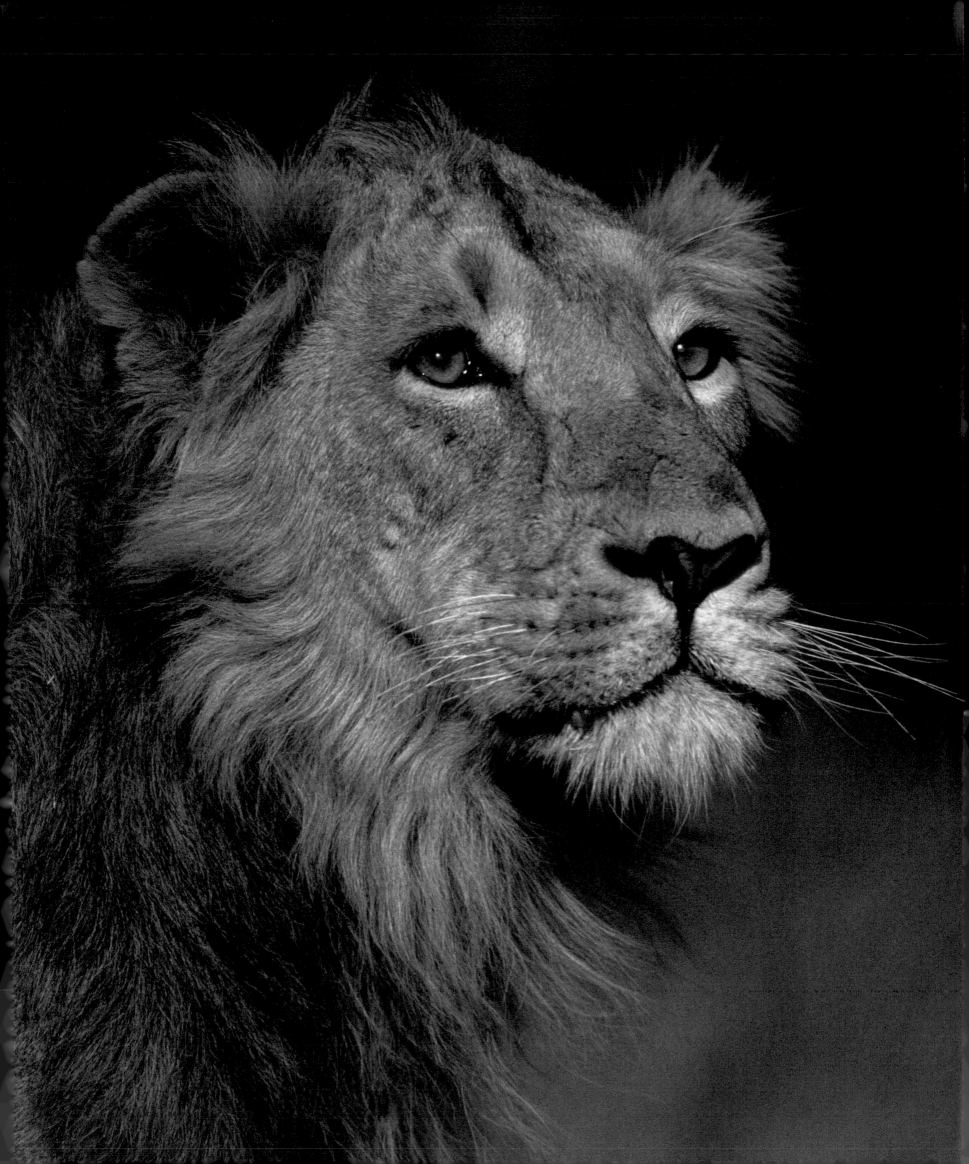

RESOURCES

There is a wealth of travel companies, both specialist and otherwise, operating tours to the places covered in this book. It is well worth looking carefully at the detail of itineraries and the amount of time spent in the field, as well as to what extent – if indeed, at all – the company concerned is making efforts to contribute to the conservation of the places to which it runs tours. Reading previous tour reports and dossiers is a critical element of pre-trip research, as is a basic degree of familiarisation with an area's flora and fauna via the vast amount of material now available both on the printed page and through the internet. Many sites can also be visited easily by independent travellers, although in such cases it is usually worth employing the services of a local guide. This not only helps reinforce the economic value of wildlife on a direct level to those that matter most, but should also help ensure that you get to see more, and develop a greater understanding of where you are and what you are looking at.

On a broader level, the following websites provide valuable background, both general and specific, on a host of environmental and wildlife-related topics:

The United Nations Environment Programme's World Conservation Monitoring Centre website contains useful information a vast range of subjects, from climate change through biodiversity to individual species accounts and conservation legislation – **www.unep-wcmc.org**

Many of the sites in this book are listed as World Heritage Sites, and more information about them, and about what WHS status means, is available at **whc.unesco.org**

There are now more organisations dedicated to the protection and conservation of wildlife than at any point in human history. The biggest players include the following:

Birdlife International **www.birdlife.org**
Fauna & Flora International **www.fauna-flora.org**
The Wildlife Conservation Society **www.wcs.org**
The World Conservation Union **www.iucn.org**
The Worldwide Fund for Nature **www.panda.org**

Organisations focused more on the state of the environment *per se* include:

Friend of the Earth **www.foe.org**
Greenpeace **www.greenpeace.org./international**
People & the Planet **www.peopleandplanet.net**
Of particular interest from the point of view of habitat conservation is
The World Land Trust **www.worldlandtrust.org**

OPPOSITE **Marooned in one National Park, the Asiatic Lion is highly vulnerable to extinction in the wild.**

INDEX

PICTURE CREDITS

The publishers would like to thank the following sources for their kind permission to reproduce the pictures in this book.

Key:

t = top, b = bottom, l = left, r = right and c = centre.

Alamy Images: /Blickwinkel: 32, 123 b, /Penny Boyd: 123 t, /Robert Harding Picture Library Ltd: 238 t, /David Tipling: 29.
Ardea: /Jean-Paul Ferrero: 137 t, /Jean-Michel Labat: 63 b.
© Daniel Bergmann: 40, 41 t, 41 b, 42, 43.
© Stevebloom.com: 52–53, 58, 59, 66–67 gatefold images no. 1 and 3, 84, 86 t, 128, 129, 131 t, 116–7, /Pete Oxford: 200 bl.
Corbis Images: /Theo Allofs: 154 tl, /Adrian Arbib: 20 b, /Ashley Cooper: 22–23, /Nigel J. Dennis; Gallo Images: 31 t /Michael & Patricia Fogden: 227 bl, /Raymond Gehman: 19, /Dan Guravich: 206, /George H. Huey: 166, /Ed Kashi: 12–13, /Craig Lovell: 171, /Joe McDonald: 70, 182, /Galen Rowell: 170 b, /Ron Sanford: 222–223 gatefold image no. 3, /Kevin Schafer: 236 t, /Brian A. Vikander: 125.
© Teresa Farino: 24 t, 24 c.
FLPA: 168 c, /Jim Brandenburg/Minden Pictures: 190 b, /Reinhard Dirscherl: 156 c, 221 t, /Michael Durham/Minden Pictures: 173 b, /John Eastcott/Minden Pictures: 169 t, /Gerry Elliis/Minden Pictures: 200 tl, 222–223 gatefold, image no. 2/Yossi Eshbol: 104 b, /Janet Finch: 143, /Tim Fitzharris/Minden Pictures: 184 b, /Michael & Patricia Fogden/Minden PIctures: 150, 154 bl, 154 cl, 154 cr, 154 br, 226, 227 t , 227 cr, 224–225, /Tom and Pam Gardner: 154 tr, /Frans Lanting/Minden Pictures: 65, 96, 113, 114–115 gatefold image no. 6, 172, 196–197, 214, 215, 216 b, 244 br, /Michio Hoshino/Minden Pictures: 188, 189, /David Hosking: 6, 15, 25, 77, 179 t, 219, /Mitsuaki Iwago/Minden Pictures: 51, 55, 78, /Gerard Lacz: 132–133, /Thomas Mangelsen/Minden Pictures: 160–1, /Colin Marshall: 114 b, /Claus Meyer/Minden Pictures: 198–199, 213, /Mitsuaki Iwago/Minden Pictures: 240, /Yva Momatiuk/John Eastcott/Minden Pictures: 194–195, /Flip Nicklin/Minden Pictures: 190 t, /Panda Photo: 33, /Patricio Robles Gil/Sierra Madre: 146 t, /Fritz Polking: 178, 208–209, /Michael Quinton/Minden Pictures: 162, /Richard du Toit/Minden Pictures: Prelim, 64–65, /S & D & K Maslowski: 169 b, /Malcolm Schuyl: 170 t, 179 b, /Tui de Roy/Minden Pictures: 184 tr, 217 tl, 222–223, gatefold image no. 5, /Jurgen & Christine Sohns: 174–175, /Ariadne Van Zandbergen: Prelim, 44–45, 79 t, 79 b, /Winfried Wisniewski: 38 b, 126, 127 b, /Martin B. Withers: 183, /Konrad Wothe/Minden Pictures: 212 t, 233, 235 tr /Shin Yoshino/Minden Pictures: 114 t, /Zhinong Xi/Minden Pictures: 130.
Getty Images: /Express Newspapers: 60, /National Geographic: 74, 75, 202–203, /Mitch Reardon/Stone: 62, /Royalty-Free: 211, /Science Faction: 158.
Nature Picture Library: /Aflo: 1, /Ingo Arndt: 86 b, 94–95, 145 b, 224, /Niall Benvie: 17 t, /Mark Carwardine: 158, /Bernard Castelein: 16 b, 124, /Jim Clare: 199, /Philippe Clement: 34–35, /Brandon Cole: 140 b, 193 t, 193 b, /Christophe Courteau: 24–25, 66 t, 67, /Delpho/ARCO: 180–181, /Angelo Gandolfi: 31 b, /Nick Garbutt: 56 t, 114–115 gatefold, images no.2 (top right), 3 (bottom right), 5, /Hanne & Jens Eriksen: 103, /Sharon Heald: 68–69, /Tony Heald: 66 c, 71, /Paul Hobson: 28 b, 63 t, /Ashok Jain: 101, /Jean-Pierre Zwaenepoel: 127 t, /Steven Kazlowski: 163, /David Kjaer: 176–177, /Luiz Claudio Marigo: 200 tl, /Lynn M. Stone: 185, Prelim , /Tom Mangelsen: 164–165, /Luiz Claudio Marigo: 212 b, /Mark Payne-Gill: 102–103, /Nigel Marven: 207, /Vincent Munier: 191,

/Pete Oxford: 54, 66–67 gatefold image no. 4, 106–107, 201, 210, 222–223, 238 b, /Patricio Robles Gil: 149, 152–153, /Michael Pitts: 137 b, /Mike Potts: 27, 28 t, /Roger Powell: 38 t, /Todd Pusser: 242, /Reinhard/Arco: 242–3, /Anup Shah: 46, 49 t, 49 b, 99 b, 100, 116, 249, / Lynne M. Stone: 173 t, /Artur Tabor: 20 t, 21, /Kim Taylor: 235 , /David Tipling: 16 t, 244–245, /Jeff Vanuga: 177, /Tom Vezo: 184 tl, /Bernard Walton: 72, /Dave Watts: 145 t, /Adam White: 141 c, /Staffan Widstrand: 85, 108, 110, 222–223 gatefold, image no.1, /Xi Zhinong: 131 br.
NHPA: /A.N.T. Photo Library: 155, /Henry Ausloos: 231 t, /Daryl Balfour: 87, 60–61, 66–67, gatefold image no. 2, /Bruce Beehler: 147, / George Bernard: 239, /Mark Bowle: 216 t, /Paul Brough: 105, /Laurie Campbell: 17b, 236 b, /James Carmichael Jr.: 234, /Bill Coster: 39 t, 223, /Vicente Garcia Canseco: 36, 37 t, / Gerald Cubitt: 99 t, 114–115 gatefold, images no. 1 & 4 (top left & bottom right), /Stephen Dalton: 24 b, /Nigel J. Dennis: 56 c, /Nick Garbutt: 57, 97 b, 115, 119, 127 b, /Iain Green: 111, /Martin Harvey: 4, 97 t, 112, 121, 136 b, 134–135, 222–223, gatefold image no. 4, endpaper, /Brian Hawkes: 221 b, /Adrian Hepworth: 228–229, 231 b, /Daniel Heuclin: 95, 148, 168 t, /Jordi Bas Casas: 34, /Rich Kirchner: 138 c, /David Middleton: 218, 240–241, /Helmut Moik: 30, /Alberto Nardi: 37 b, 39 b, /Otto Pfister: 90, /Rod Planck: 244 bl, /Andy Rouse: 120–121, 200 br, /Kevin Schafer: 209, /Jonathan & Angela Scott: 50–51, 76, 118, /John Shaw: 141 t, 245, / Eric Soder: 217 tr, /Mirko Stelzner: 26, 217 b, /Karl Switak: 136 t, /T Kitchin & V Hurst: 2–3, /James Warwick: 88–89, /Dave Watts: 135, /Martin Wendler: 230.
Photolibrary.com: 46–47, / Tobias Bernhard: 140 t, /Alan & Sandy Carey: 167, /David Cayless: 104 t, /Desney Clyne: 204–205, /Martyn Colbeck: 194, /Marty Cordano: 168 B, /Daniel Cox: 114–115 gatefold image no. 7, 142, /David Fleetham: 157 b, 192, 220 t, /Michael Fogden: 227 cl, 227 bl, /Mark Jones: 237, /Peter Lillie: 68, /Kristin Mosher: 48, /Elliott Neep: 122, /Pacific Stock: 144, / James H. Robinson: 186–187, 246–247, /Alan Root: 146 c, /Tui De Roy: 220 b, 222, /Gerard Soury: 156 t, 157 t, /Steve Turner: 151, /Konrad Wothe: 8–9, 131 bl, 232.
RSPB Images: /Steve Knell/rspb-images.com: 14.
© Snow Leopard Conservancy: 91, 92, 93 t, 93 b.
© David Wall: 138 t, 139, 141 b.
© Carlton Ward: 80–81, 81 t, 82, 82–83.

Every effort has been made to acknowledge correctly and contact the source and /or copyright holder of each picture and Carlton Books Limited apologizes for any unintentional errors or omissions, which will be corrected in future editions of this book.

Special thanks to Jean Hosking at FLPA, Rachelle Macapagal at Nature Picture Library and Tim Harris at NHPA for their help on this publication.

ACKNOWLEDGEMENTS

The author would like to thank the following people for their help and advice: Jo Anderson, Steve Backshall, Miles Barber, Sophie Blair, Clive Byers, Dominic Couzens, Deborah Evans, Teresa Farino, Nick Garbutt, Honor Gay, Andrés Hernández-Salazar, Darla Hillard, Isobel Hunter, Luke Hunter, Rodney Jackson, Mike McCoy, John & Valerie O'Dwyer, Simon Papps, Hashim Tyabji, Sarah Whittley, Sue & Malcolm Whittley and Simon Wilson Stephens. Particular thanks go to Project Editor Gareth Jones, for his cheerful patience and support throughout, to Liz Dittner for her discerning editorial eye, to Steve Behan for doing such a great job on picture research, and to Anna Pow and Smith Design.